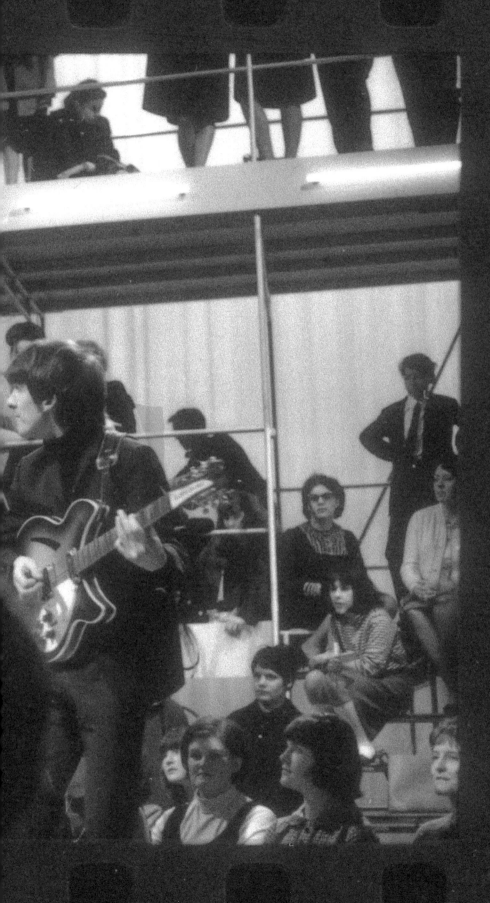

The Beatles Unseen

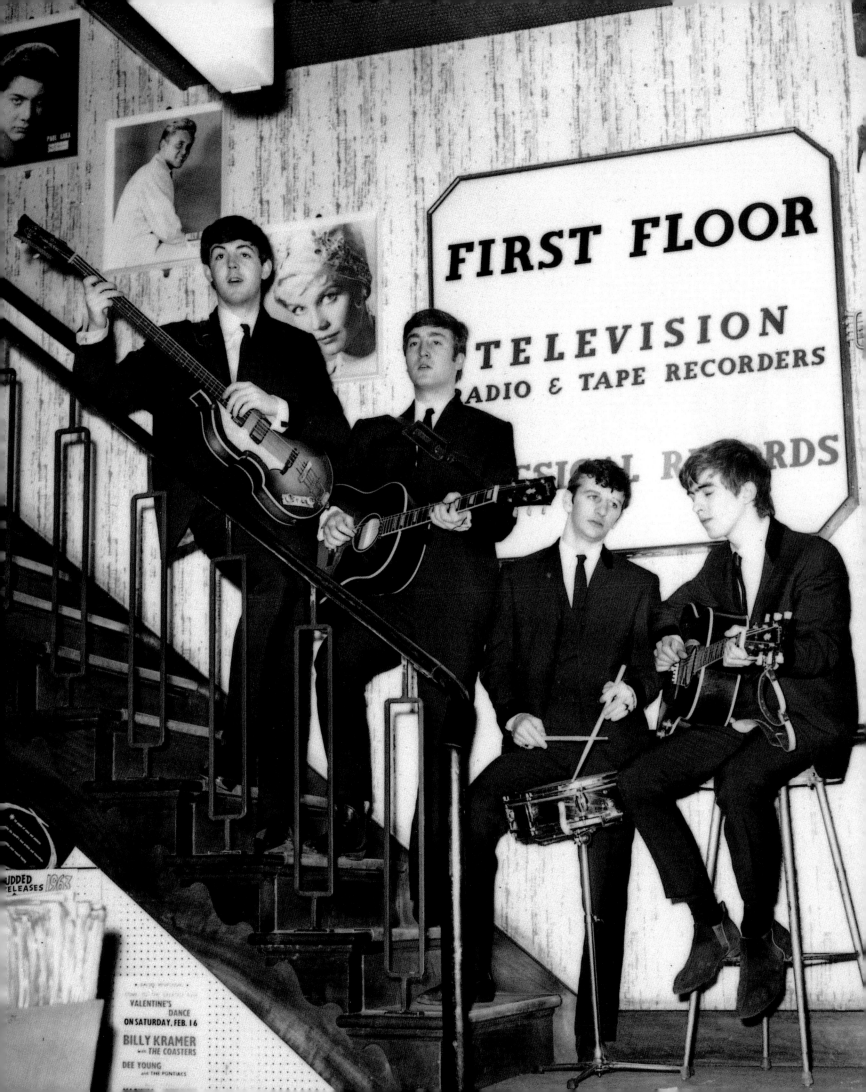

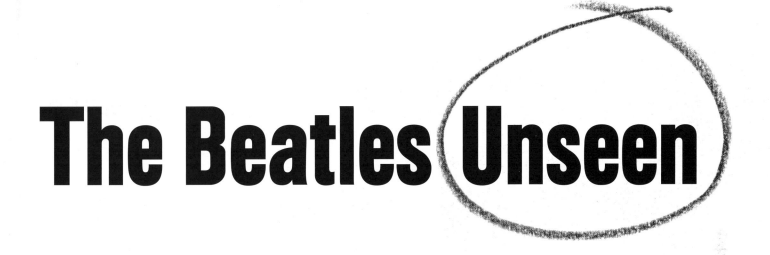

The Beatles Unseen

Mark Hayward with Keith Badman

WEIDENFELD & NICOLSON

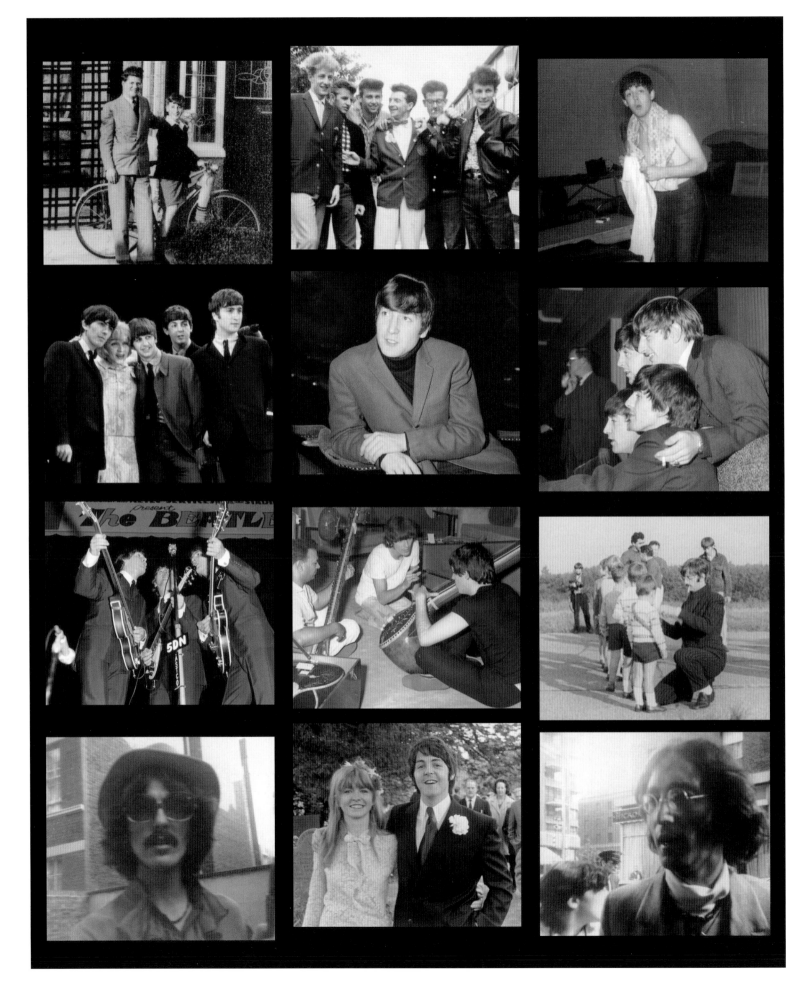

Contents

Foreword 6

1 Early Days

Growing up on Merseyside 14
John's Liverpool childhood 18
The Quarry Men 26
The Cavern days 28
Ringo performs at Butlins 30

2 Touring Years

Climbing the ladder to fame 36
Sloane Square, London 40
Shrewsbury 44
Weston-super-Mare 48
Dundee 52
The Royal Variety Performance 56
Manchester 58
Granada TV Studios, Manchester 60
Sunderland 62
Doncaster 66
BBC Paris Studios, London 78
Olympia Theatre, Paris 80
Filming A Hard Day's Night 82
The NME poll winners' concert 99
Wembley Studios, London 100
The Jimmy Nicol story 104
Touring Australia 106
Adelaide press conference 122
Eight days a week 148
Leeds 152
Southampton 154
Meeting the Queen... and the King! 164
Help! cover shoot, Twickenham 166

Trouble in the air 172
TVC Studios, London 176
A break in Trinidad 180
New Delhi, India 192
The Beatles crucified 198

3 Studio Years

The summer of love 204
Strawberry Fields 208
Penny Lane 216
Bad news in Bangor 220
The Magical Mystery Tour 222
In Cornwall 226
At West Malling airfield in Kent 238
A photographer's tale 246
New beginnings 268
The Beatle belt 270
London summer 280
The Apple business 290
White wedding 296
Releases and romances 306
Fan photos – a mixed bag 310
Let It Be 336
Live Peace in Toronto 338
The last albums 340

4 Postscript

The final days 344
The Hit Factory interview 348

Index 354
Credits 358
Acknowledgements 359

Foreword

I am a Beatle fan. They are, and always have been, the best pop/rock band; no one else comes close. The Beatles released twelve albums and their work just got better with each release. I cannot think of another band that have managed to get through their career without recording at least one bad album, yet alone produce twelve of the best.

Looking at all these unpublished photographs made me realize the vast difference in popular culture – music, arts, lifestyle, characters – between the sixties and today. Entertainment was different then. There were no home DVD surround systems, video recorders, computers and computer games to keep you in front of a screen. In the UK, the choice was restricted to three TV channels in black and white, movies, live concerts and record releases by stars like The Beatles, Bob Dylan, The Rolling Stones or Jimi Hendrix. A fan had time to listen to the music without many of today's distractions. By comparison, today's musicians have to compete to be heard with DVDs, mobile phones, computers, electronic games and a back catalogue archive of over seventy years of rock, blues and pop music easily downloadable onto portable players smaller than the cigarette packets carried around by sixties teenagers.

The sixties saw an explosion in the arts and The Beatles contributed to this. The artwork of the album cover expressed the recording artists' taste in visual art. The sleeve was a piece of art to be admired while the twenty-five minutes or so of tracks each side of the disc was listened to several times over. The Beatles were the first band to commission a famous artist to produce an album cover – Klaus Voormann for *Revolver*. They went on to commission pop artist Peter Blake to produce the album cover for *Sergeant Pepper's Lonely Hearts Club Band*. The Rolling Stones followed their example with the iconic jeans-zipper illustration by Andy Warhol for *Sticky Fingers*.

One of the few bands to travel abroad in the early sixties, The Beatles helped bring outside influences to pop music. Sitars were not widely known outside the Indian subcontinent until *Rubber Soul* tuned the masses in to Indian culture. People just didn't travel as much due to the expense of air travel (discount airlines had not been invented), so the fans looked to The Beatles to bring that outside culture to them. In music, design, fashion, they were the leaders and everyone else followed. When The Beatles grew their hair long, David Bowie followed suit.

I began by selling records in Camden Lock market in 1977 and went on to run a stall in Soho market (now a car park at the end of Chinatown). London auctioneer Sotheby's held their first pop sale on Tuesday 22 December 1981, and Phillips, Bonhams and Christie's, also in London, followed suit with two sales a year. Over the next twenty-four years there were always one or two lots per sale featuring photographs sold with copyright. The first lot of photographs I purchased was from a sale at Phillips auctioneers

For many years I have queued with friends for concerts of all kinds, praying that they don't put up a 'sold out' sign just in front of us. So I can fully understand this Australian girl's joy in obtaining that treasured Beatles ticket. This is one of my favourite photographs.

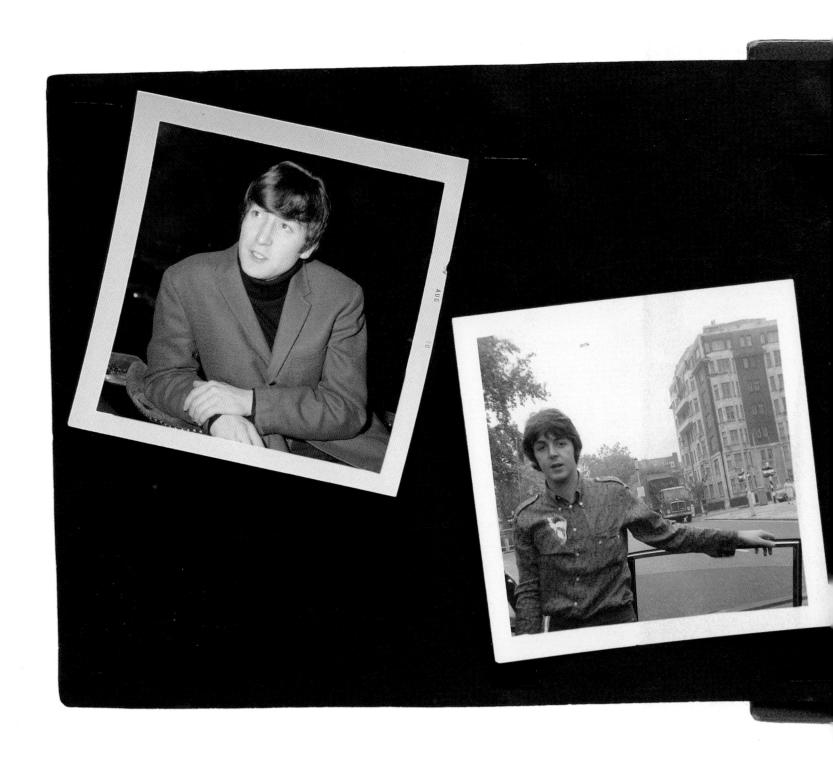

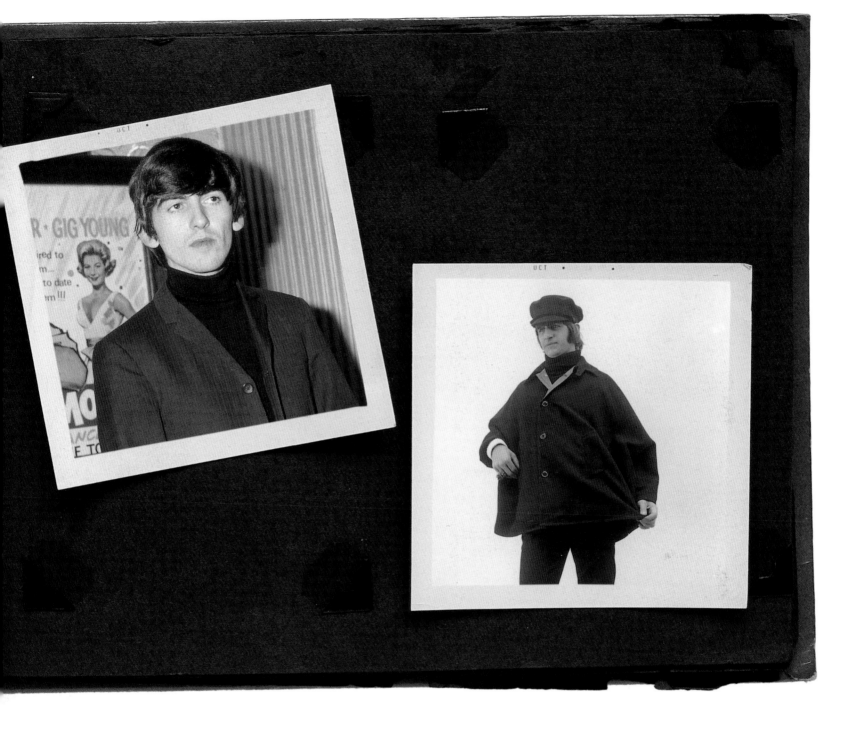

The Fab Four: a taste of things to come… *Left to right:* John, Paul, George, Ringo.

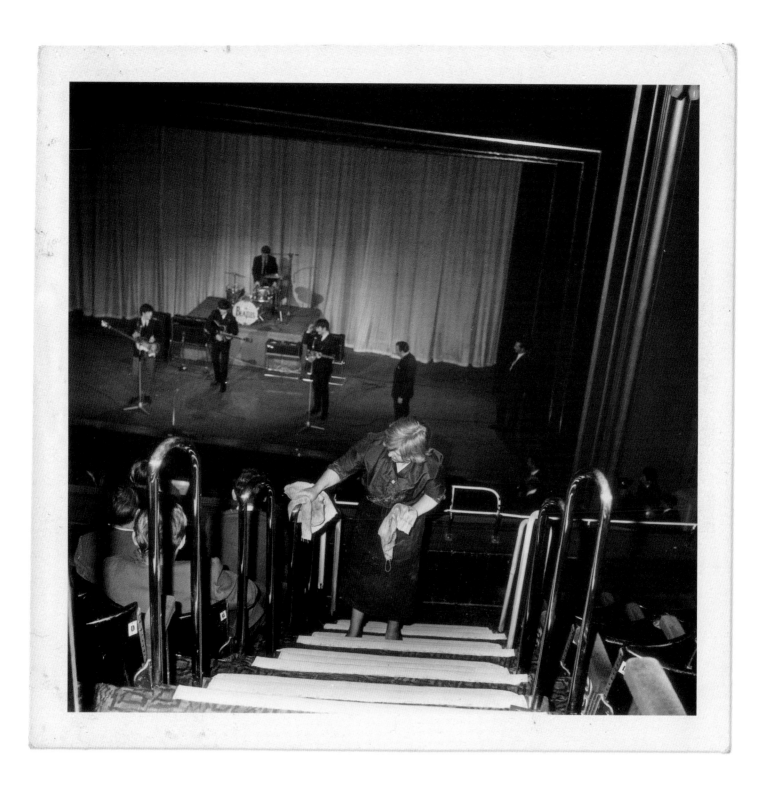

Photographers had access
to all areas, including the
circle, where this photo was
cheekily taken. To this lady,
shining the banisters took
precedence over watching
The Beatles rehearse.

in 1988. The job lot had been taken by the photographer for *Mirabelle* magazine, and included shots of Cliff Richard and The Animals as well as The Beatles. I had developed a technique for bidding successfully at auction. I would stand at the back of the room where you can keep an eye on who you're bidding against without them seeing you easily, and once the bidding had finished, and the auctioneer was about to bring the hammer down, I would put my hand up. For the last bidder, this acts as a psychological blow; they thought the auction over and the item theirs, and often wouldn't bid again after my bid – a technique now used a lot on eBay.

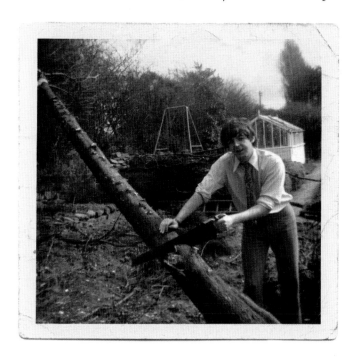

McCartney – carpenter, singer, songwriter. A very personal photo of Paul in the garden.

The next time I made a purchase at Christie's auctioneers there were few people bidding and hammer prices were low. It wasn't until Neil Aspinall of Apple Corps came up with the idea of buying photographs that prices started taking off. I was bidding against a company looking to amass an archive for what was to become the *Anthology* DVD, book and CD series. I was fortunate enough to outbid other buyers on several occasions, including my prize acquisition of the *Hard Day's Night* session in colour, as seen in this book. The previously unpublished photographs from this session give the reader the thrill of seeing scenes from the black-and-white film in full colour. I didn't succeed every time I wanted to buy photographs and film, but I have been happy with my acquisitions to date. The photographs were purchased with a view to releasing a book, but being so busy, I didn't get round to it until now.

We have tried to get in touch with the photographers themselves for their stories of how they came to take the pictures. Some have passed away, some had not much to say, but others have provided enlightening comments that are included in the book.

We wanted to make this book different to other Beatles books. We don't aim to tell the full history of The Beatles – the *Anthology* does that. Instead, the behind-the-scenes glimpse gives a different angle on some key public appearances and an insight into more private moments. The photographs featured in the Early Days and Touring Years chapters reveal an early innocence as the band has fun while working flat out; the Studio Years shots show a different side as the group begins to fracture.

MARK HAYWARD

1
EARLY DAYS

A BRIEF GLIMPSE OF JOHN, PAUL, GEORGE, PETE BEST AND RINGO

Growing up on Merseyside

John's story

From a very young age, following his parents' separation, John was raised by his Aunt Mimi. She described the young Lennon as a 'loveable rebel, who hated conformity and those who wanted to make him conform'. Mimi remembered, 'John was a handsome little boy, with shiny, silver-gold hair and big brown eyes. He was always the leader of his little gang and insisted on being the Indian and never the cowboy. I always remembered that John's word was the law. When he told his gang members, "You're dead," they would accept they were dead. John wouldn't argue about it. When he played the role of an Indian, he had all the equipment. When I made him a headdress, I used to get a bundle of feathers from the local butchers. In our back garden, John used to sit in a house which had been built in our tree. He used to hide in there for hours, drawing and making up rhymes. He called it his den. Whenever John was naughty, I sent him up to his bedroom. But when I did this, he was always so quiet up there. So one day, I decided to go and see what he did in his room. I crept up to the door, looked in and there he was, sitting quietly in his easy chair, reading a book. He was totally happy and all the time I thought I was punishing him. John loved reading. His favourite books were all about painting.'

'I think I went a bit wild when I was fourteen,' John admitted. 'I was just drifting. I wouldn't study at school, and when I was put in for nine GCEs, I was a hopeless failure. My whole school life was a case of "I couldn't care less!". It was just a joke as far as I was concerned. Art was the only thing I could do, and my headmaster told me that if I didn't go to art school, I might as well give up life! I wasn't really keen. I thought it would be a crowd of old men, but I should make the effort to try and make something of myself. I stayed for five years doing commercial art. Frankly I found it almost as bad as maths and science, and I loathed these!'

In January 1956 John purchased a 78r.p.m. copy of 'Rock Island Line' by the skiffle king Lonnie Donegan, and played it until it was almost worn out. 'I was obviously very musical from a very early age and I often just wonder why nobody in my family never done anything about it, maybe 'cos nobody could afford it. My mother played banjo and I remember my granddad playing it when I was very young. She often played it if there was ever one around but there was never one around, because we sold it, because of the hard times. I used to borrow a guitar at first. I couldn't play, but a pal of mine had one and it fascinated me. I then convinced my mother to buy me a "guaranteed not to split" guitar for ten pounds that we sent away for from one of those mail order firms. I suppose it was a bit crummy when you think about it, but I played it all the time and I got a lot of

Cousins Stanley (14) and Leila (10) with John (7) in the front garden of Fleetwood, the house where they were holidaying in Lancashire. 1947.

practice. She taught me banjo chords. If you look at the early photos of the group you can see me playing funny chords. It's a joke in the family, "A guitar's all right John, but it can't earn you money…" After a while we formed The Quarry Men with some lads including Eric Griffiths, Pete Shotton, my best mate at school, and myself. We also had a lad named Gary and somebody else named Ivan. Ivan went to the same school as Paul and he brought him along one day when we were playing at a garden fete.'

Paul appears on the scene

John Lennon's skiffle group The Quarry Men appeared in public for the first time on 24 May 1957, during the afternoon and evening at the Rosebery Street 'Empire Day' outdoor celebration in Liverpool. The line-up – John on vocals and guitar, Eric Griffiths on guitar, Pete Shotton on washboard, Len Garry on tea-chest bass, Rod Davis on banjo and Colin Hanton on drums – played on the back of a coal lorry and were not paid for their services. Six weeks later, on July 6, The Quarry Men performed three concerts at an all-day fete

held at St Peter's Church in Woolton, Liverpool. At approximately 6.15p.m. in the Scout hut on the field, Ivan Vaughan introduced John to the budding young musician Paul McCartney, who had been lured to the fete by Ivan on the promise that there would be loads of females to chat up.

'I was still fifteen when I met John at a village fete in Woolton in Liverpool,' Paul reminisced. 'John had a few beers and I finally said "Hello" to him. We were backstage and John was leaning over me with this beery breath. One of them lent me their guitar and I had to turn it round because I'm left-handed, but because I had a mate who was right-handed, I had learnt to play upside down, so that was a little bit impressive. But I also knew the words to this song that they all loved and didn't know the words, and that was enough to get me in. It was called "Twenty Flight Rock" by Eddie Cochran. That's how it started really. We used to sag off school together and we'd go back to my house when there was no one in during the afternoon. We'd smoke Twinings tea in a pipe. It didn't taste too bad actually. We'd sit around, smoking, and have a little bash on the piano. We'd write mostly Buddy Holly type songs, because they used to have the least chords. We wrote about 100 songs then, before "Love Me Do" was published.' 'Paul and I hit it off right away,' John recalled.

Paul made his live concert debut with The Quarry Men at the New Clubmoor Hall in Norris Green, Liverpool four months later, on October 18. 'I went into The Quarry Men as the lead guitarist because I wasn't bad on guitar,' he recalled. 'When I wasn't on stage I was even better, but when I got up on stage, my fingers all went stiff. I had a big solo, on the song "Guitar Boogie", and when it came to my bit… I blew it! I just blew it! I couldn't play at all and I got terribly embarrassed. My fingers found themselves underneath the strings instead of on top of them. So I vowed that first night that that was the end of my career as the lead guitarist. I goofed on that one terribly and so, from then on, I was on rhythm guitar.'

George makes music with Paul and John

'I'd met Paul while I was at school,' George Harrison remembered. 'We both had this interest in guitars. When I first wanted a guitar, my mother bought me this very cheap guitar worth three pound ten shillings. She didn't mind that I used to stay up until two in the morning polishing my guitar and trying to learn how to play. Paul actually had a trumpet first. I remember he always used to be playing "When The Saints Come Marching In" on it. Paul realized that he wasn't going to be able to sing and play the trumpet at the same time, so he traded it in and got a guitar. In those days though, they didn't cater for left-handed guitarists, so he had to buy an ordinary one and then play the chords back to front. It was a scream, really, because, instead of strumming the strings down, he had to scratch them up from the bottom.

'I used to have a group of my own called The Rebels, or some such name. I remember when Paul and I used to play guitar and John would just sing without any instrument. We were on a Buddy Holly kick in those days, with numbers like "Think It Over" and "It's

So Easy". We did the Carrol Levis discoveries show in Manchester once, and Billy Fury was at the first audition. I think we were Johnny & The Moondogs at that particular time. You were judged by the audience applause, you know, but we had to catch a train home before the end. We never did find out if we'd won, but Billy passed his audition, I know that. When I left school, I was an apprentice electrician for about four months. I remember asking my big brother, would you pack in work and have a go at music if you were me, and he said, "Well, you might as well, you never know what might happen, and if you don't, you are not going to lose anything by it." John was at art college and Paul was doing an extra year at school. Then we got the opportunity to go to Scotland and then on to Hamburg and then, after that, I forgot about doing a nine to five job.'

Ringo meets The Beatles

'When I was about fourteen,' Ringo Starr recalled, 'I was in hospital and, to keep us happy, they had a ward band and a teacher used to come along and she put up a big board with all yellow dots and red dots. When she pointed to red dots, yellow dots or green dots, the triangles or drums would play. It was a funny little band, and I would never play unless she gave me a drum. So I used to fight for the drums. That was when I was first interested in drums and then I used to bang on the locker beside my bed. I'd always liked the idea of drumming, and when I heard any music I used to tap on things. When I came home from hospital I used to put little bit of wires on top of biscuit tins and bash them with bits of firewood. When I was eighteen, for Christmas, my mum and dad got me my first drum kit which cost thirty bob and had a huge one-sided bass drum which used to drive the neighbours all mad. It was a sort of mixture of different parts, mostly about twenty-five years old, but I was really proud. Every time I got behind it, it used to hide me, what with me being little and the drum being a fantastic size. I wouldn't be surprised if you told me it was ten feet across! I eventually had three drum lessons once I got interested. I went to this little man who was in this house and he played drums and he told me to get a manuscript. He wrote it all down and I never went back after that, because I couldn't be bothered. It was too routine for me, parra-diddles and all that.'

By 1960, Rory Storm & The Hurricanes were the top band in Liverpool. This was also the year that the group's drummer, Ringo Starr, made the decision that would ultimately change his life. The Hurricanes were offered a thirteen-week engagement at the Butlins holiday camp in Wales (where the shots on pages 30–3 were taken) and Ringo knew that if he were to go to Wales he would have to sacrifice his job as an apprentice joiner. He set off for Pwllheli with the other four members of the group, Rory Storm, Charlie O'Brien, Wally Egmond and John Byrnes. Things were now on the up for Ringo. His years of bad health were behind him, and after a successful stint in the camp Rory Storm & The Hurricanes were given the chance to go to Germany, where the group would soon be topping the bill at Hamburg's Kaiserkeller night club. It was during that engagement that Ringo would meet another Merseyside group, The Beatles, for the very first time.

'Every time I got behind it, it used to hide me, what with me being little and the drum being a fantastic size.'
RINGO STARR

John's Liverpool childhood

The images of John Lennon at seven, nine and fourteen, shown over
the next few pages, came from Stanley Parkes, John's cousin.
For a family member to sell such personal photographs is unusual, and
the fact that they are of John Lennon makes them exceptionally rare.

MARK HAYWARD

'John was a handsome little boy, with shiny, silver-gold hair
and big brown eyes. He was always the leader of his little gang
and insisted on being the Indian and never the cowboy.'

AUNT MIMI

Above, left to right: First cousins
Michael, Leila and David,
John's half-sister and John
(aged 9), at Ardmore
(Stanley's original house) in
Rockferry, Cheshire. 1949.

Below: Aunt Mimi (bottom
left, standing on left)
and other family members,
taken by Stanley Parkes.

Left: John with his mother Julia (known in the family as Judy) at Ardmore, 1949. She was the inspiration for the song 'Julia' on the *White Album*. Taken by Stanley Parkes. *Above*: Aunt Mary (known as Mimi) at Ardmore.

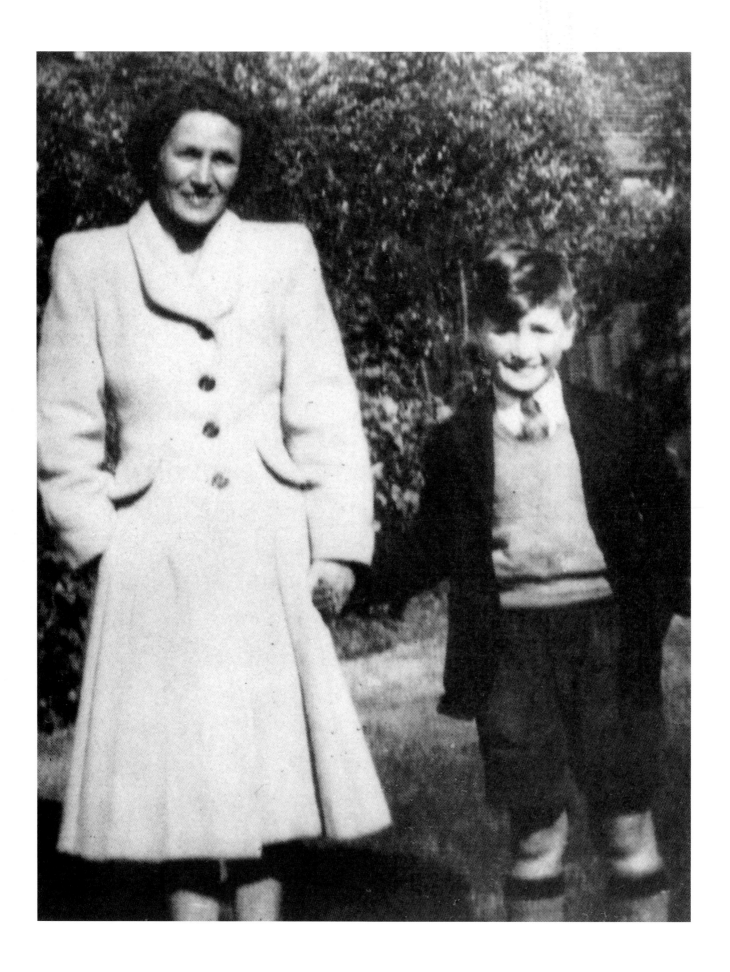

'John was a loveable rebel who hated conformity and those who wanted to make him conform.'
AUNT MIMI

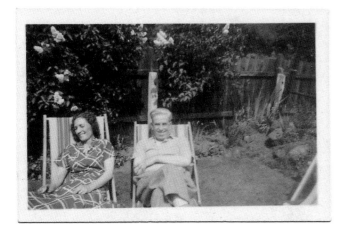

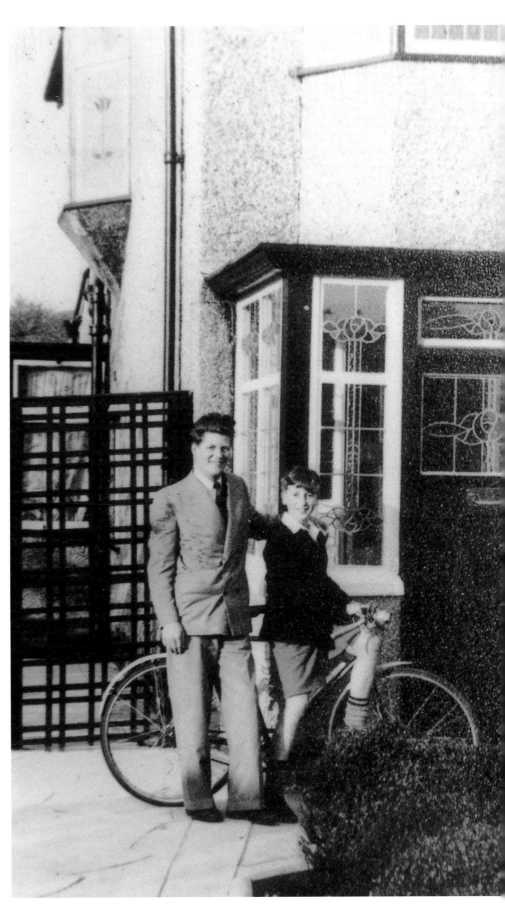

Left: John with his cherished Aunt Mimi, who brought him up after the loss of his mother. *Above*: Aunt Mimi and Uncle George in the back garden of their home, Mendips, in Woolton, Liverpool. Mid-1940s. *Right*: Stanley (20) and John (13) at the door of Mendips in 1953. John's first bike was given to him by his Uncle George.

'Me at Fleetwood the year I lost my trunks in Mr Shipway's garden.'

JOHN LENNON

Self-portrait taken by John (probably aged 7) in the front garden of Fleetwood – an early interest in the art of photography. Amazing to find this photo with John's own handwriting on the reverse.

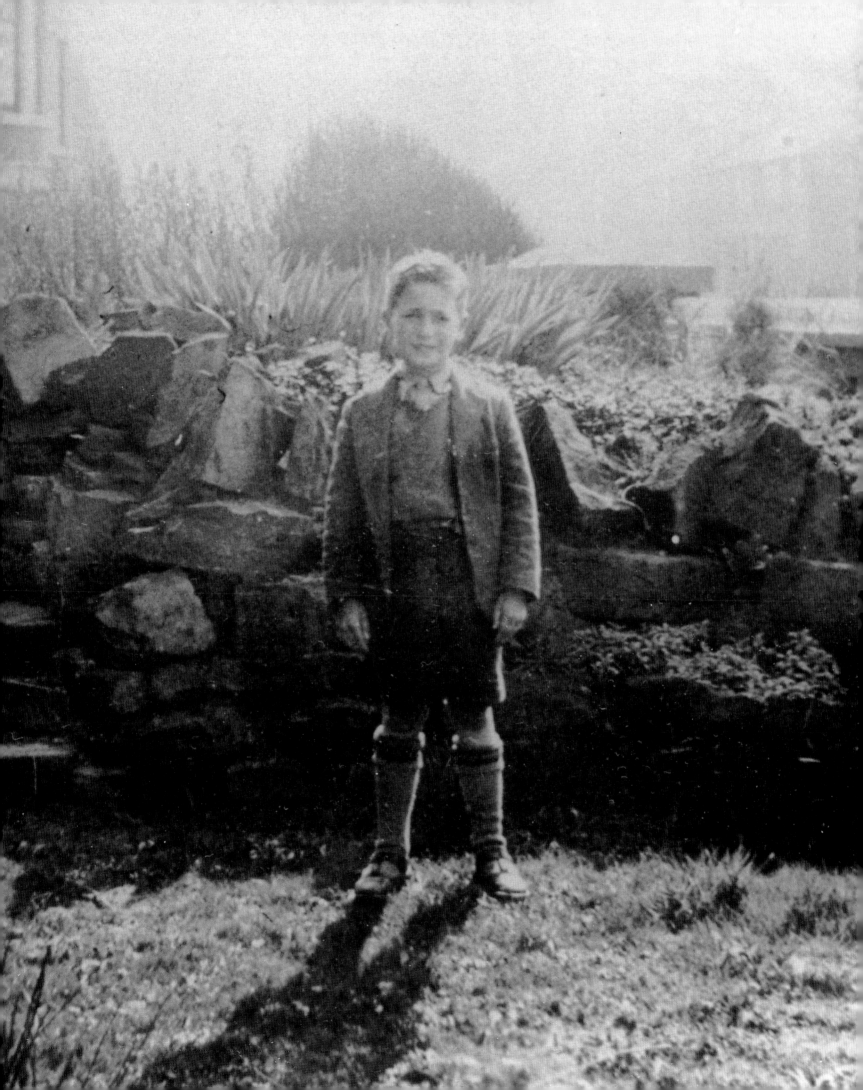

The Quarry Men

'I was still fifteen when I met John at a village fete in Woolton in Liverpool. John had a few beers and I finally said "Hello" to him. We were backstage and John was leaning over me with this beery breath. One of them lent me their guitar and I had to turn it round because I'm left-handed, but because I had a mate who was right-handed, I had learnt to play upside down, so that was a little bit impressive. But I also knew the words to this song that they all loved and didn't know the words, and that was enough to get me in.'

PAUL McCARTNEY

Below: The programme for the fete in St Peter's Church Field, Woolton, on 6 July 1957, where Paul met John for the first time. John was playing at the fete in The Quarry Men Skiffle Group.

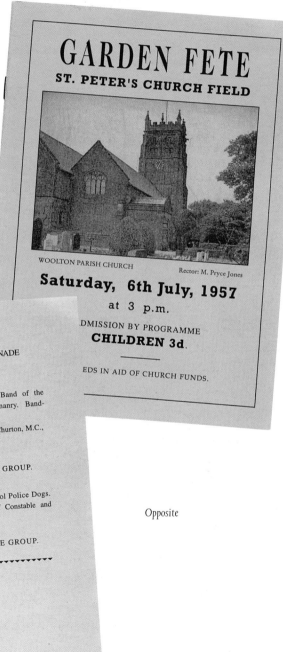

GARDEN FETE
ST. PETER'S CHURCH FIELD

WOOLTON PARISH CHURCH Rector: M. Pryce Jones

Saturday, 6th July, 1957
at 3 p.m.

DMISSION BY PROGRAMME
CHILDREN 3d.

EDS IN AID OF CHURCH FUNDS.

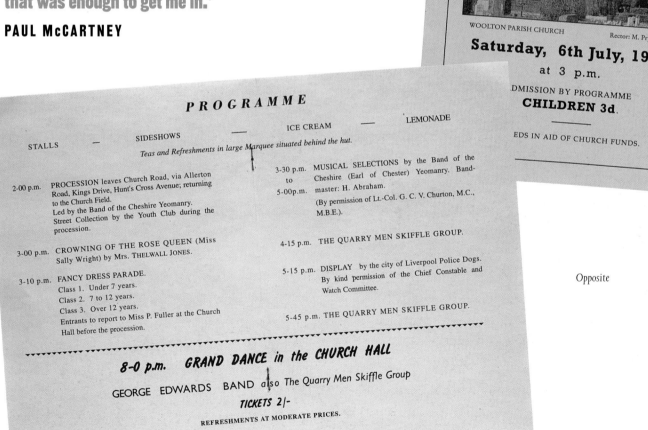

PROGRAMME

STALLS — SIDESHOWS — ICE CREAM — LEMONADE

Teas and Refreshments in large Marquee situated behind the hut.

2-00 p.m. PROCESSION leaves Church Road, via Allerton Road, Kings Drive, Hunt's Cross Avenue; returning to the Church Field.
Led by the Band of the Cheshire Yeomanry.
Street Collection by the Youth Club during the procession.

3-00 p.m. CROWNING OF THE ROSE QUEEN (Miss Sally Wright) by Mrs. THELWALL JONES.

3-10 p.m. FANCY DRESS PARADE.
Class 1. Under 7 years.
Class 2. 7 to 12 years.
Class 3. Over 12 years.
Entrants to report to Miss P. Fuller at the Church Hall before the procession.

3-30 p.m. MUSICAL SELECTIONS by the Band of the
to Cheshire (Earl of Chester) Yeomanry. Band-
5-00 p.m. master: H. Abraham.
(By permission of Lt.-Col. G. C. V. Churton, M.C., M.B.E.).

4-15 p.m. THE QUARRY MEN SKIFFLE GROUP.

5-15 p.m. DISPLAY by the city of Liverpool Police Dogs. By kind permission of the Chief Constable and Watch Committee.

5-45 p.m. THE QUARRY MEN SKIFFLE GROUP.

8-0 p.m. GRAND DANCE in the CHURCH HALL
GEORGE EDWARDS BAND also The Quarry Men Skiffle Group
TICKETS 2/-
REFRESHMENTS AT MODERATE PRICES.

Opposite

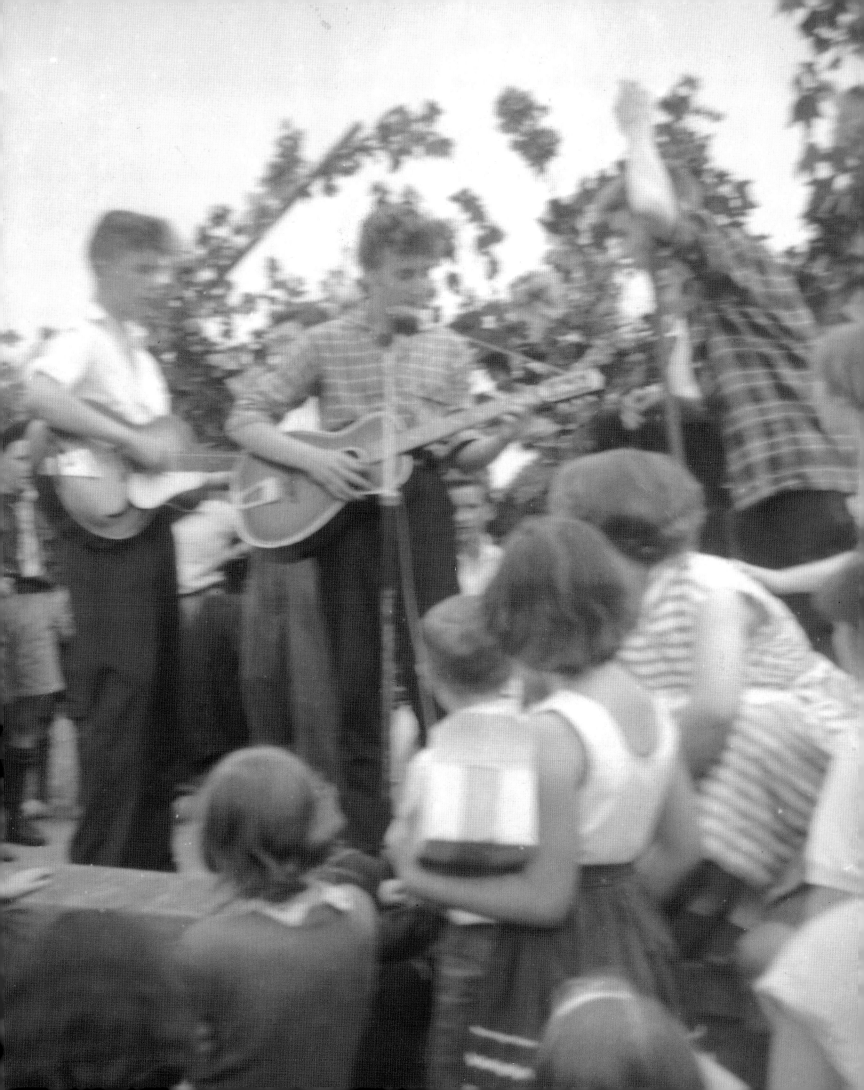

The Cavern days

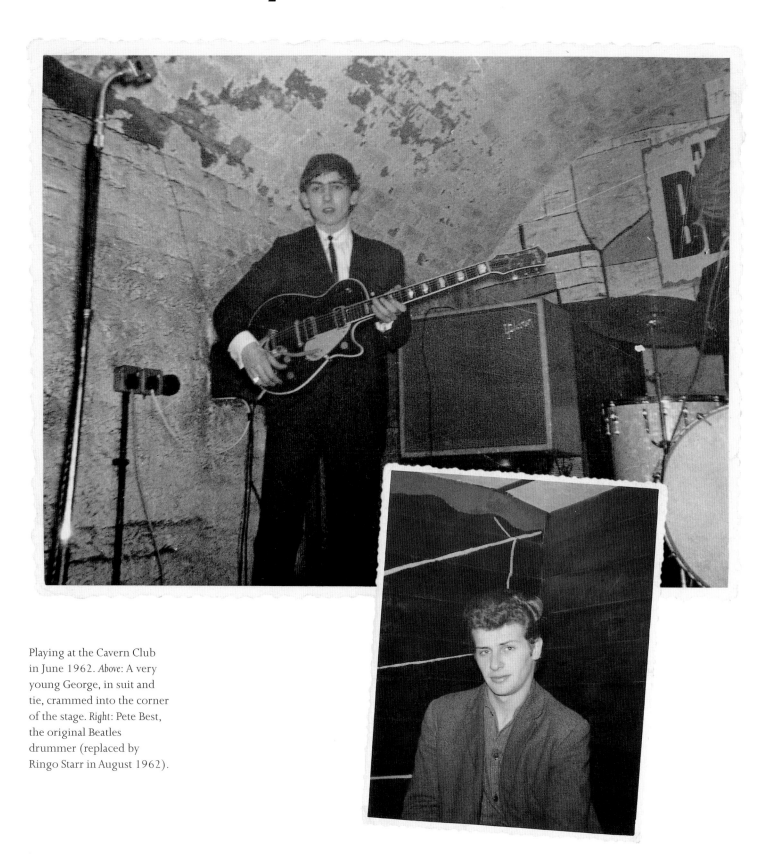

Playing at the Cavern Club in June 1962. *Above*: A very young George, in suit and tie, crammed into the corner of the stage. *Right*: Pete Best, the original Beatles drummer (replaced by Ringo Starr in August 1962).

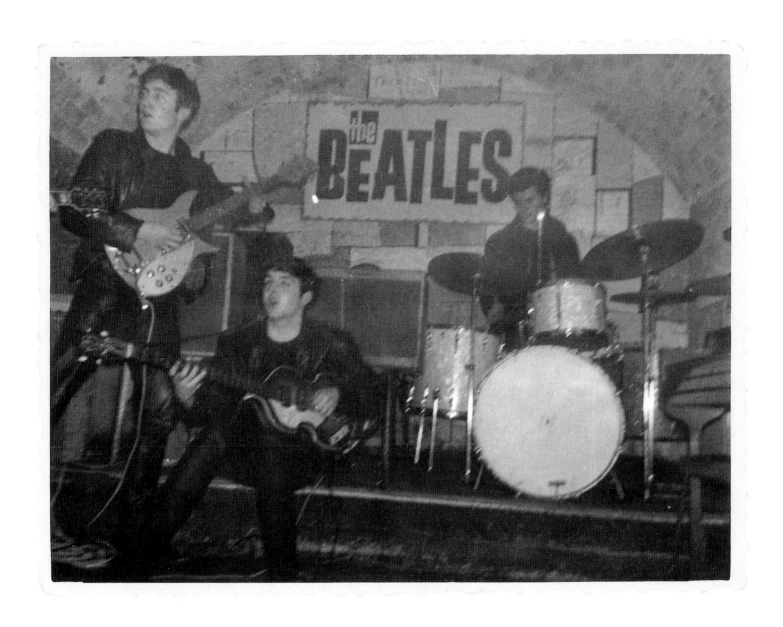

The Silver Beatles, as they were known for a short time, often appeared in leathers, as in the original photograph featured on the cover of the *Anthology* LP and CD. John, Paul and Pete Best, June 1962.

Ringo performs at Butlins

Above: Gene Vincent (*second from left*) with some of The Hurricanes. *Opposite*: Ringo with his bandmates, Rory Storm & The Hurricanes, at Butlins, Skegness, in summer 1962. To those of you not familiar with it, Butlins is a holiday camp featuring chalets/apartments, glimpsed here in the background. *Left to right*: Rory Storm, Ringo, Ty Brian, a Butlins 'redcoat', Lou Walters, Johnny Guitar.

By 1960, Rory Storm & The Hurricanes were the top band in Liverpool. This was also the year that the group's drummer, Ringo Starr, made the decision that would ultimately change his life.

A very rare photograph purchased at Sotheby's auctioneers in London, depicting a young Ringo Starr in Rory Storm & The Hurricanes at Butlins holiday camp, Skegness, in July or August 1962. When I got the picture home, out slipped the original paperwork for a Rory Storm gig later that summer: Rory Storm was paid £100 for contract number 409 as a salary for the week ending 31 August by New Century Artists Ltd, based in 112/114 Great Portland Street, who took £10 for their booking fee.

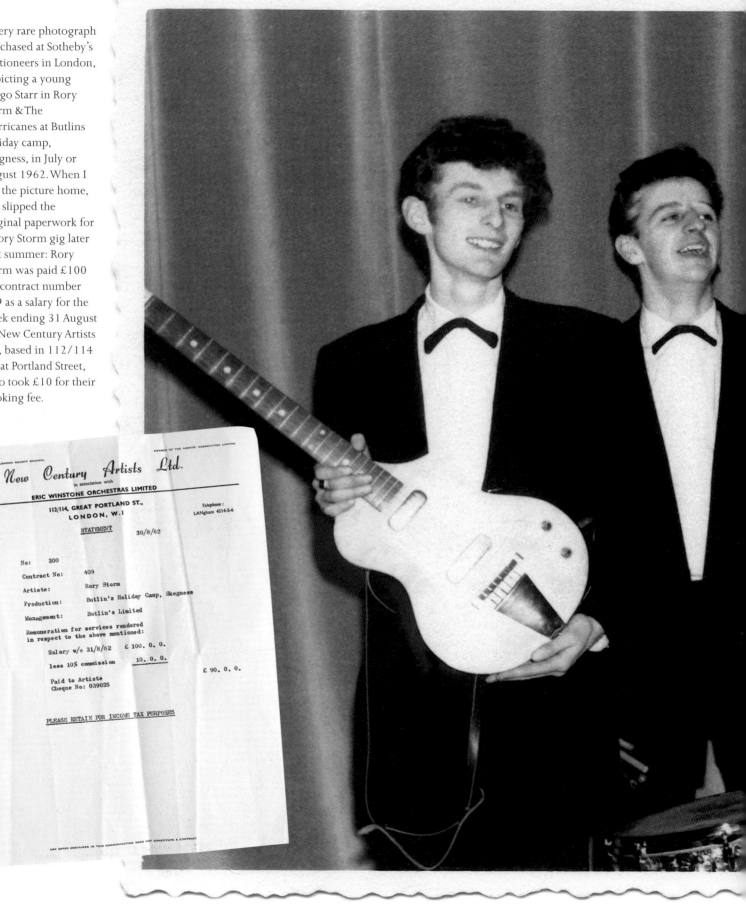

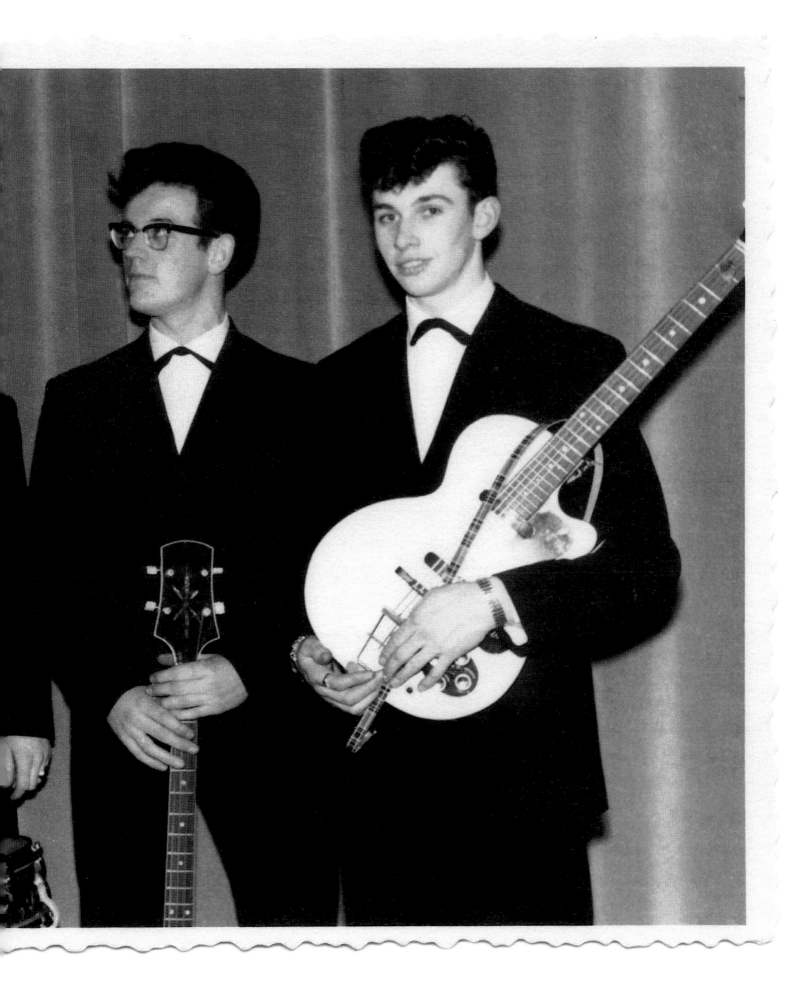

2
TOURING YEARS

CHALLENGING DAYS ON THE ROAD, 1963-6

Climbing the ladder to fame

1963 began with The Beatles' television debut on the ITV pop music show *Thank Your Lucky Stars*. Then on February 11, the group assembled at EMI's Abbey Road Studios in St John's Wood, London, with the producer George Martin, to rush-record ten new tracks and thus finish, in one swift thirteen-hour session, their debut album, *Please Please Me*. The Beatles' rise to the top was picking up speed. As the year progressed, regular appearances on various British television shows and BBC radio programmes such as *Here We Go*, *Saturday Club* and *Easy Beat* interspersed a hectic UK touring schedule.

For their second tour of the year, The Beatles found themselves supporting the young 'Walking Back To Happiness' chart star Helen Shapiro, dubbed by the press 'Britain's international teenage star'. 'The first thing I remember about this tour was being introduced to The Beatles at the start of the tour on one of the stages,' she recalled. 'Paul, who was always the spokesman and the diplomat, introduced me, one by one, to the rest of the group. I had heard of them, of course, and heard "Love Me Do". I loved it! What I also remember is that they opened the show and a lot of people said at the time they were very good but over-amplified because they didn't know much about working on a big theatre stage, so they had a lot to learn. I also remember certain incidents, like Paul practising his autograph loads of times on a photograph and coming in to show me and asking me what I thought of them. George was always talking about being rich and wanting to make loads of money.

'The basic difference between The Beatles and groups like The Shadows was that they weren't so immaculate and smart. Their music was much more earthy and basic, with a bit of rock and roll in it. It got the kids really rocking, because they knew what they liked. The Beatles did their own thing. I used to watch them at every show and, although sometimes they were very loud, and some things used to go wrong with their amplifiers, they still had this magnetic quality. You just had to watch them, because you didn't know what they were going to do next. They looned around on stage and their music was just a good, happy sound.'

In those days, in contrast to today's concerts where usually there is just one headline band and maybe a support act, tours were typically of the package kind, a style that had evolved from music halls with their variety acts. A number of bands would perform on any one occasion, often quite briefly; the more successful performers topped the billing, of course, and success could be traced by how quickly a band progressed up the billing ladder. As The Beatles shot up the billing ranking, sales of their records also increased in leaps and bounds. Helen Shapiro comments, 'When "Please Please Me" went to No.1 in the NME UK

singles chart, their first reaction was very wild. They were knocked out! I remember sitting with them as they watched themselves on their first national TV appearance and they could not believe what they looked like. Of course, from that moment on, they took over the tour. The kids just went wild and potty and used to chase them around the hotel and theatres. Through them, of course, we packed them in more and more. The audiences just went wild! I had a huge crush on John, but I was only sixteen! He treated me like a little sister. He was the one that looked after me and made sure that I didn't get run over and so on. What none of us knew was that he was already married.'

But this climb up the British package-tour ladder was unfortunately having an adverse effect on The Beatles, as John recalled. 'The music was dead before we even went out on the theatre tours of Britain,' he admitted. 'We were feeling shit already because we had to reduce an hour or two hours playing, which we were glad about in one way, to twenty minutes and go on and repeat the same twenty minutes every night. The Beatles died then as musicians. That's why we never improved as musicians. We killed ourselves to make it, and that was the end of it. George and I were more inclined to say that.'

Beatlemania

On May 18, and with no time to relax and take stock of their successes, The Beatles performed at the Adelphi Theatre in Slough at the start of their third and biggest British tour. Fellow Liverpool band Gerry & The Pacemakers joined them, and top of the bill was the legendary singer Roy Orbison. At the theatre before the concert, The Beatles' producer George Martin presented the group with a silver disc for their third single, 'From Me To You'. With chart-topping singles such as 'She Loves You' and 'I Want To Hold Your Hand' following soon after, presentations like these became a regular occurrence throughout the remainder of 1963. In October, as the sessions for their second album, *With The Beatles*, were drawing to a close, the Fab Four performed to a television audience of fifteen million on the variety show *Sunday Night At The London Palladium*. The following morning's newspapers carried stories about 'riots' by Beatles fans outside this famous building. The *Daily Mirror* wrote, 'Police fought to hold back 1,000 screaming teenagers.' The over-hyped reports were just that. Eyewitnesses and bystanders later remarked that at best just eight young girls were present. Nevertheless, the first major seeds of mania surrounding the group were planted in the minds of the general public.

On October 23, The Beatles journeyed to Sweden for their first-ever European tour. They returned to the UK on October 31 and just one day later the decidedly weary Beatles arrived at the Odeon Cinema in Cheltenham to begin yet another British excursion. The group were no longer one of the support acts. They had finally reached the peak of the package-tour tree.

Another turning point in The Beatles' rise to fame came on November 4 when they appeared in front of the Queen Mother at the prestigious *Royal Variety Performance* at the Prince of Wales Theatre in London. The following morning, the phrase 'Beatlemania' was officially coined for the very first time when the wording appeared on the front page of

the *Daily Mirror* in a report focusing on the hordes of screaming fans outside the venue. But a rival UK newspaper, the *Daily Express*, was less than enthusiastic about the fans' behaviour, remarking, 'This mass hysteria only serves to fill empty heads.'

Aside from these few press criticisms, as 1963 ended it seemed as if the whole of Britain had fallen for The Beatles' charm. The Beatles' fourth single, 'She Loves You', had sold more than a million copies in the UK alone and their latest release, 'I Want To Hold Your Hand', had sold over 950,000 in advance copies, an unprecedented sales mark. In addition to fronting their own weekly BBC radio show, *From Us To You*, The Beatles also appeared once as a group on the panel of BBC TV's popular weekly new releases show, *Juke Box Jury*, and headlined their own television special, *It's The Beatles*.

The group even inspired a Christmas novelty single, when the British comedy actress Dora Bryan released 'All I Want For Christmas Is A Beatle'. On December 24 The Beatles began their own *Christmas Show* at the Astoria Cinema, Finsbury Park, London, supported by Billy J. Kramer & The Dakotas, Tommy Quickly, Cilla Black, The Fourmost and The Barron Knights. The Australian celebrity and artist Rolf Harris was the compere. 1963's crowning glory came on December 27, when *The Times* in London acknowledged Lennon and McCartney as the best composers of the year. *The Sunday Times*'s music critic, Richard Buckle, heaped further praise on The Beatles when he called them 'the greatest composers since Beethoven'. Two days later, on December 29, at 12.50a.m., 'I Want To Hold Your Hand' was broadcast for the first time in America, on the New York WMCA radio station.

Breaking in America

As 1964 began, the *Beatles Christmas Show* was still running at the Astoria in Finsbury Park, London, 'I Want To Hold Your Hand' was still at No. 1 and 'She Loves You' was in its eighteenth week in the Top 10. The Beatles' albums were also enjoying immense success. *Please Please Me* was spending its forty-first week in the Top 10, while *With The Beatles* was still in the top position after six straight weeks.

On January 14, just days after appearing for the second time on the television show *Sunday Night At The London Palladium*, John, Paul and George flew to France to begin another series of concerts, starting on January 16, at the Olympia Theatre, Paris, with nineteen-year-old French singing star Sylvie Vartan. It was reported that the fog at Liverpool's Speke Airport had prevented Ringo from joining his colleagues. Not fancying the trip was much nearer the truth. After some persuasion, he eventually flew out a day later. Joining The Beatles in Paris was the noted British film director Richard Lester, who was familiarizing himself with the lads in readiness for their upcoming film together. The project would be entitled *A Hard Day's Night*.

'The film's writer Alun Owen, producer Walter Shenson and I went to Paris where The Beatles were doing their Olympia concerts with Sylvie Vartan,' recalled Richard Lester. 'We watched them in their hotel rooms at the George V, and their behaviour was extraordinary. In other words, they were prisoners of their success. They saw the back

door of the Olympia and they went to their hotel rooms. They stayed there, sandwiches were brought to them and a screenplay began to form in our minds because we were watching this happen and because we all wanted to make this documentary, or a fictional lives documentary. All we were doing was trying to keep our eyes open.'

During their time in Paris, on January 16, while staying at the George V Hotel, news reached The Beatles that 'I Want To Hold Your Hand' had climbed to No. 1 in the US *Cashbox* singles chart. 'We were in Paris when a telegram came through from Capitol Records saying that "I Want To Hold Your Hand" had gone number one in America,' Paul recalled. 'We just jumped on each other's backs and screamed the whole place down. The cheekiest thing The Beatles ever did was say to our manager that we didn't want to go to America until we were number one. Cliff Richard, Tommy Steele, you know, the big British stars, would go to America and be third or fourth on the bill to Frankie Avalon, and then they'd come back and we'd read in interviews that, although they had a wonderful time over there, they never became big hits. We thought, "Surely the Americans were going to buy their records," but what they proved in the end was that they were little European acts who got a bit too out of their depths.'

The celebrations that followed in The Beatles' hotel room became so exuberant that the group's usually reserved manager Brian Epstein allowed himself to be photographed wearing a chamber-pot on his head. Even more risqué was the present given to The Beatles by local journalists, who arranged for prostitutes to perform lesbian acts in the room adjacent to Brian's.

The timing of The Beatles' first US chart-topper was impeccable. The group were set to visit America for the first time anyway on February 7. But instead of arriving as relative unknowns, they landed in America with their music already familiar to millions of record-buying teenagers. When they touched down at New York's Kennedy Airport they were greeted by pandemonium from youngsters who had crammed themselves, shoulder to shoulder, along any vantage point at the airport. The hysterical reception caught the group by surprise. Even John later admitted that they thought the welcome was for someone else. Soon after disembarking and taking part in an obligatory press conference, The Beatles were whisked away to the nearby Plaza Hotel. Hysterical scenes were replicated at the hotel when fans began camping outside.

Two days later, and with George suffering from flu symptoms, The Beatles made their first live appearance on the top-rated CBS TV variety programme *The Ed Sullivan Show*. It was a monumental broadcast, receiving an unprecedented 72.7 percent share of the ratings. It was estimated that approximately seventy-three million Americans tuned in that night. It gave them their first taste of Beatlemania, up close and personal. In response to this appearance, the American entertainment legend Elvis Presley sent a congratulatory telegram to the group. Naturally, many US newspapers gave The Beatles valuable inches of column space reviewing their performance. The *Herald Tribune* remarked, '75 percent publicity, 20 percent haircuts and 5 percent cheerful mourning', while the *Daily News* observed, 'Elvis performances are nothing compared with The Beatles' stage image.' High praise indeed.

'The cheekiest thing The Beatles ever did was say to our manager that we didn't want to go to America until we were number one.'

PAUL McCARTNEY

Sloane Square, London

On 10 February 1963, four months after the release of their single 'Love Me Do', and four weeks after they had made their national television debut on the pop music show *Thank Your Lucky Stars*, The Beatles took part in a shoot with photographer Cyrus Andrews in and around London's Sloane Square.

MARK HAYWARD

The Beatles would have been flattered to be asked for their autographs in Sloane Square. This lady with her friend, camera in hand, managed to take these rare photos and returned to obtain signatures once they had been developed.
Left: Holding up the silver disc for the single 'Please Please Me' awarded by the music paper *Disc and Music Echo* and just collected from the Royal Court Theatre on Sloane Square. *Above*: Ringo at the wheel. *Opposite, clockwise from top left*: Paul, Beatles roadie Neil Aspinall and George, with Peter Jones department store in the background; John; John with the fan; George admires the photos.

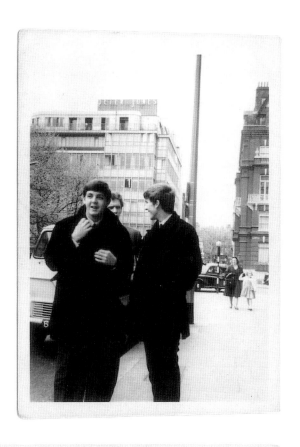

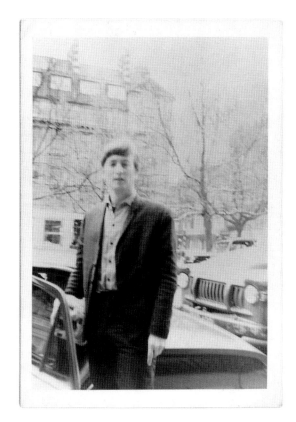

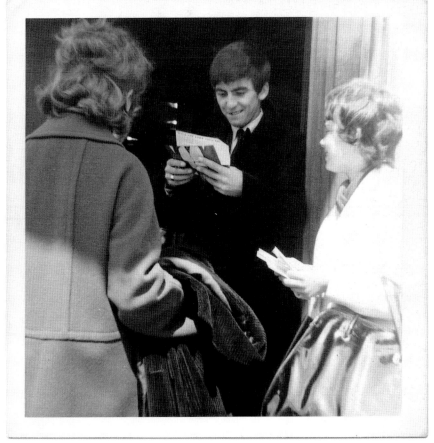

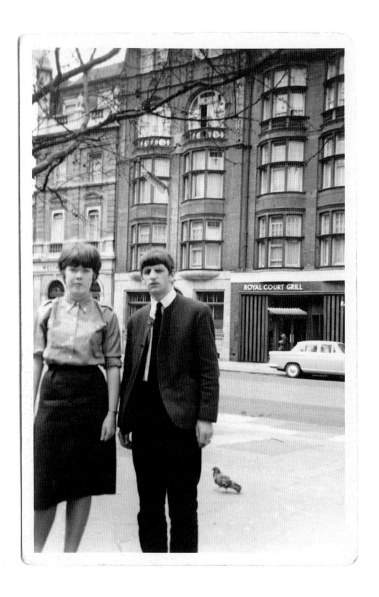

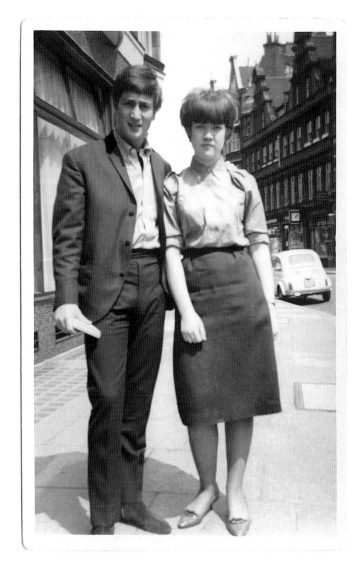

Having seen the *Beatlemania* play at the Royal Court Theatre in Sloane Square in 1975, I never thought that I would have the opportunity to purchase photos of The Beatles in Sloane Square. Although Apple's offices are only five minutes away, they would have felt a little out of place in old-money Knightsbridge: the contrast between their homes in Liverpool and the wealth in Sloane Square could not have been greater.

Posing with Ringo (*above left*) and with John (*above*), 10 February 1963.
Opposite: The fan returns later, in a different outfit, to get Paul's autograph on a photo.

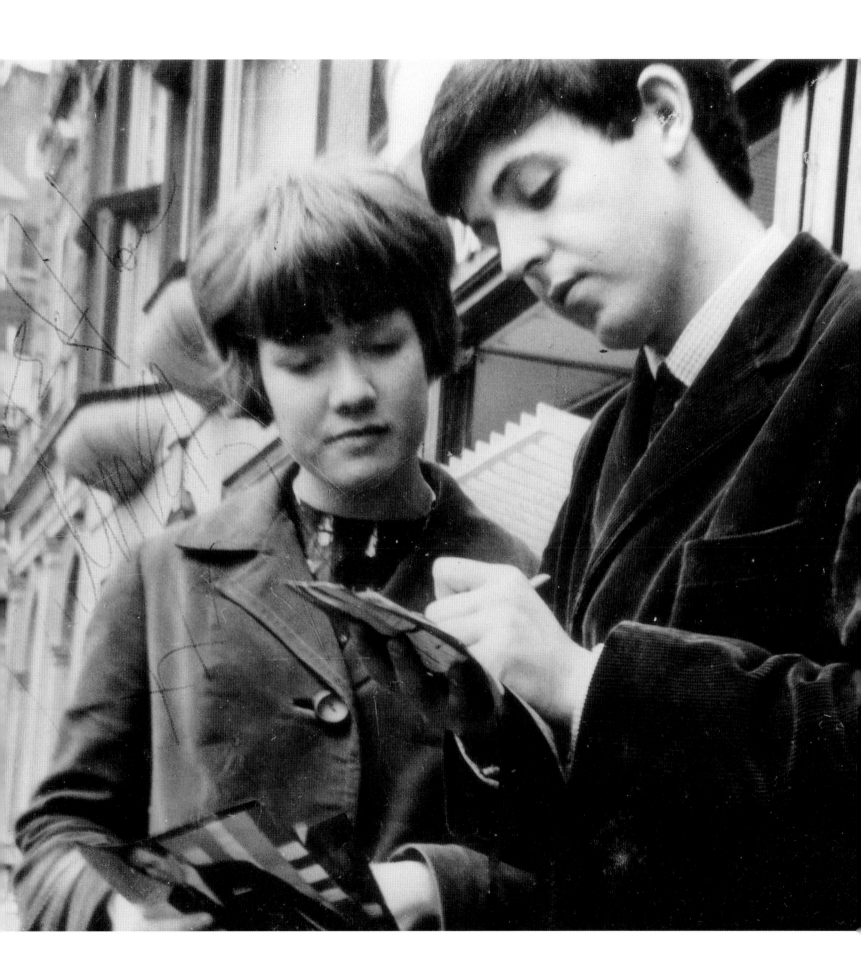

Shrewsbury

Backstage at Shrewsbury
Music Hall, 26 April 1963.
Opposite: Roadie Neil Aspinall
(*top, back to camera*) listens as
The Beatles rehearse, while a
lady photographer takes a
few snaps (*bottom right*). Extra
chairs, neatly stacked
backstage, were brought in
in case required.

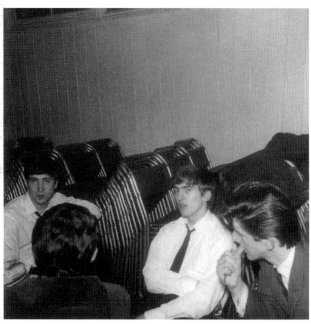

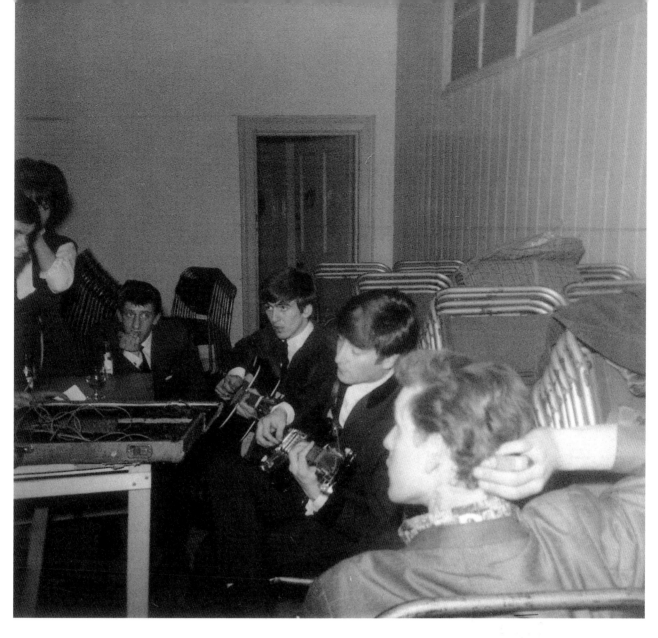

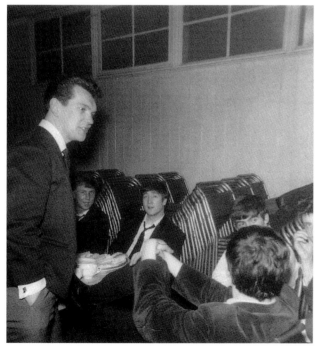

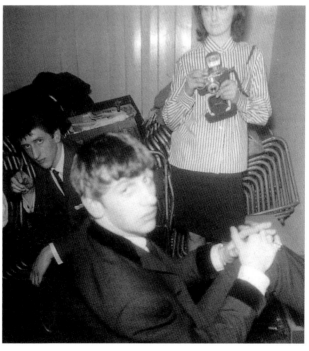

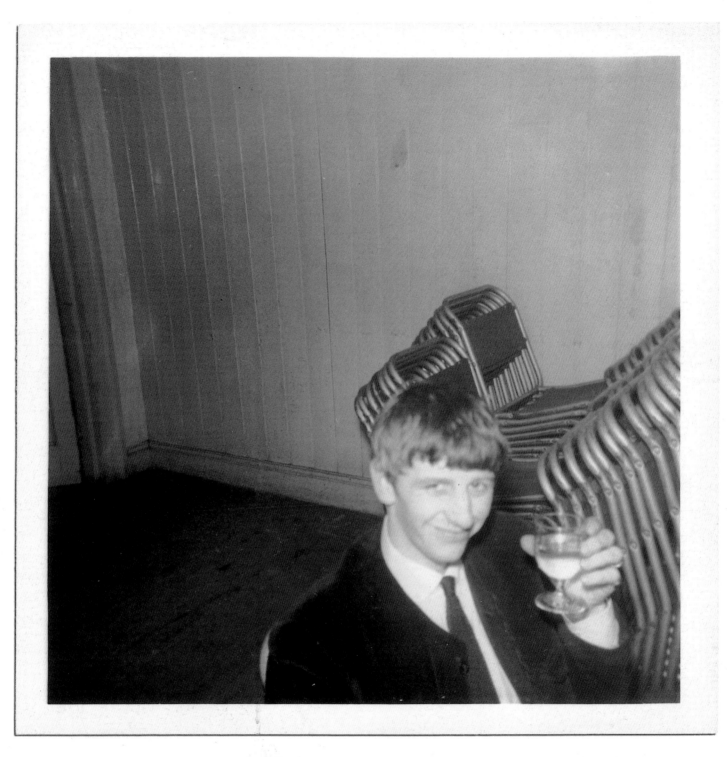

Ringo (*above*) and Paul (*opposite*) backstage after the show. There were very few showers in England in those days, just baths where you had to put a 3d coin in the meter to obtain hot water, so it must have been uncomfortable, especially having performed a live show in suits under stage lights. No wonder the shirts are off – they must have been dripping wet.

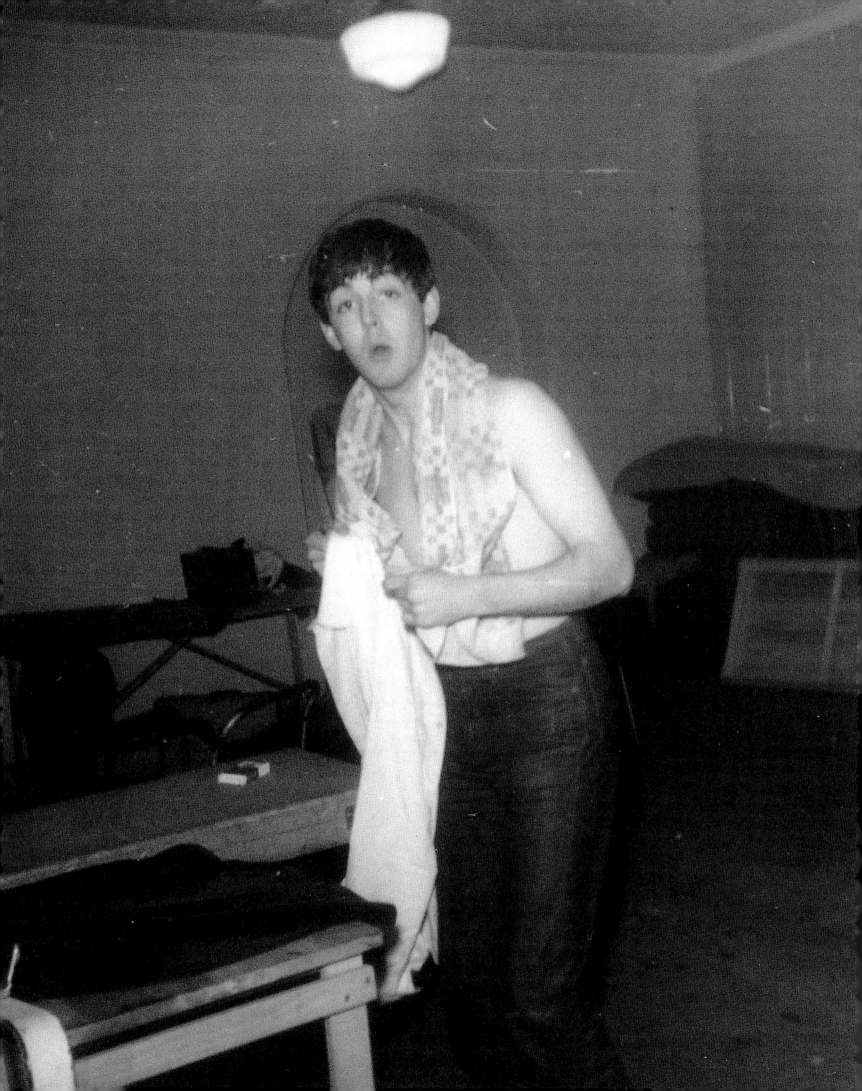

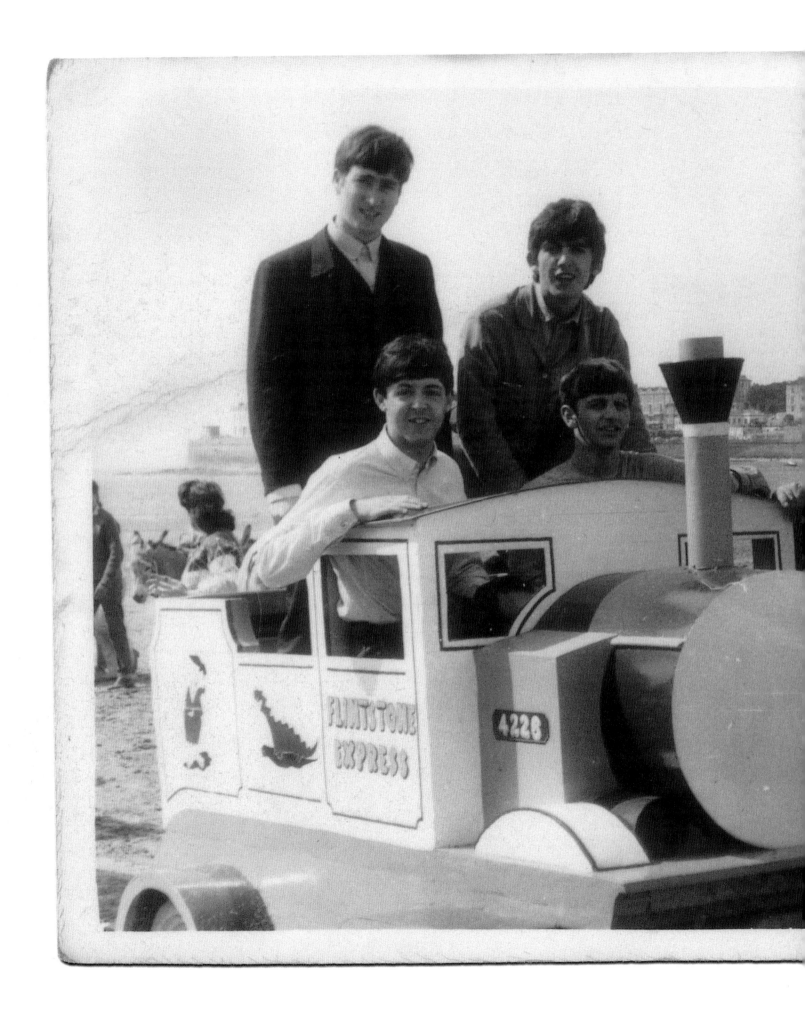

Weston-super-Mare

This page and overleaf: Old-fashioned images of the Fab Four, on Weston-super-Mare beach, 22 July 1963. You don't see many donkeys, considered a health hazard, on beaches these days (although they are protected on Blackpool beach). In the sixties they were commonplace, but as far as I know this is the only picture of The Beatles on donkeys. Amazing that the donkeys behaved and didn't make a run for it while being photographed, as so often seen on TV bloopers. The unknown donkeyman made his fame for five minutes by squeezing into the shots with The Beatles.

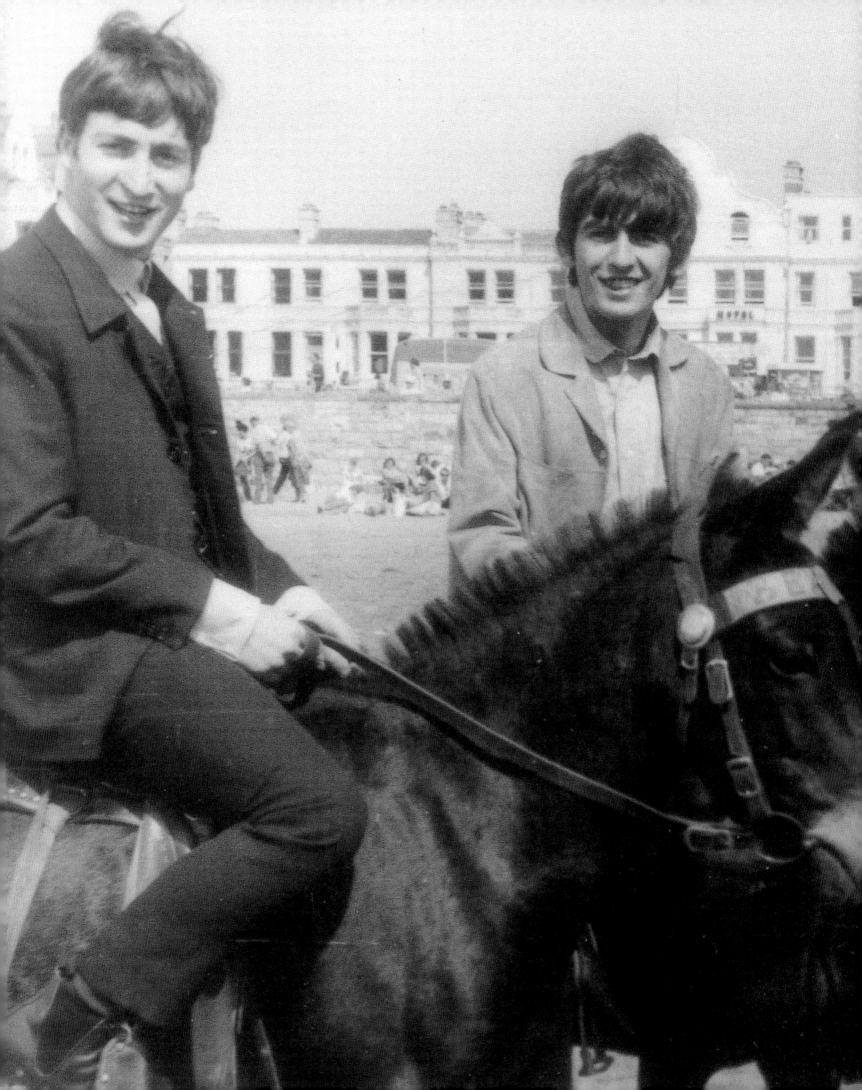

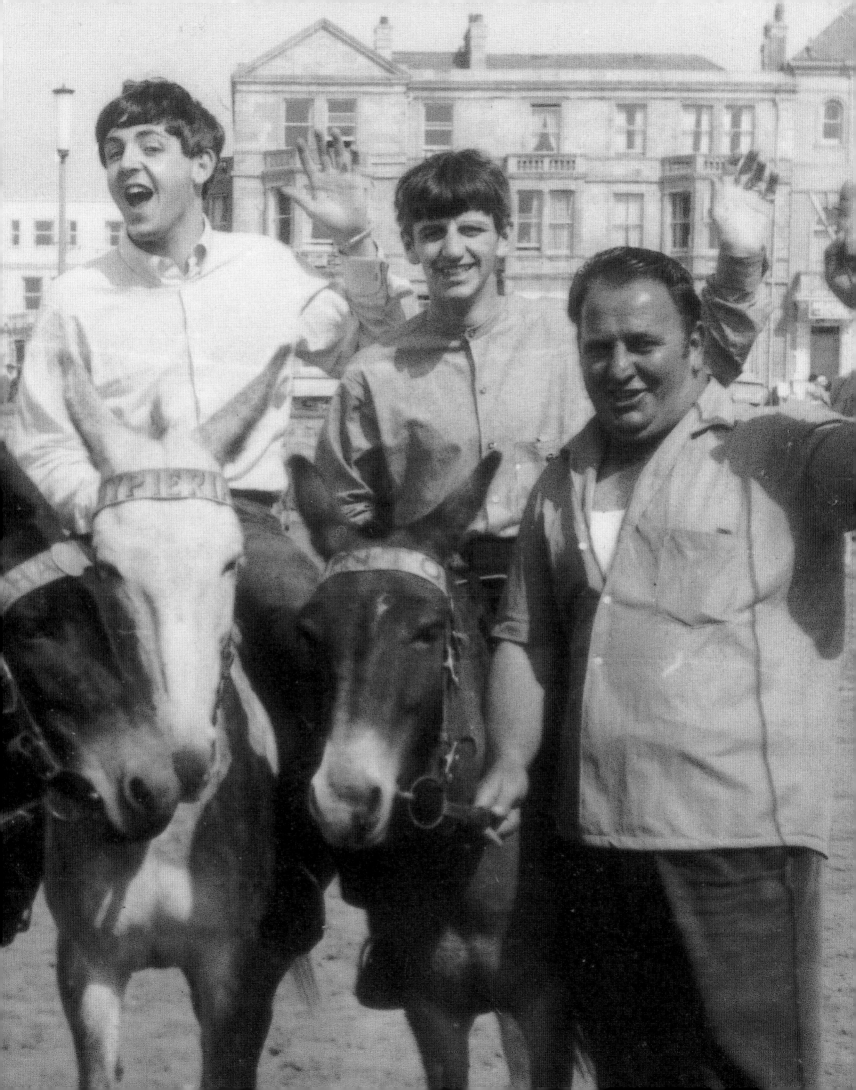

Dundee

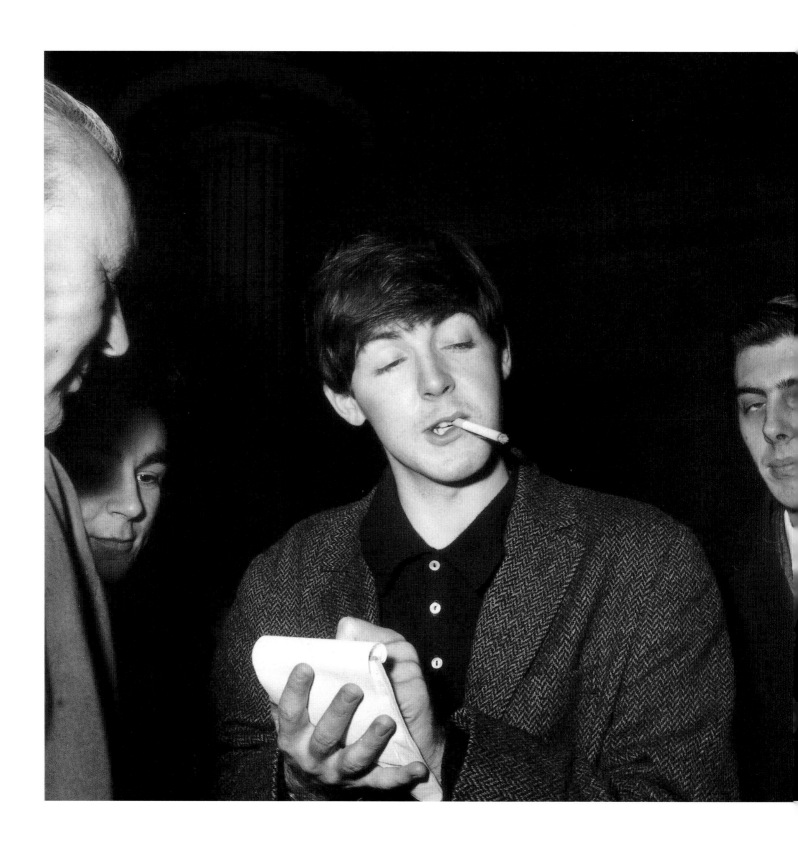

The Beatles meet the press. *Opposite*: Paul signs a valuable autograph while thinking of the tune 'Smoke Gets In Your Eyes'. *This page*: John (*left*) and Ringo (*below*) mix with the press. 7 October 1963.

Christie's auctioneers split a large collection of negatives up in the late eighties, selling four at a time instead of all in one go; this gave the vendor a better price, as most fans could afford to buy four photographs so the bidding was competitive. When bidding starts at a low price, £100 for instance, the next bid would only go up by £10 in most circumstances so ten people might be bidding on one item but the price would only increase by £100 in a few minutes; when people are bidding in tens of thousands, the price increases by £2,000 a time and before you know it, the item has sold for £100,000. These photographs sold for £500 per photo on average so several fans were able to buy photographs. I purchased a few.

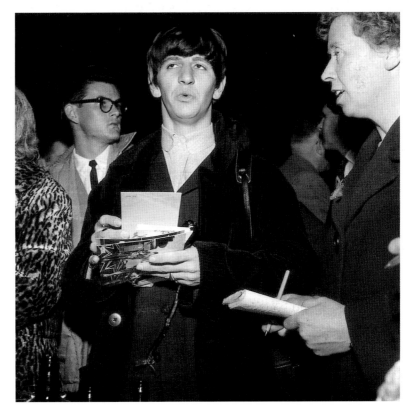

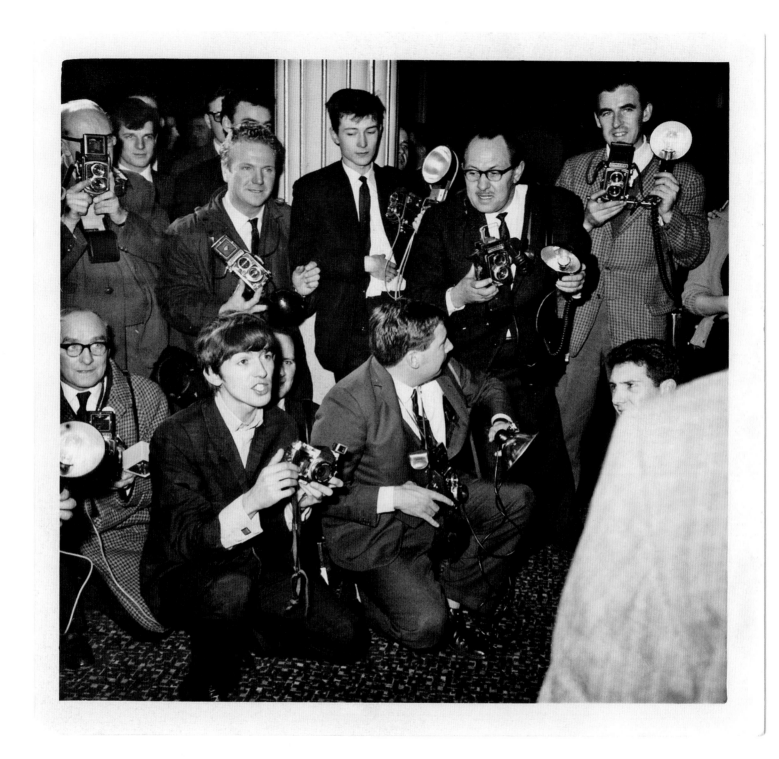

George shows the press how
to take a photograph.

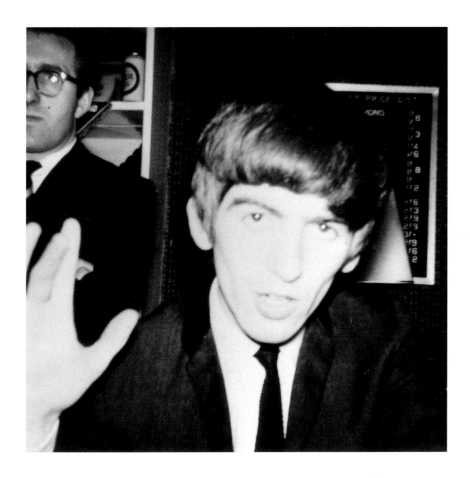

Left: George behind the bar with Mal Evans watching over his shoulder. *Below*: Paul serves up drinks behind the bar, in the background a typical sixties old-fashioned till and Double Diamond lager banner.

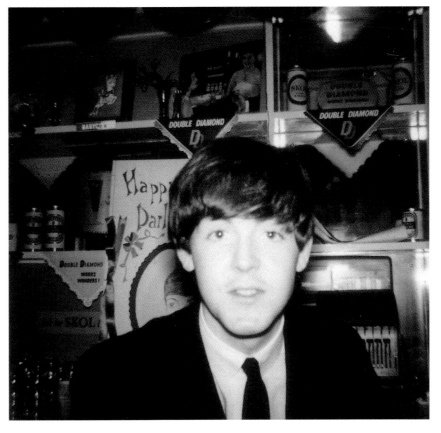

The Royal Variety Performance

On 4 November 1963, The Beatles appeared in front of the Queen Mother at the Prince of Wales Theatre in London. The group are seen here before the concert with the show's bill-topper, the film star and singer Marlene Deitrich. Many thought that John's much-quoted line during the show was impromptu. But the gag had been prepared long before, when the Fab Four had said to each other, 'What we can't use is the normal corny routine, you know, clap your hands and all that kind of stuff. We'll have to do something different.' So when John announced their final song, 'Twist And Shout', he said, 'For the next number, those of you in the cheaper seats can clap your hands… the rest of you can just rattle your jewellery.'

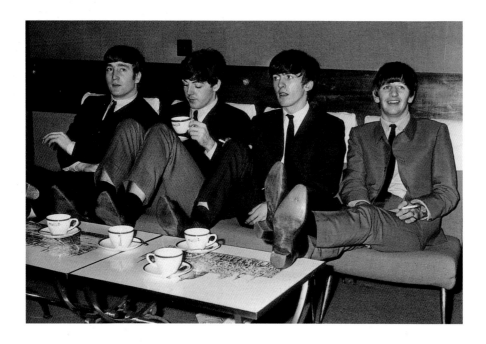

Above: Relaxing backstage before the Royal Variety Performance, 4 November 1963. *Right*: The Beatles pose with the show's headline star, Marlene Dietrich, at the Prince of Wales Theatre, London. Bandleader Joe Loss is on the far right, Buddy Greco on the far left.

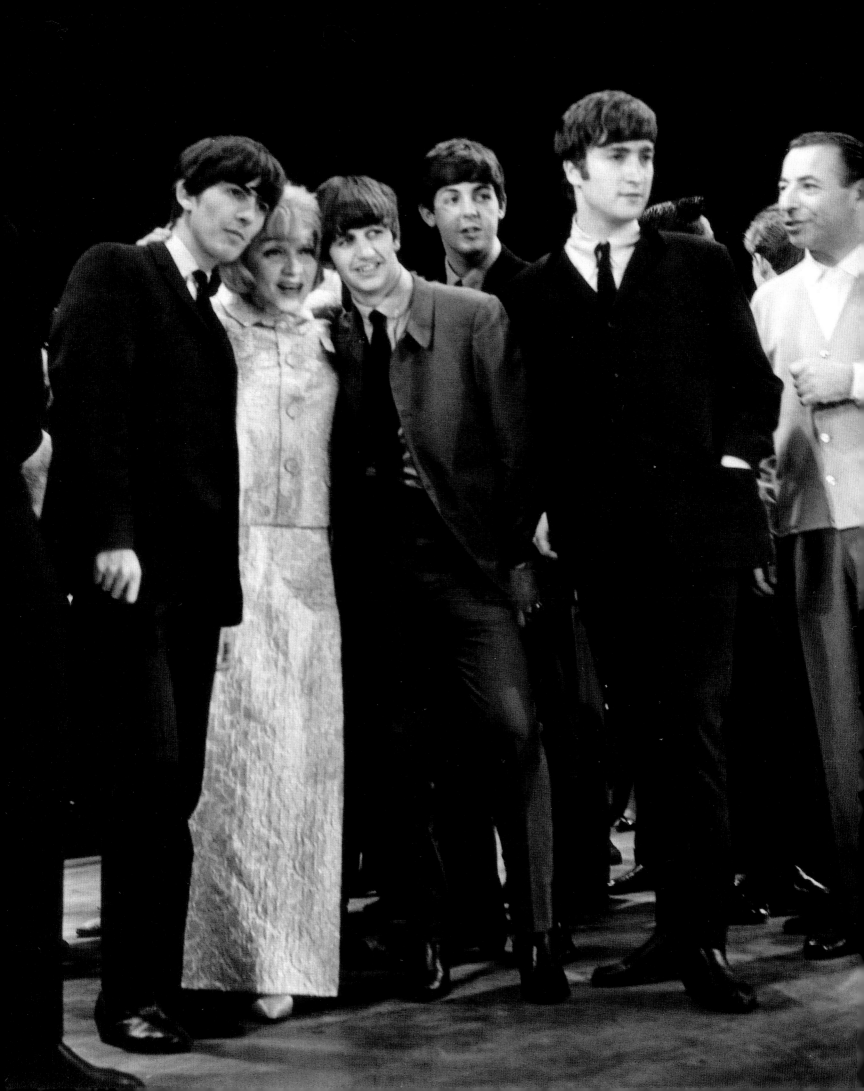

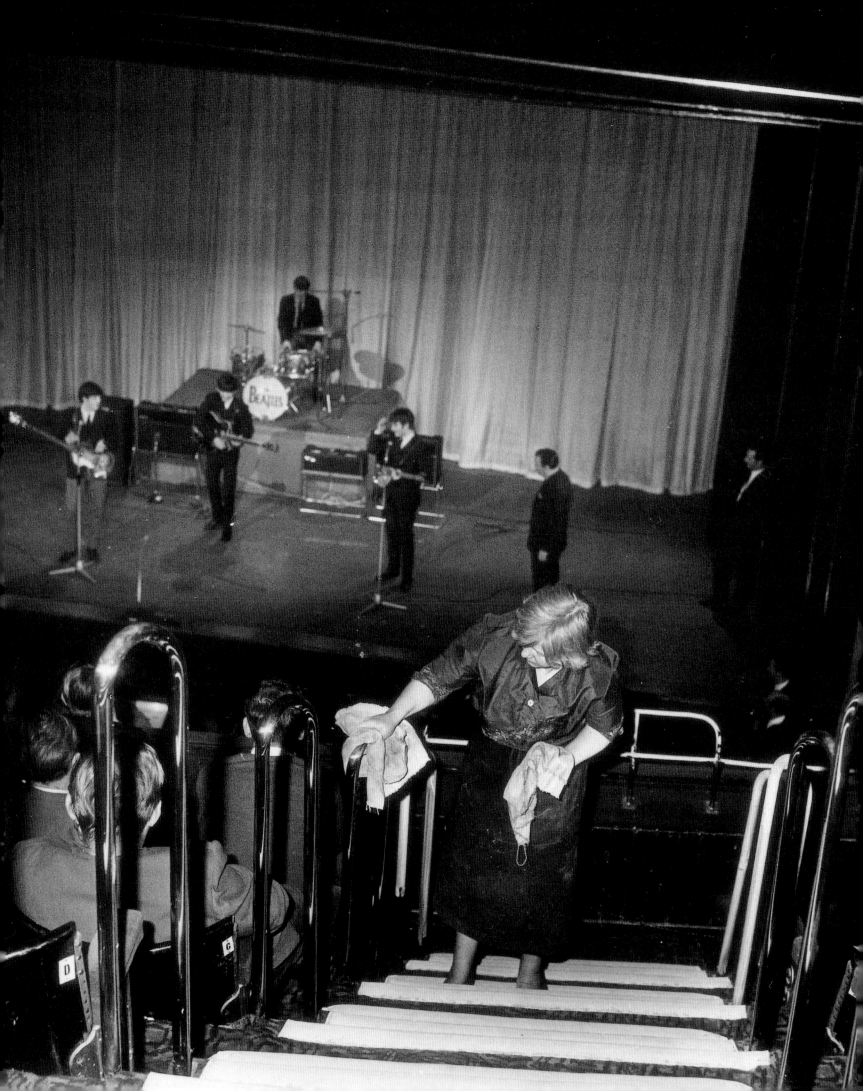

Manchester

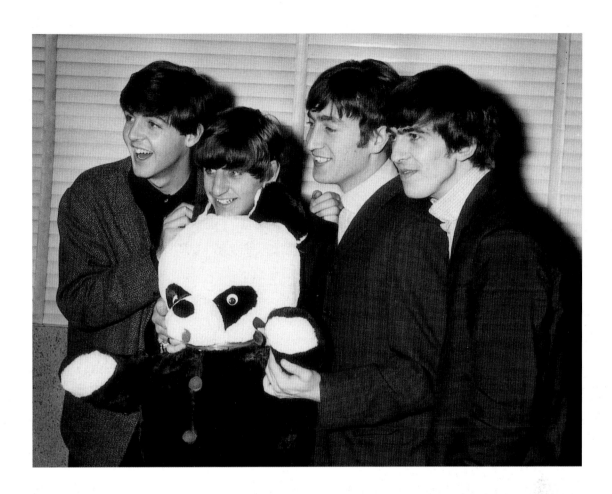

Opposite: One of my favourite photographs: the brass banisters get a clean at the ABC Cinema, Manchester, while The Beatles rehearse on stage, 20 November 1963. *This page:* The Beatles are filmed holding a toy panda by Pathé News for *Beatles Come To Town* (filmed in colour).

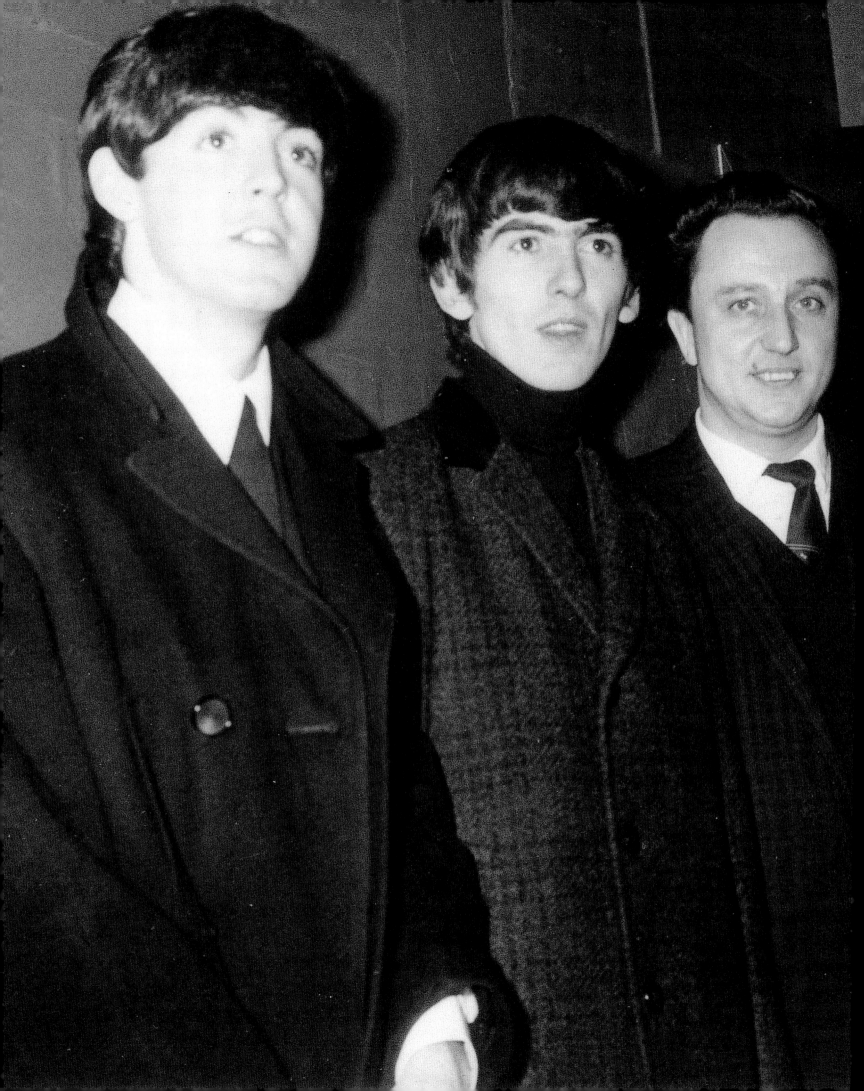

Granada
TV Studios,
Manchester

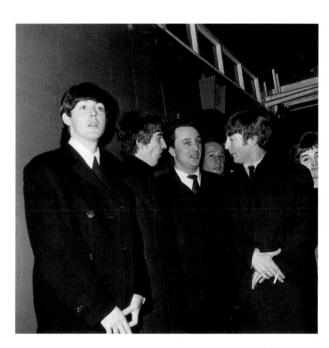

Ken Dodd, a very English
comedian known in the UK
for his TV series featuring
'the Diddymen', waits
backstage with The Beatles,
a very international act.
25 November 1963.

Sunderland

As my collection built up I was aware I required some good early black-and-white photographs of all four Beatles together in the same photograph. This set had all four Beatles in all seven prints – a rarity in itself. The stage is only just big enough to fit the band, but 1963 was early days: small, portable Vox amplifiers, no Beatles drum skin, mixing with photographers with ease, eager to be of help to the local camera crews. Beautiful prints, beautiful innocence.

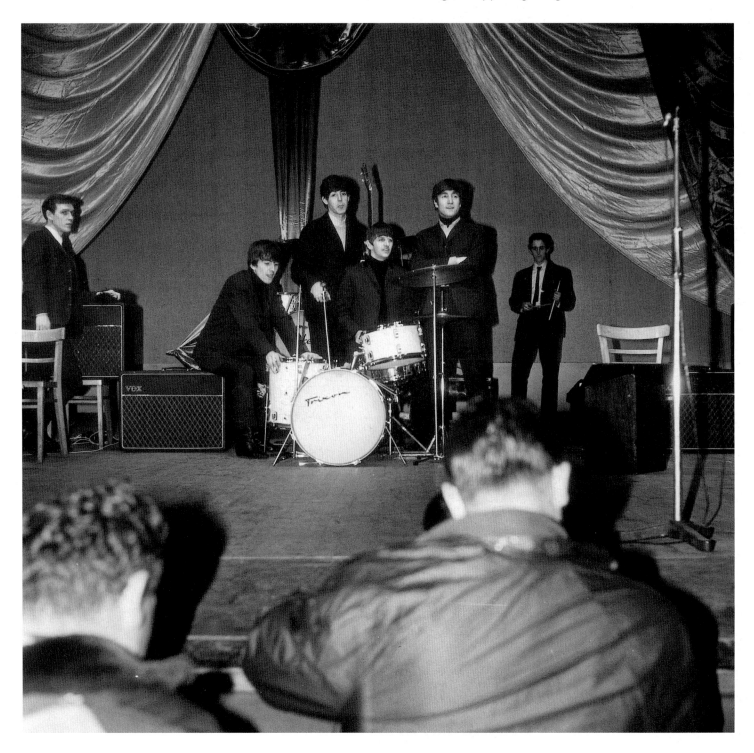

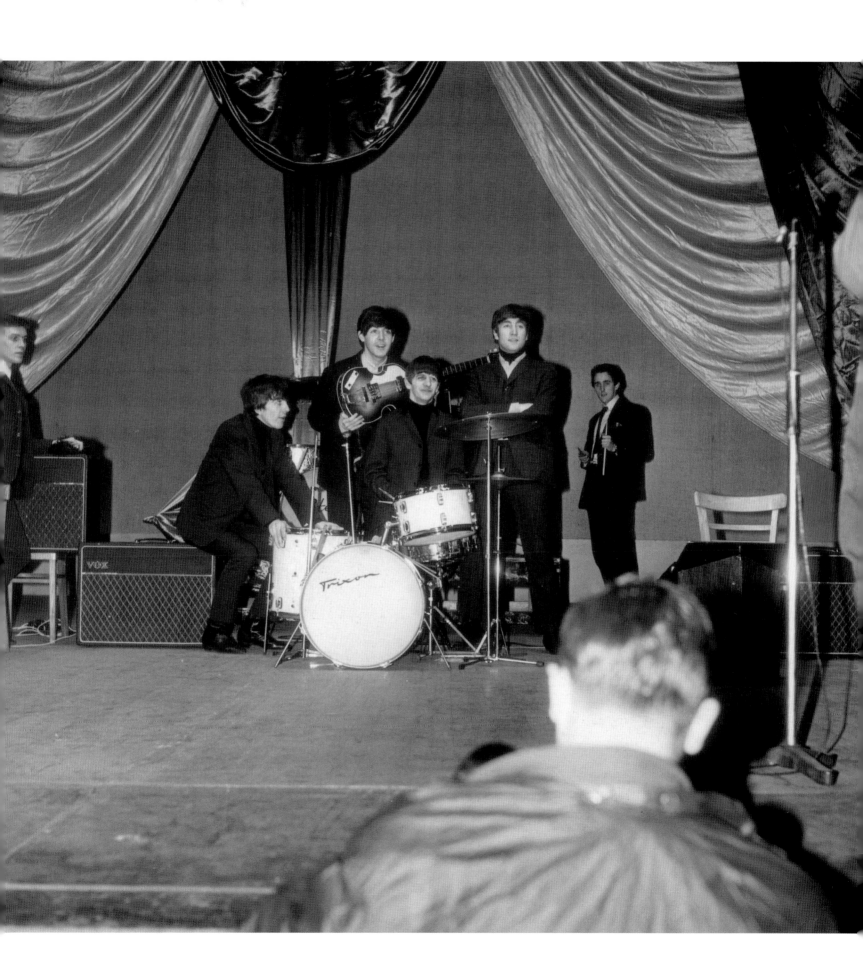

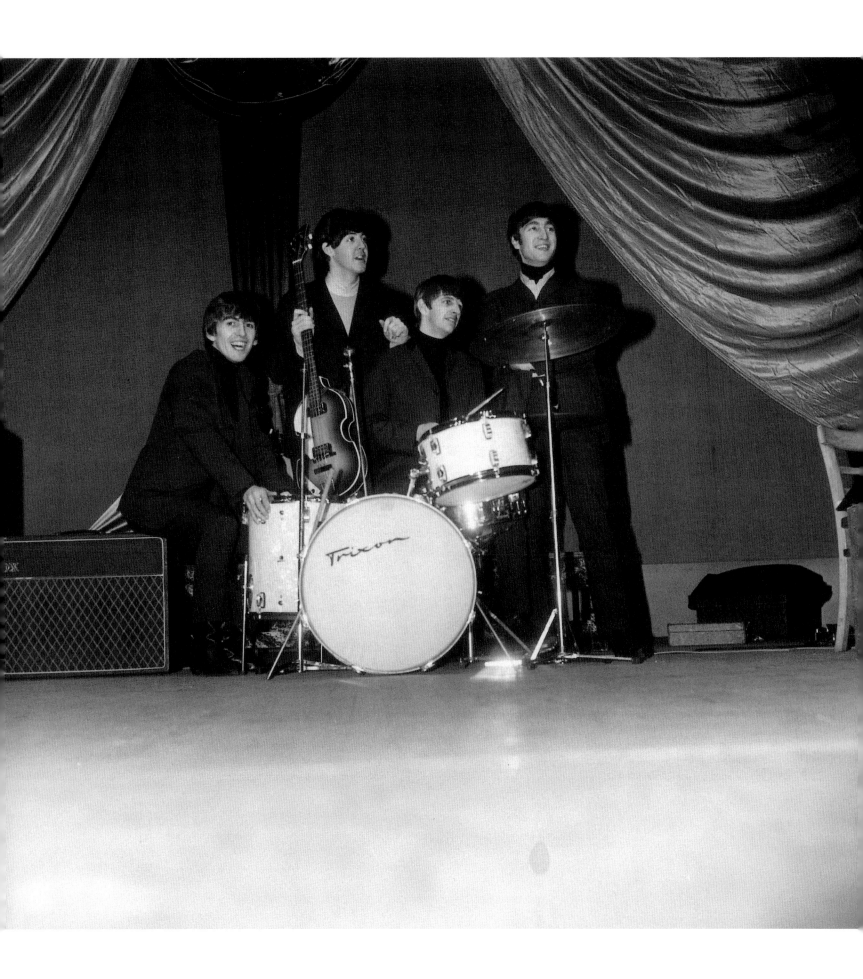

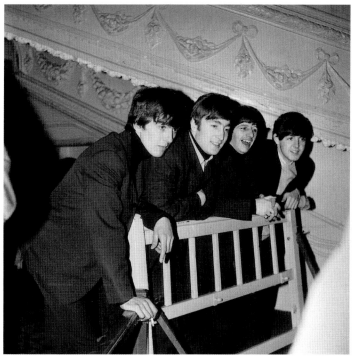

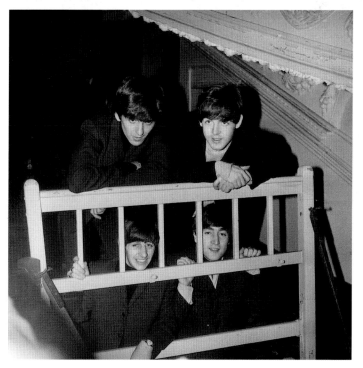

Opposite: One of the best Beatles photos in the book. Purchased at Christie's auctioneers in Old Brompton Road, London, whose glamorous, lively pop 'n' rock department has sold not only Beatles memorabilia but also Eric Clapton's guitars and, perhaps of greater interest to Beatles fans, a necklace belonging to The Beatles' friend 'Magic' Alex.

Doncaster

'The music was dead before we even went out on the theatre tours of Britain. We were feeling shit already because we had to reduce an hour or two hours playing, which we were glad about in one way, to twenty minutes and go on and repeat the same twenty minutes every night. The Beatles died then as musicians. That's why we never improved as musicians. We killed ourselves to make it, and that was the end of it. George and I were more inclined to say that.'

JOHN LENNON

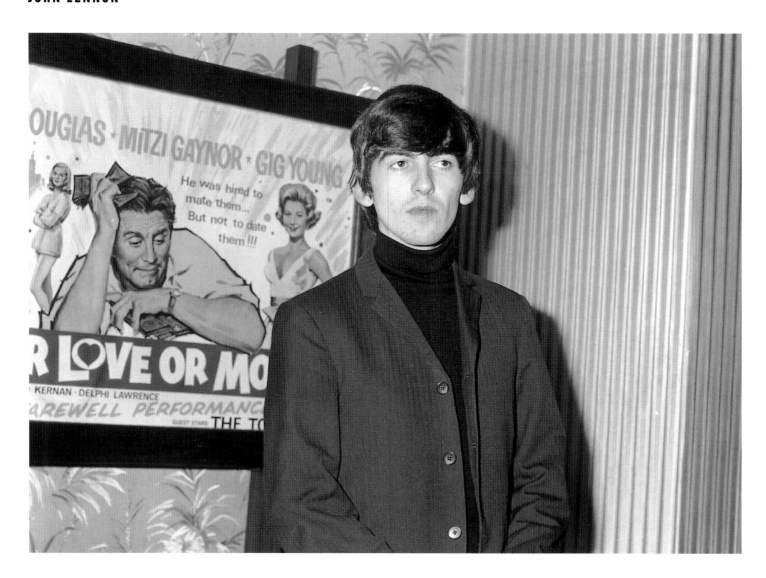

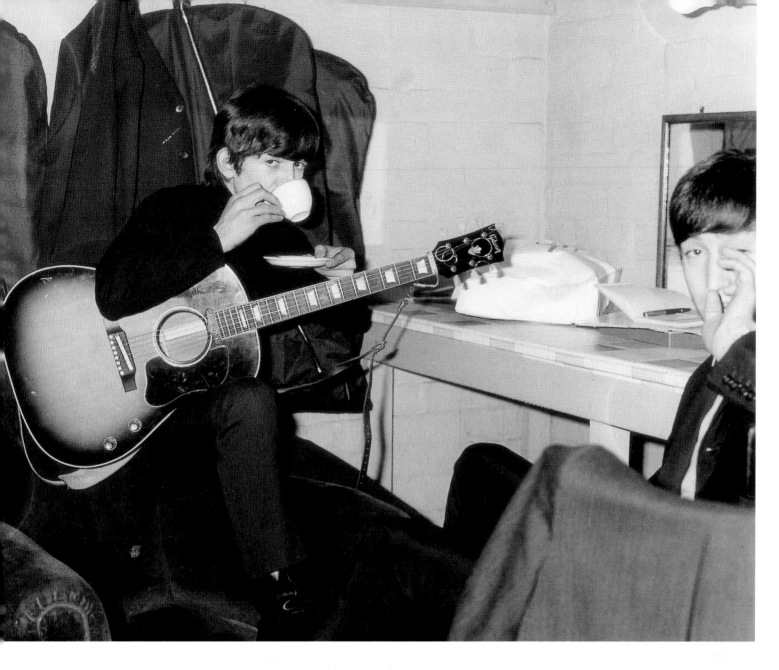

In the dressing rooms at the Gaumont Cinema, Doncaster, 10 December 1963. *Opposite*: George in his suit while Kirk Douglas, father of Michael, looks on from a film poster for *For Love Or Money*. *This page*: A genuine cup of tea for George (*above*), his suit hanging up behind him along with dry-cleaner covers, while Ringo (*left*) takes a seat before going on stage.

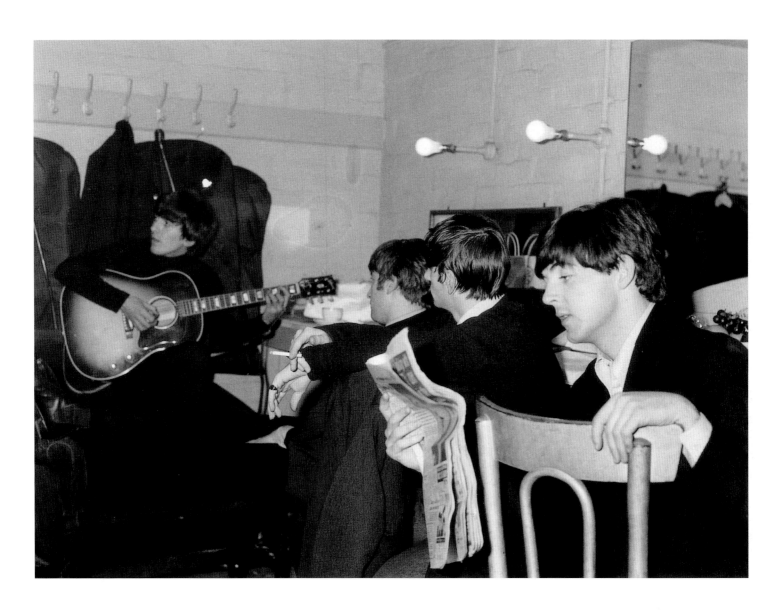

Paul seems delighted,
reading a favourable review.
By the end of 1963 the
perks have clearly improved,
fresh fruit appearing
backstage.

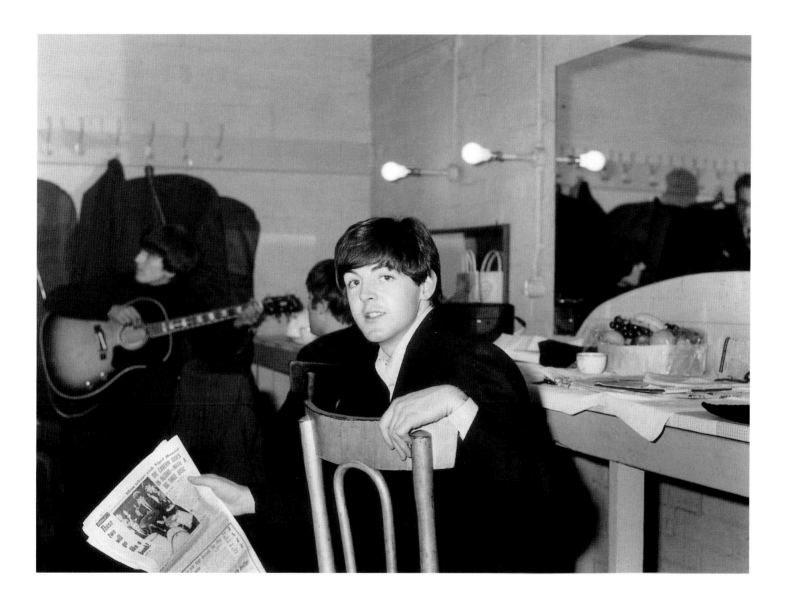

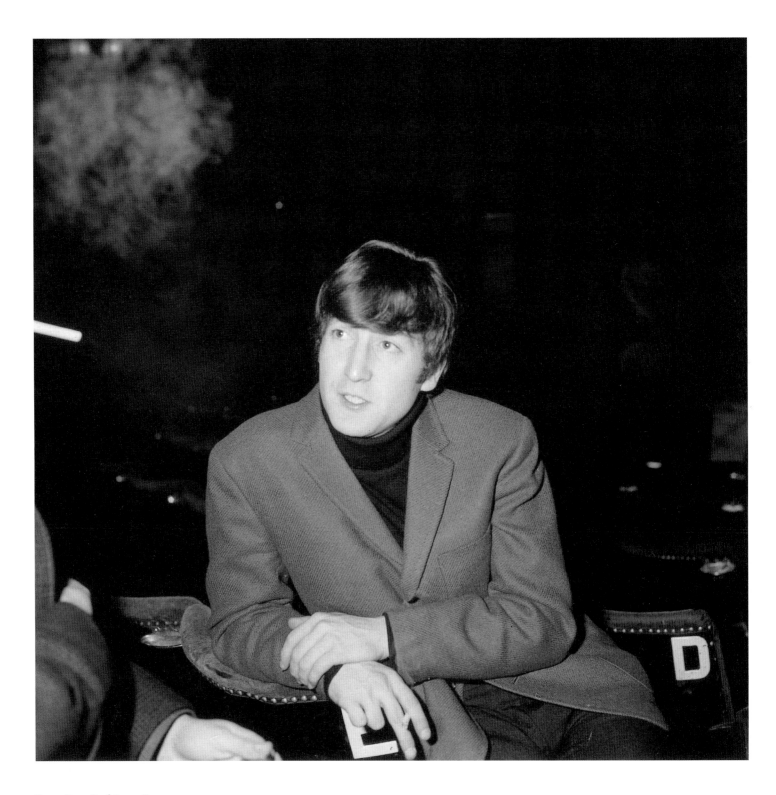

From Row E of the stalls,
John talks to a journalist
seated in the row above him.

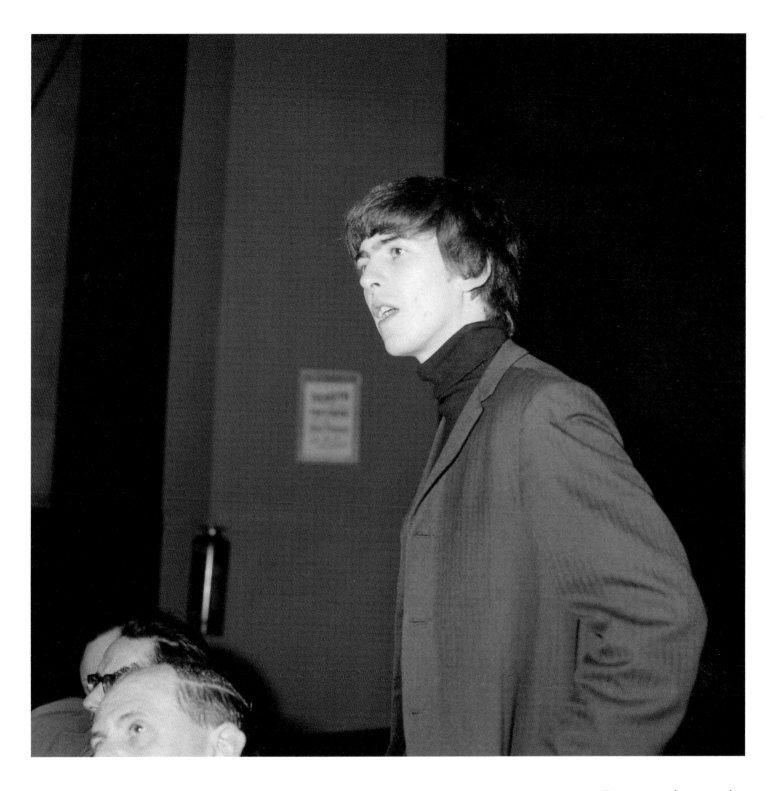

George responds to a member
of the press.

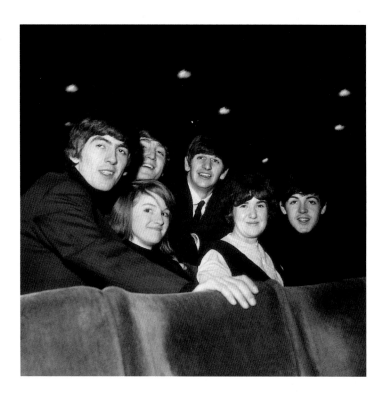
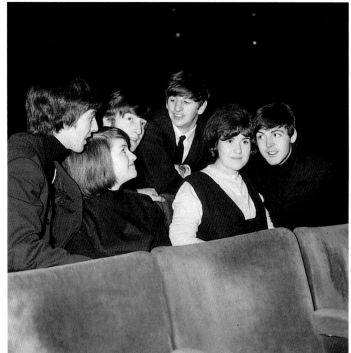

We don't know who the
lucky lasses were (get in
touch), but George gets the
girls, much to Paul's posed
frustration (*opposite*).

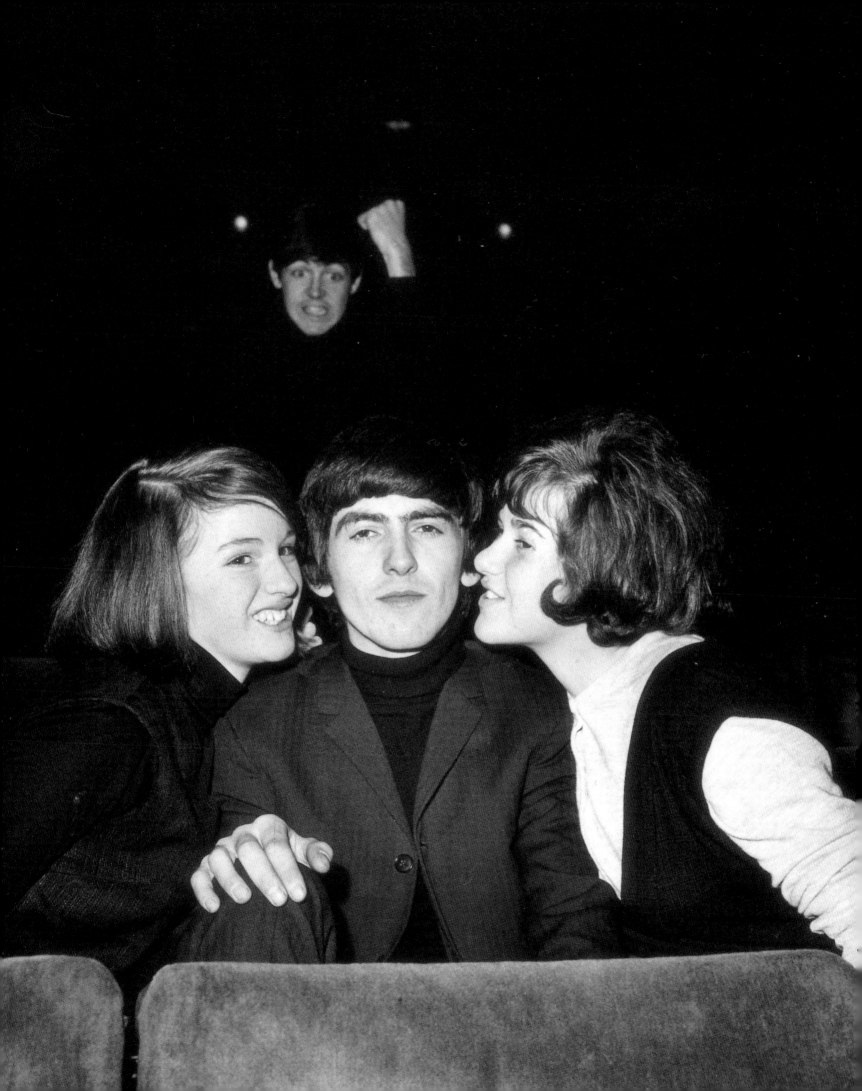

A superb caught-off-camera side pose of all Fab Four at the Doncaster Gaumont.

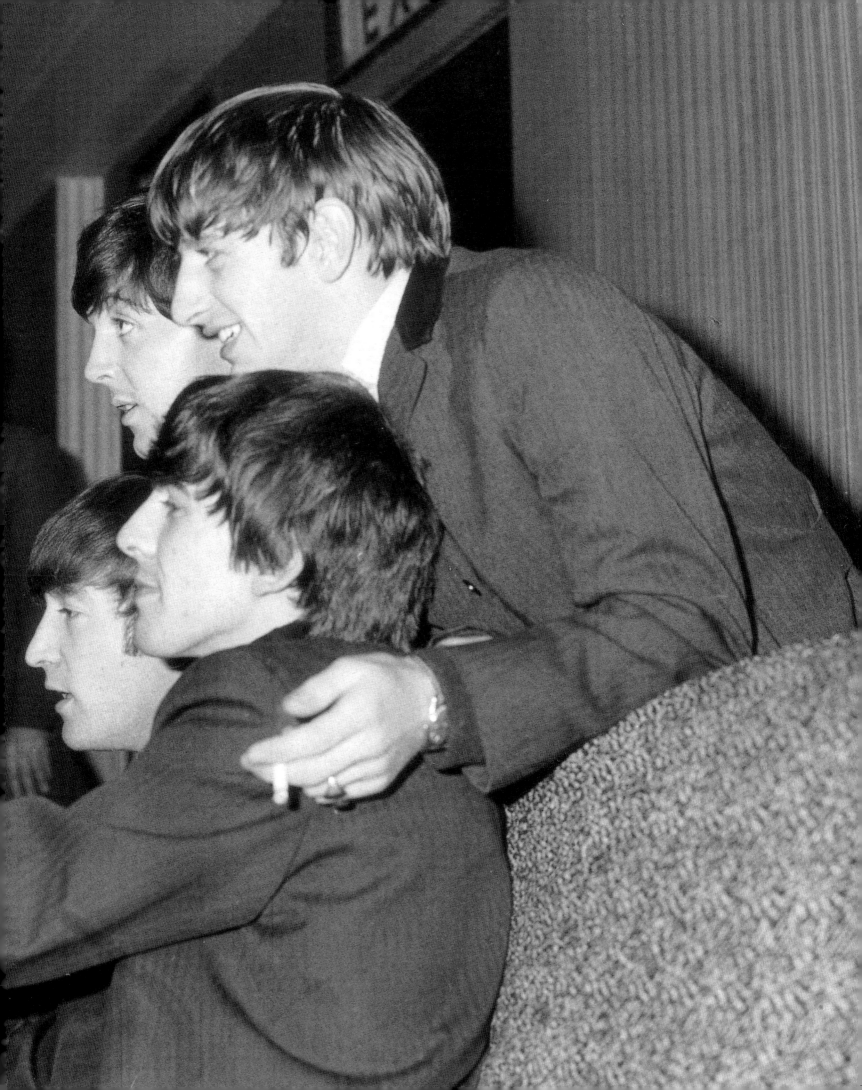

Countdown from Paul
before clicking his camera,
at the Gaumont Cinema.

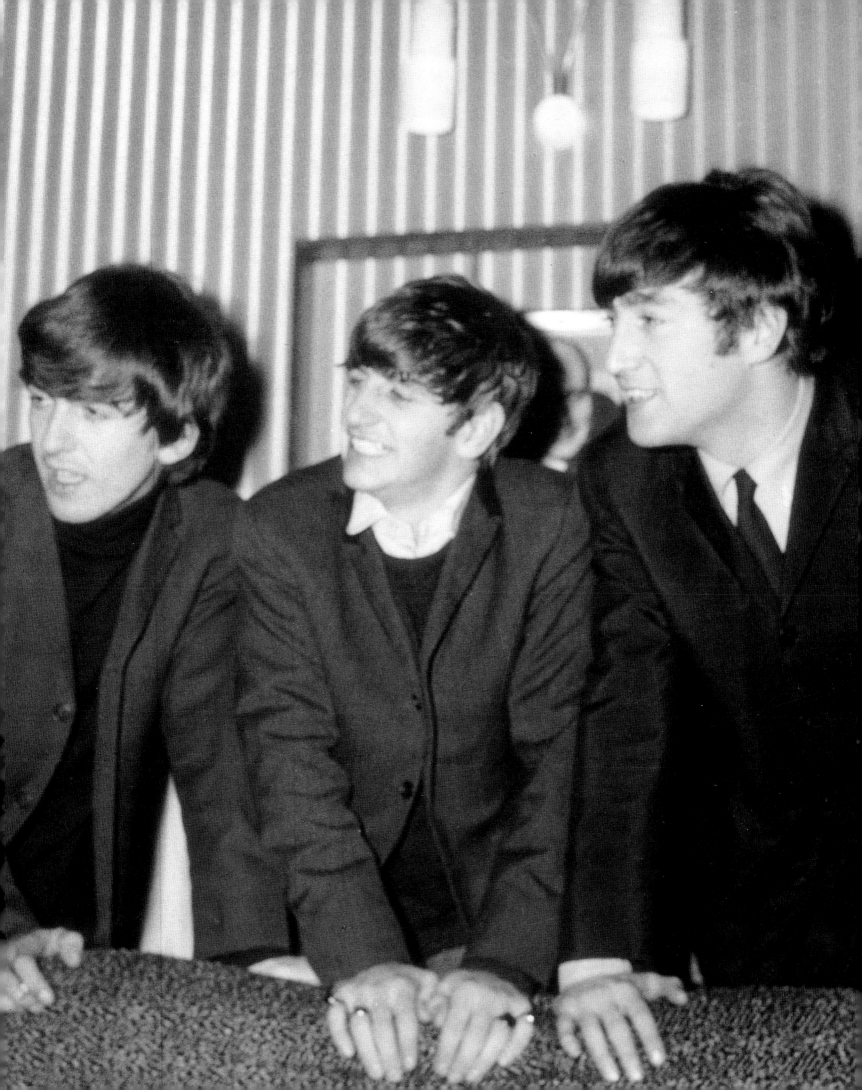

BBC Paris Studios, London

Paul and John exchange bass lines with chords before recording for their BBC Light Programme special, *From Us To You*, in London on 18 December 1963. Hosted by Rolf Harris, the programme featured favourite songs such as 'She Loves You', 'All My Loving', 'Roll Over Beethoven', 'Till There Was You', 'Boys', 'Money (That's What I Want)', 'I Saw Her Standing There' and 'I Want To Hold Your Hand'.

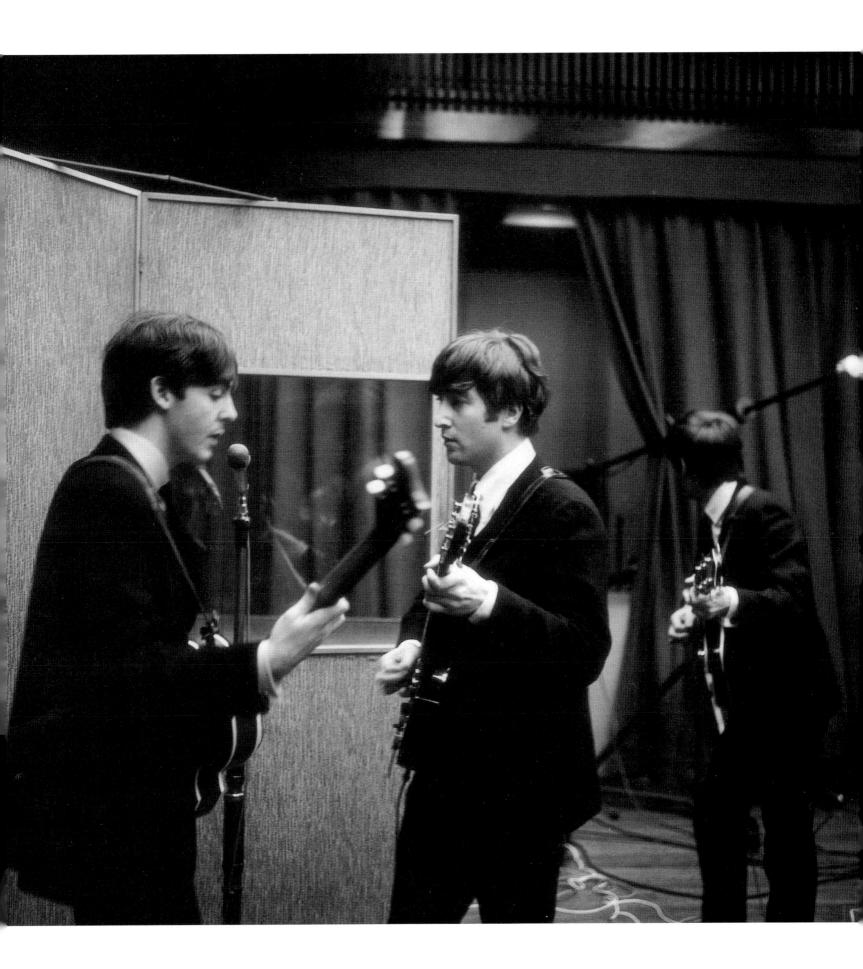

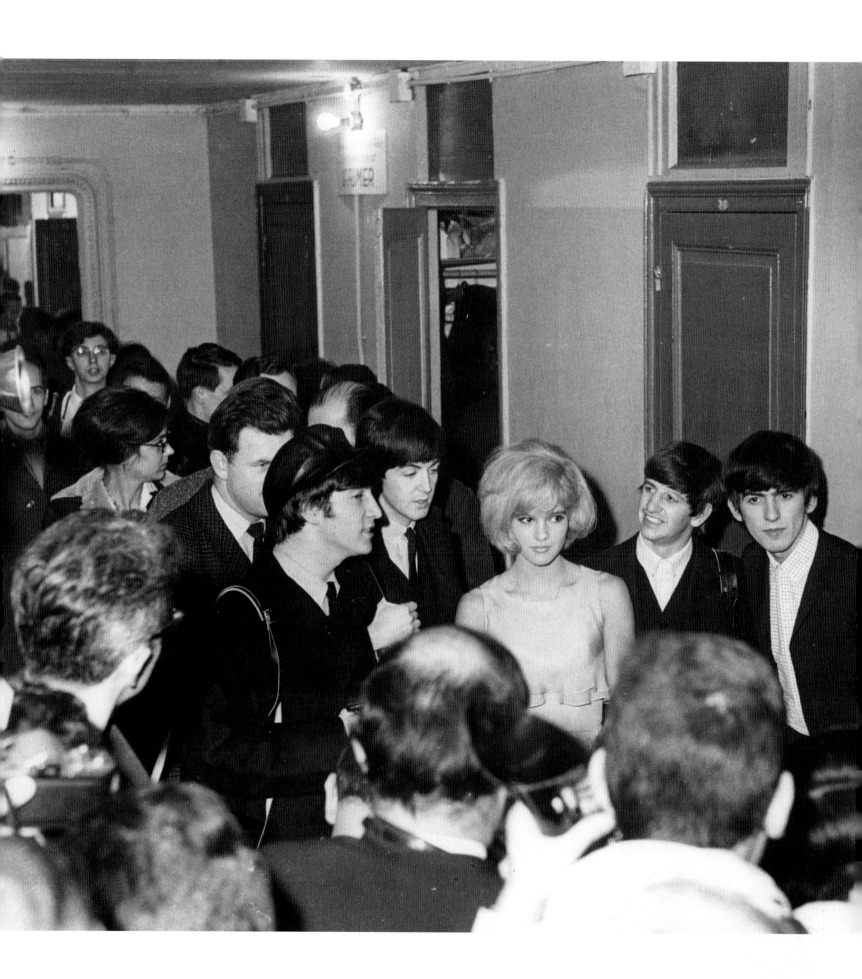

Olympia Theatre, Paris

'The film's writer Alun Owen, producer Walter Shenson and I went to Paris where The Beatles were doing their Olympia concerts with Sylvie Vartan. We watched them in their hotel rooms at the George V, and their behaviour was extraordinary. In other words, they were prisoners of their success. They saw the back door of the Olympia and they went to their hotel rooms. They stayed there, sandwiches were brought to them and a screenplay began to form in our minds because we were watching this happen and because we all wanted to make this documentary, or a fictional lives documentary. All we were doing was trying to keep our eyes open.'

RICHARD LESTER, DIRECTOR *A HARD DAY'S NIGHT*

The press surround The Beatles and French singer Sylvie Vartan backstage at the Olympia Theatre, Paris, France. 16 January 1964. This most glamorous of French stars was married to the French icon/rocker Johnny Halliday, so the French cameras made a big fuss, creating a great opportunity for The Beatles to be seen. On the far right of the picture, wearing glasses, is The Beatles' publicist, Brian Sommerville. While in France, The Beatles heard that their single 'I Want To Hold Your Hand' had reached number one in America: they would no longer be mere background to the French starlet.

Filming A Hard Day's Night

Shooting for *A Hard Day's Night* began at 8.30 on the morning of 2 March 1964 at London's Paddington Station. But before shooting could start, acting novices The Beatles hurriedly had to join the actors' union, Equity. The movie's director, Richard Lester, recalled, 'The whole first sequence of the film was set on the train. We hired this train from British Rail, at a cost of £800 a day, and we went to, I think, Taunton and back every day. We just drove back and turned everyone so they faced the other way, so it didn't look like it was shot by shot, there was some piece of continuity going on.'

'We travelled 2,400 miles in all,' George remarked soon afterwards. 'I counted 'em! But I didn't mind that bit, it was just that business of getting up early. Usually, after a job, we don't get up until around 1p.m. We're really night owls, that early bit just killed us.'

Patti Boyd meets The Beatles

During the first day's shooting, The Beatles met the young model and actress Patti Boyd, who played a schoolgirl in one of the train sequences at the start of the film. 'I met them and they said "Hello". I just couldn't believe it,' she recalled. 'They were so like how I had imagined they would be. They were just like pictures of themselves coming to life. George hardly said hello, but the others came and chatted to us. When we started filming, I could feel George looking at me and I was a bit embarrassed. Ringo seemed the nicest and easiest to talk to, and so was Paul. But I was terrified of John. After the first day's shooting, I asked them all for their autographs, except for John. I was too scared. When I was asking George for his, I said could he sign it for my two sisters as well. He signed his name and put two kisses each for them, but under mine he put seven kisses. I thought, "He must like me a little."'

In July, shortly after the film's release, John voiced his opinion on *A Hard Day's Night*. 'We're satisfied,' he said. 'But we're not self-satisfied. There's a lot which is embarrassing for us, you know. For instance, the first bit of the film is a drag as far as we're concerned because that was the first sort of acting we had done and it looks it. The train bit embarrasses us now. I'm sure it's less noticeable to people who are just watching it in the cinema, but it is the bit we know that we are dead conscious in every move we make. George has said that it would be nice to make a film without any music in it, but it's the music bit that we all enjoy. Paul and I enjoyed writing the music for the film, but we've always been the kind of people who didn't like musicals because there were always embarrassing parts when, all of a sudden, a song started. We tried to get away from, all of a sudden, saying "How about a song?" There's even one [scene] in the film where I say

the cliché, "Say kids, why not do the show right here?" But it was a joke originally that we just threw in, but it doesn't work. It looks as though I meant it. We thought this gag line would break it down and everybody would get the joke and a number would just follow. That's probably why George doesn't want any numbers in the next film. But there will be numbers in the next film, because that's what we sell.'

George was also asked his view on the movie. 'We like it, but we're not trying to kid ourselves that we're actors,' he admitted. 'We've seen the film and we all agree that Ringo comes out of it better than anybody. It's hilarious really, we made a lot of it up as we went along.' Paul later admitted, 'The worst thing about the film was that all of us felt that we could have been better. We were put into a picture and we weren't actors and we had to try and do it. It was a completely new medium for us. We had lines to say, whereas we've never done anything with a script. Nobody has ever written jokes for us to put into our act, even at the Palladium. John and ourselves would make up any stuff that we needed. But, in the end, all we could get into the film was a few ad-libs.'

Drawing a crowd while waiting to film a sequence for *A Hard Day's Night* on a London street outside the Scala Theatre. 15 April 1964.

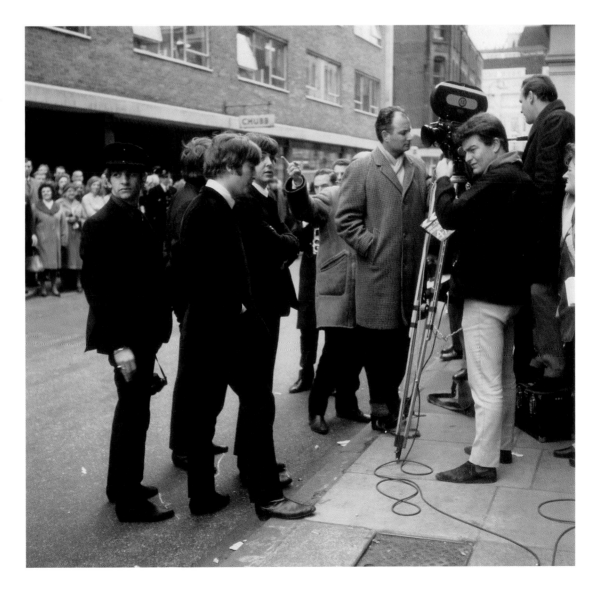

'We got up about five o'clock in the morning. It took some doing. I never thought we would learn our lines. The idea was that we are supposed to learn them that night for the following day, but it never worked out like that. We all read them frantically in the car going down to the studio. It was a bit like school. We were not really actors, you know, we were first of all singers and then musicians of sorts, and last of all actors, so we didn't really know how to act. But a lot of people on the film helped us, you know, the real actors, like Wilfrid Brambell and Norman Rossington. They helped us with it and told us what to do.'

PAUL McCARTNEY

The thirty-seven-year-old screenwriter and former actor Alun Owen had written the screenplay for *A Hard Day's Night* following his meeting with the group in Dublin on November 7 the previous year. 'I liked them as soon as I met them,' Owen recalled. 'They were my kind of people. They were much more amusing and fantastic off-stage than on. I had to get to know them pretty well to write this film and that's what really made my mind up how to write it. In real life, The Beatles were surrounded by fantasy. Fantastic things happened to them all the time, like the time this girl fell on her knees before them. She was a parlour maid in a hotel in Dublin where The Beatles and I were staying. She had brought in a tray of coffee and cakes in a nice normal, sensible fashion, walking across the room and setting down the tray. Suddenly, she flung off her cap, dropped to her knees and cried, "I'm going to pray for you, boys! I'm going to pray for you!" They weren't shocked. They didn't laugh. They weren't embarrassed. Paul just helped her to her feet and talked to her as if they had been nicely introduced at a party.'

But John was unimpressed with Alun. 'He had to come round with us to see what we were like, but he was a bit phoney. He was like a professional Liverpool man, like a professional American. He stayed with us for two days, and he wrote the whole thing based on our characters then. Me, witty; Ringo, dumb; George, this; Paul, that.'

John and George with *A Hard Day's Night*'s writer, Liverpudlian Alun Owen.

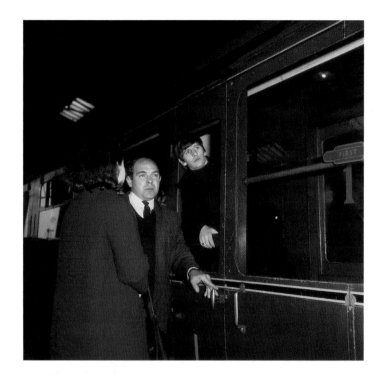

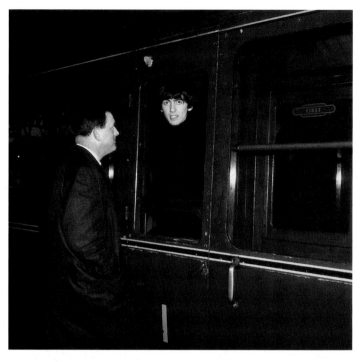

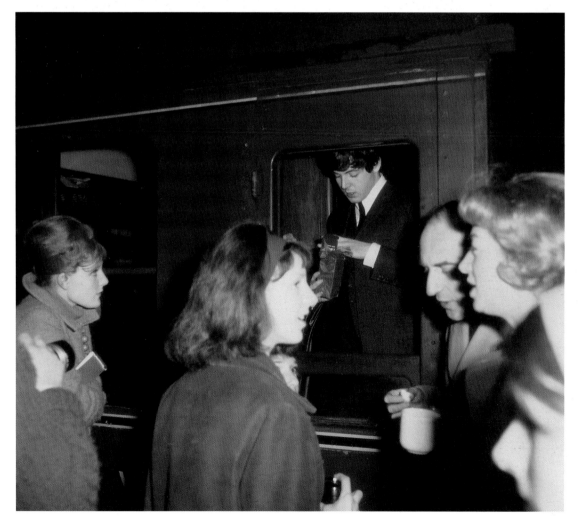

The cast and crew of *A Hard Day's Night* prepare to start filming on platform five of Paddington Station, London. 2 March 1964. *Opposite:* Ringo with Wilfrid Brambell of *Steptoe and Son* TV fame. These pictures were a prized purchase from Christie's: a plastic clip bag containing twenty-two colour transparencies showing the Beatles filming *A Hard Day's Night* (at Paddington and Marylebone stations and on the train en route to the West Country), a real treasure trove.

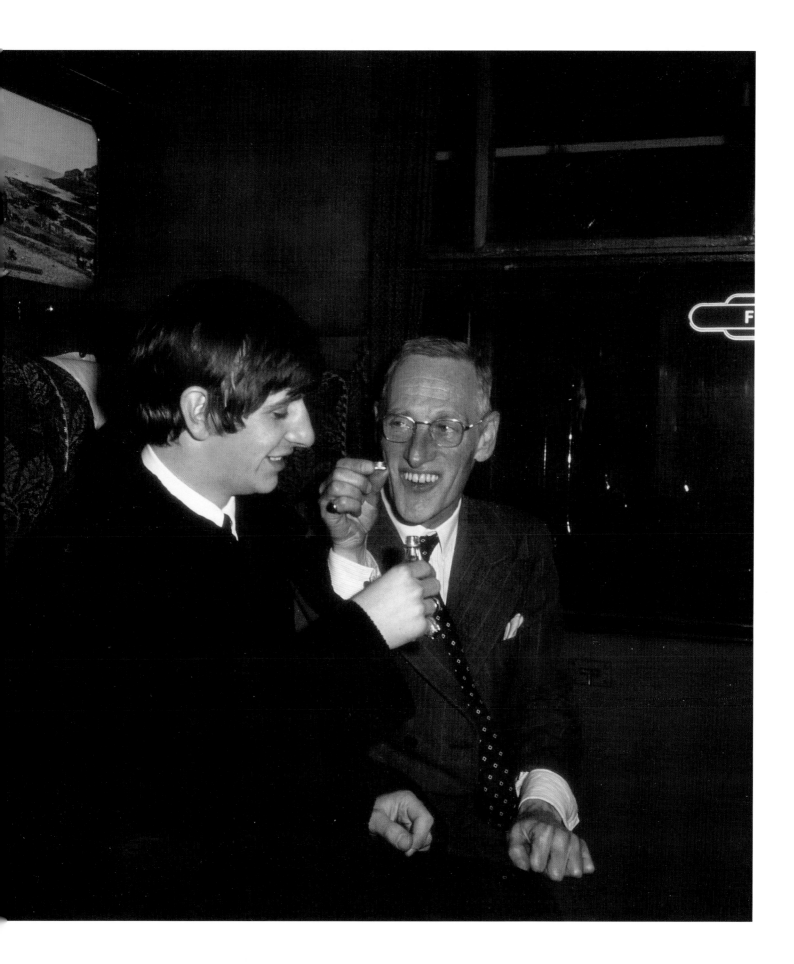

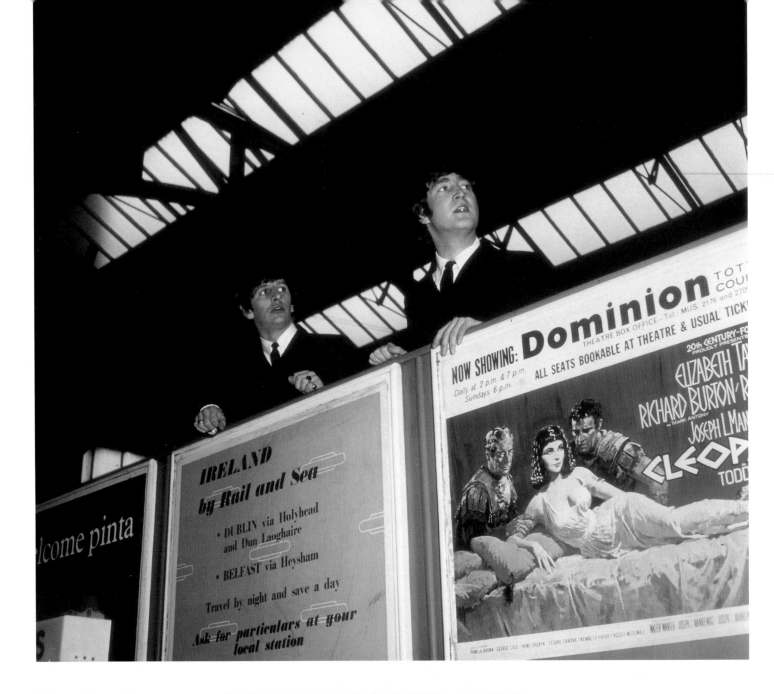

This page: John and George wait anxiously to make a run for it before the girls come running after them, below them a poster for Elizabeth Taylor in *Cleopatra* showing at the Dominion Theatre, Tottenham Court Road, more recently the venue for the Queen musical *We Will Rock You*. *Opposite*: In a First Class compartment on the train with Wilfrid Brambell.

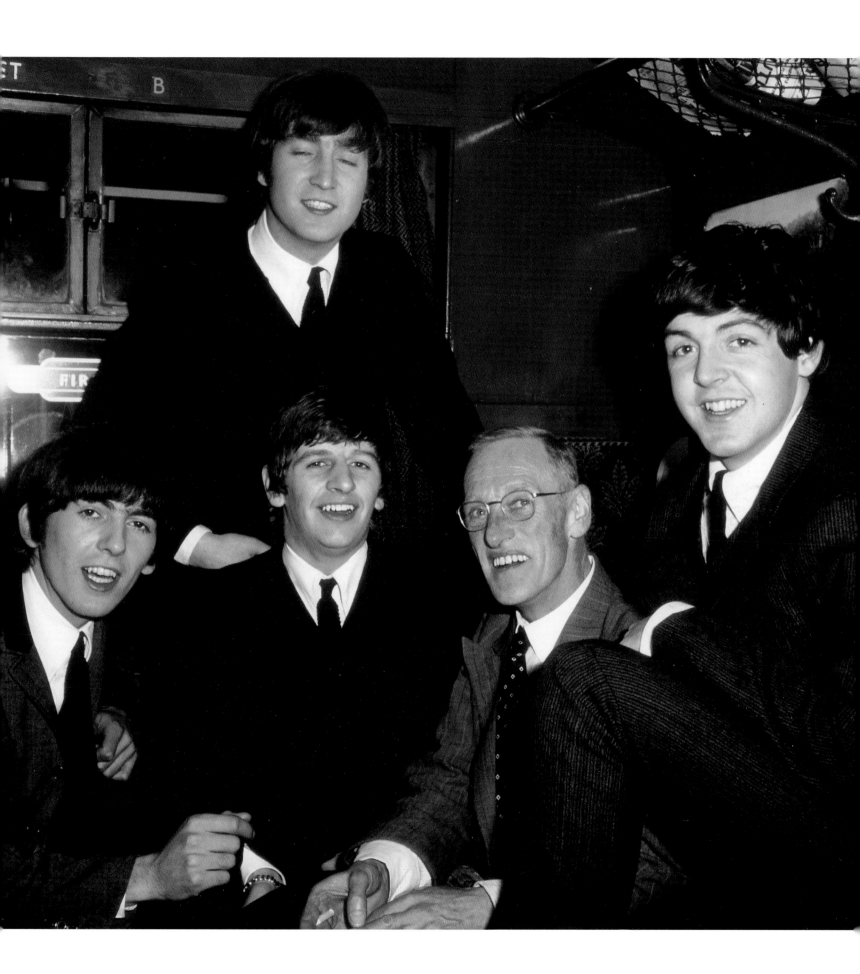

Paul demonstrates to
Wilfrid Brambell how to
pull off a false moustache.

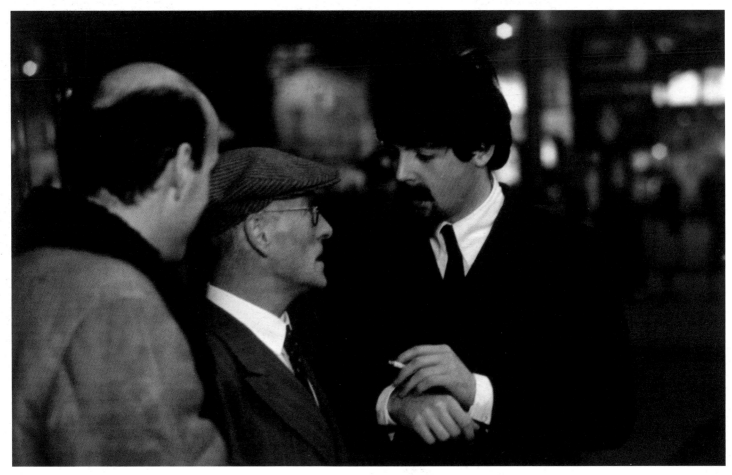

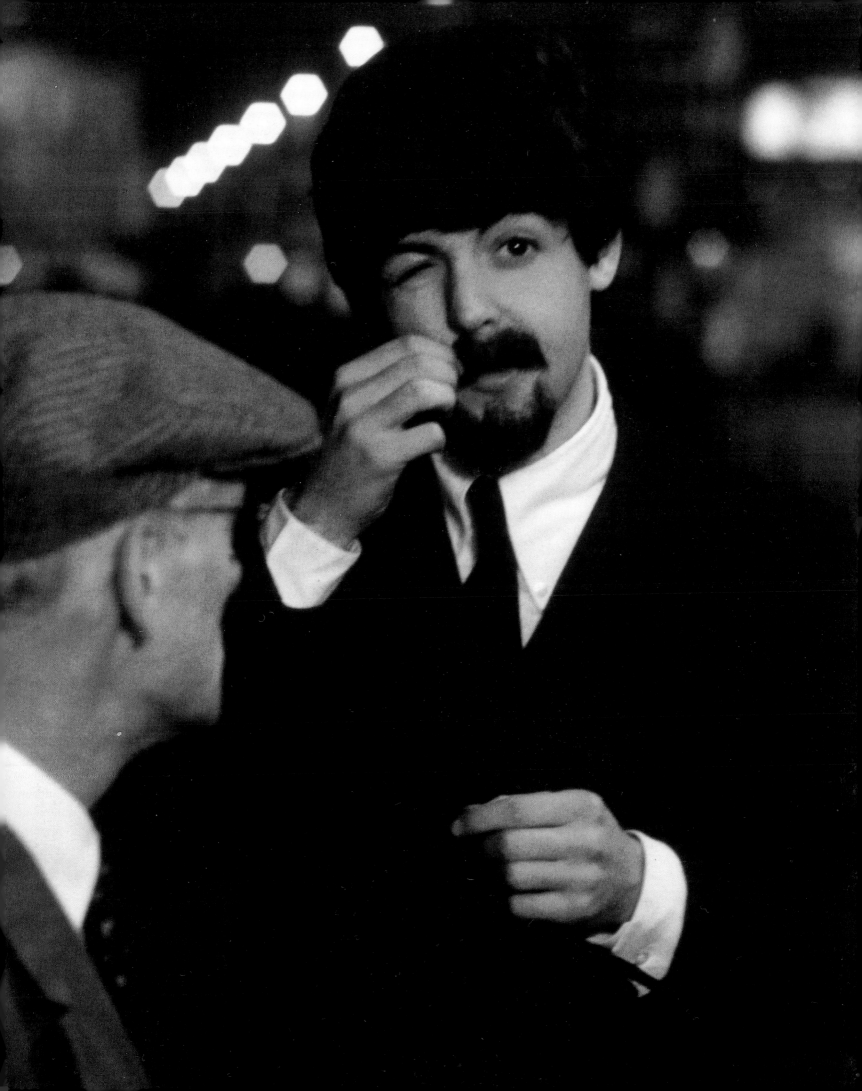

On the train, Paul tries the crossword, sitting next to blonde Patti Boyd (*right of picture*). Phil Collins may have been in the crowd for the movie, but Patti is the lady of importance: an extra in the film, she was to become George's wife, and later Eric Clapton's girlfriend – and inspiration for 'Layla', one of the best tunes ever written in rock history. 2 March 1964.

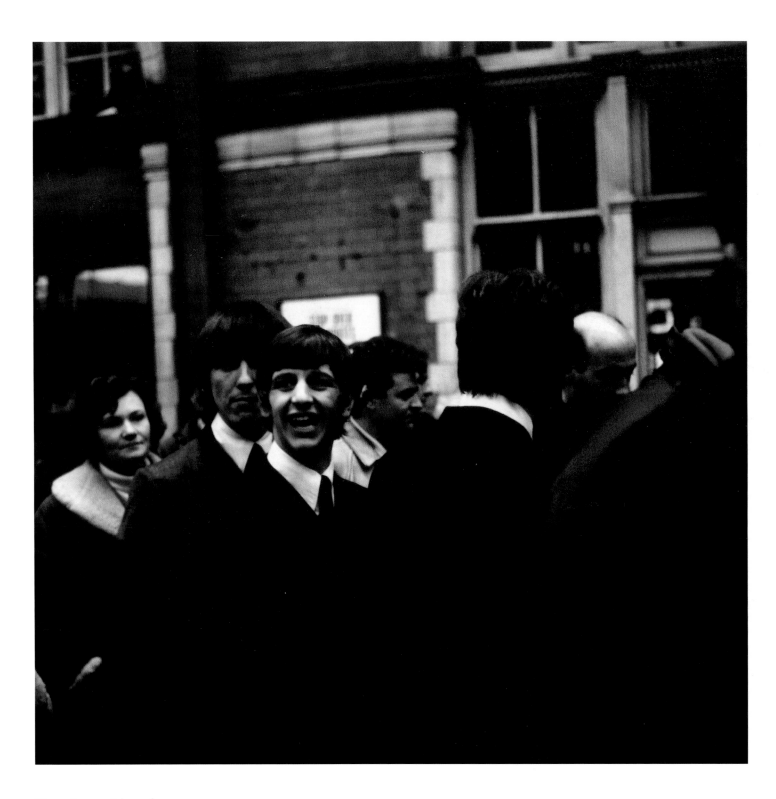

Ringo, George, John and
Richard Lester wait patiently
for the next clip in the
opening sequence to be
filmed. Marylebone Station,
5 April 1964.

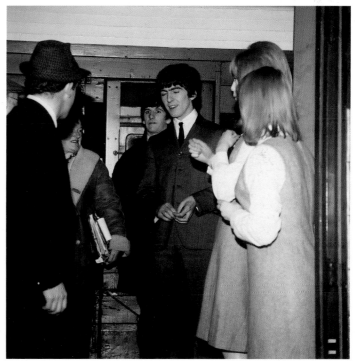

George comes face to face
with his cigarette-smoking
future wife, Patti Boyd, in
what was the postal
compartment of the train.

Left: George makes a run for it in hot pursuit of Paul. *Opposite*: Police protect The Beatles from thronging fans and photographers. Marylebone Station, 5 April 1964.

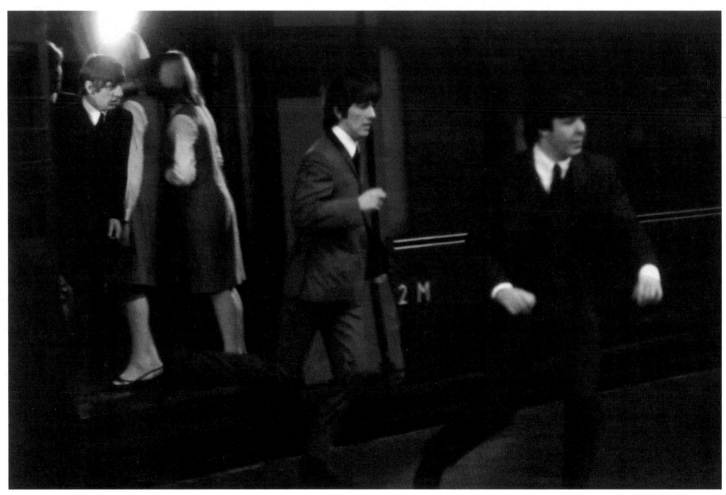

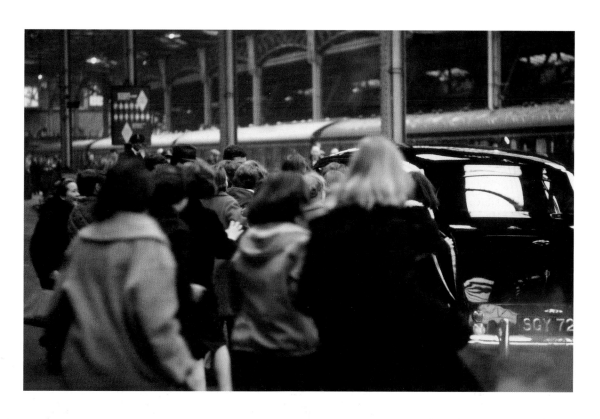

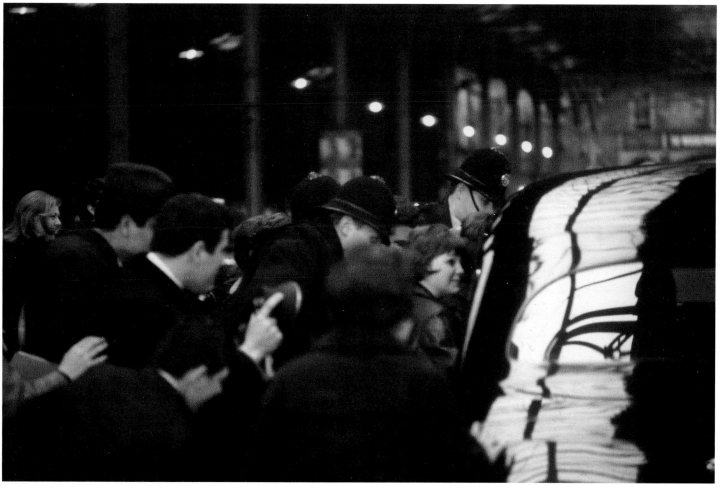

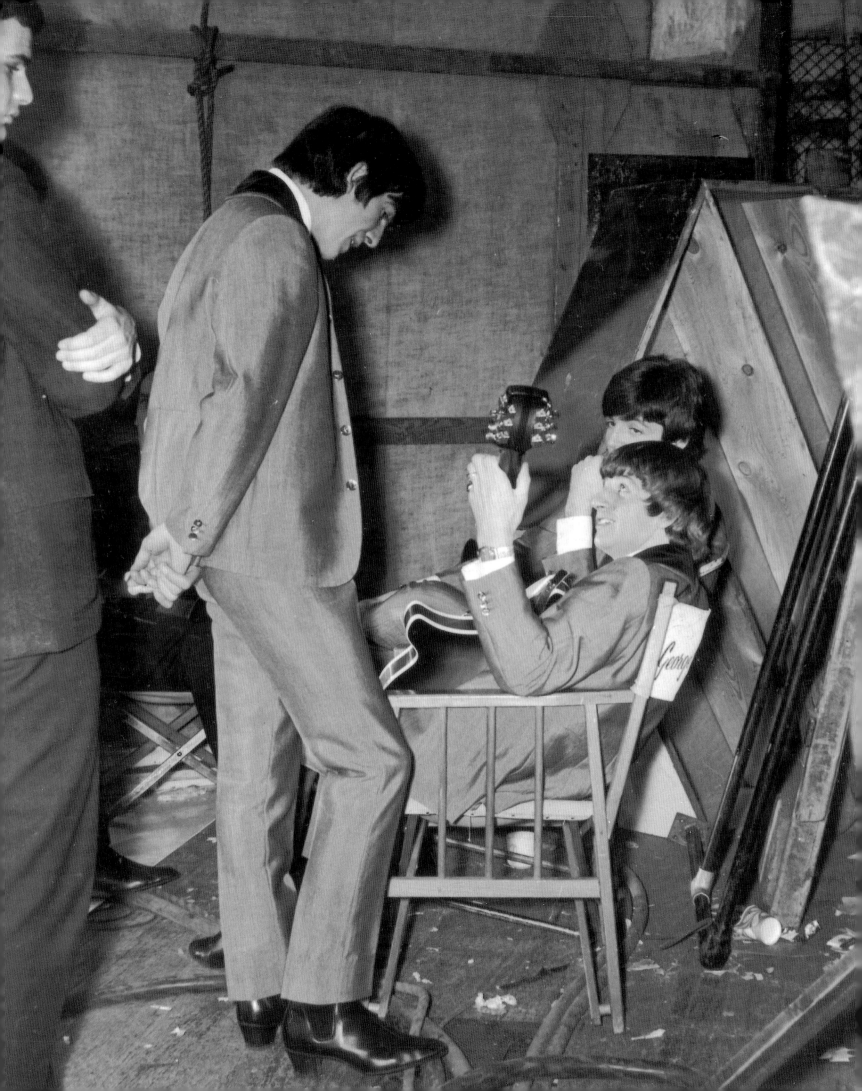

The NME poll winners' concert

Opposite: Relaxing behind the scenes at the Scala Theatre, London while shooting *A Hard Day's Night*. The Beatles' sharp dress style is seen in the classic mohair suits which they wore in the film. 31 March 1964.

The NME (*New Musical Express*) poll winners' concert was an annual show (held at the Empire Pool, Wembley, London) featuring the winners of the previous year's vote by readers of the paper. At this concert on 26 April 1964, attended by 10,000 fans, The Beatles topped the bill. They collected their awards (*below*) from Roger Moore (*far right*), star of TV's *The Saint*.

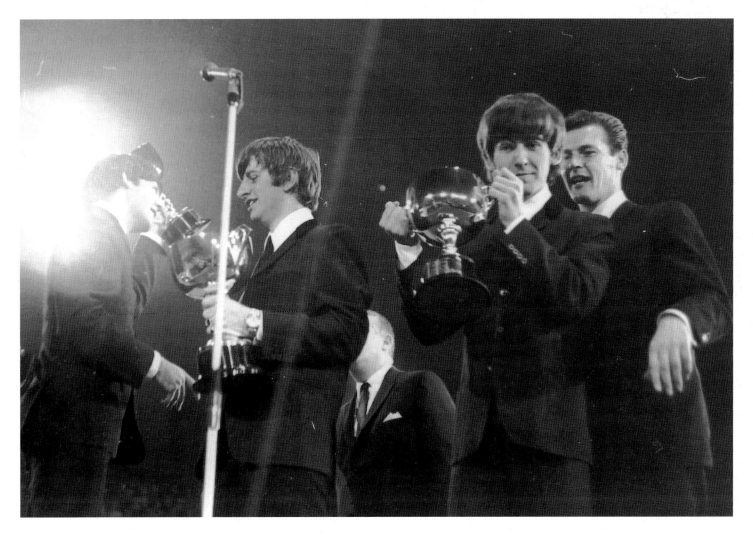

Wembley Studios, London

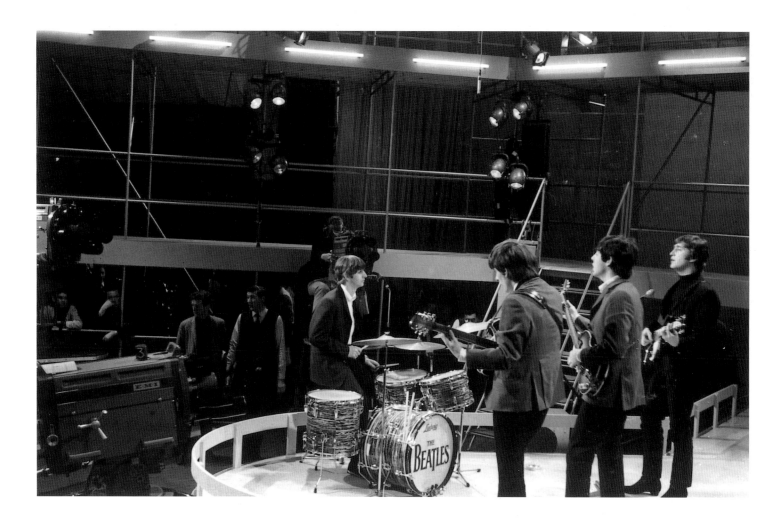

Around The Beatles was filmed for Rediffusion television on 28 April 1964. The negatives for these pictures, which I purchased at Phillips, were unfortunately stolen from my shop, but we still had six, printed here for the first time, showing the rehearsals for the concert section before the props had been added to the scaffolding.

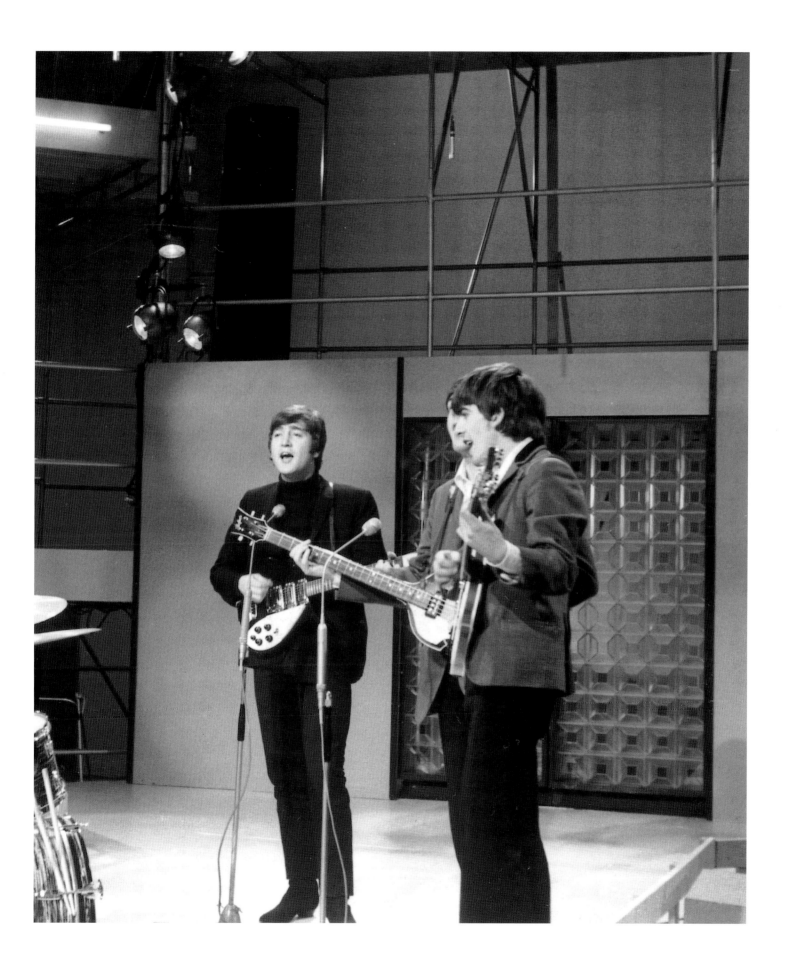

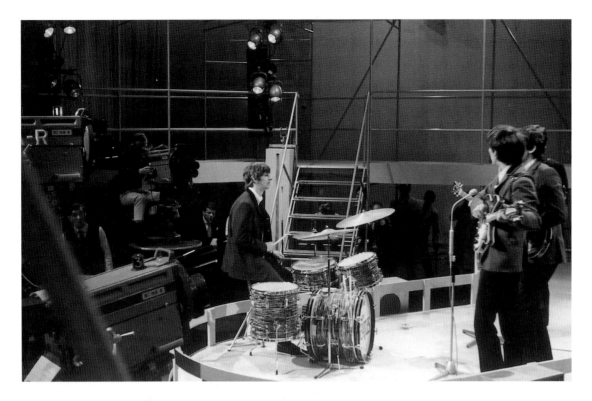

More TV rehearsals (*left*) plus a print-out of a contact sheet (*opposite*) showing The Beatles in Shakespearean costume. In the late nineties The Beatles' costumes worn on this programme came up for sale at Christie's auctioneers.

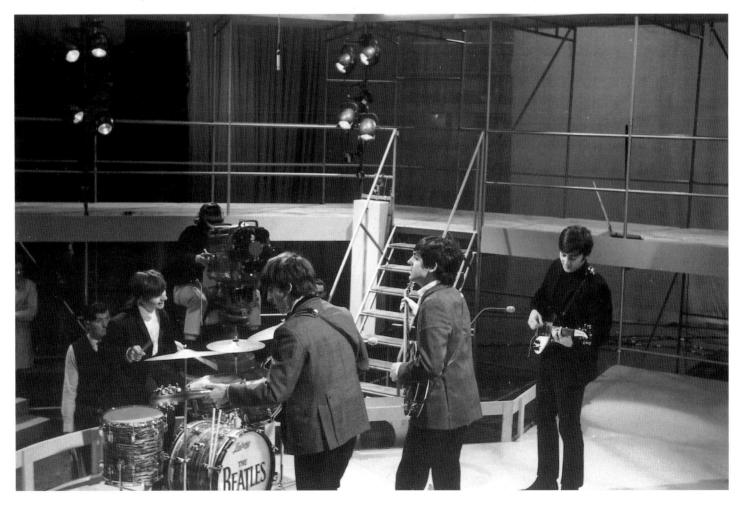

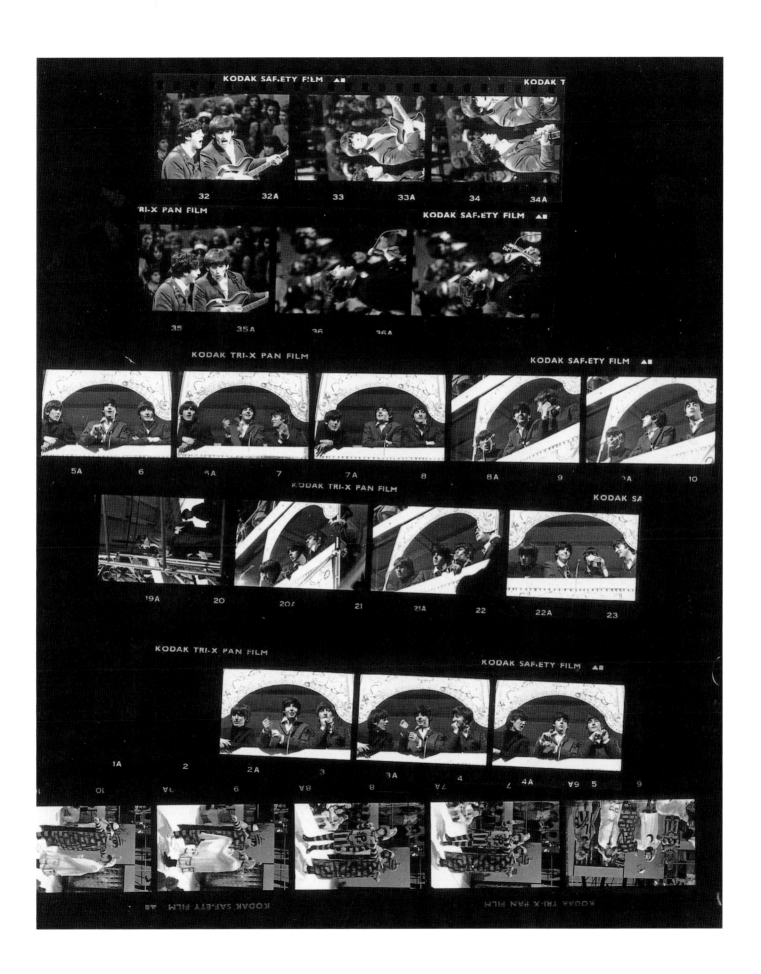

The Jimmy Nicol story

In 1992 I purchased several negatives by Bob Woolfe, who claimed to be the only photographer in Adelaide, Australia at the time of The Beatles' visit in 1964. Featuring the only known photographs of Jimmy Nicol standing in as drummer for Ringo Starr (who had tonsillitis at the time), these images are a unique piece of history. I *had* to buy these photographs: I can't recall any other moment in pop history where a concert of this magnitude took place with a replacement drummer. Today, there is no way that a group would keep to their commitment to perform if one of a four-piece band was too ill to travel.

I thought I had the only Adelaide photographs of The Beatles, so imagine my amazement when, in 2000, I found a larger, even better batch of 112 photographs for sale at Christie's. These photographs, taken with unlimited access by Rosemary Blackwell, depict Beatlemania down under. Here for the first time are photographs of The Beatles stepping off a plane into an open-top car, parading through Adelaide on their way to the Town Hall for a wave to the fans, and attending a press conference to be followed by the concert and drinks reception afterwards. The queue for ticket sales at a department store was for a concert added to the schedule as an extra date due to public demand from a radio station that had gathered a petition by 80,000 fans. My favourite photograph, funnily enough, is not one of The Beatles but one of a happy fan kissing her ticket that she had purchased at the store.

MARK HAYWARD

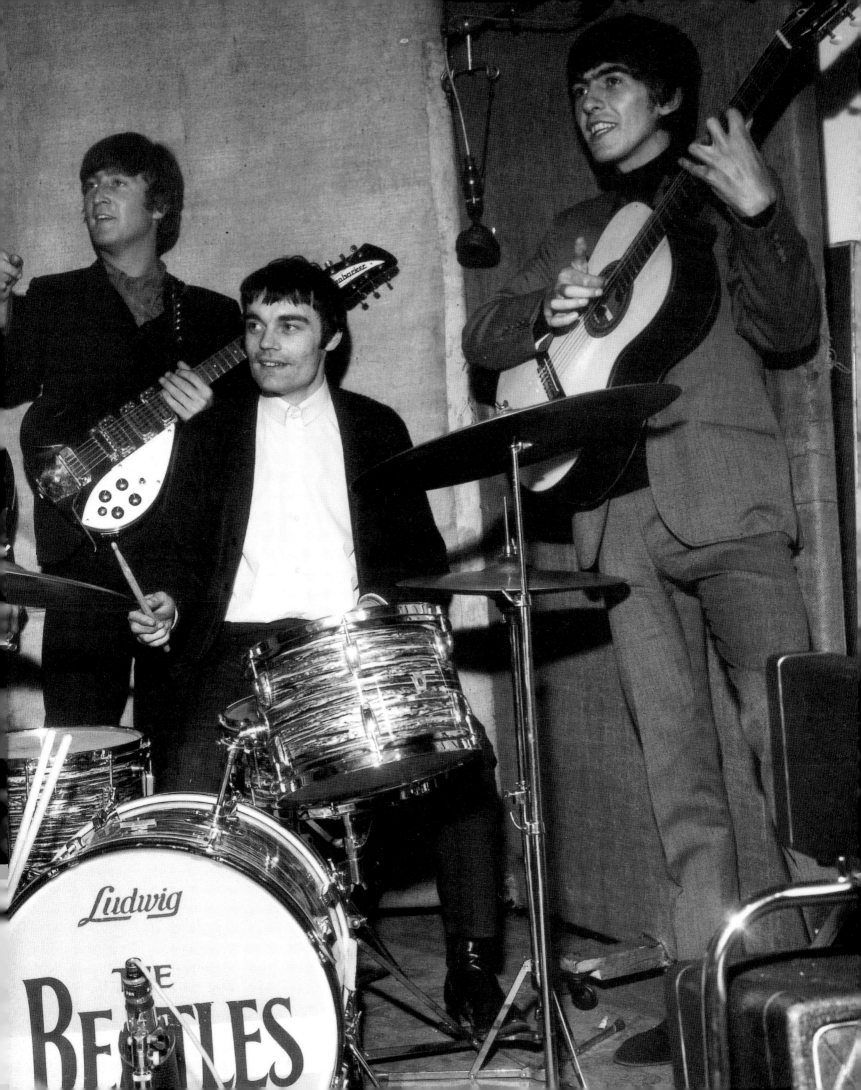

Touring Australia

On Thursday 11 June 1964, just seven weeks after filming their last scenes for *A Hard Day's Night*, The Beatles landed in Sydney, Australia, right in the middle of a tropical rainstorm. The visit was part of their twenty-seven-day 'world tour', which had so far taken in Denmark, Amsterdam and Hong Kong. After a brief stop for fuel, The Beatles and their entourage flew on to Adelaide in a chartered jet, arriving on the morning of June 12. It was The Beatles' first and only time in Australia and, just like in their first film, Beatlemania was at its height, giving all concerned little time for rest. But instead of the group featuring its regular line-up of John, Paul, George and Ringo, the line-up of musicians billed as The Beatles and seen in Adelaide that day consisted of John, Paul, George and... Jimmy!

Ringo's illness

Nine days before their arrival, Ringo collapsed and, because of acute tonsillitis and pharyngitis, was unable to join the start of their world tour. Beatles roadie Neil Aspinall recalled, 'Ringo has never been particularly strong. He collapsed during a photo session… I was with them when it happened and I got quite a fright when I saw Ringo sink to his knees.'

The event naturally threw the upcoming tour into doubt. 'John and Paul readily agreed that it was a sensible thing to do to get a replacement for Ringo on this tour,' Beatles record producer George Martin remembered. 'But George was a little more difficult. In fact, he was downright truculent. He said, "If Ringo's not going, then neither am I. You can find two replacements." Brian Epstein and I had quite a time persuading him it was in the interests of the group, as a whole, for him to go.' Years later, George admitted, 'I was dead against carrying on without Ringo. Imagine, The Beatles without Ringo! Anyway, I bowed to the pressure and off we went, but I was none too pleased, even thought Jimmy was actually quite a lovely guy.'

Ringo's replacement was the relatively unknown session drummer, Jimmy Nicol. Up to this point, his most notable musical work had been when he had appeared on stage supporting such stars as Joe Brown and Billy Fury. 'One day I was having a bit of a lie-down after lunch when the phone rang,' he recalled. 'It was George Martin. He asked, "What are you doing for the next four days? Ringo is ill, and we want you to take his place on The Beatles' tour. Would you mind going to Australia?" Would I mind! "Be at Abbey Road Studios at three o'clock," Martin continued, "The Beatles want to run through some numbers with you." Believe me, I couldn't get there fast enough. I met

> 'Imagine, The Beatles without Ringo! Jimmy was actually quite a lovely guy.'
> **GEORGE HARRISON**

George Martin and he took me into the control room, where I was introduced to John, Paul and George. I wouldn't be human if I didn't admit I was nervous, but they put me at ease straightaway. The instruments were already set up and I took my place at Ringo's drums. We rehearsed five numbers, "I Want To Hold Your Hand", "I Saw Her Standing There", "This Boy", "Can't Buy Me Love" and "Long Tall Sally". I didn't have any music, but that didn't matter because I already knew the numbers by heart. Brian Epstein then took us into the room next door and started talking money. They were going to pay me £2,500 per gig and a £2,500 signing bonus. That floored me! Then John protested, "Good God, Brian. You'll make the chap crazy. Give him £10,000!" They all had a good laugh. Two hours after I got there, I was told to pack my bags for Denmark. The day before this, girls weren't interested in me at all. The day after, with the suit and the Beatle haircut, riding in the back of the limo with John, Paul and George, they were dying just to get a touch of me. It was very strange and also quite scary.' There may be dramatic licence in Jimmy's memory of the sums involved, but the impact on him was undeniable.

For The Beatles, their time 'down under' in Australia was nothing but a blur of planes, cars, hotel rooms, interviews, crowds, screams and concerts. Police reports suggested that over 30,000 people had lined the ten-mile route of their motorcade from Adelaide Airport to the city centre. At least 300,000 Beatles fans, half the population of Adelaide, had converged in King William Street, the area surrounding the city hall, where The Beatles made their first stop. It was quite a reception. Kym Bonython, the tour's co-promoter, remarked, 'You could hardly move in the streets. Everyone was packed, standing shoulder to shoulder. Even at 4a.m., there were hundreds of teenagers in the street, screaming, "We want The Beatles, we want The Beatles." It was just incredible.' Even John was later forced to admit, 'The reception that Adelaide gave us will stick in our memories.' At the city hall the group met Mayor Irwin, the city council and their families, who presented The Beatles with toy koala bears.

Performing in Australia

Later that evening, the group gave two performances at the Centennial Hall, supported both times by Sounds Incorporated, Johnny Devlin, Johnny Chester and The Phantoms. The tour's promoter was Ken Brodziak, who had booked the group through Brian Epstein back in June 1963. He had agreed to pay the group just £2,500 a week. For that, they were expected to perform twelve shows a week, two shows a day. As Ken later admitted, 'That sum was absolute peanuts! They were earning far more at this time.'

The following day saw two further sold-out shows at Adelaide's Centennial Hall, and on June 14 Ringo, who had been discharged from London's University College Hospital just three days earlier, arrived in Sydney to be greeted by the obligatory screaming fans and clamour from the waiting press. Following the ninety-minute stopover, which had included the mandatory press conference, Ringo and The Beatles' manager Brian Epstein flew on to Melbourne, where the crowd at the airport was already large, waiting to greet the other Beatles, who were not due to arrive for at least another five hours. Ringo and Brian immediately headed off to the Southern Cross Hotel, where another large crowd greeted them. The other Beatles, meanwhile, left their Adelaide hotel and arrived at Melbourne's Essendon Airport to be welcomed by a crowd that had now swollen to 5,000!

John, Paul, George and Jimmy then set out to the Southern Cross. Protected by twelve motorcycle outriders, the entourage arrived at the hotel, where they were greeted by the sight of 300 police and 100 members of the military trying to control the large, excited crowd. Subsequent activities resulted in cars being crushed and fans breaking bones after falling from nearby trees. It was therefore suggested that, to relieve the pandemonium that was unfolding, The Beatles show themselves to the assembled hordes. The group duly obliged and waiting fans were treated to the unusual sight of five parading Beatles, who appeared waving to the crowd on the first-floor balcony of the Southern Cross Hotel. The roar from the crowd was so loud that it made John think of a Nuremberg rally, prompting him to give the crowd a Nazi-style salute and shout 'Sieg Heil', even holding his finger to his upper lip as a Hitler-style moustache. The Fab Five then assembled inside the hotel, where they faced another press conference. But this duty was to be Jimmy's last as a Beatle and, on the morning of June 15, he slipped away from the Melbourne hotel. Brian Epstein accompanied Jimmy to the airport and presented him with a cheque for £500 and an inscribed gold watch, a present from Brian and the four Beatles. Engraved on it was the message: 'From The Beatles and Brian Epstein to Jimmy – With appreciation and gratitude.'

What next for Jimmy?

Once back in England, Nicol reflected on his brief spell as one of The Beatles. 'Literally overnight, I became the deputy Beatle: the only outsider to get on the inside of the group that has become an international cult. John, Paul and George made me feel welcome from the start. But the funny thing is that I felt like an intruder, as though I had wandered into the most exclusive club in the world. They have their own atmosphere and their own

sense of humour. It's a little clique and outsiders just can't break in. But we worked together long enough to become great pals. I loved every minute of it, but after living through it, I don't ever want to become a Beatle! I nearly went potty! They spend their lives in little boxes in airliners, hotel rooms and dressing rooms. Me? I want to be free to keep out of those boxes. During the tour, which took me to Denmark, Holland, Hong Kong and Australia, I often went out alone. Hardly anybody recognized me and I was able to wander around. In Hong Kong I went to see the thousands of people who live on little boats in the harbour. I saw the refugees in Kowloon, and I visited a night club. I like to see life. A Beatle could never really do that.'

Jimmy continued, 'Often in Australia, I was tagged as the lonely Beatle. But I cut out on my own because I wanted to. The boys were very kind. Wherever we went, they walked with me in the middle, as part of them. We shared many funny moments together. Once, we were driving back to our hotel after playing at the theatre when our driver just pulled out into a dual carriageway, and in front of a car that was coming towards us fast. We all put our hands over our eyes and held on. We are all thought this was our lot. I also remember a blind man who stood there waving his stick as we passed by. Imagine that, a blind man. Someone must have told him as we got there. It was fantastic, just great!'

Shortly afterwards, Paul reflected on Jimmy's time as part of the Fab Four. 'If Ringo's illness had been permanent, The Beatles would have broken up,' he admitted. 'If anything happened to one of us, we wouldn't go on. We didn't want to go to Holland and Australia. It'd be a drag without him, we thought. If it hadn't been a temporary illness, then that would have been it. We'd all have packed it in. If one of us dropped out, the group would break up! We definitely won't perform as three Beatles. I hate the idea! Jimmy's fine, but he wasn't Ringo, and it was Ringo we missed.'

Unfortunately, Jimmy Nicol was never able to reach such heights in the music industry again. Less than a year later, on 29 April 1965, he appeared in the London bankruptcy court with debts of £44,066 and assets of just £30. Thereafter, Nicol began a slow and painful slide into obscurity.

Ringo, meanwhile, was back full-time in the Beatle fold and ready to re-join the group for the first of six performances at the Festival Hall, Melbourne, beginning later that night and spanning the next three days. The Beatles' Australian tour also took in performances at Sydney Stadium before they headed off to New Zealand on June 21, to be greeted at the airport by approximately 7,000 fans.

'If one of us dropped out, the group would break up! We definitely won't perform as three Beatles.'
PAUL McCARTNEY

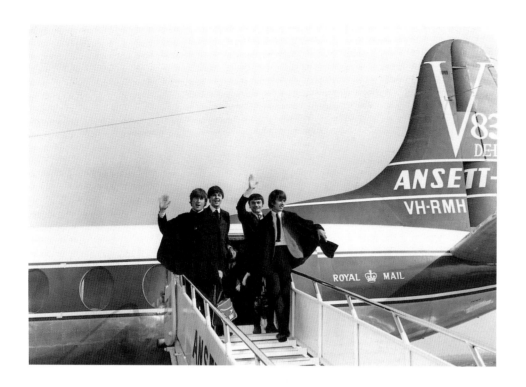

The effort of transporting people to Australia in 1964 was immense, taking in several stopovers for refuelling in a gruelling thirty-six-hour journey without the in-house entertainment of aircraft these days. The Beatles' names were printed on the side of the open-top car (*opposite*) that met them at Adelaide Airport, but Jimmy Nicol's name had not been added. Press officer Derek Taylor (*to right of car*) sees them off. 12 June 1964.

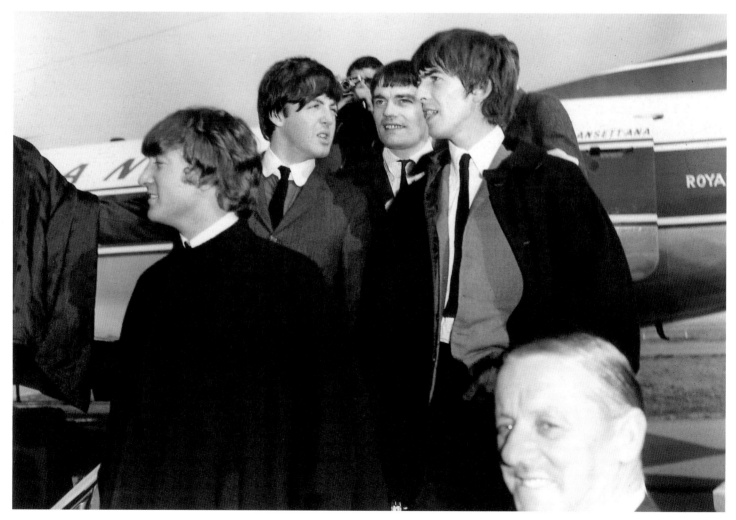

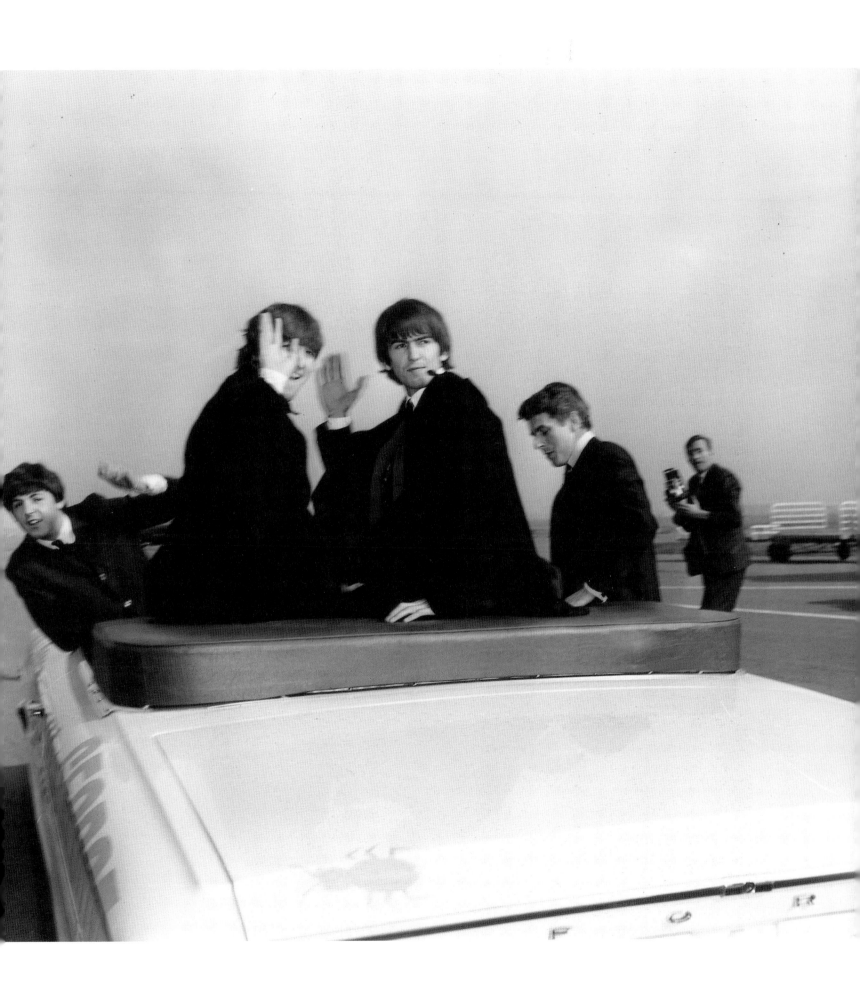

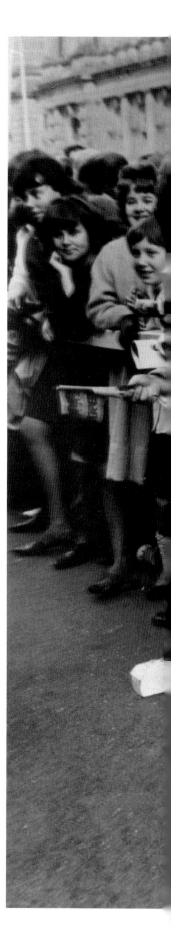

TV Week, an Australian television-schedule magazine, publicized The Beatles' arrival, causing pandemonium along the drive from the airport with a welcome normally reserved for royalty. 12 June 1964.

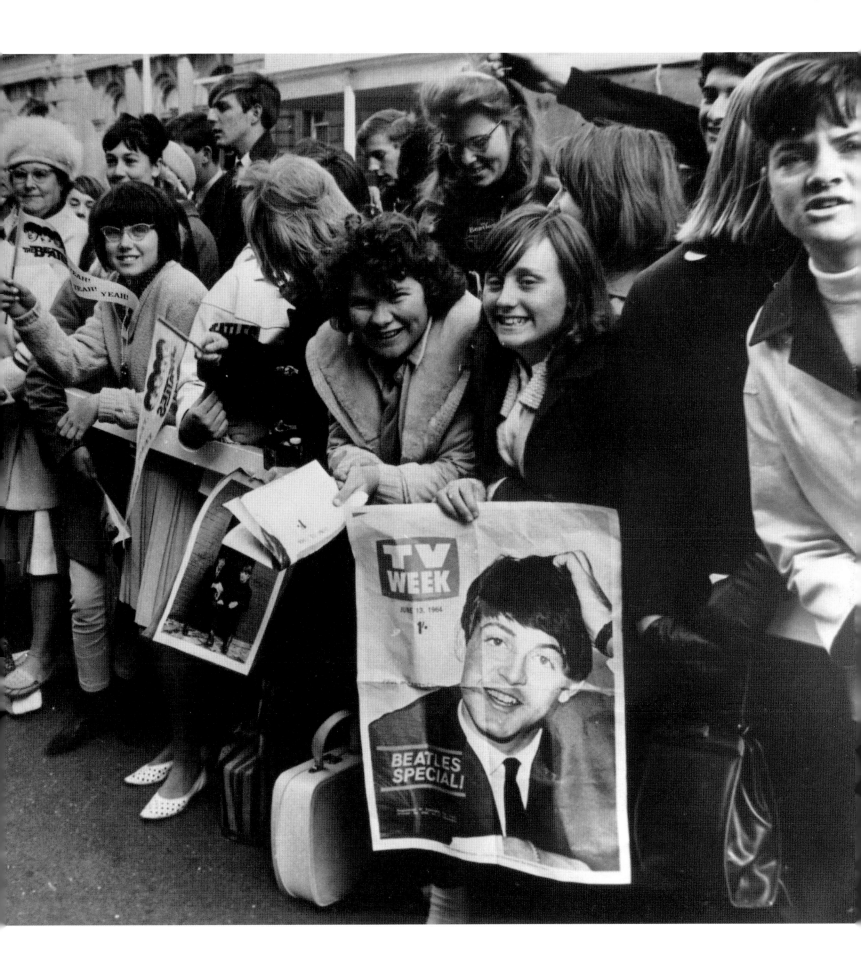

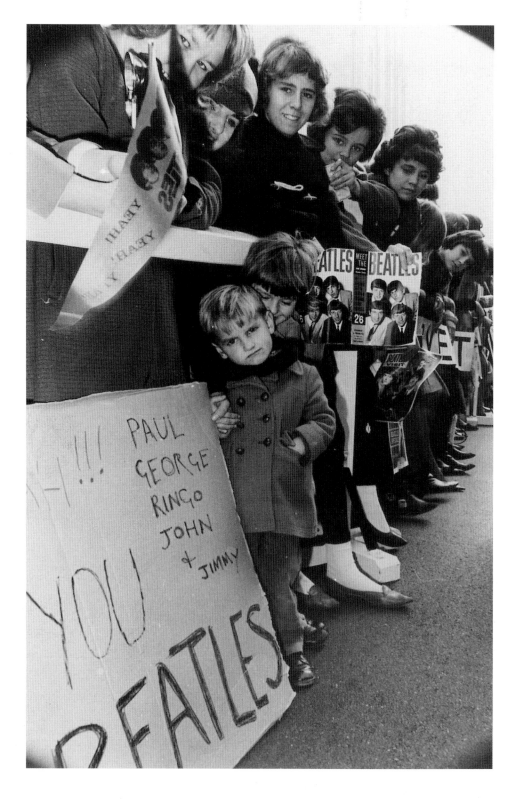

'We love you Beatles Paul George Ringo John + Jimmy' hastily added in crayon to a large home-made welcome banner.

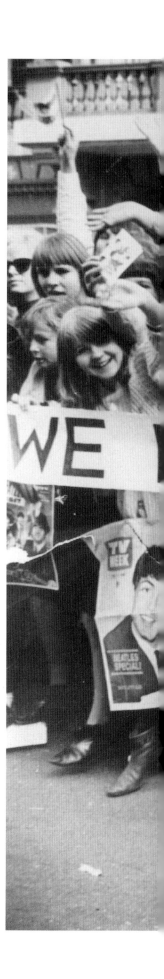

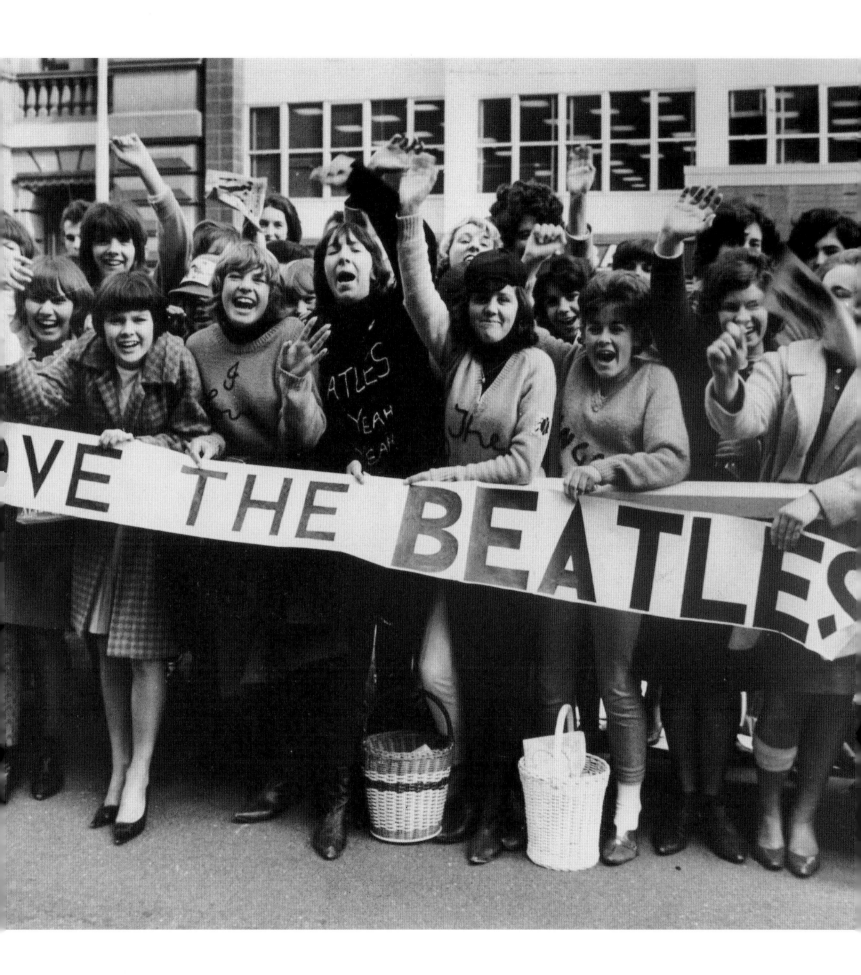

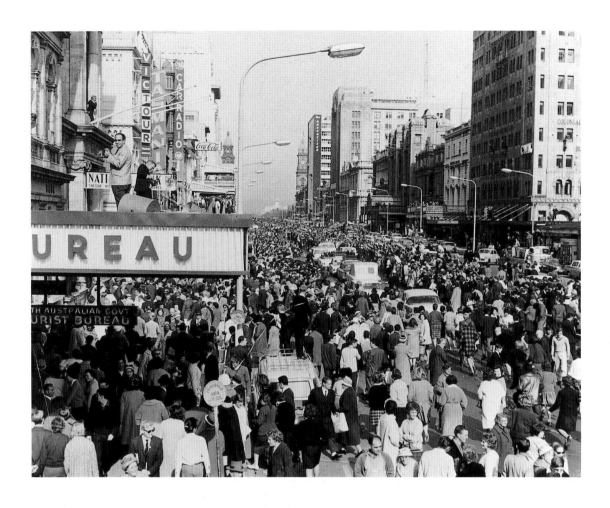

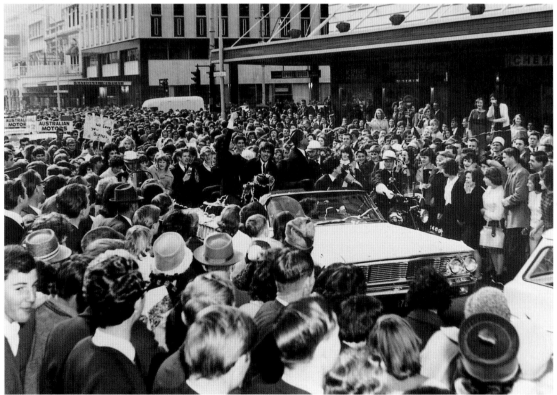

The whole of Adelaide's main street was closed off for The Beatles' welcome: Beatlemania had truly arrived. Scenes like this had never before been seen in Australia for pop stars, but then international pop stars rarely visited the continent.

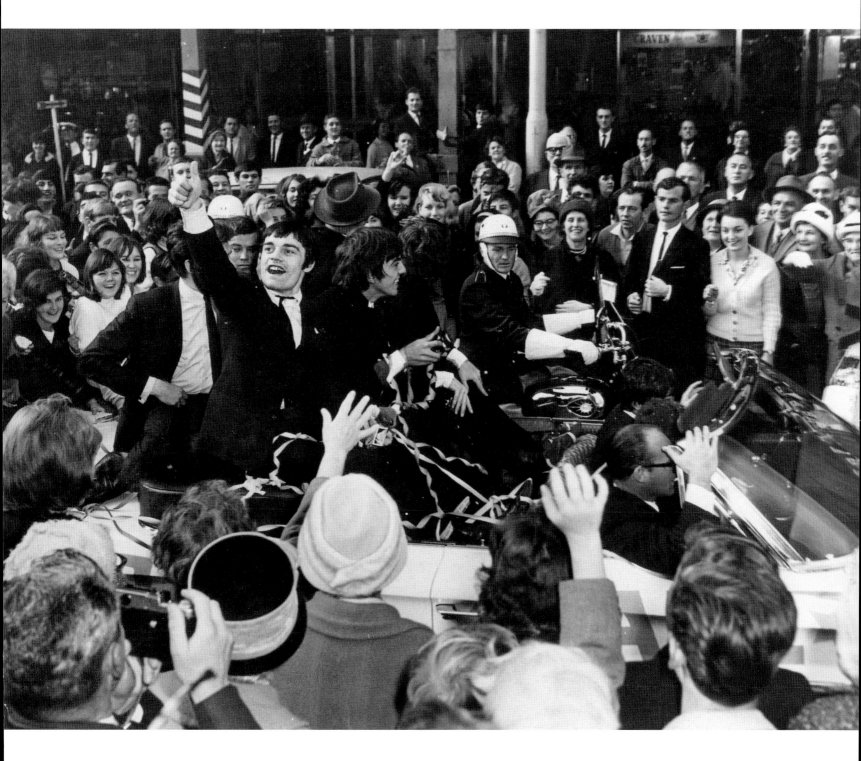

Jimmy Nicol gives a thumbs up, perhaps wishing the adulation could last forever. These fantastic photographs are a unique piece of history. All contracts these days have a rider to state that if the artists are too ill to play, they can cancel the tour.

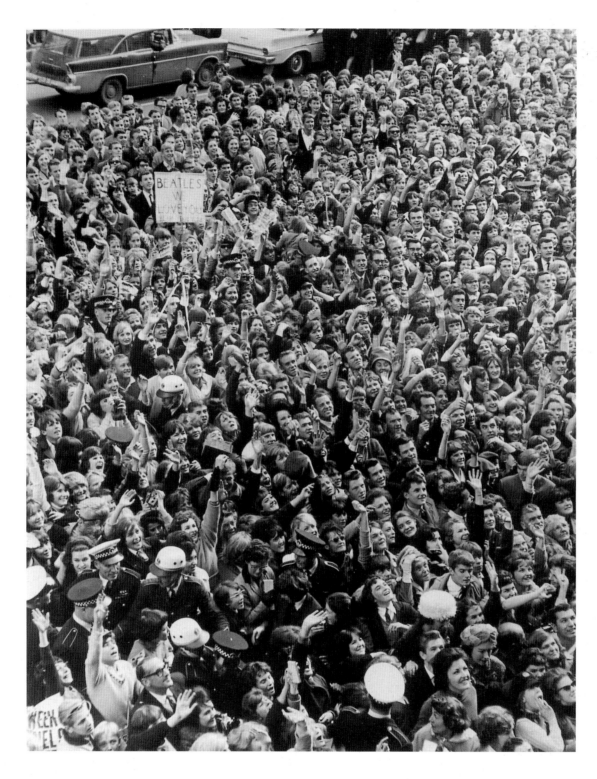

Opposite: John's face says it all: it took The Beatles by surprise. A paparazzo photographer hangs on for dear life taking a photograph from the outside of the second floor of the town hall. 12 June 1964.

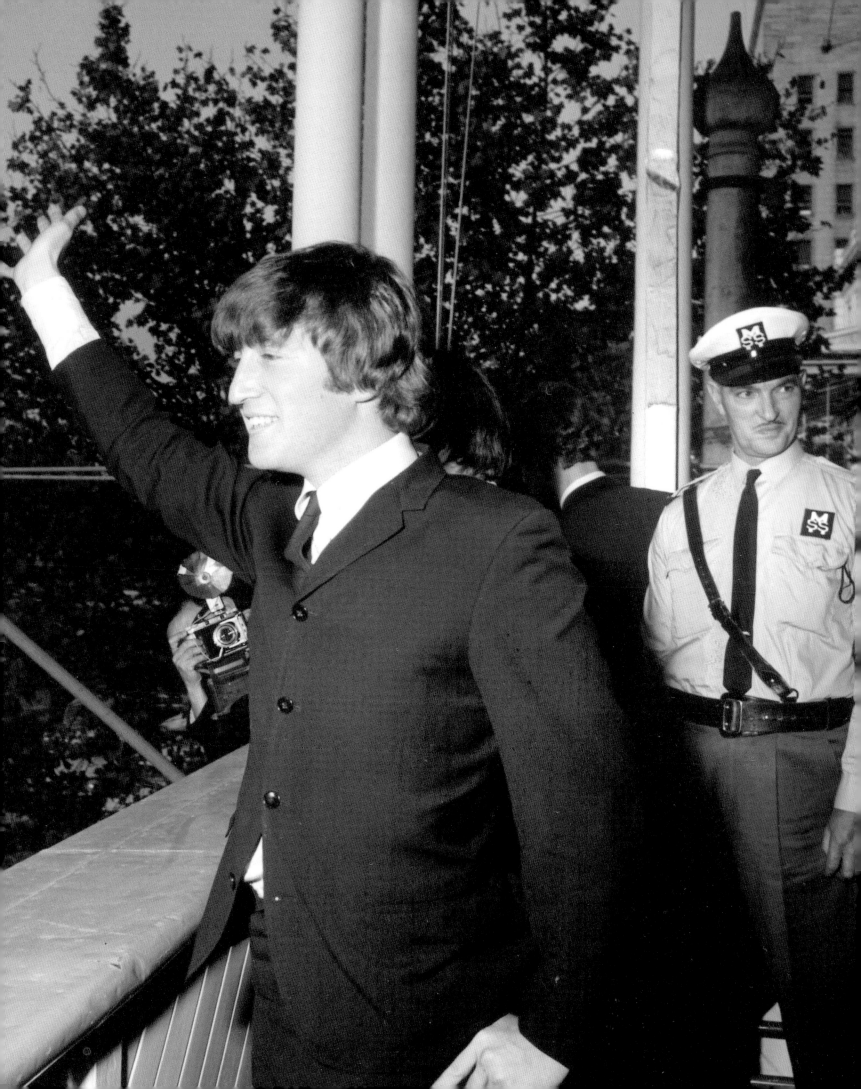

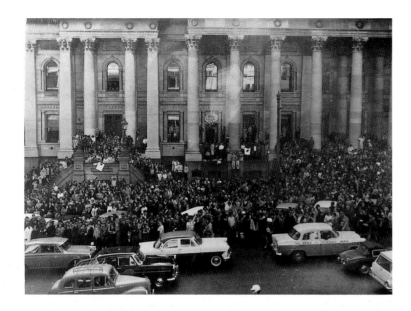

Police and security guards attempt to smooth the way. *Opposite*: A security guard, oblivious to this photograph being taken, takes note when George tells a photographer off, while the remaining Beatles keep waving to the crowd.

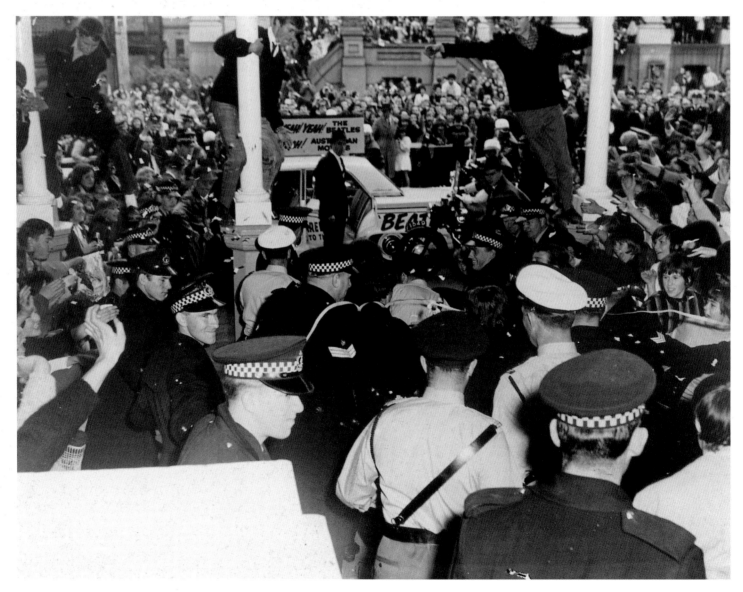

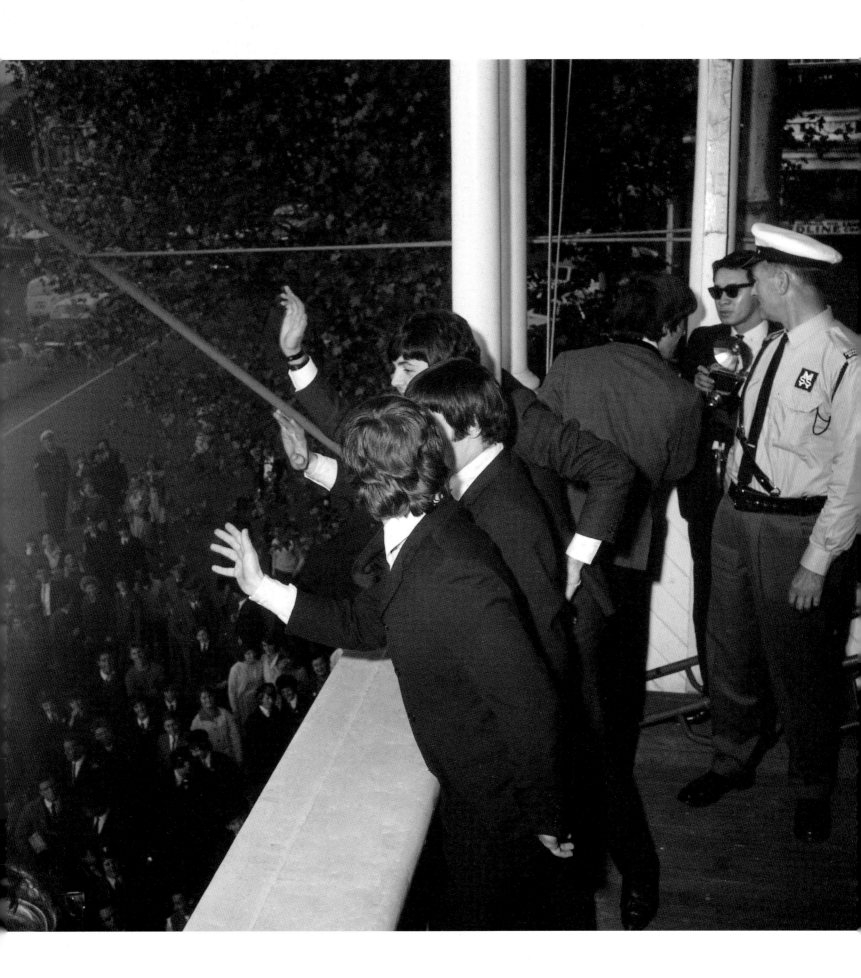

Adelaide press conference

Soon after their City Hall reception, the group faced the country's media at a press conference…

Reporter: 'Well fellas, tell me, what did you think of the Adelaide reception?'

John: 'Oh, it was great! The best ever.'

Reporter: 'Was it like I'd mentioned to you on the plane it would be?'

John: 'Yeah, it was better!'

Reporter: 'Was it like anything you'd ever had before?'

George: 'No, much better.'

John: 'We'd never done one of those "drives" as well. It was marvellous.'

Reporter: 'How would it compare with the ones in the United States when you arrived there?'

Paul: 'This was bigger. There was more people there.'

Reporter: 'Do you think it was very well conducted?'

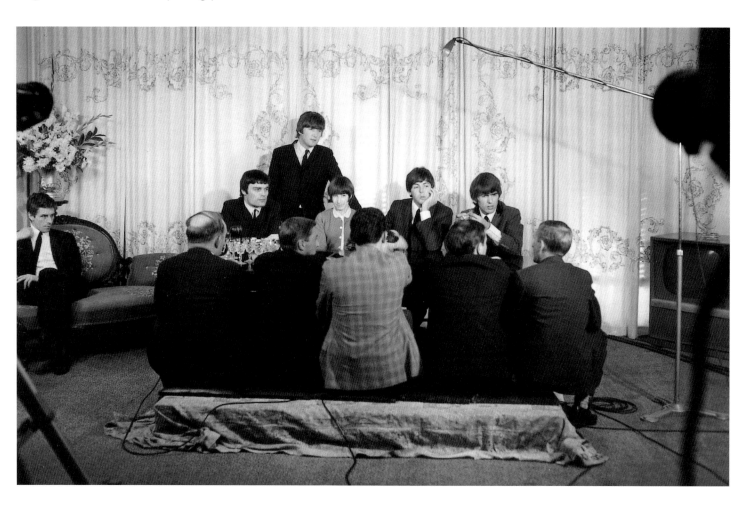

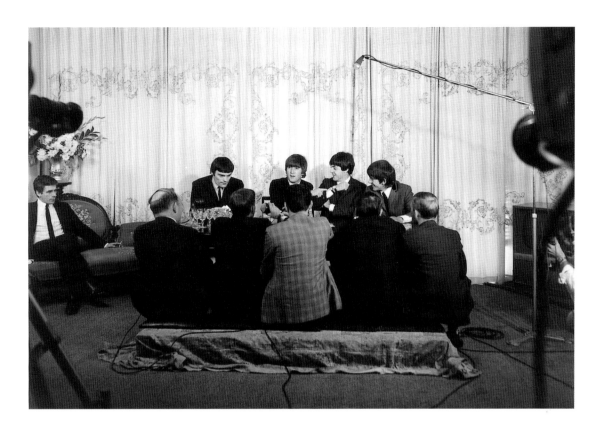

John: 'Yes. Everybody was well behaved.'
Reporter: 'Did you get a fright at all outside the Town Hall?'
John: 'Not fright. Shock, you know, because there was so many.'
Reporter: 'Do you ever get this feeling that maybe someone's gonna try and knock you off or something?'
George: 'I had a feeling we might've got shot, 'cos it's the first time we'd been sitting in the back of a car waving, you know.'
Reporter: 'Were you disappointed that the airport was closed and that the kids couldn't get close to the plane?'
John: 'I didn't think it mattered, with them all being able to see us anyway along the route.'
George: 'They saw us better I think by lining the road.'
[*Jimmy Nicol enters the room.*]
John: 'Come here, Jim.'

Paul: 'There he is. Jimmy!'
Reporter: 'There's Jimmy Nicol, drummer for Ringo Starr. Tell me, what did the Lord Mayor say to you?'
George: 'He said it was very nice to have us here, he was all pleased and said, "Have a drink."'
Reporter: 'And what did you say to the Lord Mayor?'
Paul: '"Thanks."'
Reporter: 'What did you drink?'
Paul: 'Scotch and Coke, actually.'
Reporter: 'Jimmy, do you think that Brian Epstein is going to wave his magic wand at you sometime and include you as a fifth Beatle? Or as a stand-in drummer for Ringo permanently?'
Jimmy: 'That I don't know.'
Reporter: 'Jimmy, having played with all of these bands, what is it like being suddenly thrust in with The Beatles?'
Jimmy: 'It's the "end" you know.'

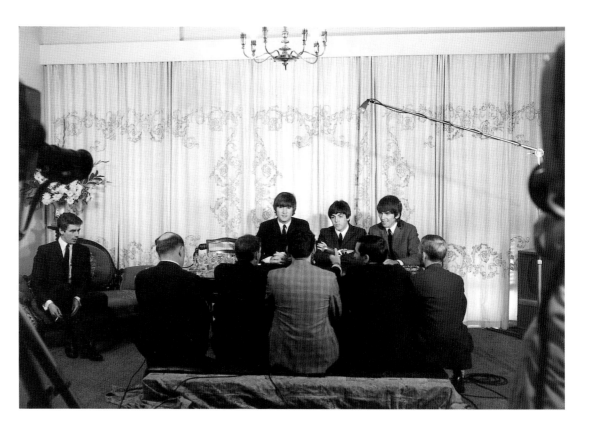

The three Beatles face the press (*this page*) before Jimmy joins in to answer some questions (*opposite*).

Reporter: 'Do you have any trouble getting the same beat as Ringo?'
Jimmy: 'Well, I do my best.'
John [*humorously*]: 'Ah!'
[*Laughter fills the room.*]
Reporter: 'George, what have been your most exciting moments in show business?'
George: 'I can't remember, there's so many. Ever since last September, you know, everything's been exciting. I think when we got to America and we found out that they'd gone potty.'
Reporter: 'Are you ever scared of being hurt by some of the over-enthusiasm? Have you ever been hurt?'
Paul: 'That's why we're not scared, because we've never been hurt. Maybe if we had, we'd be a bit worried about it.'
Reporter: 'In South Australia, not only teenagers go wild over you, but maybe you noticed today, coming in from the airport, there was a heck of a lot of adults, especially grandmas…'
John: 'They're great.'
Reporter: 'Is it the same in England?'
John: 'Well, I've never seen so many grandmas at once.'
[*Laughter again fills the room.*]
Press question: 'What do you think made the difference that put you up above all the other groups?'
George: 'We had a record contract.'
Question: 'What record do you agree is generally your best recording? Not the best seller, but rather the best musically?'
John: 'We always like the one we've just made, don't we? So "Long Tall Sally".'
George: 'I like "You Can't Do That", personally.'
Question: 'What about you Jimmy? How do you feel being in with The Beatles? A newcomer standing in for Ringo?'
Jimmy: 'It's a good experience, man.'

Question: 'How is Ringo?'

Jimmy: 'He's much better. He joins us on Sunday.'

Question: 'What do you do then?'

Jimmy: 'I go back to London, where they're fixing up a band for me. I'll do some television…'

John [*interrupting*]: 'And he's away.'

Question: 'Do you ever go to the barber's, John?'

John: 'No. I haven't had my hair cut since the film. The woman on the film cut it. I don't trust anybody else.'

Question: 'This is the film *Beatlemania*, is it?'

John: 'No. It's not called that. That's another one. *A Hard Day's Night* it's called.'

Question: 'Are you satisfied with the finished product?'

John: 'Well, it's as good as it can be with anybody that can't act!'

Reporter: 'Are you individually millionaires yet?'

John: 'No, that's another lousy rumour. We wish we were.'

Reporter: 'Is Brian Epstein a millionaire?'

John: 'No, even he's not one. Poor fellow.'

Reporter: 'Where does all the money go?'

John: 'Well, a lot of it goes to Her Majesty!'

George: 'She's a millionaire.'

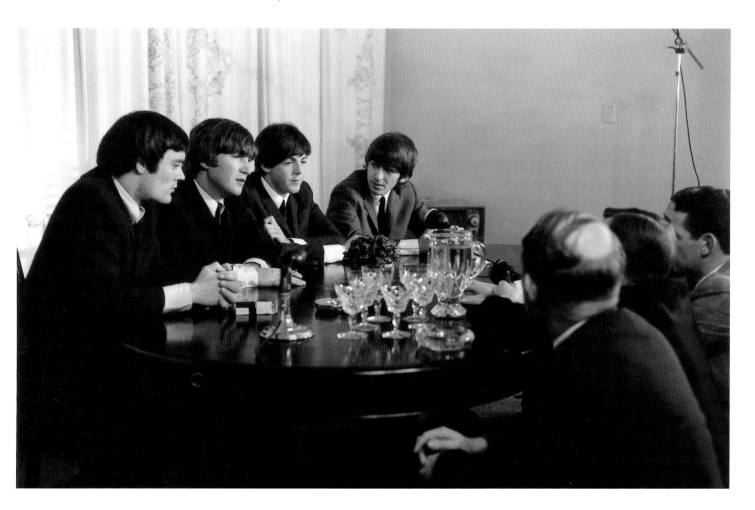

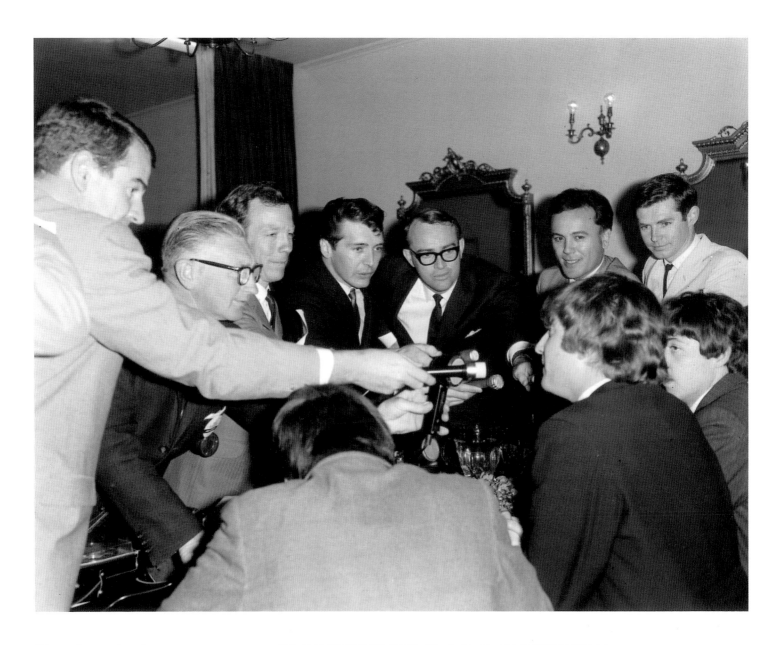

This page: Seven microphones thrust in the direction of John while George tries to take care of two of the interviewers. *Opposite:* Jimmy Nicol poses with the three Beatles inside Adelaide's city hall.

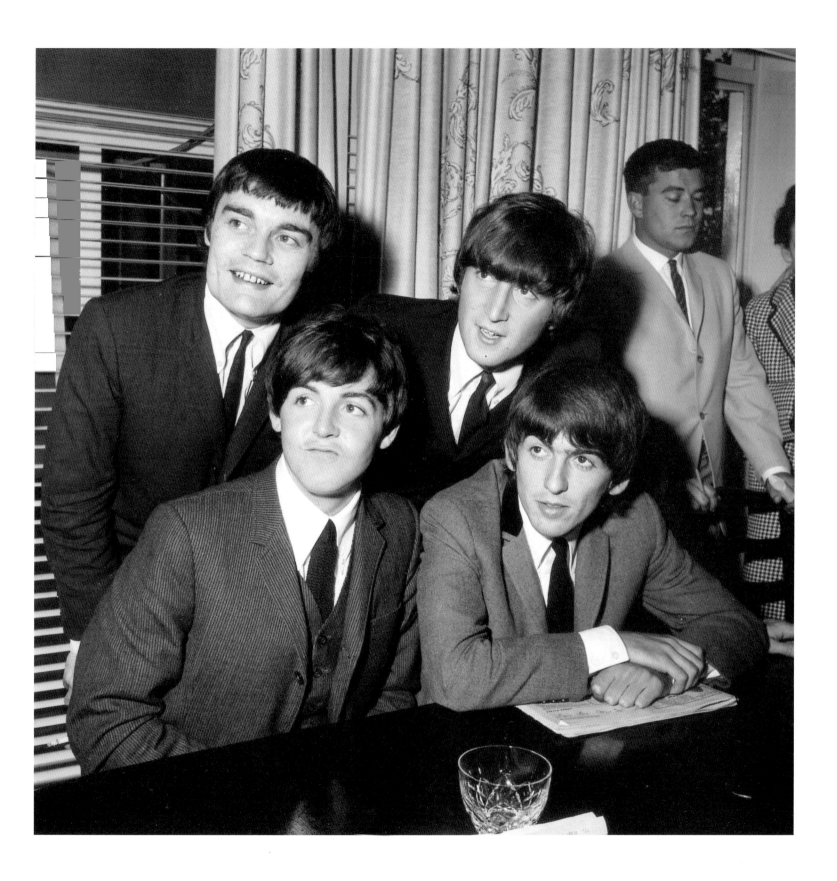

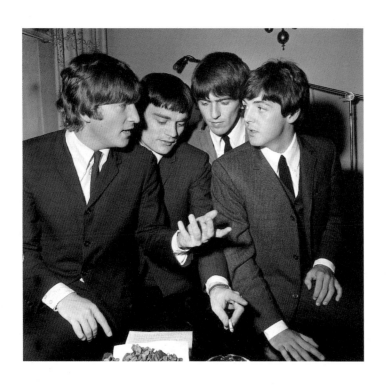 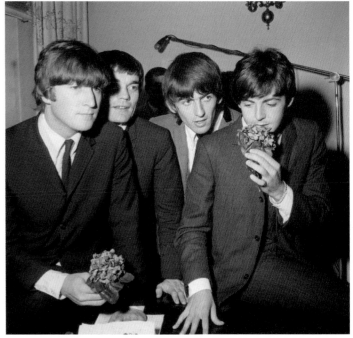

An Australian present of
flowers for The Beatles, one
they could not take home
due to customs restrictions.

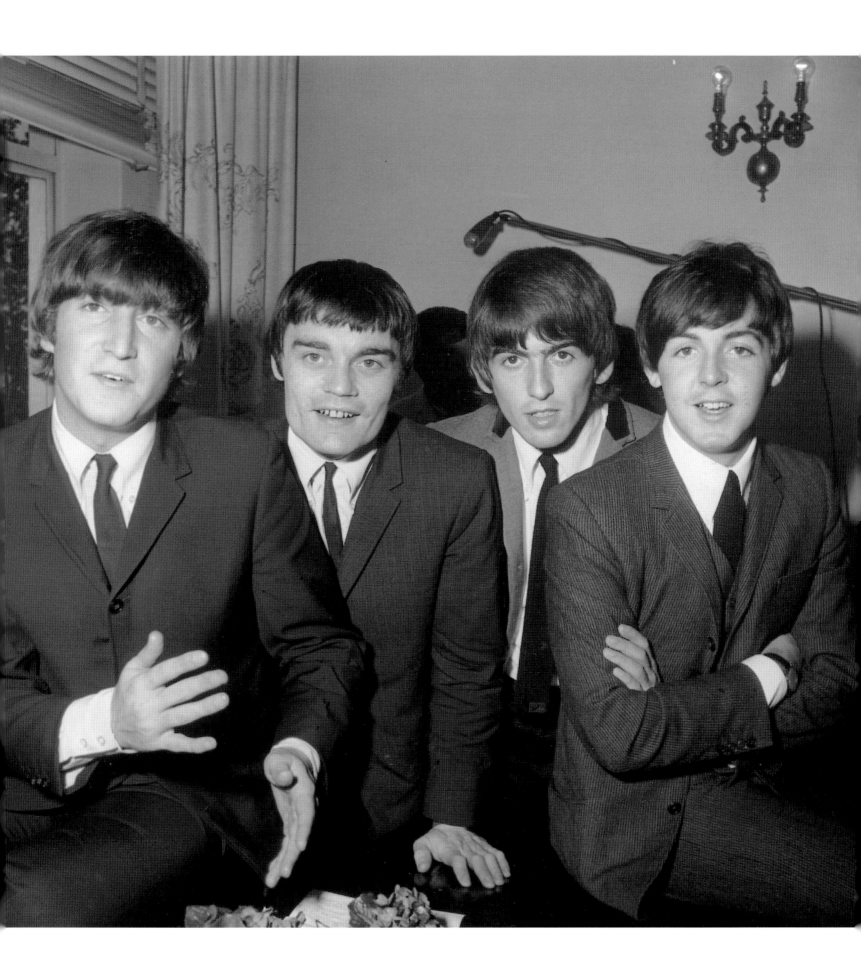

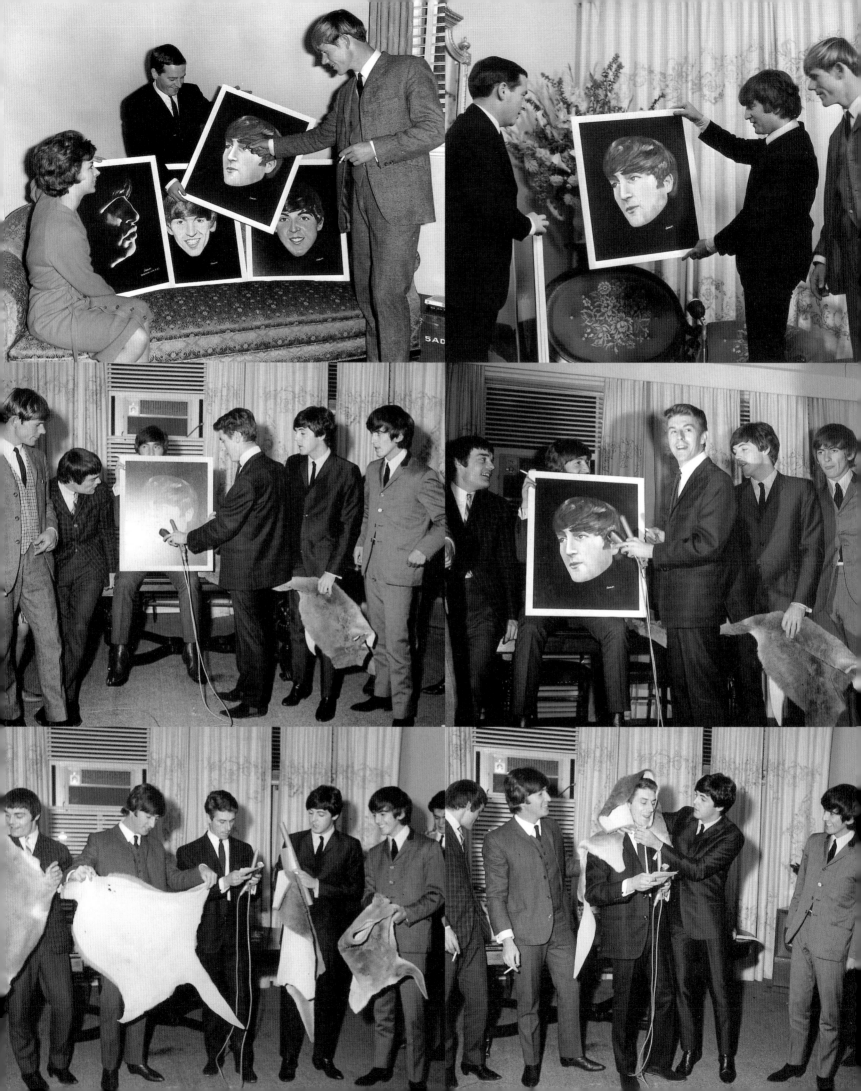

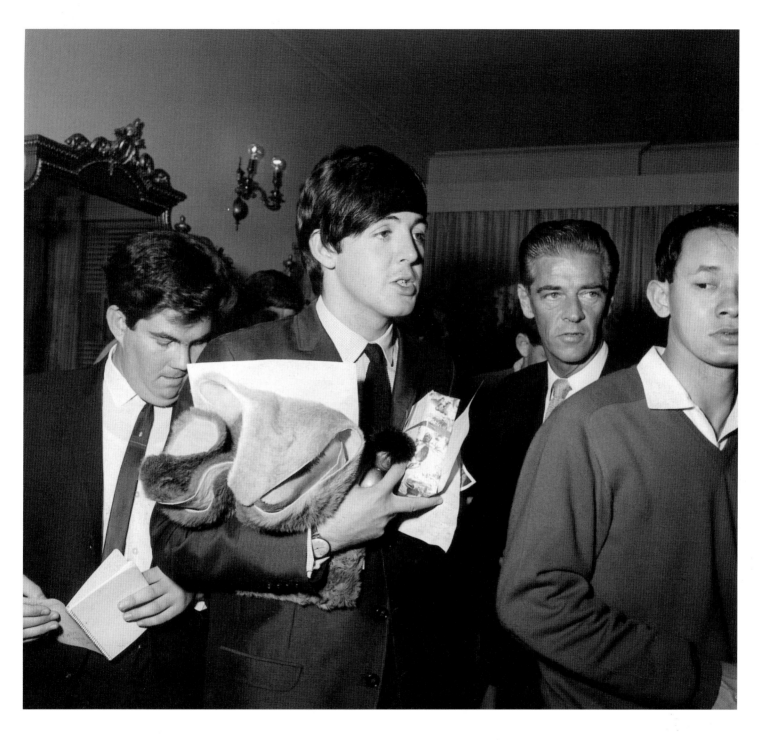

More gifts. *Opposite:* John makes his painting talk while Paul wraps his animal skin around press officer Derek Taylor's head.

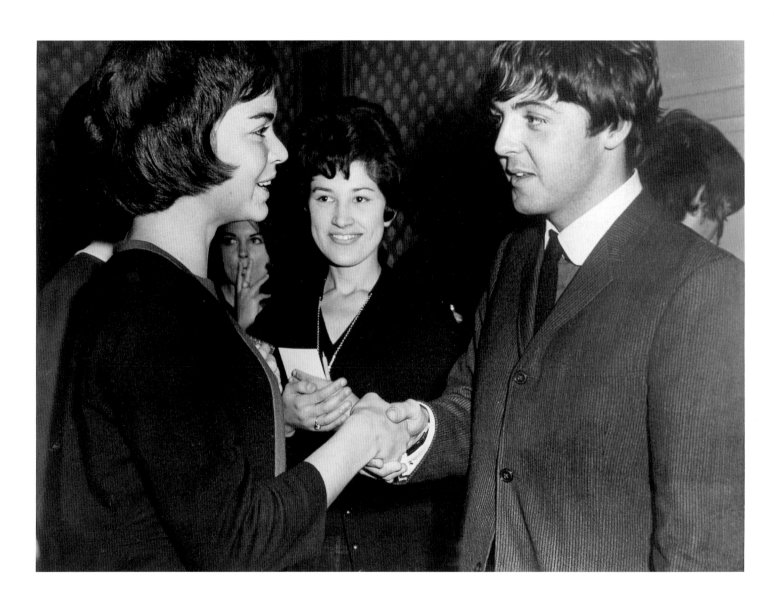

I'm happy to meet you too.
The obligatory meet and
greet, 12 June 1964.

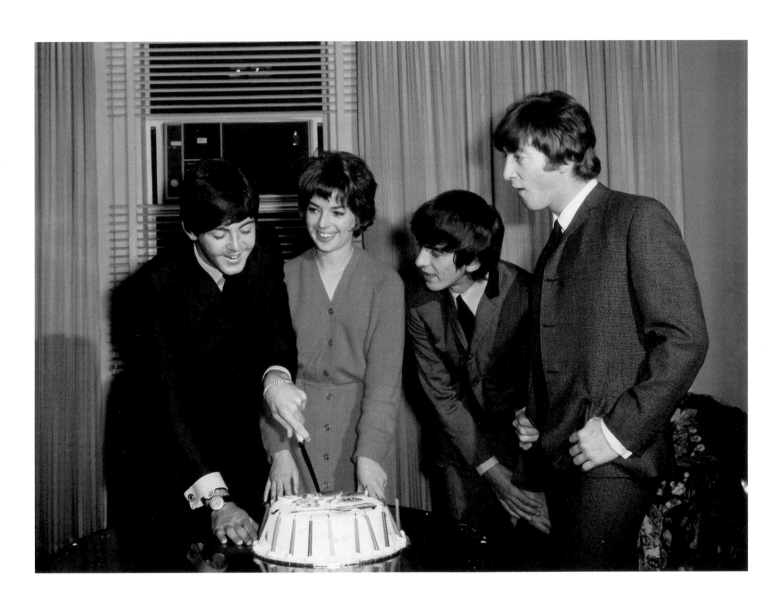

Celebrating a birthday – but not Paul's. What quip has he made to provoke John's wry expression?

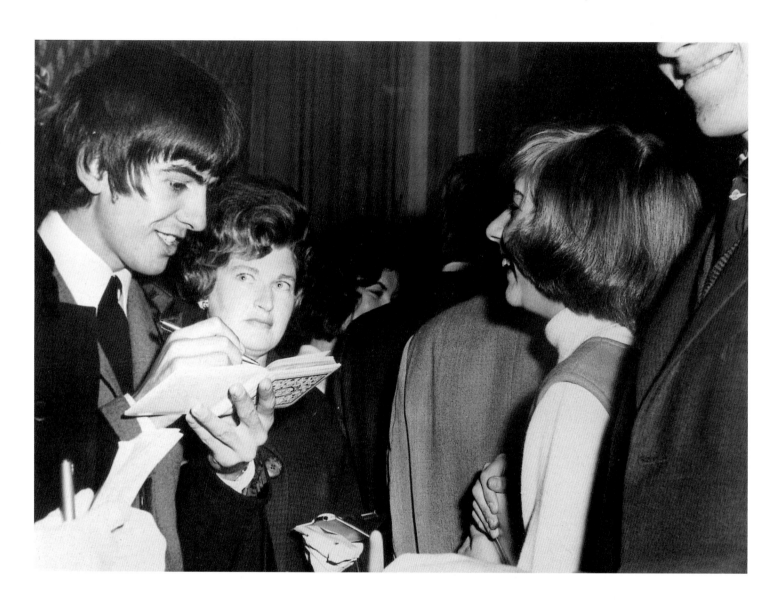

George signs an autograph
for a lookalike for British
singer Cilla Black (*above*)
while Paul's hand is gripped
by a potential future rugby
player (*right*).

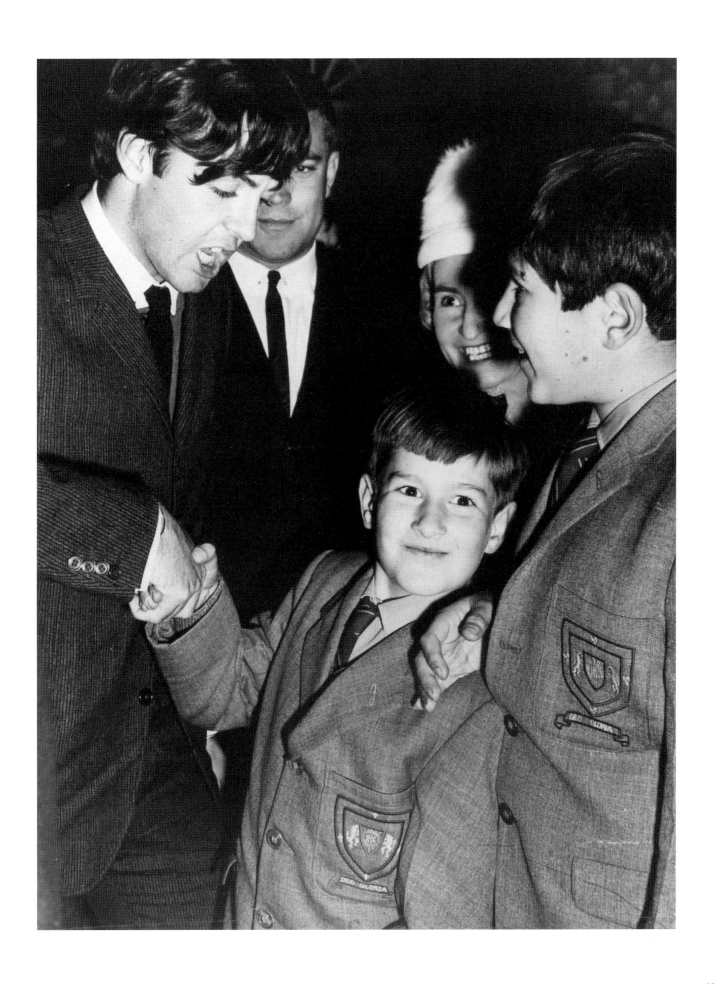

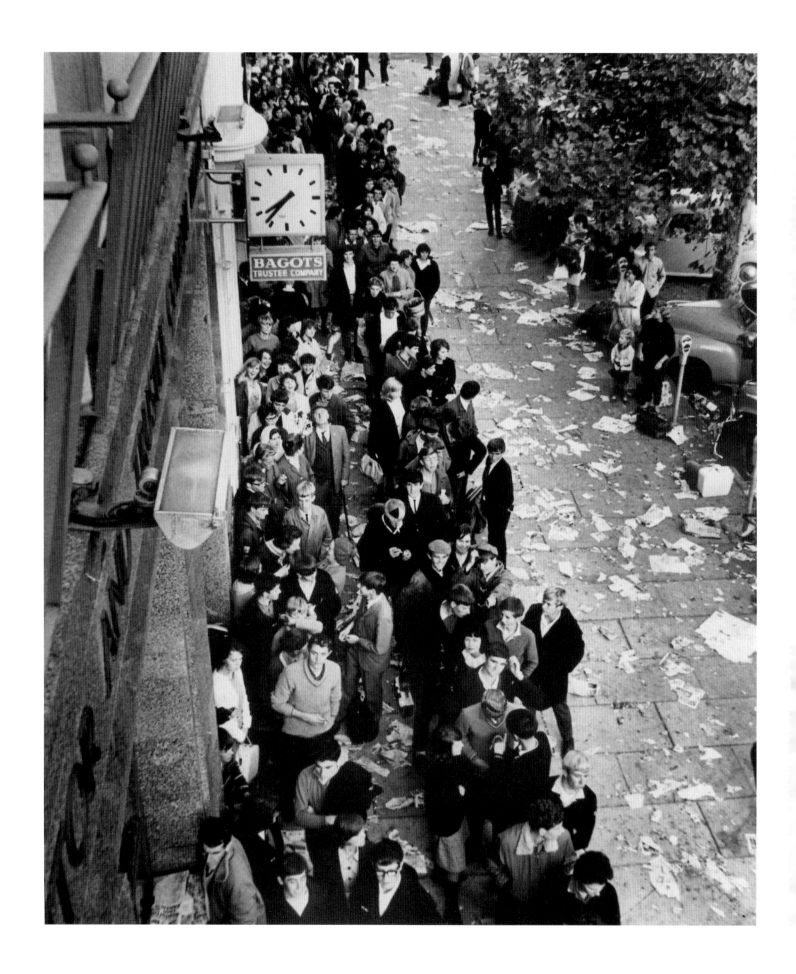

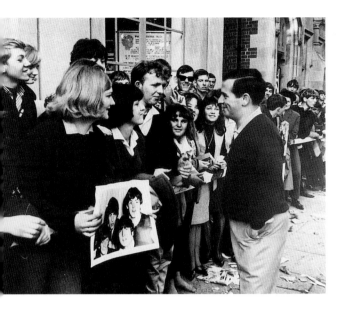

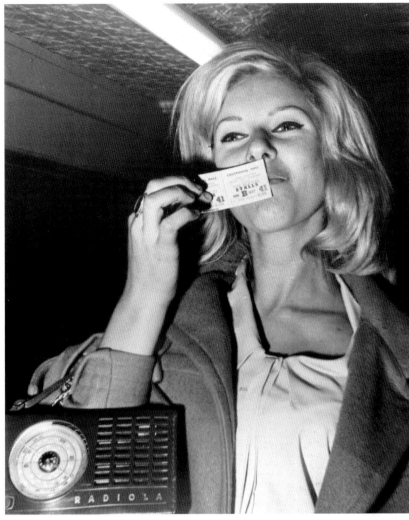

The queue for tickets stretched for miles. The elation on this girl's face (*right*) at managing to purchase a ticket, having waited in line with her radio, sums up how important The Beatles' visit was for youth culture in Australia: they were the first major act to hit the country.

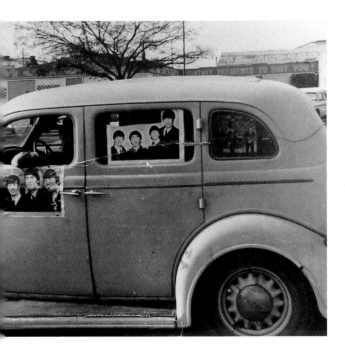

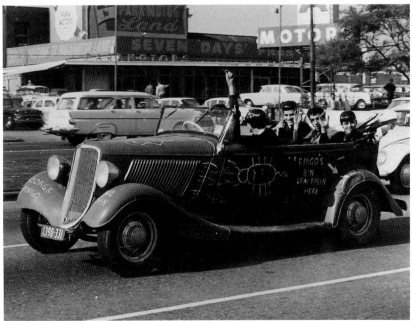

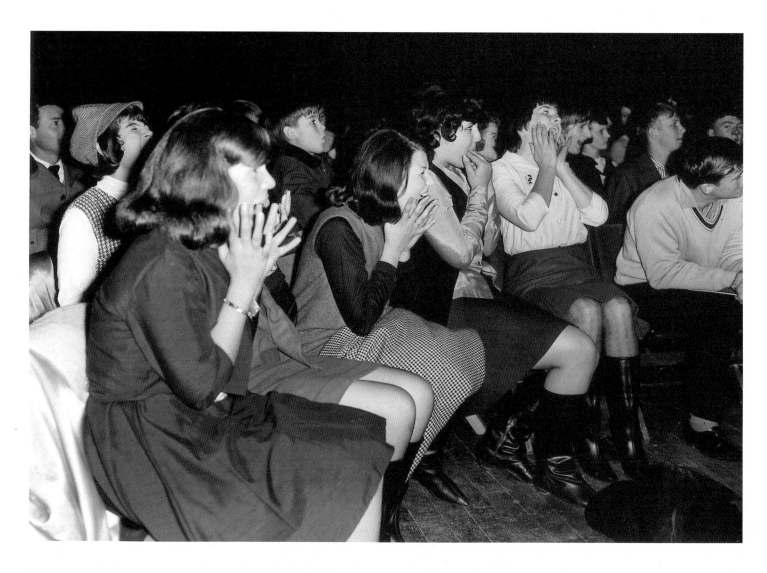

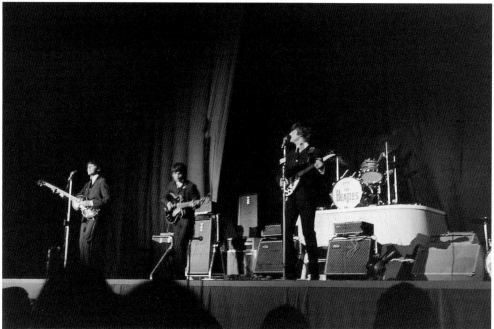

The screaming starts to drown out the music, played out of small Vox and Fender amps. 12 June 1964, Centennial Hall, Adelaide.

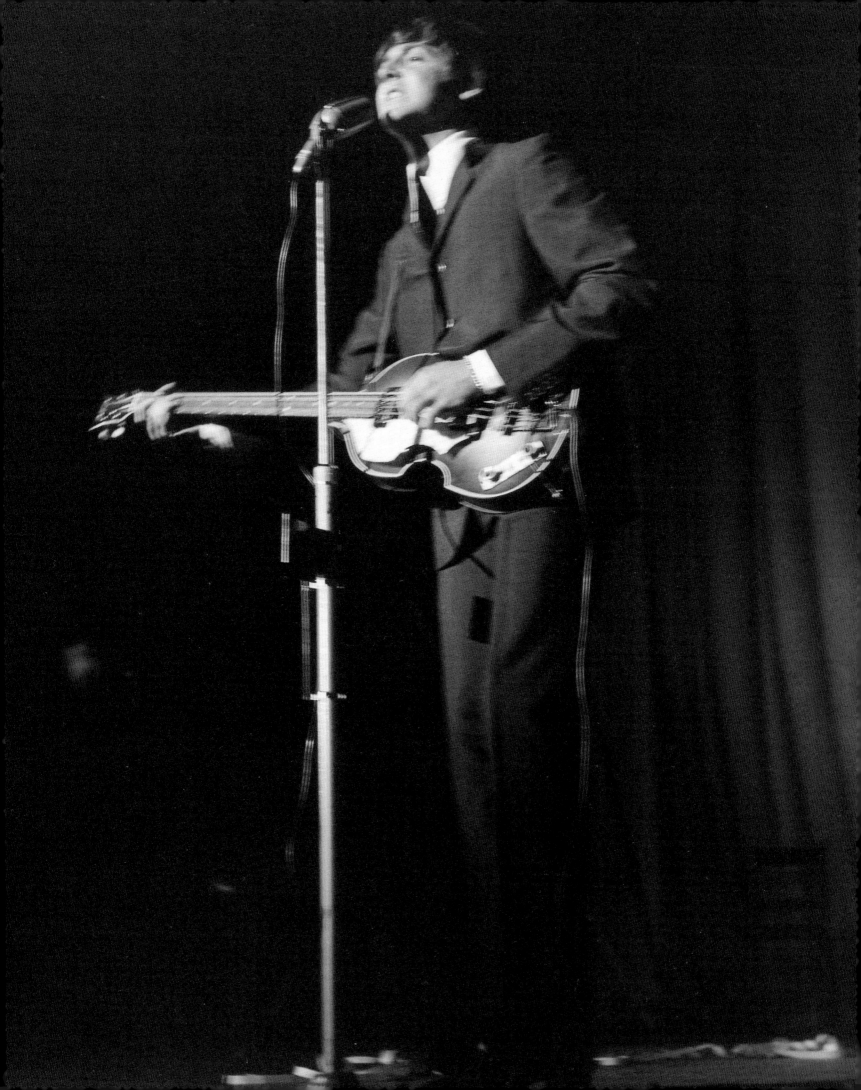

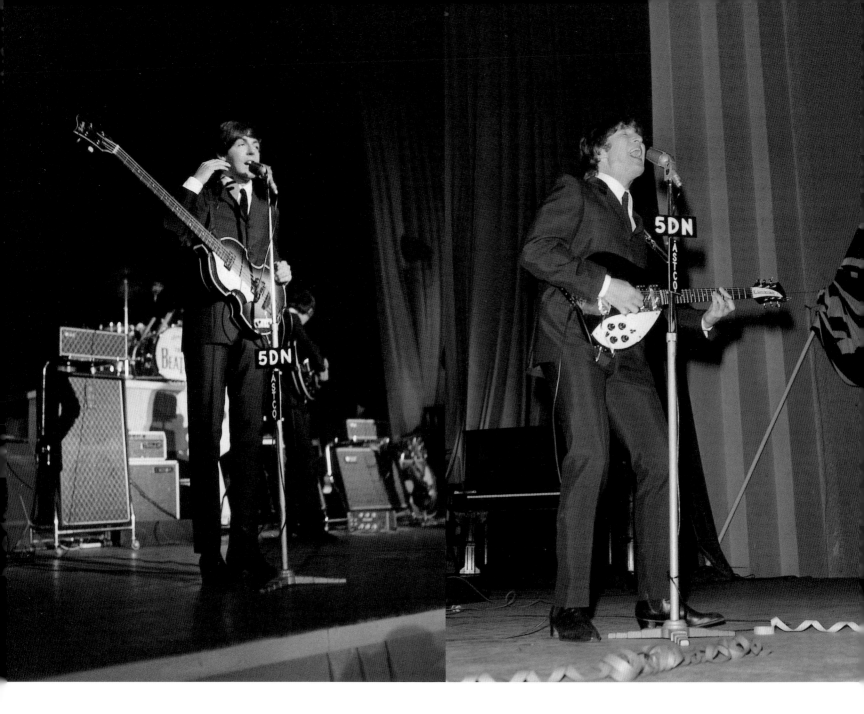

Left to right: Paul with his familiar left-handed Hofner bass guitar, which he always played from the earliest Cavern Club days. John plays a favourite Rickenbacker, and George changes from his Gretsch to a Rickenbacker according to the song being played.

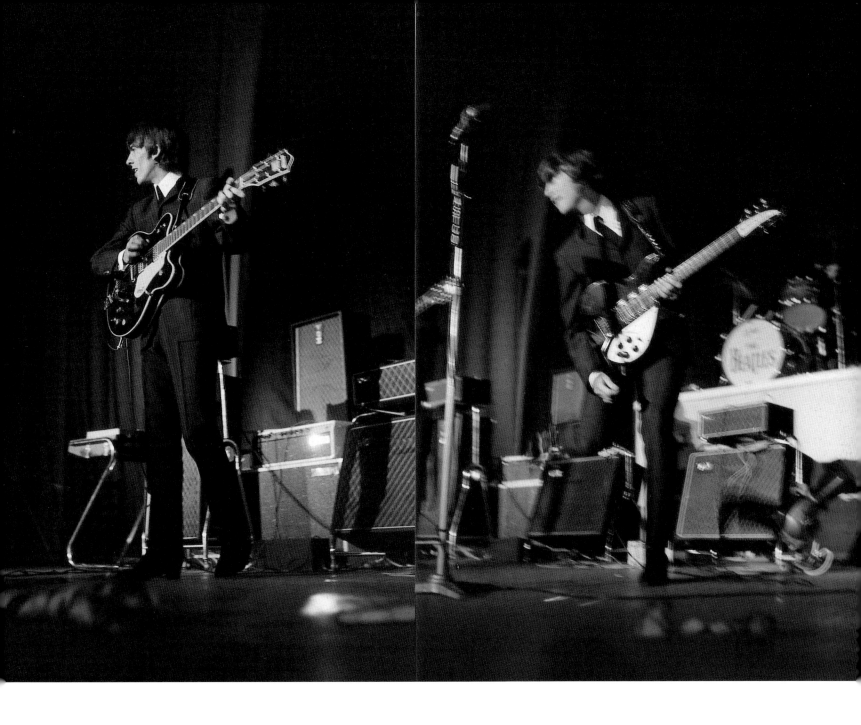

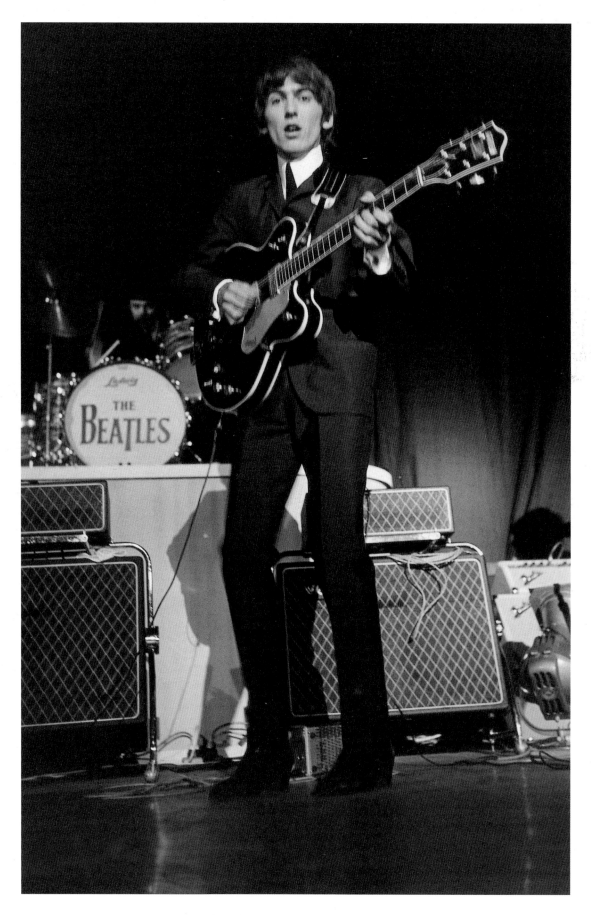

These pages: George plays a
Gretsch guitar with Bigsby
tremolo arm.
Overleaf: George and John
perform 'All My Loving'
during the first Centennial
Hall concert.

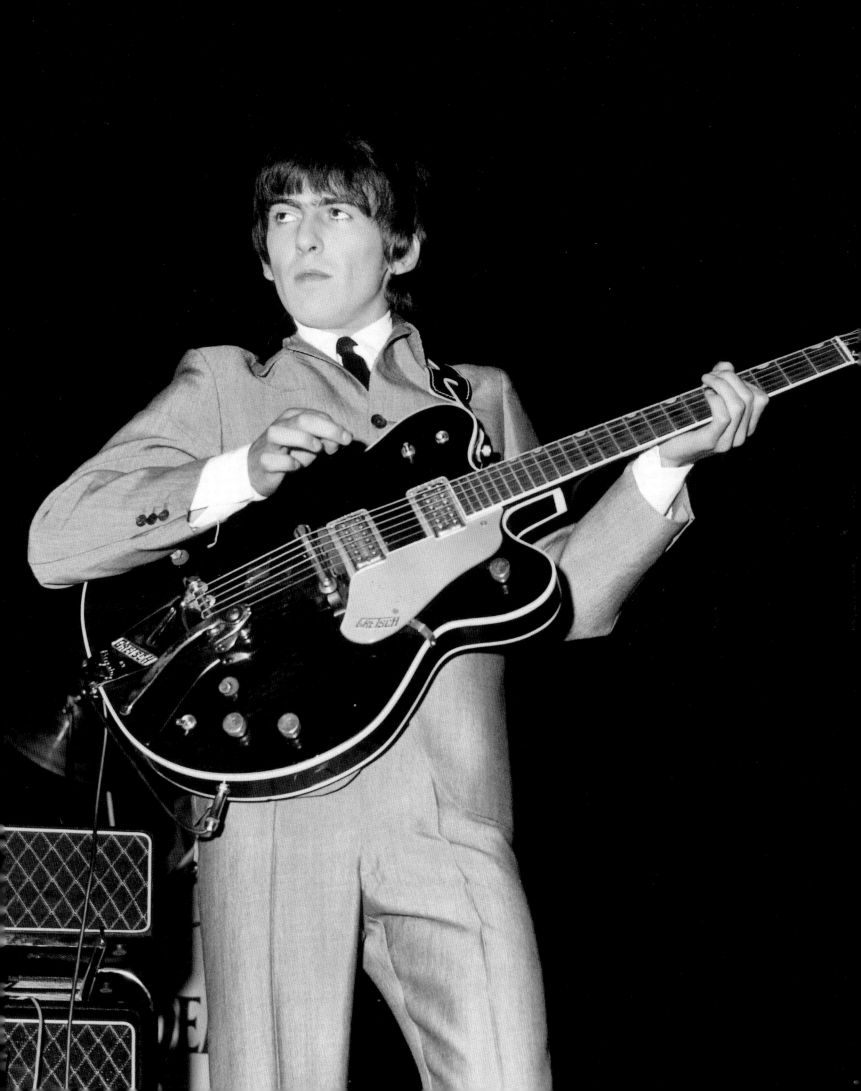

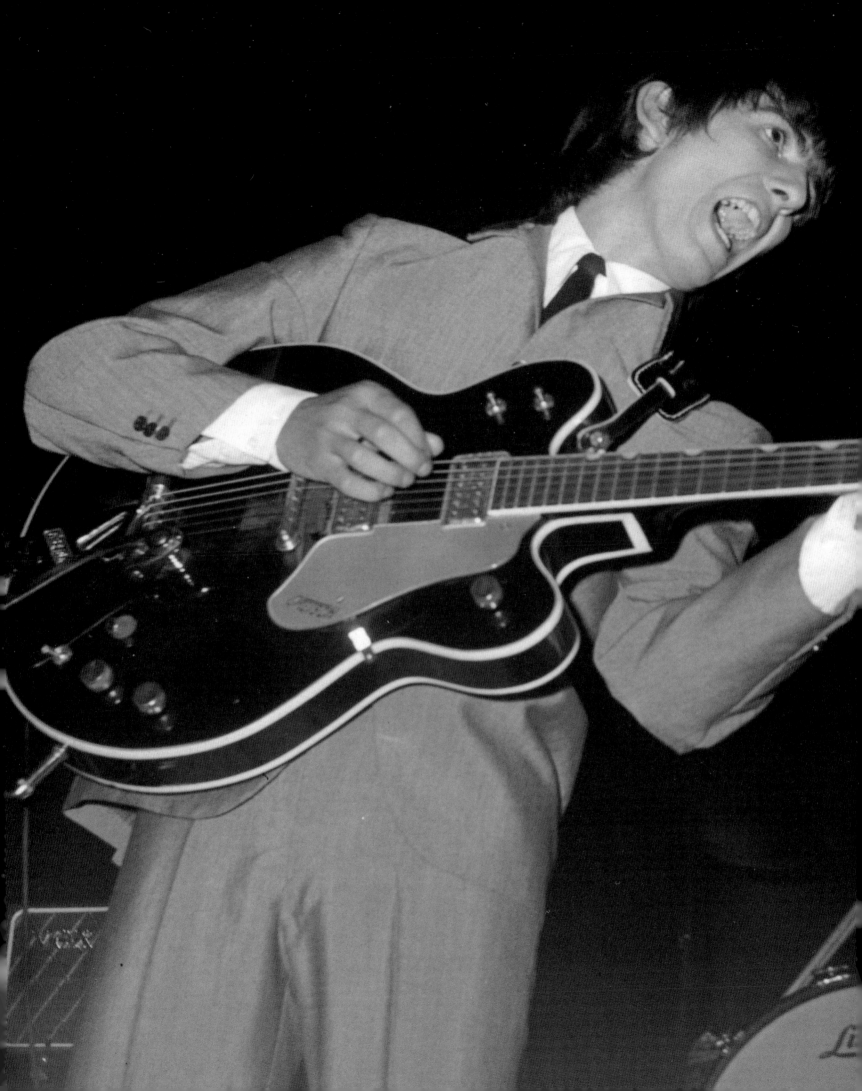

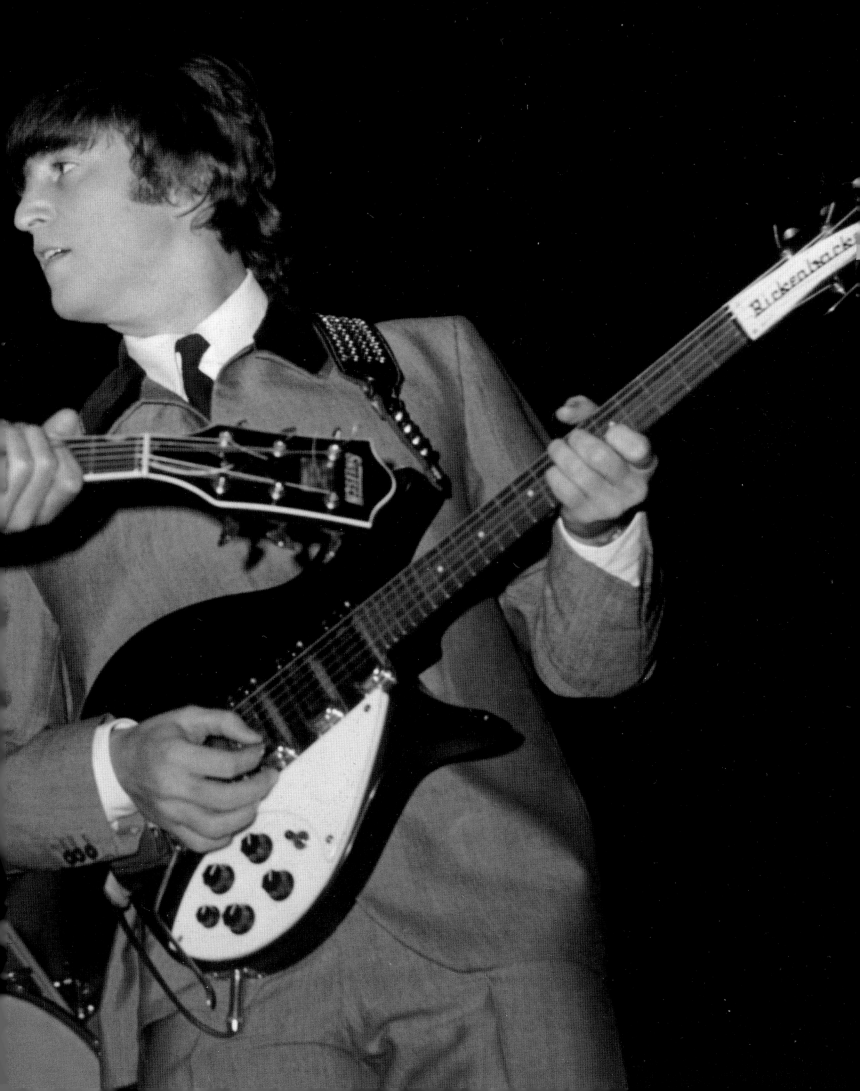

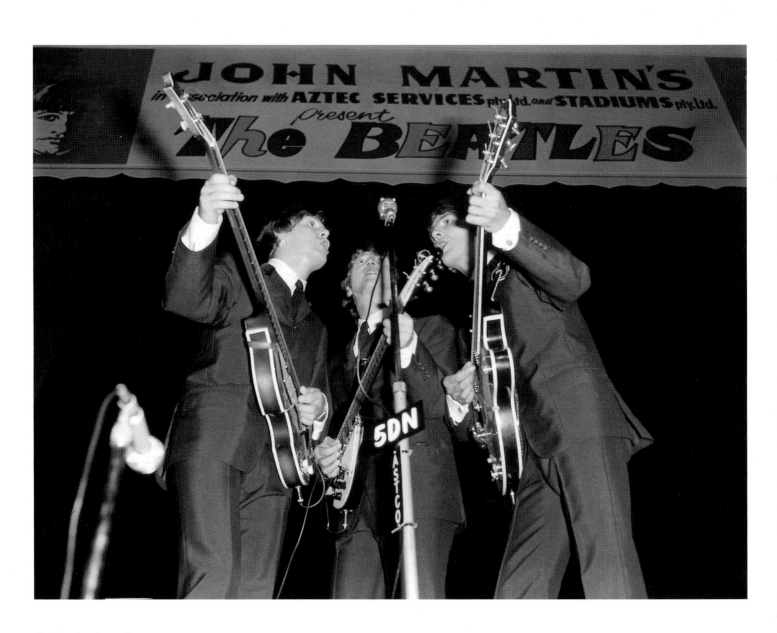

The Beatles share a harmony
on 'This Boy'. The banner
above displays Aztec
Services, who went on to
promote the Australian tour
by The Who and the Small
Faces four years later.

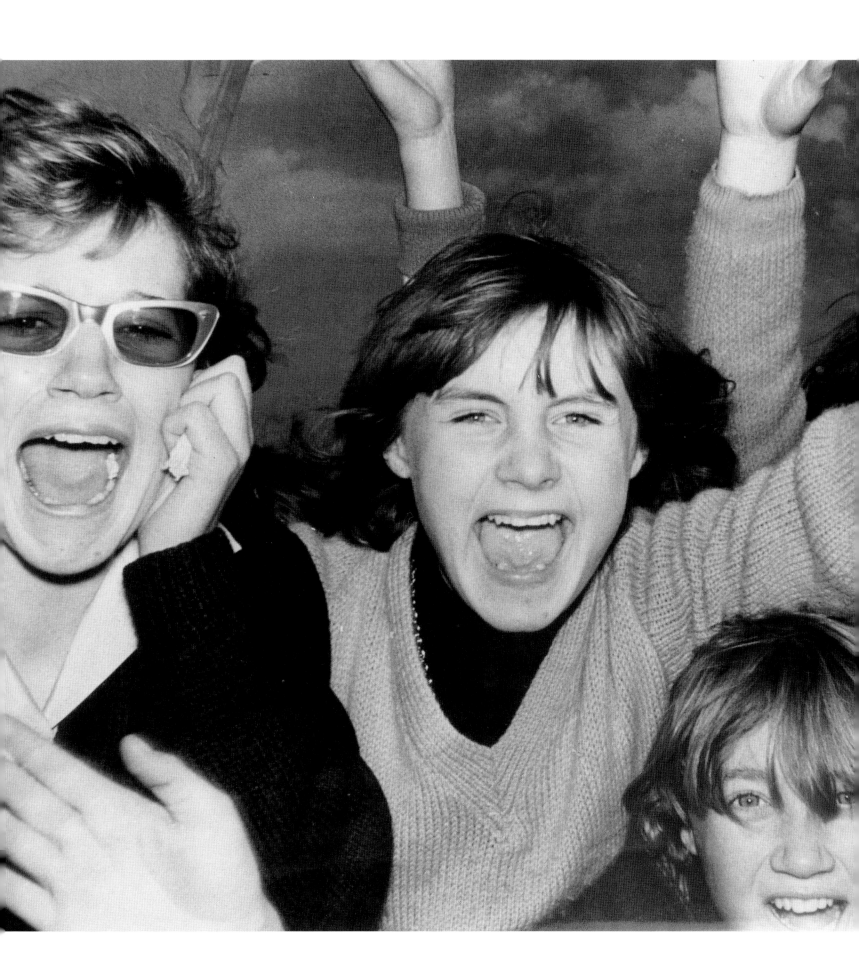

Eight days a week

With Beatlemania reaching a peak, the Fab Four continued to be in demand in all corners of the globe. Their calendar was chock-a-block with a mixture of personal appearances and concert, TV and radio bookings. For the next couple of years, life was one giddy whirl from continent to continent.

Back to America

Following their successful Australian tour, the first major tour of America soon beckoned. On 23 August 1964, The Beatles performed to sell-out crowds at the world-famous Hollywood Bowl in Los Angeles, California. And on August 28, the group met up with the legendary folk singer Bob Dylan at the Delmonico Hotel in New York. On Dylan's insistence, Paul, George and Ringo smoked marijuana for the first time. John had been initiated into this recreation the previous year. As the tour came to a climax, America's *Billboard* magazine announced that the sales of guitars had reached its highest point since 1957, when Elvis Presley first appeared.

English encore

The Beatles returned to their homeland, and on October 9 began another tour – a four-week excursion around theatres and cinemas in Britain. The Leeds and Southampton pictures shown on pages 152–63 are from that jaunt. In December, with their latest single, 'I Feel Fine', and album *Beatles For Sale* at the top of the respective UK charts, The Beatles wrapped up another highly successful year with *Another Beatles Christmas Show* at London's Hammersmith Odeon. They were supported by The Yardbirds, Freddie & The Dreamers, BBC DJ Jimmy Savile, Elkie Brooks, Mike Haslam, and The Mike Cotton Sound.

A group of photographs that came up at a sale in 1986 included large transparencies of The Byrds in Soho Square, Roy Orbison, The Animals, the Small Faces, and in the middle of that lot, by a photographer from the magazine *Mirabelle*, were three colour transparencies of The Beatles eating cheese and looking slightly worse for wear. Was it the cheese or something else that glazed George's eyes? I purchased these priceless photographs, a true piece of Beatle history, and never looked back in building my collection over the next twenty years.

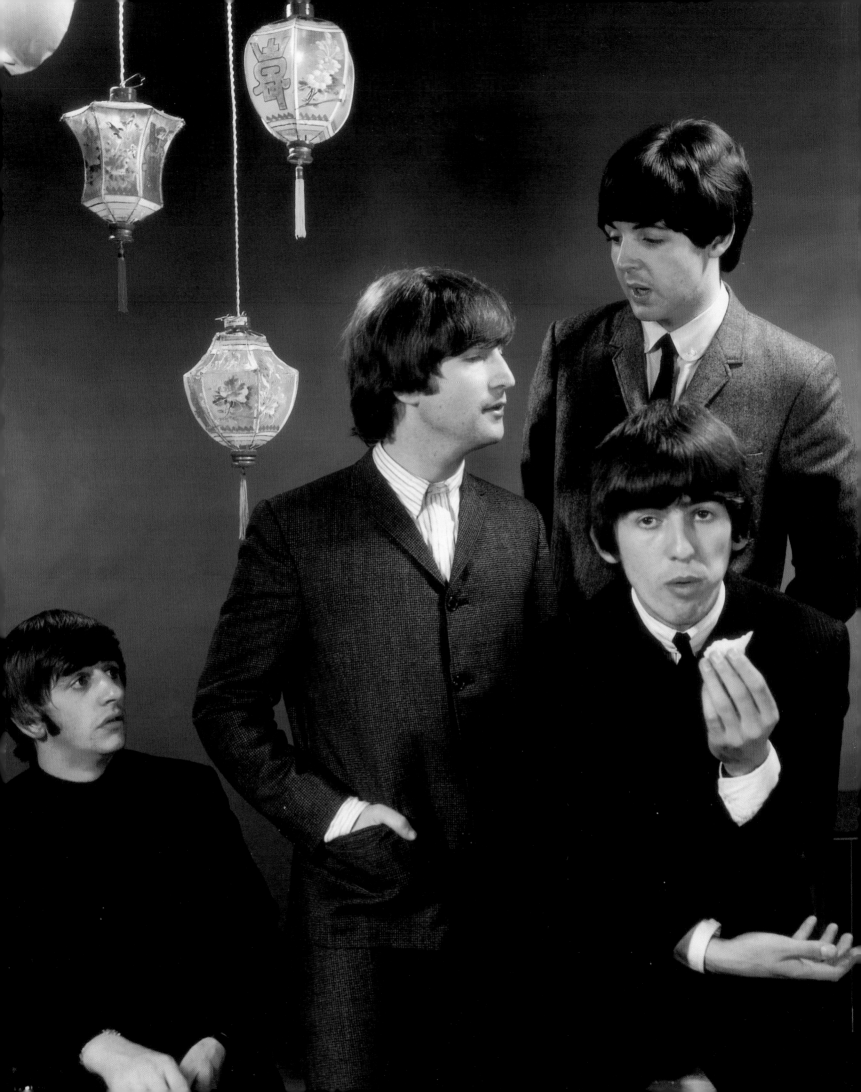

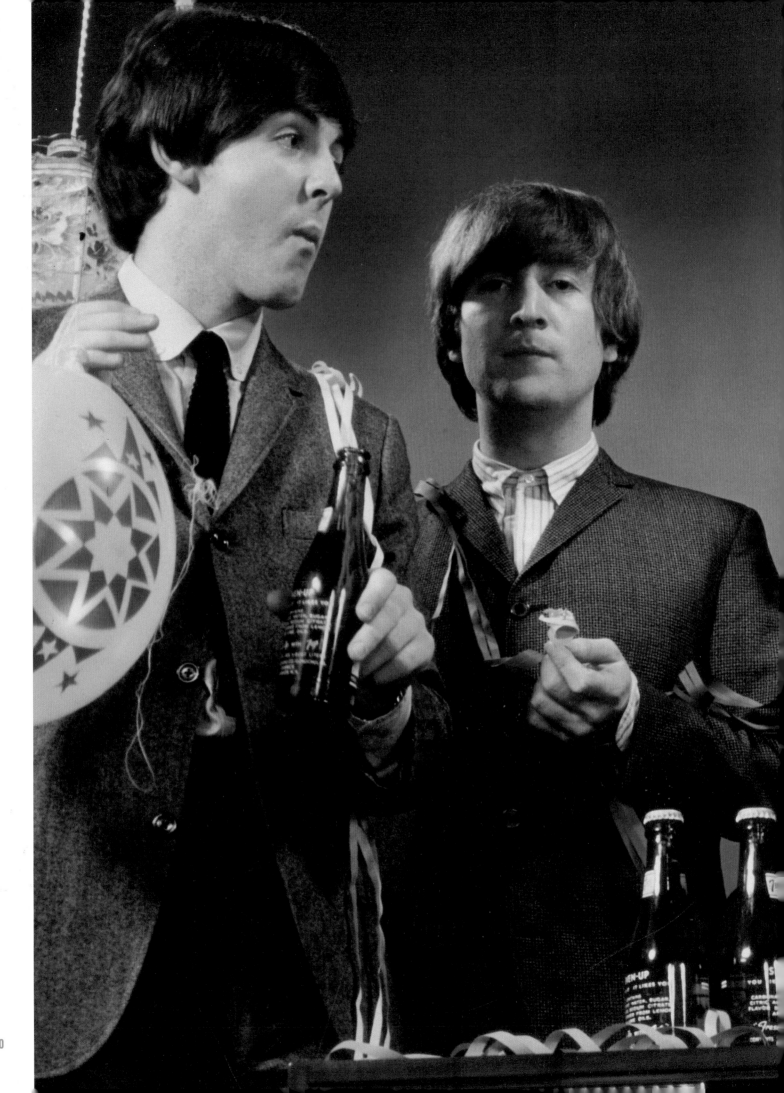

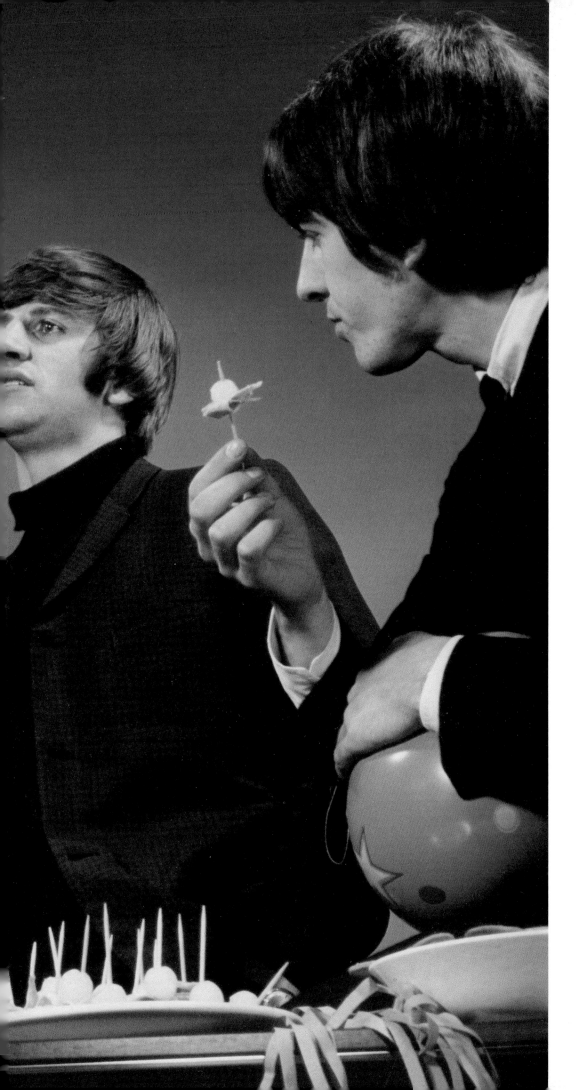

In the early days of pop memorabilia sales *c.*1984 onwards, big batches such as the one that contained this classic shot sometimes came up for sale at Phillips auctioneers. Phillips were based in Salem Road, just behind Queensway in London. Their rock 'n' pop department at that time was run by a young man called Andrew Milton, who had a good eye and sold several of Michael Jackson's artefacts when Michael was at the peak of his career. Philips got out of the rock 'n' pop auctions when Andrew left to join me in setting up the world's first pop memorabilia shop in Hanway Street, London, now a Soho housing benefit building. Bonhams auctioneers have since acquired Phillips, and Salem Road is now empty.

Leeds

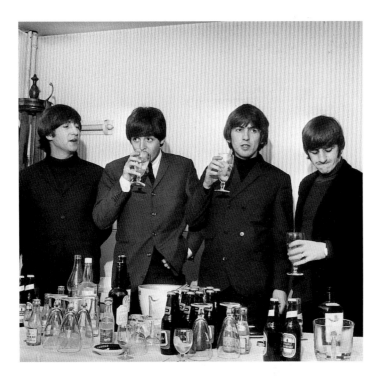

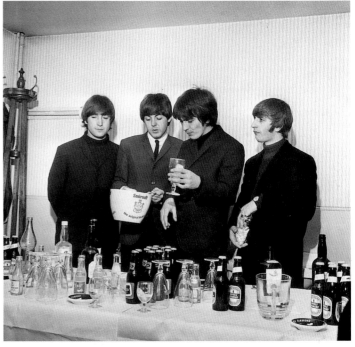

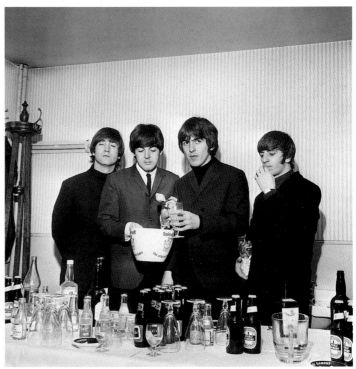

Ringo enjoys the crisps while Paul passes the ice bucket to keep the Double Diamond lager cold, backstage at the Odeon Cinema, Leeds, 22 October 1964.

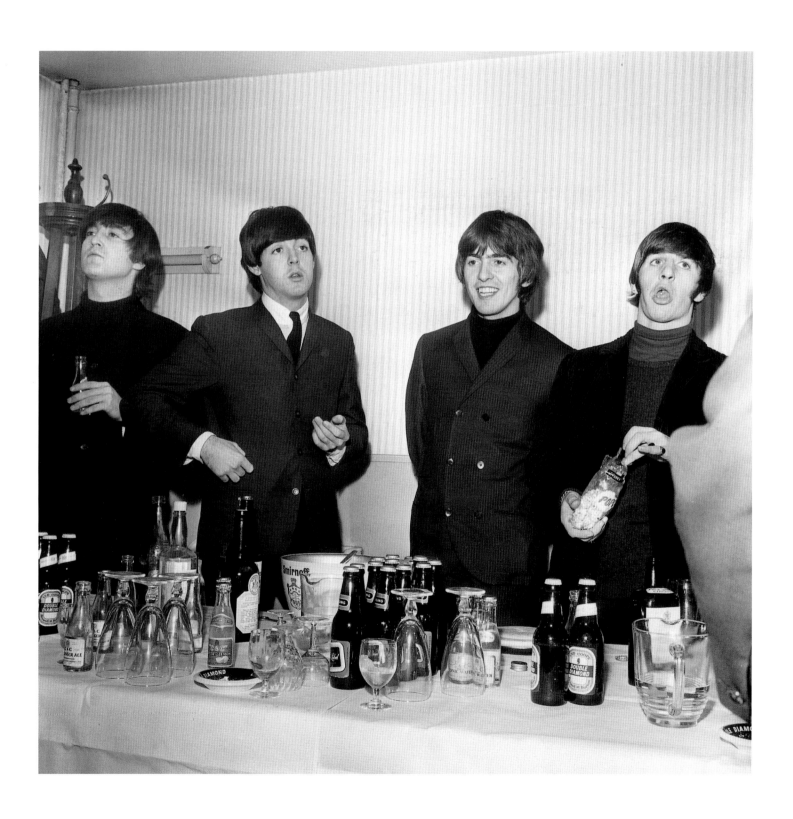

Southampton

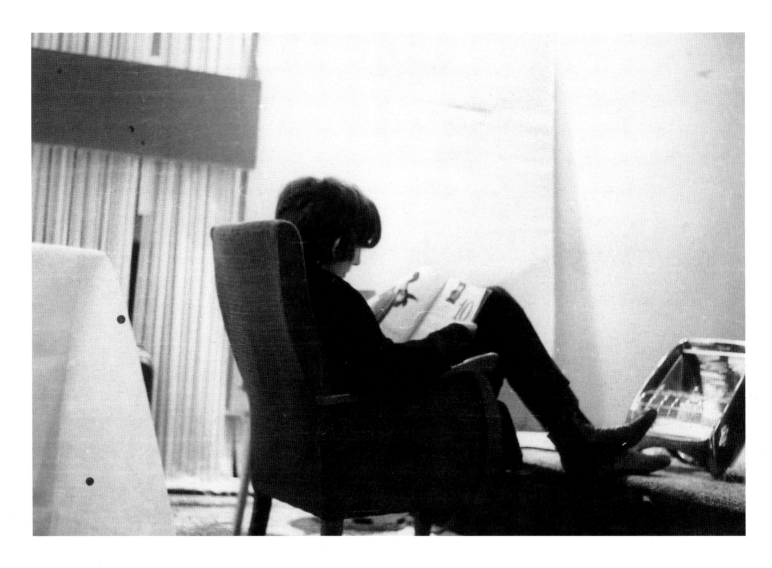

Relaxing backstage at
the Gaumont Cinema,
Southampton,
6 November 1964.

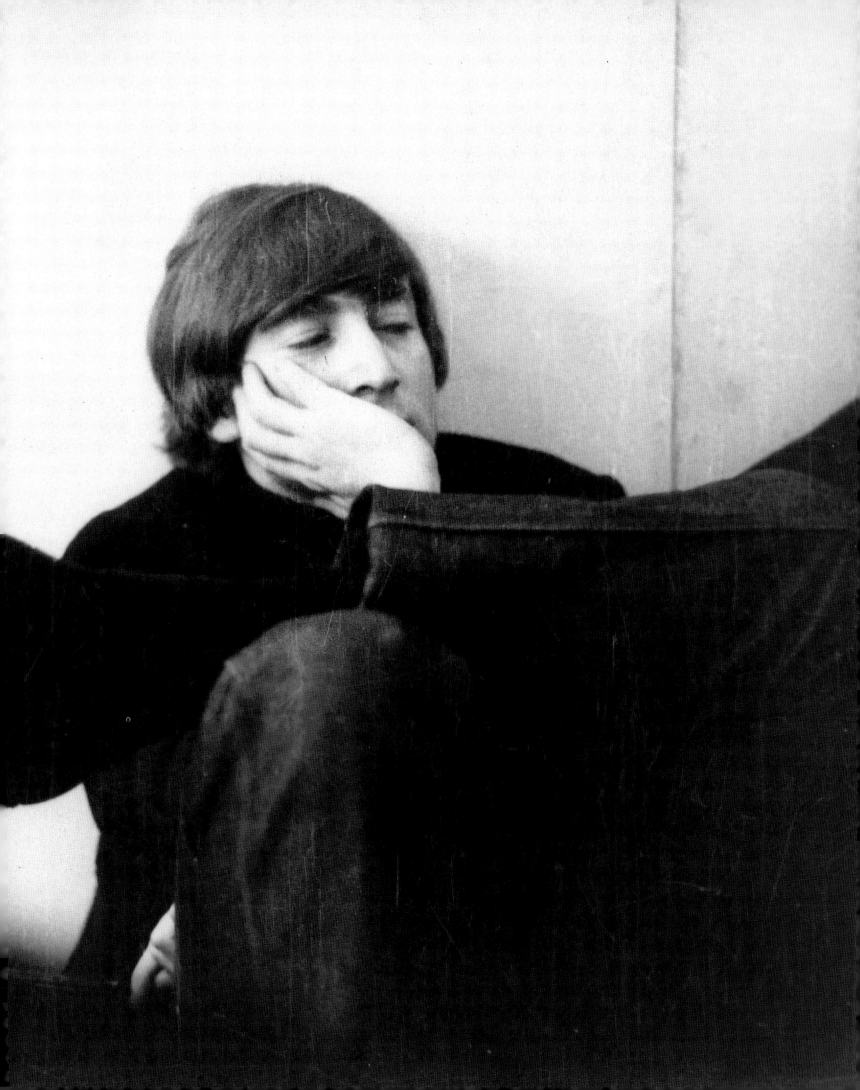

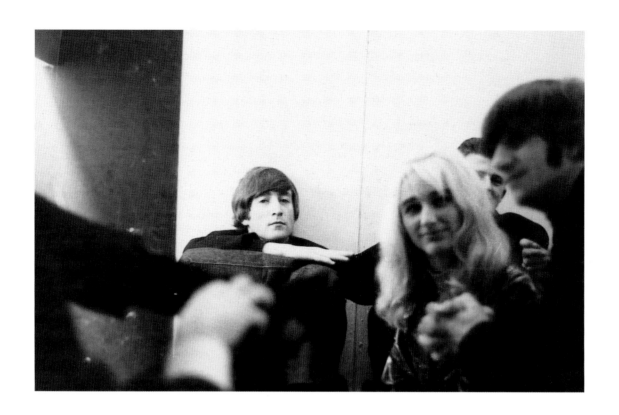

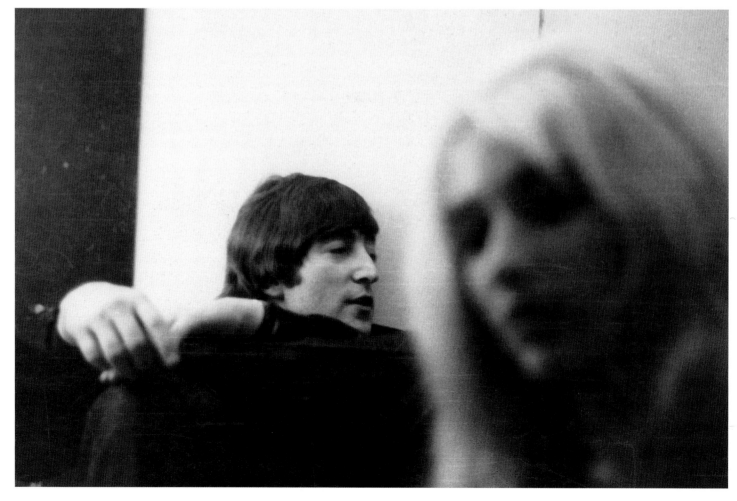

I have next to no information as to who these fans are, but The Beatles are characteristically at ease with them. On the reverse of one of these pictures is written in black biro, 'My sister with John Lennon (very valuable) 1965'. In the corner (*top right*) is The Beatles' roadie, Mal Evans.

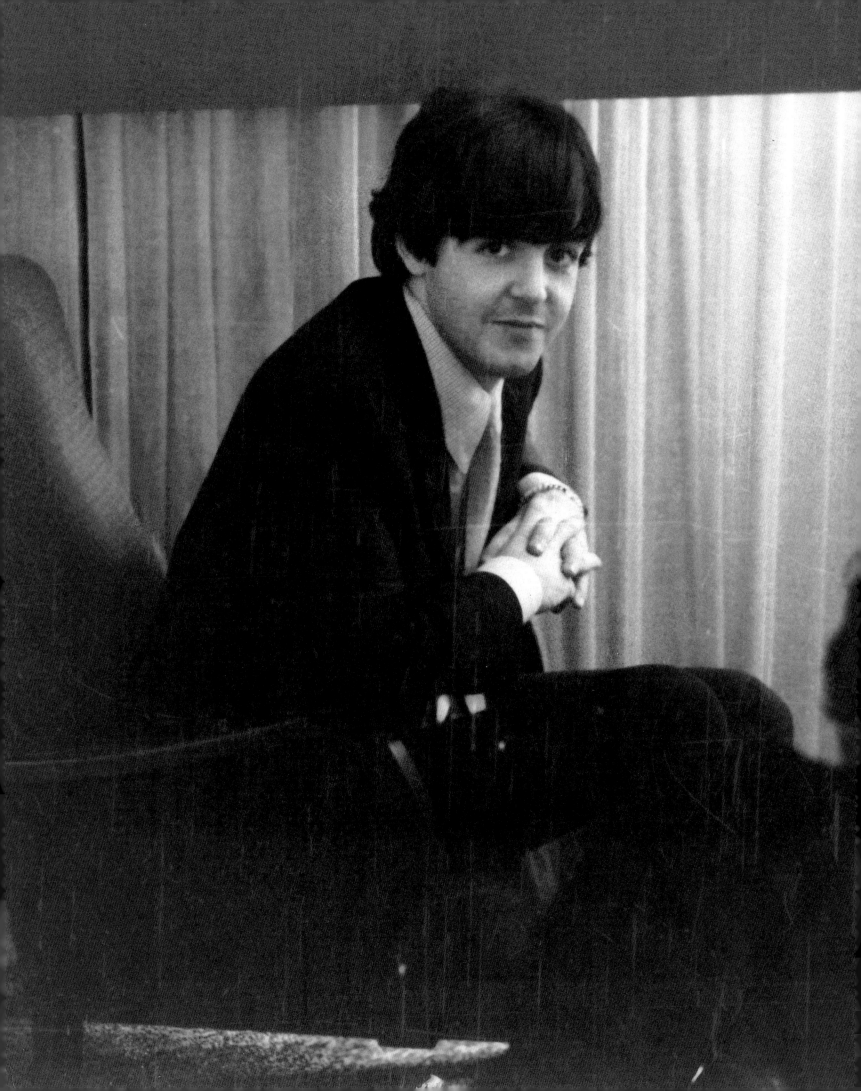

These photos were purchased at Bonhams auctioneers, which was run out of a converted warehouse in Lots Road, Chelsea, London – not a very glamorous place to view and buy products. They now operate with ex-Sotheby's expert Stephen Maycock out of White City and Knightsbridge. The expert at the time of buying these, Ted Owen, went on to start Fleetwood Owen, an auction house selling rock 'n' pop, along with Mick Fleetwood, founder of Fleetwood Mac. Ted later set up the world's number-one pop auction house, Cooper Owen, now based in Egham, Surrey.

Above: On the back of this
picture is written in black
biro, 'Carol (sister) with
Ringo Starr 1965'.
Left: Paul hams it up.

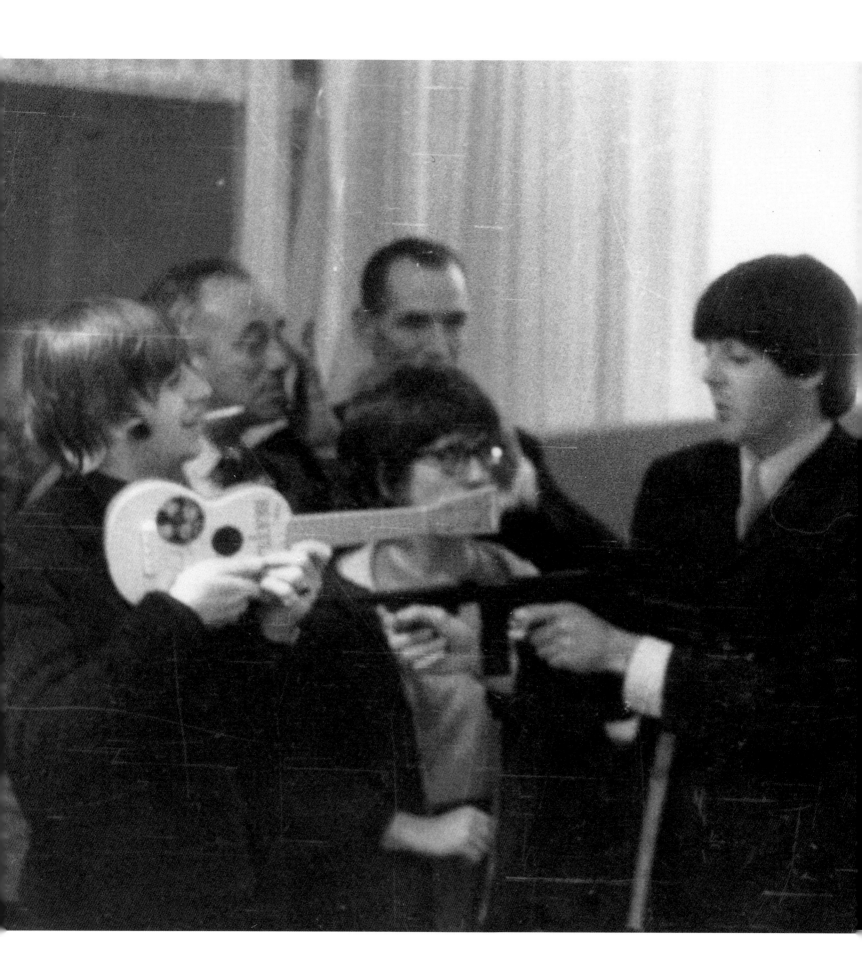

Paul plays with a toy
machine gun while Ringo
returns fire with a toy Beatle
guitar, The Beatles' roadie
Mal Evans standing by.
This picture sold the batch
of photographs to me.

Meeting the Queen... and the King!

The first two weeks of 1965 saw *Another Beatles Christmas Show* at London's Hammersmith Odeon. In the British record listings The Beatles' latest releases, the album *Beatles For Sale* and single 'I Feel Fine', were both in the No.1 positions. 'I Feel Fine' had also reached No. 1 in America's *Billboard* chart. However, manager Brian Epstein was aware that such success was fleeting: on January 16, in a *Melody Maker* article headed 'Brian Epstein Predicts', he gave the group just 'two or three years more at the top'. This prediction was of no concern to Ringo when, on February 11, at London's Caxton Hall Register Office, he married his long-term girlfriend, Maureen Cox. Four days later, after Ringo's short honeymoon in Brighton, The Beatles returned to Abbey Road Studios to start work on music for their next film, originally titled *Eight Arms To Hold You*, but ultimately to become *Help!*. Recording for the album, with George Martin at the helm, continued until February 20.

Filming began early on the morning of February 23 in Nassau in the Bahamas. Early scenes of *Help!* were shot in the Caribbean not on artistic grounds but because The Beatles' lawyers were keen to investigate the country's status as a tax haven for British nationals. Shooting then shifted to the village of Obertauren in the Austrian Alps on March 13, before switching to Twickenham Film Studios in England. Production was wrapped up on May 18. Beatles folklore has it that the semaphore image on the *Help!* album jacket was taken during filming in Obertauren in March 1965. In fact, the cover shot was taken on May 7, in the car park at Twickenham, during a break in the final sequences of filming. The photographer Robert Freeman attempted to re-create an eye-catching scene he had noticed during filming in Austria just under two months previously.

Help! gets critical notices

Unfortunately, the movie received a mauling at the hands of the critics. 'We are a bit baffled that some of the critics should knock the film,' George later admitted. 'I must confess that when we first saw the completed film we were knocked out, but obviously some people weren't. Let's face it, the whole thing is a fast-moving comic strip, just a string of events. What did the critics expect from it? *Cleopatra* or *King Of Kings?*'

Ringo remarked, 'I have come to the conclusion that it would not have had the raves even if it had been noticeably better than it was – or even better than *A Hard Day's Night*. When we saw the completed film, we all turned round to Walter Shenson with the one remark, "You can release it now, Walter." That's how pleased we were. I am afraid that many people just didn't appreciate Richard Lester. They just didn't realize what he had set out to do. I think he did a great job; for me, he is just fantastic!'

Honoured in gold

On June 11, a British government spokesman announced that The Beatles had been awarded MBEs. At a hastily arranged press conference, Paul joked that 'MBE must stand for Mister Brian Epstein'. (In fact, it signifies an order of chivalry and stands for Member of the Order of the British Empire.) An unprecedented backlash saw several previous recipients return their medals in protest at The Beatles' award. John was unimpressed by the honour anyway and described its acceptance as 'our first big sell-out'.

Back in the USA

The group and Brian Epstein left on August 13 for a second North American tour, once again hooking up with Bob Dylan. The meeting took place in their rooms at the Warwick Hotel in New York. On August 15, The Beatles made their legendary appearance at New York's Shea Stadium, attracting 56,000 people – the group's biggest and most famous show. But musically, for John, it was a non-event. 'It was a great experience, all this happening with all the screaming and yelling, but we were just disappointed musically,' he admitted years later. 'It just became a joke. You can see it in the film, George and I weren't even bothering playing half the chords. We were just messing about. There wasn't enough in it for us musically and we were basically musicians. As an event and a happening it was fantastic and we enjoyed it, but as far as music was concerned, it was nowhere.'

During the evening of August 27, the group finally met their idol Elvis Presley, at his Bel Air house. 'I know Paul, George and Ringo were feeling as nervous as I was,' John revealed later. 'This was the guy we had all idolized for years, from way back when we were just starting out in Liverpool. He was a legend in his own lifetime.' Two days later, The Beatles gave the first of two performances at the Hollywood Bowl in Los Angeles. The tour concluded on August 31, when they performed at San Francisco's Cow Palace.

London calling: a visit to the Palace

Having returned to Abbey Road on October 12 to begin recording their next album, *Rubber Soul*, The Beatles took a brief break on October 26 to receive their MBEs from Queen Elizabeth II at Buckingham Palace. In 1970, in an interview with the French magazine *L'Express*, John recollected that just prior to the investiture, 'We smoked hashish in the toilets and were guffawing like madmen… We wanted to laugh, but when this sort of thing happens to you, you don't laugh any longer. We were so nervous. I accepted it because the other Beatles wanted to go for fun... we had nothing to say [to the Queen]. It was a dream. It was beautiful. People played music. I looked at the ceiling, not bad, that ceiling. It was historic.'

1965 wrapped up with The Beatles celebrating the success of their new single and album. 'Day Tripper' / 'We Can Work It Out' raced to the top of charts around the world, as did *Rubber Soul*. On December 24, it was announced that the disc had sold enough copies in America to warrant Gold status. Next day, George gave his girlfriend Patti a romantic Christmas present: a marriage proposal.

'This was the guy we had all idolized for years, from way back when we were just starting out in Liverpool.'

JOHN LENNON

Help! cover shoot, Twickenham

'The Beatles were standing on a skyline in the snow waving their arms round to a music playback. From this, I had the idea of semaphore spelling out the letters of *Help!*. But when we came to do the cover shot, the arrangement of the arms with those letters didn't look good. So we decided to improvise and ended up with the best graphic positioning of the arms.'

ROBERT FREEMAN, ALBUM-COVER PHOTOGRAPHER

Why are The Beatles wearing winter clothes for this photo shoot, on 7 May 1965? The purpose was to establish continuity with the earlier *Help!* shots taken in the Alps, where Robert Freeman had conceived the idea for the album cover.

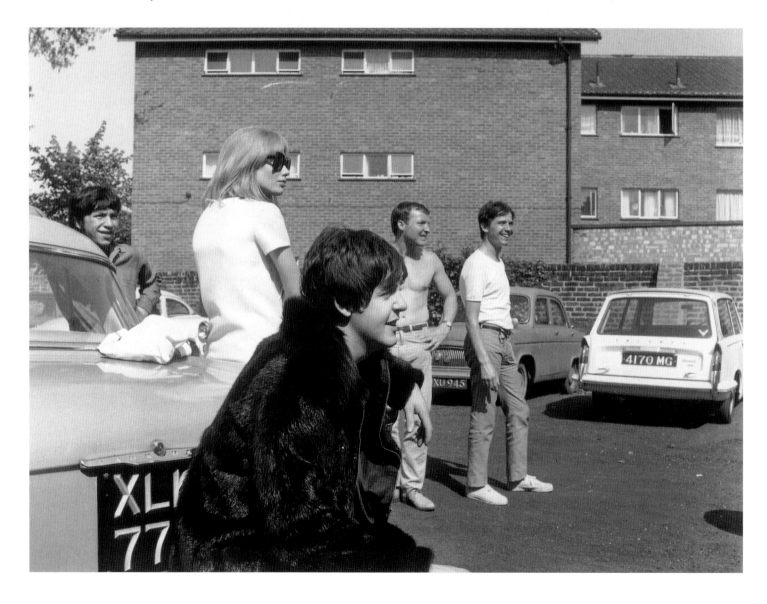

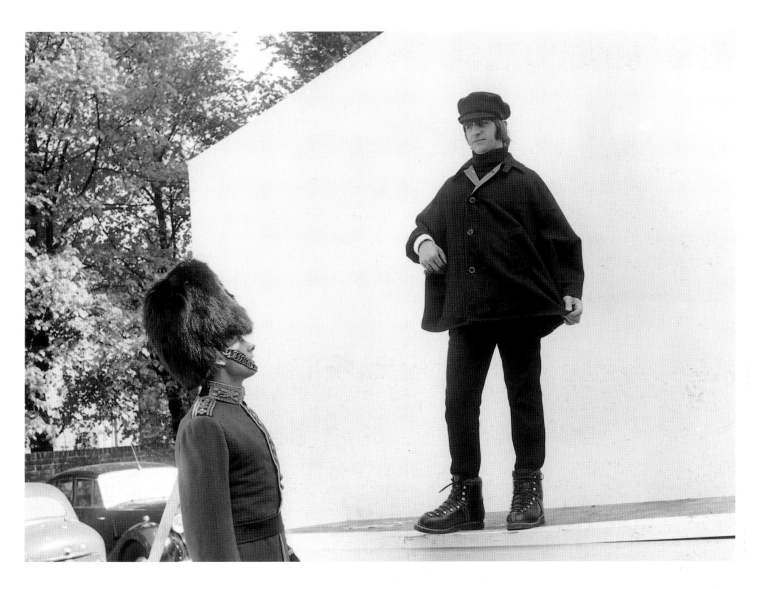

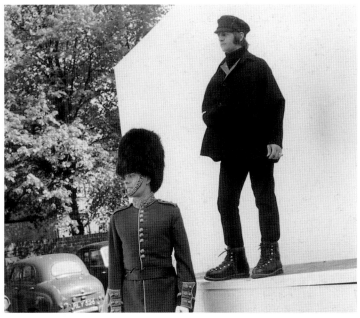

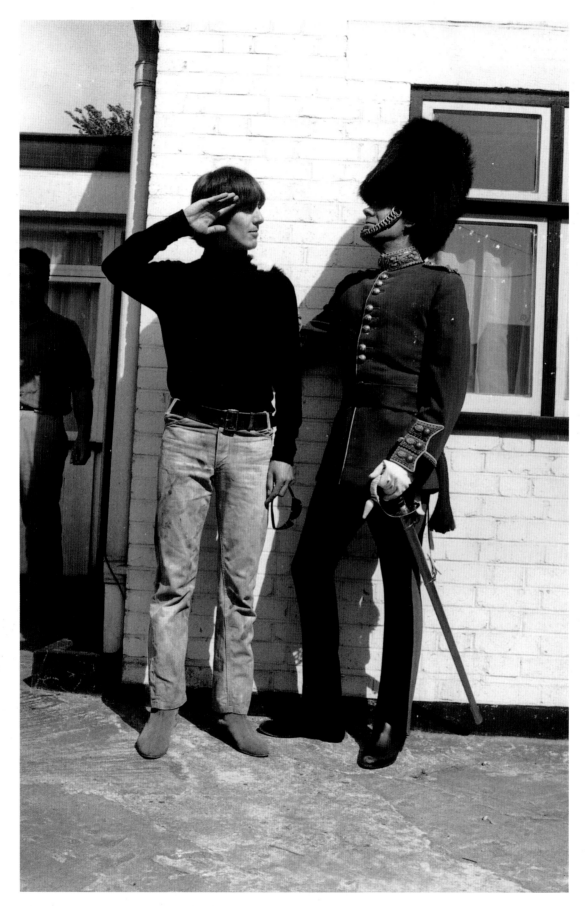

Pictured with George (*this page*) and John (*opposite*) is actor Victor Spinetti, one of the co-stars of *Help!*. He described the movie as 'a straightjacket of a film for The Beatles. They had to act out parts and they weren't really happy about it.'

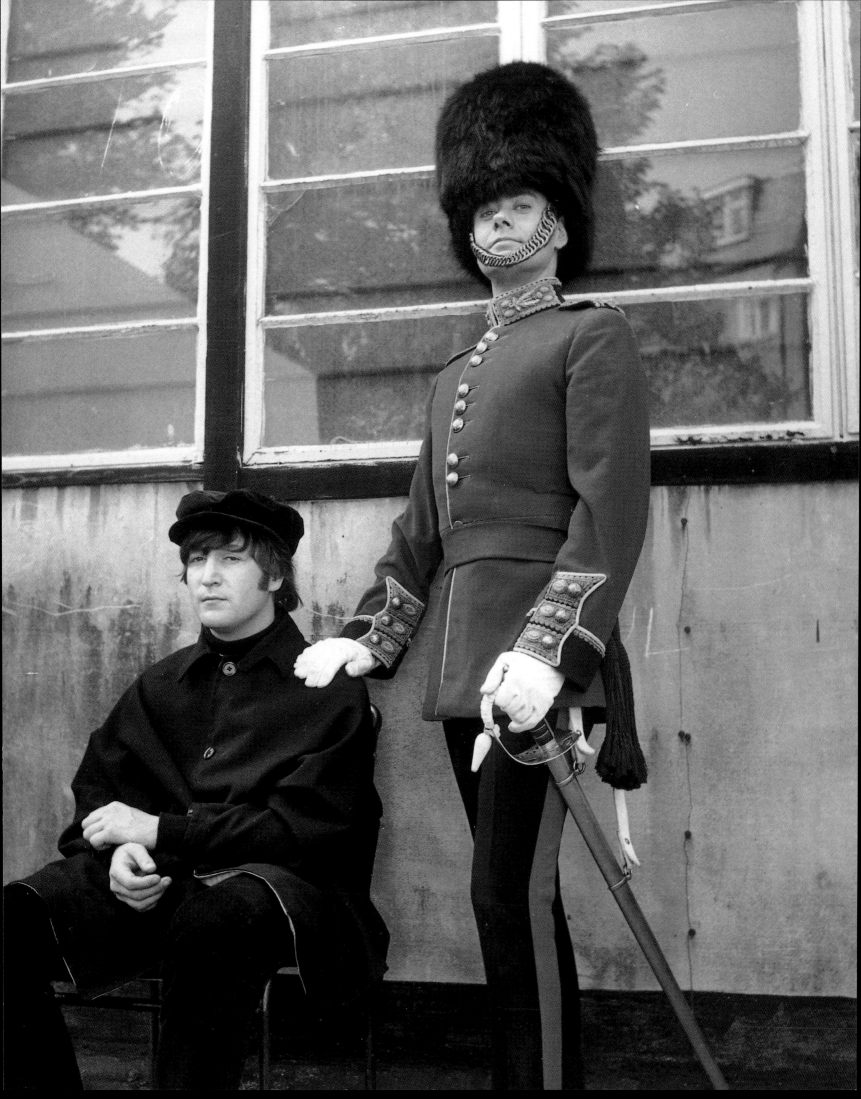

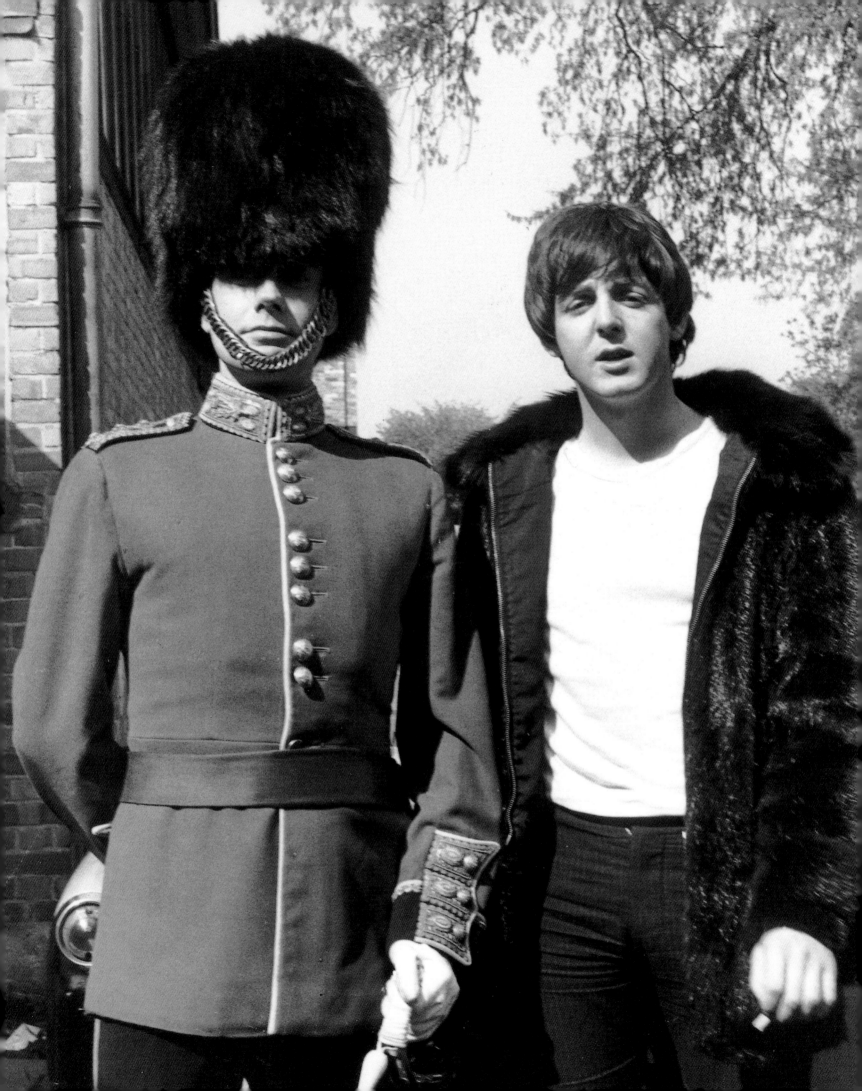

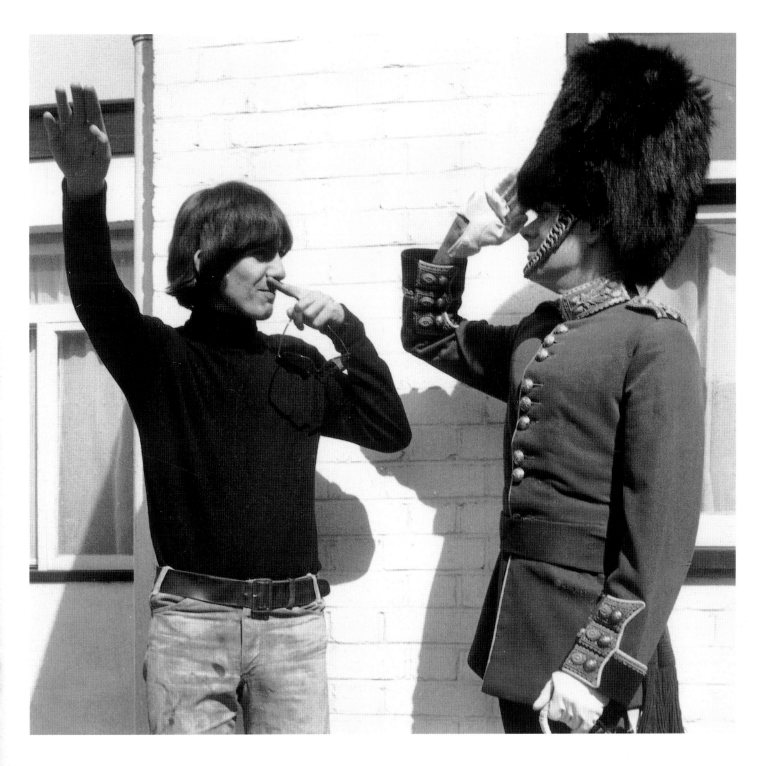

Victor Spinetti with Paul (*opposite*) and George (*above*). The series of pictures was purchased at Christie's on 30 April 1998. Twelve magnificent photographs (with negatives) by the late Don Pagination, sold by his widow.

Trouble in the air

1966 was a transitional year for the group. After three years of intensive touring, concerts and media shows, no one was aware that this year was to be the group's last as a fully functioning touring band. The Beatles had started to make major creative leaps forward musically and they knew that this new style of music was going to prove almost impossible to re-create on stage. And as far as live performances were concerned, the group had seemingly given up on quality control because most of their playing and singing was being drowned out anyway by the incessant screaming from the crowd. 'We could just stand on stage, sing nothing and no one would know,' John admitted years later.

As the year began, it was business as usual in the Beatle camp. Their latest single, 'Day Tripper'/'We Can Work It Out' was No. 1 in the British and American singles charts and their newest album, *Rubber Soul*, was also in the top spot in the respective worldwide long-player listings. On January 21, George married his girlfriend of nearly two years, Patti Boyd, at the Esher Register Office in Surrey. Brian Epstein and Paul were best men. John and Ringo did not attend, choosing instead to prolong their winter break in Port of Spain, Trinidad with their partners.

John on Jesus

On March 4, London's *Evening Standard* newspaper published the journalist Maureen Cleave's candid spring 1965 interview with John, in which he commented unreservedly on Christianity. 'Christianity will go. It will vanish and sink. I needn't argue about that. I'm right and will be proved right. We're more popular than Jesus now. I don't know which will go first – rock 'n' roll or Christianity. Jesus was all right, but his disciples were thick and ordinary. It's them twisting it that ruins it for me.'

'I can't express myself very well,' John explained later, when confronted about the interview. 'That's my problem. I was just saying, in my illiterate way, what I had gleaned from a book I had been reading called *The Passover Plot* by Hugh J. Schonfield. The main thing is I did the article with a quite good friend [Maureen Cleave], who has been with us since we began. I was talking to her in my own home and because we know each other so well, I was being even less expressive, knowing that she would put it right. But when it was taken out of my house and into her business, something happened to it. Actually, though, if I'm going to blame anyone, it's myself for not thinking about what people a million miles away were going to say about it. I'm more of a Christian now than I ever was. I don't go along with organized religion and the way that it has come about. I believe in God, but not as an old man in the sky. I believe that what Jesus and Mohammed and

'I can't express myself very well. That's my problem.'
JOHN LENNON

Buddha and all the rest said was right. It's just that the translations have gone wrong. Jesus says one thing and then all the clubs formed telling their versions and the whole thing gets twisted. It's like a game of having six people in a line and I whisper something to the guy next to me. By the time it gets to the end of the line, it's altogether something else.'

Maureen Cleave commented at the time, 'John was certainly not comparing The Beatles to Christ. He was simply observing that, so weak was the state of Christianity, The Beatles were, to many people, better known. He was deploring rather than approving this. John Lennon's remarks were taken out of context and did not accurately reflect the subject as it was discussed. What actually occurred was a lengthy conversation between John and me in which the subject of Christianity was discussed. He observed that the power of Christianity was on the decline in the modern world and that things had reached such a ridiculous state that human beings, such as The Beatles, could be worshipped more religiously by people than their own religion. He did not mean to boast about The Beatles' fame.' Although his remarks went largely unnoticed in his homeland, they would have major repercussions later in the year.

Back to the studio

With *Rubber Soul* still riding high in charts across many parts of the world, The Beatles returned to Abbey Road Studios on April 6 to start work on their next album. The group set to work recording John Lennon's ground-breaking 'Mark I' (the working title of 'Tomorrow Never Knows'), with producer George Martin and engineers Geoff Emerick and Phil McDonald. It was the first session for the new album *Revolver* and, with the song's unique use of backward tape, became a major turning point in The Beatles' creativity in the recording studio. Sessions for the album continued intermittently until June 22.

German visit

On June 23, The Beatles, their manager Brian Epstein, roadies Neil Aspinall and Mal Evans, and Cliff Bennett & The Rebel Rousers, a support act on the upcoming tour, flew to Munich, Germany to begin their 1966 world concert tour, an excursion which culminated in their biggest-ever series of concerts across the United States in August. Apart from their headlining appearance at Wembley's NME poll winners' concert on May 1, The Beatles had not given a single public performance since their UK tour six months earlier.

Sean O'Mahony, editor of *The Beatles Book Monthly*, recalled, 'On their arrival in Germany (on June 23), The Beatles were faced with a unique problem. Six months [sic]

of *Revolver* meant that they hadn't played any of their old numbers for over half a year. 'Let's face it', George admitted to everyone in earshot, 'we're all a little rusty.' So, on arrival at the Bayerischer Hof Hotel in Munich, Paul quickly organized rehearsals. Even so, when they finally went on stage at the Circus Krone the following evening, their new bottle-green suits and watered silk lapels couldn't hide the slightly rusty way in which their act started. But the very first number, 'Rock And Roll Music', blew the cobwebs out of their heads and they were away. Shows in Essen on June 25 and Hamburg on June 26 rounded off the visit.

Nightmares in Manila

One week later, on July 3, following performances in Japan, The Beatles landed in Manila, in the Philippines, for two concerts, scheduled for the following day at the Rizal Memorial Football Stadium. The Beatles were also expected at the Malacanang Palace that day to meet President Marcos, his First Lady Imelda and 300 children. They failed to arrive. Beatles press officer Tony Barrow explained, 'Before the concert in Manila, The Beatles were invited to visit the presidential palace. I remember Brian didn't give a direct answer that first evening. He said he would reply to the invitation the next day. While we were watching TV that night we saw a news item that surprised us. The palace dignitaries were waiting for The Beatles to show up. The next edition of Manila's newspapers carried the headline "Beatles Snub President". There was a general uproar and Brian was invited to go on TV and explain what had happened. But, for some reason, his speech was drowned by terrible interference, and nobody could make out what he said. Sentiment was running so strongly against The Beatles that we actually had the feeling their lives might be in danger.'

Vic Lewis, the agent for the tour, recalled, 'Somebody had told me that The Beatles were supposed to attend a garden party, but I knew nothing about it, and told Brian and he knew nothing about it as well. So he told me, "We are not going!" I said, "Wait a minute, I don't think we should say we're not going. Don't forget, we are in a foreign country and they seem hot-headed over here. I think we should think about it." But Brian, in the way that he was, said, "I'm not thinking about it. As far as I'm concerned, I received no official invitation from the Palace or the President and, as such, I'm not going to have the boys go round there."' John Lennon later admitted, 'That was Brian's cock-up, because he'd had the invitation given to him, and declined it, and never told us. Then next day, they wouldn't accept that we'd declined it.' Within a couple of hours, newspapers and the TV news carried reports of The Beatles' apparent snubbing of the President.

'Let's face it, we're all a little rusty.'
GEORGE HARRISON

Further problems arose when, on July 5, just as The Beatles and their entourage were preparing to leave the country, there was a knock on the door of Vic Lewis's hotel room. 'There was a man saying, "I'm from the Department of Income Tax and you owe us $80,000,"' Lewis recalled. 'I naturally said to him, "I beg your pardon?" So he said, "Yes, from your concert last night." I told him, "You're completely wrong. I am the agent of this whole affair and I set the whole deal up. I know exactly the contract from top to bottom without reading it, but if you'd like to see it, I'll bring out a copy." This I eventually did and showed him the relevant clause where it stated that all income taxes, whether domestic or internal, connected to the tour, would be borne by the promoter in each country. So I phoned down and told Brian about this and he said, "We don't want to have any trouble with these people, so let's just get out of here. I'm waiting for the promoter to bring me the money and when he does, we'll go." So I said, "As far as I can see, this man's going to stop us from leaving the country."'

Not long afterwards, at Manila Airport, The Beatles and their entourage were faced with a hostile crowd as they attempted to fly out from the Philippines. Paul recalled, 'We got to the airport and our road managers had a lot of trouble trying to get the equipment in because the escalators had been turned off. So, we got there and we were put into the transport lounge and we got pushed about from one corner of the lounge to another.' Shortly after the event, John, who faced allegations of stirring up hostility by shouting out 'woof, woof' to reporters' questions while in the country, remarked, 'They shouted to us, "You're treated like ordinary passengers, ordinary passengers," they were saying as they were kicking us. And we said, "Ordinary passengers? What? He doesn't get kicked, does he?" They even started knocking over our road managers. I swear there were about thirty of them.'

The Beatles' entourage rushed to catch their plane. 'I remember running across the tarmac with my hand on my back, thinking that if a bullet hit me, it wouldn't hurt me so much,' Lewis recalled. 'As luck would have it, we flew across the tarmac, all of us. There was about nine or ten of us in our party and we all flew up the stairs into the plane. It looked like a battleground. Mal Evans [The Beatles' road manager] had his ribs kicked and Brian [Epstein] was hit across the face. I don't think any of The Beatles got physically hurt, but wherever we were going, people were throwing things at us and it was awful. Anyway, we got on the plane and a girl started putting plasters around Mal's ribs. He was in agony and was bleeding. Brian was also cut and was bleeding, and with the heat, it was just unbelievable.'

TVC Studios, London

On 11 November 1964, King Features set about
making a series of animated cartoons featuring a
Beatles song in each episode. Jack Stokes set out the
ground rules: 'As far as I'm concerned, the sponsors
paid for the Beatle tracks and the kids want to hear
them, so anything else must suffer before the music.
It would have been marvellous to start with rough
stories and then get The Beatles to ad lib dialogue,
but the results might have been too off-beat.'

John reads the story boards
(*below*), later hiding under a
table (*opposite, right*). Paul
Frees made the voices of
John and George, while
Lance Percival did Paul and
Ringo. Fifty-two episodes
were made, premiering on
US TV in September 1965
and topping the ratings.

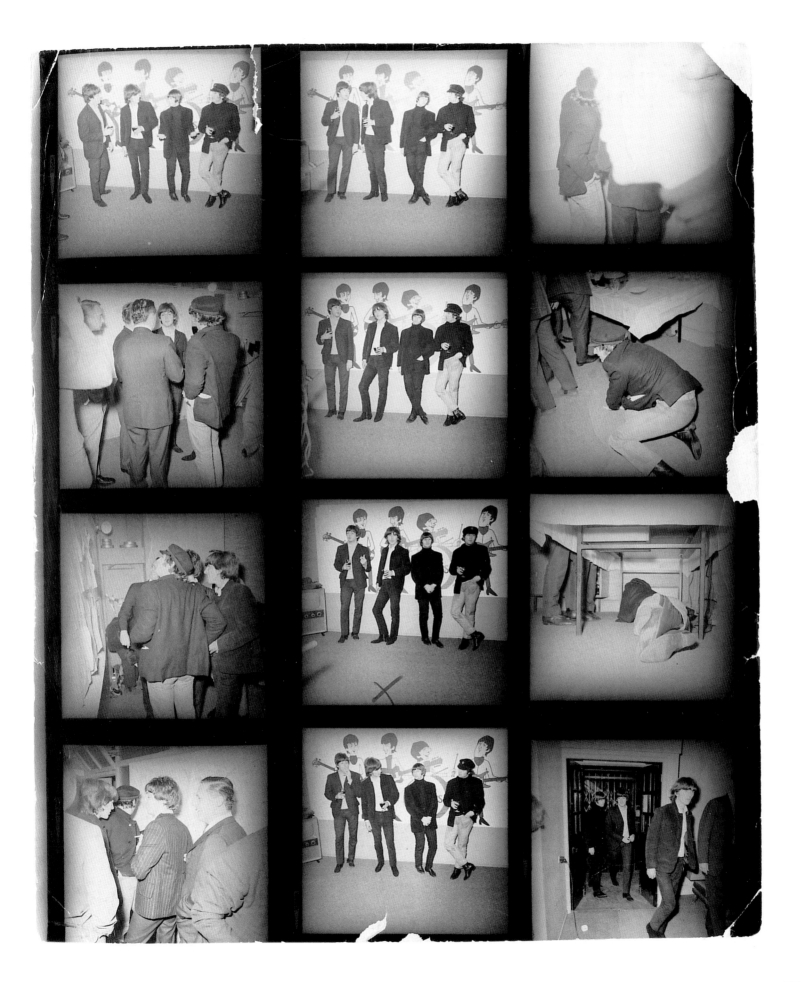

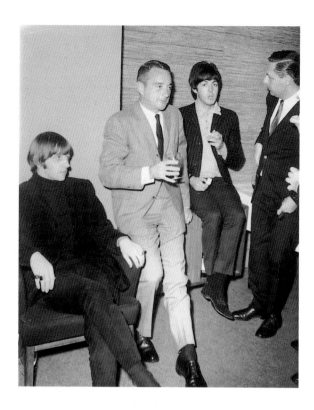

Al Brodax of King Features
previews one of the
programmes to The Beatles.

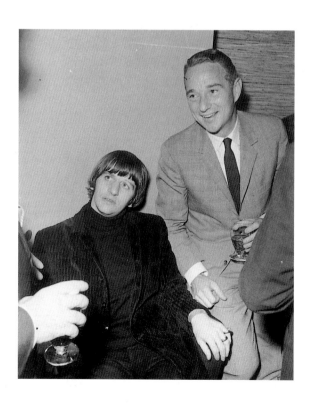

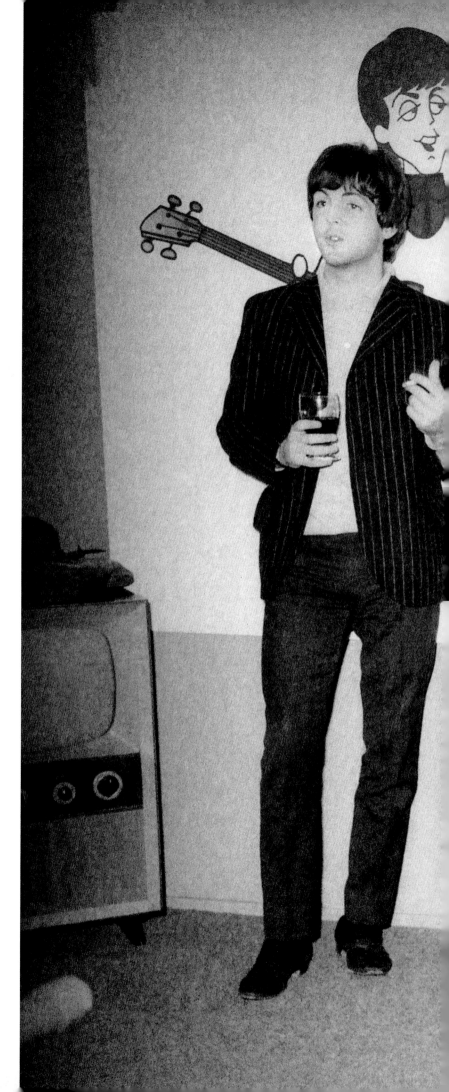

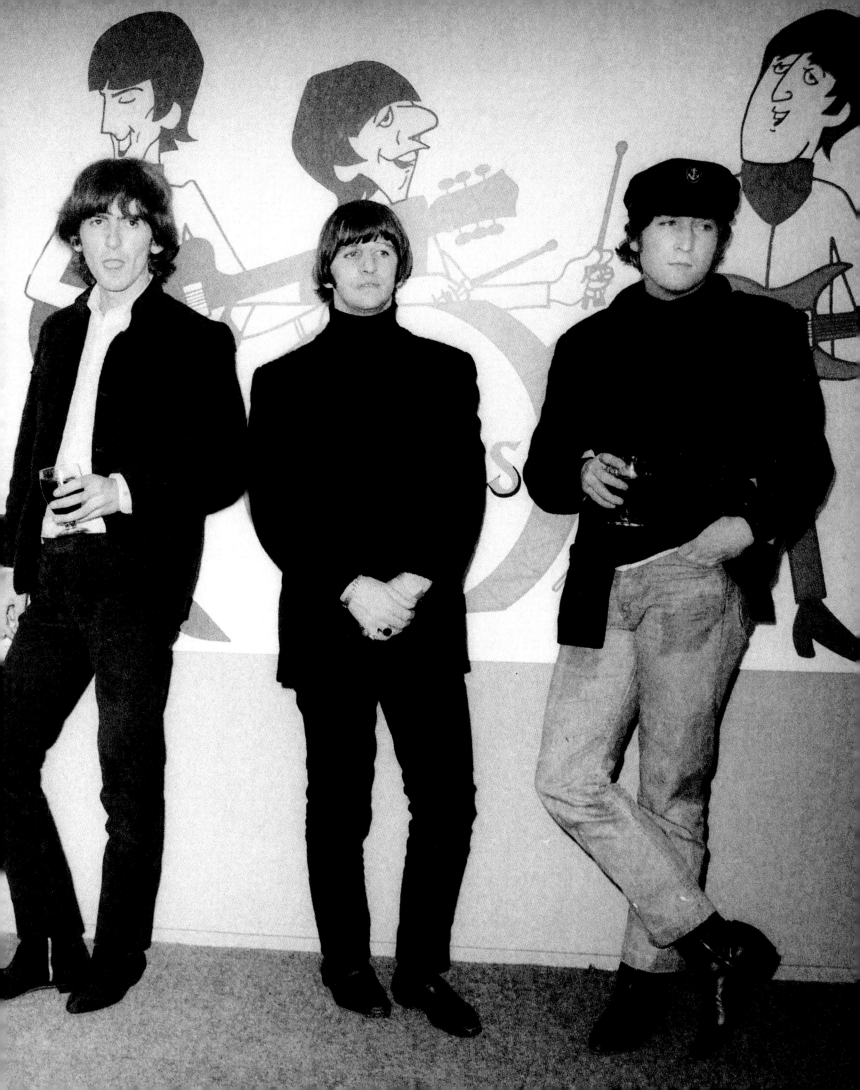

A break in Trinidad

At Sotheby's in the late eighties I purchased thirty-two holiday snapshots of John, Ringo and their wives, not often seen together in photographs. Even then it was so unusual to get holiday snaps of stars; today the *Hellos* and *OKs* of this world pay handsomely for any such pictures. Here, John and wife Cynthia, January 1966.

John relaxes in the shade at the rented accommodation in Port of Spain, Trinidad.

True Brits abroad.
Here Ringo and his wife
Maureen are in very relaxed
mood, Ringo not bothering
to shave – a very British trait
on holiday.

Every Liverpudlian aspired to a winter holiday in the sun, proof of having made it financially. The typical Brit was out in the sun on the first day; forgot to put on sun-protection cream, as it was seen as a bit feminine in those days; got sunburnt; then stayed indoors for the rest of the holiday, eating English food.

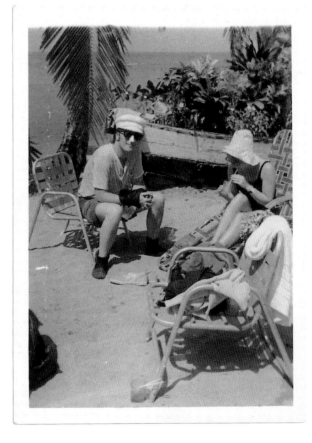

John and Cynthia sunning
themselves in Trinidad.

Head, nose and torso remain
protected even in the
swimming pool. The only
other shots I'm aware of
featuring John in a pool are
the Robert Freeman photos
taken while filming *Help!*.

New Delhi, India

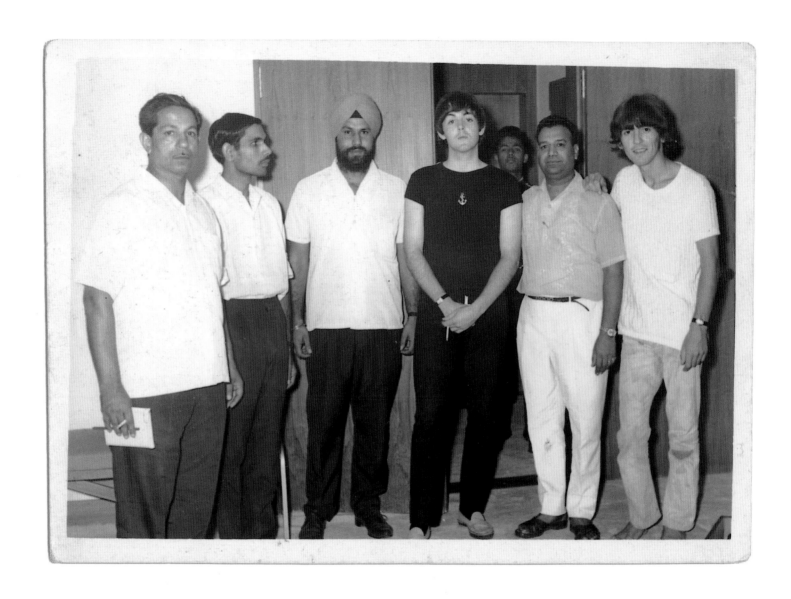

'The first time that we were aware of anything Indian was when we was making the *Help!* film. On the set in a scene in a restaurant, they had these sitars. It was supposed to be an Indian band playing in the background, and George kept staring and looking at them.'

JOHN LENNON

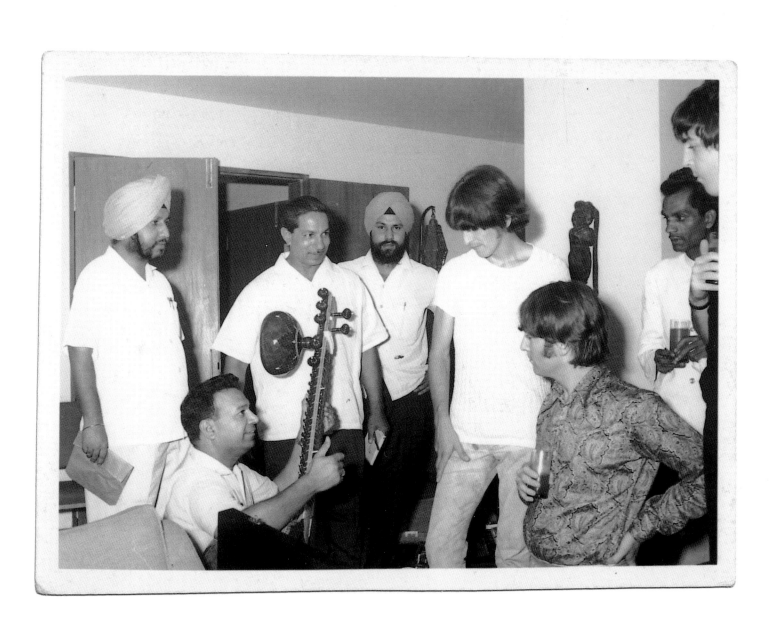

Following a suggestion by the sitar legend Ravi Shankar, George, accompanied by John and Paul, visited the home of Rikhi Ram, a renowned instrument maker and repairer, and proprietor of the shop Rikhi Ram & Sons, to purchase his first decent sitar on 6 July 1966.

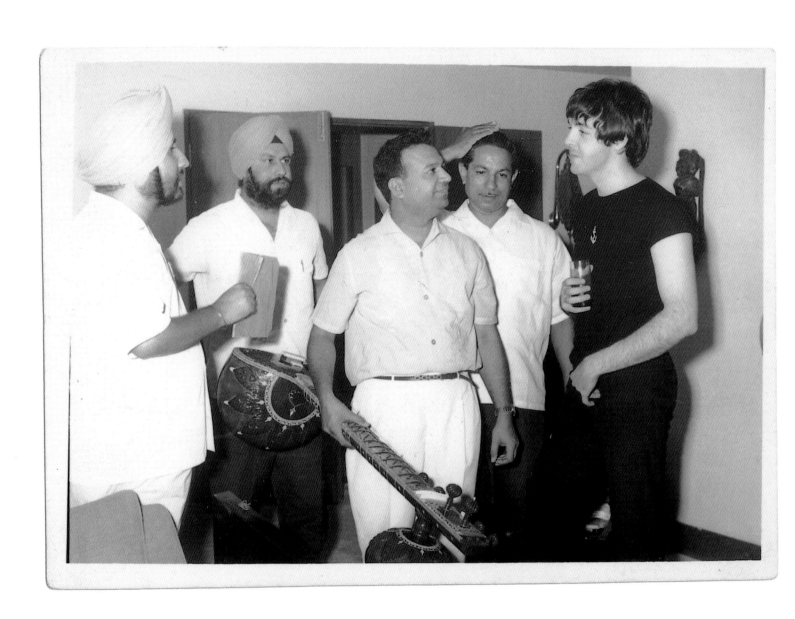

Six negatives and photographs came up for sale in 1996 at Bonhams auctioneers, originally purchased from Tony Bartello, a photographer himself, after he placed an advert in *Loot* magazine. These were some of the rarest photographs I had ever seen: a photographer being present in India in 1966 at the sitar maker's house was highly improbable.

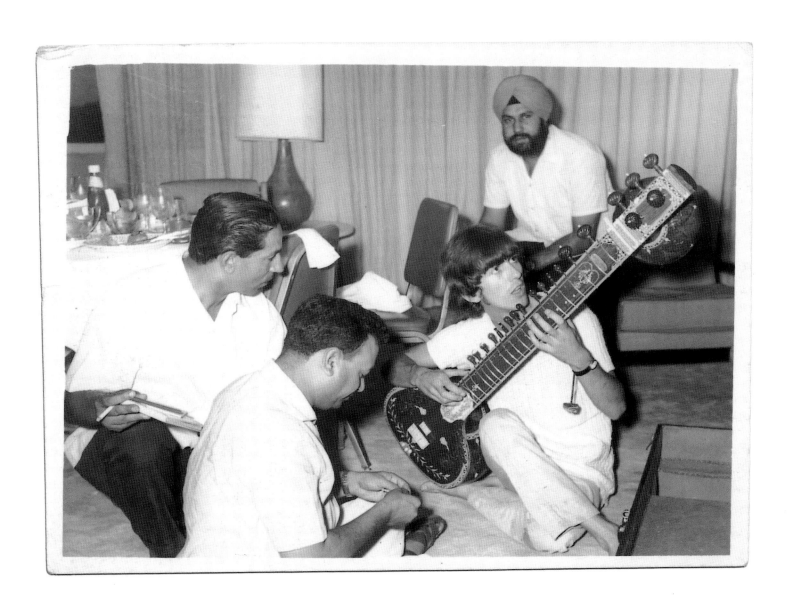

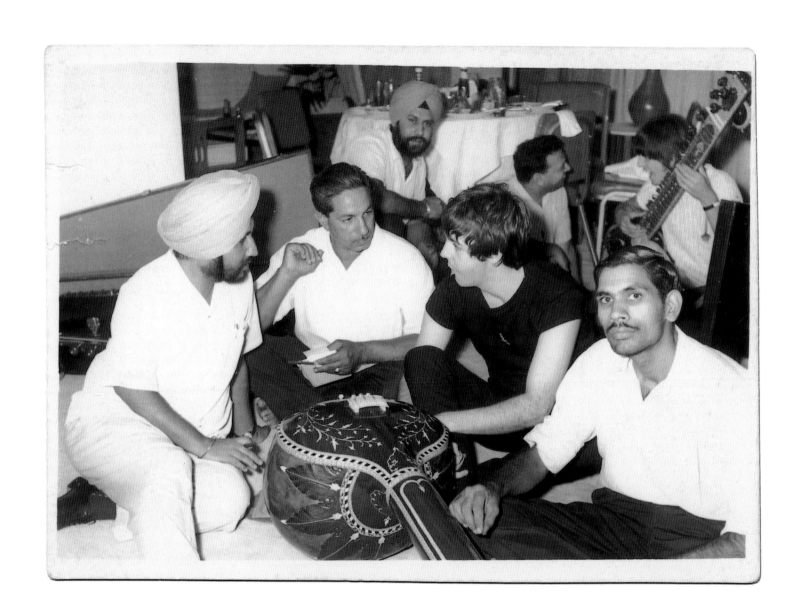

These photographs show that, contrary to popular belief, Paul and John were totally immersed in creating different sounds for incorporation on future tracks to be recorded in London. The pictures from India prove beyond doubt McCartney's interest in Indian music.

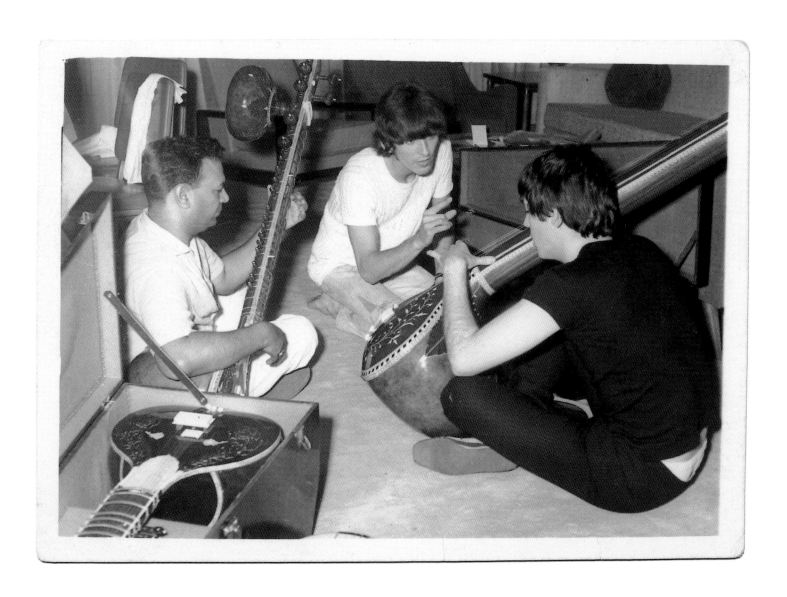

'We were waiting to shoot the scene in the restaurant when the guy gets thrown in the soup and there were a few Indian musicians playing in the background. I remember picking up the sitar and trying to hold it and thinking, "This is a funny sound." It was an accidental thing.'

GEORGE HARRISON

Crucified by the press

Two days after leaving the Philippines, on 8 July 1966, The Beatles arrived home in England at London Airport and immediately faced the press. Naturally, their trouble in Manila was at the top of the agenda…

George: 'If I go back. It will be with an H-bomb to drop on it. I intend to tip off The Rolling Stones about the place, because they are due to go there shortly.'

John: 'I would not even fly over it now. Let alone land there.'

Ringo: 'Go back there? You must be joking!'

Paul: 'You can't print my answer. I would not want my worst enemy to go there. We have never been jeered before. I must say that it is different.'

George: 'I have never been so terrified in my life. We will never go back there.'

Religious backlash in America

On July 29, just two weeks before The Beatles were due to land in America to start the next leg of their tour, the US magazine *Datebook* published John's unfortunate but innocent spring 1965 declarations on Christianity. Interestingly, it wasn't the first time that John's statement had been printed in the United States. The first excerpts had in fact appeared without any great fanfare on 13 April 1966, in the 'Our Fearless Correspondent' column of the *San Francisco Chronicle*. But with The Beatles' return to America now imminent, publicity-seeking DJs and journalists were quick to act on John's remarks and so the great American backlash against The Beatles began.

On July 31, the furore took a turn for the worse when the WAQY radio station in Birmingham, Alabama broadcast a show by the DJ Tommy Charles and his colleagues Jim Cooper and Doug Layton. In the transmission, many thousands of listeners were told of John's 'The Beatles are more popular than Jesus' remark. Almost immediately, over thirty American radio stations, from as far north as the Canadian border town of Ogdensburg, in New York State, to Conroe in Texas, from the Bible-touting Salt Lake City in Utah to Anderson in North Carolina, united in condemning The Beatles and their music. Other countries started to join in: on August 4, the South African government prohibited radio stations broadcasting Beatles records.

Brian Epstein meets the press

With no alternative, especially since The Beatles were due to arrive in the USA the following week, Brian Epstein was forced to cut short his much-needed holiday. He left the village of Portmeirion in North Wales and flew to New York to face the American press. Epstein's hastily arranged late-evening conference on August 5 took place at Manhattan's Sheraton Hotel. 'The comment which John made to a London columnist nearly three months ago [sic] has been quoted inappropriately, misrepresenting Lennon as a person; it was understood by him to be exclusive to the *Evening Standard*,' Brian announced to the throngs of waiting American press. 'It was not anticipated that it would be displayed out of context and in such a manner as it was in an American teenage magazine.'

After which, Brian began taking questions from the gathering…

Reporter: 'We're wondering whether you're going to change the itinerary of The Beatles to avoid areas where the radio stations are now burning their records and their pictures?'

Brian: 'This is highly unlikely. I've spoken to many of the promoters this morning. When I leave here, I have a meeting with several of the promoters who are anxious that the concerts should not be cancelled at all. Actually, if any of the promoters were so concerned and wish that the concerts be cancelled, I wouldn't, in fact, stand in their way.'

The Beatles face the music in Chicago

Three days later, on August 8, The Beatles' latest album, *Revolver*, was issued in the United States along with their latest single, 'Eleanor Rigby'/'Yellow Submarine'. The group arrived in America at Logan Airport, Boston on August 11. From there, they flew to Chicago's O'Hare Airport, where a relatively paltry crowd of 250 Beatle-worshippers greeted them.

That evening, The Beatles faced two press conferences. Once again, John tried to explain his declarations on Christianity. 'If I had said that television is more popular than Jesus, I might have got away with it,' he suggested. 'It's a fact, in reference to England, we meant more to kids than Jesus did, or religion at that time. I wasn't knocking it or putting it down. I was just saying it, as a fact and it's true, more for England than here. I'm not saying we're better or greater or comparing us with Jesus Christ as a person or God as a thing, or whatever it is, you know, I just said what I said and it was wrong, or was taken wrong, and now it's all this!'

Reporter: 'There have even been threats against your life, there's been record burnings, you've been banned from some radio stations, does that bother you?'
John: 'Well, it worries me.'
Paul: 'You know, it's bound to bother us.'
Reporter: 'Do you think you're being crucified?'
John: 'No, I wouldn't say that at all!'
Reporter: 'Are you sorry you said it?'
John: 'I am, yes, even though I never meant what people think I meant by it. I'm still sorry I opened my mouth.'
Reporter: 'What's your reactions to the repercussions?'
John: 'Well, when I first heard it, I thought it can't be true. It's just one of those things like bad eggs in Adelaide, but when I realized it was serious, I was worried stiff because I knew how it would go on, all the nasty things that would get said about it and all those miserable-looking pictures of me looking like a cynic. And they'd go on and on and on until it would get out of hand and I couldn't control it. I really can't answer for it when it gets this big. It's nothing to do with me now.'
Reporter: 'A disc jockey from Birmingham, Alabama, who actually started most of the repercussions, has demanded an apology from you.'
John: 'He can have it. I apologize to him. If he's upset and he really means it, you know, then I'm sorry. I'm sorry I said it for the mess it's made, but I never meant it as an anti-religious thing, or anything, you know, I can't say anything more than that. There's nothing else to say really, no more words. I apologize to him.'
Reporter: 'Mr Lennon, are you a Christian?'
John: 'Well, we were all brought up to be. I don't profess to be a practising Christian, and Christ was what he was and anything anybody says great about him I believe. I'm not a practising Christian, but I don't have any un-Christian thoughts.'

Reporter: 'Was there as much of a reaction to your statements throughout Europe and other countries around the world as there was here in America?'

John: 'I don't think Europe heard about it, but they will now! It was just England and I sort of got away with it there, in as much as nobody took offence and saw through me. Over here, it's just as I said, it went this way.'

Southern press conference

On August 19, between the two shows at the Mid South Coliseum in Memphis, Tennessee, the group faced another press conference…

Reporter: 'John, what do you think of the Beatles record bans?'

John: 'I don't mind people banning our records, or not liking them. That's their right, to ban 'em or not play 'em.'

George: 'A lot of banning seems to have been for publicity. They seem to be lifting the bans now because they've got their publicity, but they still seem to need to play our records.'

Reporter: 'Ringo, when are you going to release some pictures of your baby?'

Ringo: 'When someone else sneaks in and takes some I guess!'
[*Room fills with laughter.*]

Reporter: 'John, how does it feel to be in the Bible Belt?'

John: 'We've never heard of it before. It's just like a tag, like the Mop Top Four. It really doesn't mean anything.'

Reporter: 'Why are you appearing in a movie without the other three?' [This was a reference to John's role in Richard Lester's upcoming film *How I Won The War*, details of which had been released to the press on August 3.]

John: 'Some men rang me up and said, "Do you want to appear in a movie without the other three?" and I said, "Yeah."'
[*Laughter again fills the room.*]

Reporter: 'It was said that you would record Revolver in Memphis. What happened?'

Paul: 'Little things kept getting in the way, like money. We wanted to come. A couple of tracks would have been much better if we had come. We wanted Steve Cropper, a guitarist for Booker T & The MGs, to A & R the session. He's the best we've heard.'

Reporter: 'John, some people say you are the first pacifist heroes. What do you say to that?'

John: 'I don't mind. That's one title we don't mind having pinned on us.'

Hostilities continue

Disruptions occurred at the concert that followed, when members of the Ku Klux Klan were seen protesting outside the venue. There were even problems inside when a firecracker exploded on the stage, causing The Beatles to fear that one of them had been shot. Tony Barrow recalled, 'I was standing in the wings at the concert and the worst moment was when a firecracker exploded in the audience. Each Beatle just glanced at the others to see if one of them would drop. It says something for them that they didn't miss a note.' With The Beatles' nerves now severely shredded, the tour rolled on with performances at the Busch Stadium in Saint Louis, Shea Stadium in New York and Dodger Stadium in Los Angeles.

Californian conference

On the morning of August 28, The Beatles dropped in to the Capitol Records Tower in Los Angeles to hold yet another press conference. And the 'Beatles Are Bigger Than Jesus' controversy once again reared its ugly head…

Question: 'Do you consider that now, since you've been in the United States for almost a week [sic], that this religious issue is answered once and for all?'

John: 'I hope so.'

Question: 'Would you clarify and repeat the answer you gave in Chicago?'

John: 'I can't repeat it because I don't know what I said.'

Question: 'Well, would you clarify the remarks that were attributed to you?'

John: 'You tell me what you think, and I'll tell you if I agree.'

Question: 'Some of the remarks attributed to you compared the relative popularity of The Beatles

with Jesus Christ and intimated that The Beatles were more popular. This created quite a furore in this country, as you are aware.'

Paul [sarcastically]: 'Did you know this, John? You created a furore.'

Reporter: 'Now, would you like to clarify the remark?'

John: 'I've clarified it about eight hundred times! I could have said TV or something! And that's just as clear as it can be! I used Beatles because I know about them a bit more than TV. I could have said any number of things, but it wouldn't have got as much publicity.'

Question: 'Do you think controversy has hurt your careers or helped?'

Paul: 'It hasn't helped or hindered, I don't think. I think that most sensible people took it for what it was. It was only the bigots that thought it was on their side. They thought, "Ha, ha, here's something to get them for." But when they read it they saw there was nothing wrong with it really. They thought by John saying we were more popular than Jesus, that he must be arrogant.'

End of the tours

For The Beatles the ordeal was almost over. On August 29, the group gave their last concert of this American tour and their last-ever public performance as a working band. The venue was San Francisco's Candlestick Park. George Harrison recalled, 'The sound at our concerts was always bad and we would be joking with each other on stage just to keep ourselves amused. It was so impersonal. We were so sick of it. I think we all were. We were all like nervous wrecks, getting flown around everywhere and doing press conferences everywhere we went. It was all too much. There was a certain amount of relief after the Candlestick Park concert. Before one of the last numbers, we actually set up this camera, I think it had a fisheye, a wide-angle lens. We set it up on the amplifier and Ringo came off the drums, and we stood with our backs to the audience and posed for a photograph, because we knew that was the last show.'

On October 27, almost two months after The Beatles' last public performance, their manager Brian Epstein flew back from the USA to England. Next day, he informed The Beatles' US promoter, Sid Bernstein, that there were no plans for the group's next North American tour. Two weeks later, on November 9, Epstein phoned The Beatles' UK concert promoter, Arthur Howes, and told him that the group would not accept any more bookings for live performances. With immediate effect, The Beatles had ceased to exist as a touring band.

With time on his hands, Paul starting composing the music for the British film *The Family Way*, starring father and daughter John and Hayley Mills. George, meanwhile, travelled to Bombay, India, spending most of the time with his friend Ravi Shankar. Ringo took a vacation in the Caribbean and chose to spend time with John, who had accepted an invitation to appear as the servile character Private Gripweed in Richard Lester's latest movie, the satirical war film *How I Won The War*. For the role, John had his Beatle mop-top unceremoniously trimmed and sported round National Health spectacles. Upon his return to London in early November, John paid a visit to the exhibition *Unfinished Paintings And Objects By Yoko Ono* at the Indica Gallery in London and was introduced to artist Yoko. John Lennon had just found his soul mate. For The Beatles, the year concluded with the group starting work on their next studio album, a little production ultimately to be called *Sgt Pepper's Lonely Hearts Club Band*.

3
STUDIO YEARS

FROM THE SUMMER OF LOVE TO LIVE PEACE VIA THE *WHITE ALBUM*

The summer of love

The new year began with further recording sessions for the new album, *Sgt Pepper's Lonely Hearts Club Band*. On 4 January 1967, work resumed at Abbey Road on Paul's 'Penny Lane', a song honouring a place dear to his heart in his hometown of Liverpool. But unfortunately, after four years of extensive working and creating there, EMI's Abbey Road Studios no longer excited certain members of The Beatles. George described the group's musical base as 'a dirty, big white room that hadn't been painted for years'. In an interview conducted in 1987, he remarked, 'It wasn't a very nice atmosphere. When you think of all the songs that were made in that studio, No. 2, it's amazing, because there's no atmosphere in there. We made the atmosphere ourselves.' George's grievances towards Abbey Road Studios extended to a number of issues, including the paper used in the building's toilet. 'It felt like lino,' he blasted, 'and "EMI" was stamped on every piece. Even the refrigerator at Abbey Road had a padlock on it. If we wanted a cup of tea, we had to break open the padlock on the fridge just to get the milk out.'

Paul, too, was frank about life in the Fab Four's camp. On January 16, at his home in St John's Wood, London, in a conversation with the British journalist Derek Jewel, he revealed, 'We [The Beatles] are ready to go our own ways. We'll work together only if we miss each other. Then it'll be hobby work. It's good for each of us to go it alone.' Paul's admissions also moved towards finance. 'Two years ago I was worried about money, but now, I'm surprised to find that I'm rich, yet I'm not miserable.'

Away from their homes and the confines of the recording studio, The Beatles surprisingly found their position as the world's most popular pop group under threat. In the annual *New Musical Express* end-of-year readers' poll, the Fab Four had lost their 'Top World Vocal Group' crown to America's Beach Boys, whose recent, quite spectacular single 'Good Vibrations' had set new benchmarks in terms of production and arrangement for a pop single. But they weren't the only challengers from the United States. Another threat to The Beatles' popularity came in the shape of the TV-manufactured pop group The Monkees, whose weekly comedy- and music-filled television series was being watched by record audiences in both America and England. In the third week of 1967, 'I'm A Believer' was sitting pretty at No. 1 in the UK charts and Monkeemania had become the craze of millions of teenagers. The mania surrounding the group evoked memories of when Beatlemania first broke out at the end of 1963.

Fearing that The Beatles were falling out of favour with the record-buying public, the group's manager Brian Epstein paid a visit to their record producer, George Martin. 'Brian Epstein wanted a single out,' he recalled. 'He was genuinely frightened that

'When you think of all the songs that were made in that studio, it's amazing, because there's no atmosphere in there.'
GEORGE HARRISON

The Beatles were slipping. He wanted another single out that was going to be a blockbuster, and so I put together "Strawberry Fields Forever" and "Penny Lane" and said to him, "If this isn't going to be a blockbuster, then nothing is!"' But unfortunately, the great British public thought otherwise. The Beatles' new single was beaten to the coveted No.1 position by Engelbert Humperdink's 'Please Release Me'.

Shooting a piano in a tree

To help promote the single, The Beatles shot short colour films with the help of the thirty-one-year-old Swedish television director Peter Goldmann. 'I received a cable from Mr Epstein and got a plane over to England the same day,' he recalled at the time for *Filming Today*. 'Originally, my enthusiasm for presenting English groups on TV in Sweden was fired by *A Hard Day's Night*, Richard Lester's fine film of The Beatles. I thought that movie was fantastic. My first meeting with the group was at Ringo's house. He took me for a walk in his garden with his wife Maureen, and their little white poodle, Tiger. I got my boots all muddy, and Ringo insisted on giving me another pair to replace them. That was really typical of him. I was very happy about working with The Beatles and I wanted to present their new music in an original and interesting manner on TV.'

Beatles promotions man Tony Bramwell also recalled the filming. 'Klaus Voorman [a friend of The Beatles from Hamburg and designer of the *Revolver* album cover] came up with the idea of a strange instrument in a tree for the "Strawberry Fields" promo,' he said. 'So I had to find a site with a suitable tree, which was Knole Park. We found a piano, ripped it up, and then spent ages going up and down the tree with miles and miles of that glittery string you use to wrap Christmas presents. We didn't have a storyline as such. We were just trying things out, like changing the speed of the camera, and running the film backwards.'

Sergeant Pepper's special tracks

When filming for the 'Strawberry Fields' and 'Penny Lane' promotional films was finished, The Beatles turned their attention back to their new album, *Sgt Pepper*, work on which concluded on April 21. George Martin remembered that the album took him '700 actual working hours to complete'. The final piece of this masterwork came when The Beatles taped the extremely short, alcohol-fuelled recording, 'Sgt Pepper's Inner Groove'.

In an interview for *Record Producer* magazine, Martin recalled the making of this unusual track. 'At the end of *Pepper*, when we finished the whole album, we all felt pretty

elated to have finished it. So, as a little in-joke for ourselves, we decided to fix the very end of the record so that there would be something on it, on the run-out grooves on the album, on the second side. We said, "Let's just put a noise on the end, so people would say, 'What the hell is that?'" During one of the recording sessions, Paul had suggested that we should include a track especially for dogs. And so, in a pause after "A Day In The Life", we put an electronic note pitched at 18 kilocycles, a whistle inaudible to the human ear, and outside the range of modest record players, but on high-fidelity equipment, a loud and clear call to all dogs.

'But we also wanted another recording, something from The Beatles to go on the run-out groove. So John, Paul, George and Ringo went down into the studio and just started shouting, saying a lot of gibberish in a chaotic sort of way. I recorded them for about thirty seconds and I took, literally, about four seconds of it and wrapped it into the groove around the centre, so it just kept on going round and round, the same noise. It was a completely random recording. EMI engineers thought I had taken leave of my senses when I explained what I wanted. But, a month after the album was released, we found out that people had been playing the damn thing backwards, and found out, by playing it backwards, there was an obscene word to be heard. And, sure enough, Paul said, "Have you heard it?" And when you play it, it does say an obscene word.'

At the time of the album's release, Paul was quick to point out, 'As I say, nine times out of ten, it's really nothing. The backward thing, at the end of *Sgt Pepper*, "We'll fuck you like supermen." Some fans even came around to my door, giggling. I said, "Hello, what do you want?" They said, "Is it true that bit at the end? Is it true? It says, 'We'll fuck you like supermen.'" So, I said, "No, you're kidding! I haven't heard it, but I'll play it." It was just some piece of conversation that was recorded and turned backwards. I went back inside after I had seen them and played it studiously, turned it backwards with my thumb against the motor, turned the motor off and did it backwards. And there it was, sure as anything, plain as anything. "We'll fuck you like supermen." I thought, Jesus, what can you do?'

Brian Epstein entertains

On May 19, Brian Epstein hosted a dinner party for a select group of journalists to launch The Beatles' new album in the drawing room at his Belgravia home at 24 Chapel Street, London. 'When we launched the *Sgt Pepper* LP, we considered, for a long time, the best way to do it,' Epstein recalled at the time. 'Finally, we decided to have a party at my pad. It was difficult to decide whom to invite. We wanted people who were close to us and people who would spread the word. I suppose we had about fifteen journalists there. It proved a good idea because the story went round the world...' During the get-together, Paul met for the second time the American photographer Linda Eastman.

'There was a typical Epstein array of gourmet foods and fine wines,' the British music journalist Ray Coleman remembered. 'The glazed poached salmon, the caviar and the vintage champagne. I have this vivid memory of George telling me that he felt that

they had broken through a real barrier with the album. He said, "We've really jumped up onto a new layer with this one."'

But unfortunately, George left the party early when a member of the gathering said unflattering things about his track on the album, 'Within You, Without You'. He needn't have worried. The album reached No.1 immediately after its official UK release on June 1. (The US release took place one day later. Once again, the No.1 spot beckoned.) The eye-catching cover, photographed by Michael Cooper on March 30 at the Chelsea Manor Studios in London, was designed by the Pop Art artist Peter Blake and depicted the four Beatles, dressed in brightly coloured satin uniforms, posing as the band Sgt Pepper in a park, surrounded by a collage of their heroes.

Drugs in the lyrics

Unfortunately, the superb new album didn't prevent controversy from once more rearing its ugly head. *Sgt Pepper*'s concluding song, 'A Day In The Life', was immediately banned by the BBC due to its apparent references to drugs, then on June 18, Paul let slip to a reporter that he'd had four LSD trips that year. As expected, the media wanted to know more, most importantly an ITN news crew the following day. 'They cornered him,' John remarked years later. 'The press got on to it and went to his house. But they were too late. It was old news. When they cornered Paul about LSD, it was a year after we had all taken it. We'd all had acid, including Paul, by the time *Revolver* was finished.'

All You Need Is Love

On June 25 The Beatles were chosen to represent Britain in the worldwide TV spectacular *Our World*, billed by the BBC as 'for the first time ever, linking five continents and bringing man face-to-face with mankind'. During the groundbreaking global tele-fest, which also featured diverse activities such as opera and circus performances from countries like Australia, Japan and America, the group premiered John Lennon's recently composed anthem, 'All You Need Is Love'. Sitting at The Beatles' feet in Abbey Road's Studio 1 that evening were many of their pop music contemporaries, including Rolling Stones Mick Jagger and Keith Richard, Cream's Eric Clapton and The Who's Keith Moon.

While the world was experiencing the so-called 'summer of love', the timing for 'All You Need Is Love' was nothing short of perfect. The Beatles were sitting proudly at the top of the pop music tree and no one looked likely to topple them. On August 25, they boarded a train at London's Euston Station en route to Bangor, North Wales, where they intended to study transcendental meditation with their new guru, the Maharishi Mahesh Yogi. Surprisingly, the idea of meeting him had not come from the deeply spiritual George but from his wife, Patti. Just six months earlier, she had joined the Spiritual Regeneration movement, with which the Maharishi was closely associated.

'We'd all had acid, including Paul, by the time *Revolver* was finished.'

JOHN LENNON

Strawberry Fields

Don Long took these amazing photographs, showing director Peter Goldmann and others, while filming the 'Strawberry Fields' and 'Penny Lane' videos with his independent production company in Knole Park, Sevenoaks, Kent, on January 31 and February 7. I purchased them because they showed The Beatles actively involved in all aspects of the filming process, from painting props to reading light meters and cleaning lenses. The Beatles were true artists, taking a great interest in every aspect of the arts. These short films introduced a new format in terms of promotional music videos in that the footage showed scenarios that explored the meaning and the feeling of the accompanying song rather than just showing a performance.

MARK HAYWARD

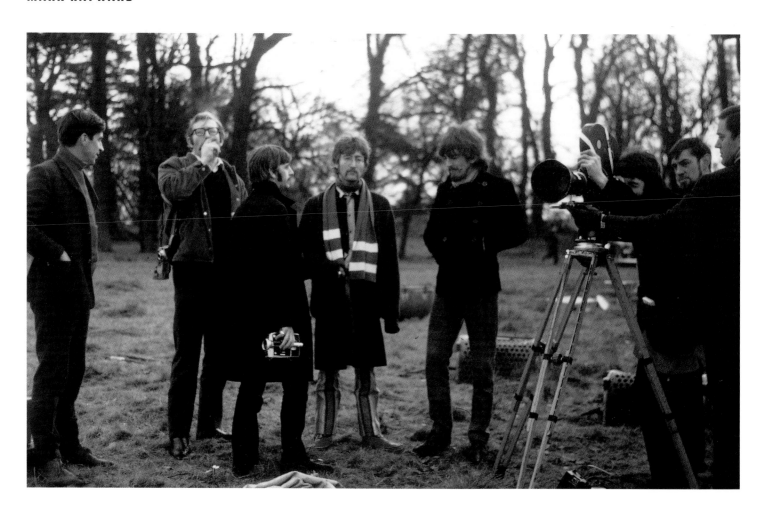

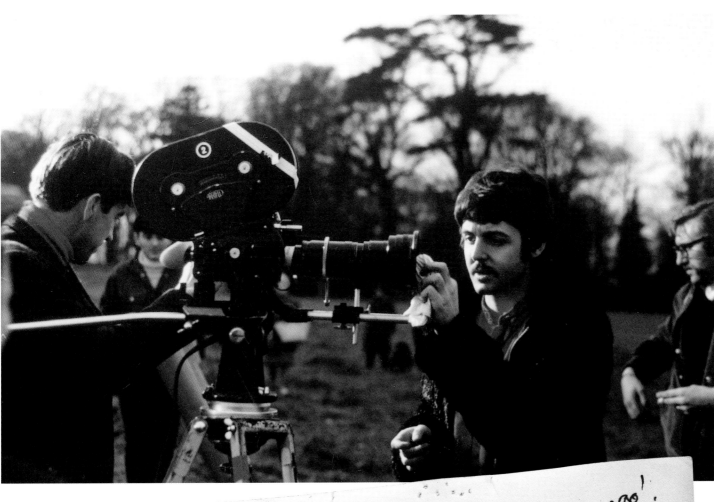

Paul took an avid interest in all aspects of the arts, experimenting with new techniques such as putting vaseline on the lens of a camera (already tried and tested on The Rolling Stones' *Between The Buttons* album cover). The photograph above is signed on the reverse to Don Long, owner of the production company that filmed 'Strawberry Fields'. Knole Park, Sevenoaks, Kent, 31 January 1967.

To Don!
all the breast from long ago!
Paul McCartney
(1985!!)

KODACHROME ENLARGEMENT
MADE BY KODAK LIMITED
MARCH 1967

KODACHROME ENLARGEMENT
MADE BY KODAK LIMITED
MARCH 1967

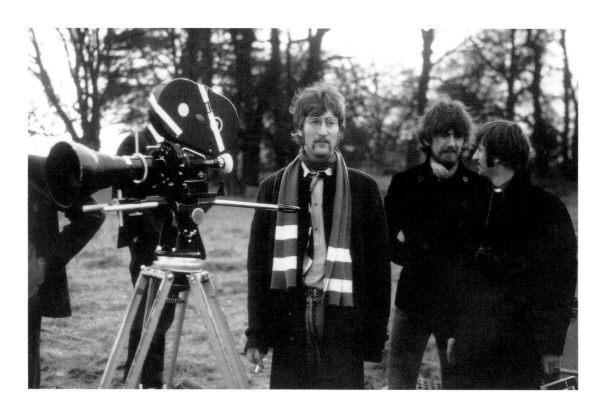

Below: Don Long looks on as Ringo passes Mal Evans's video camera, which I now own, to John. *Opposite:* John test-filming with the camera for special lighting effects.

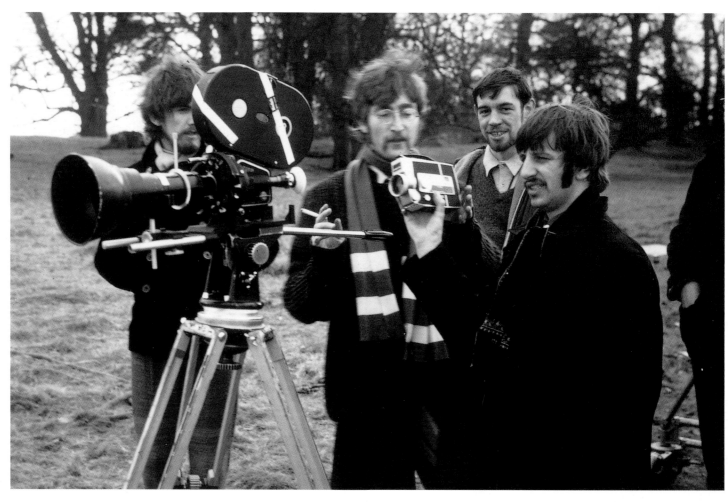

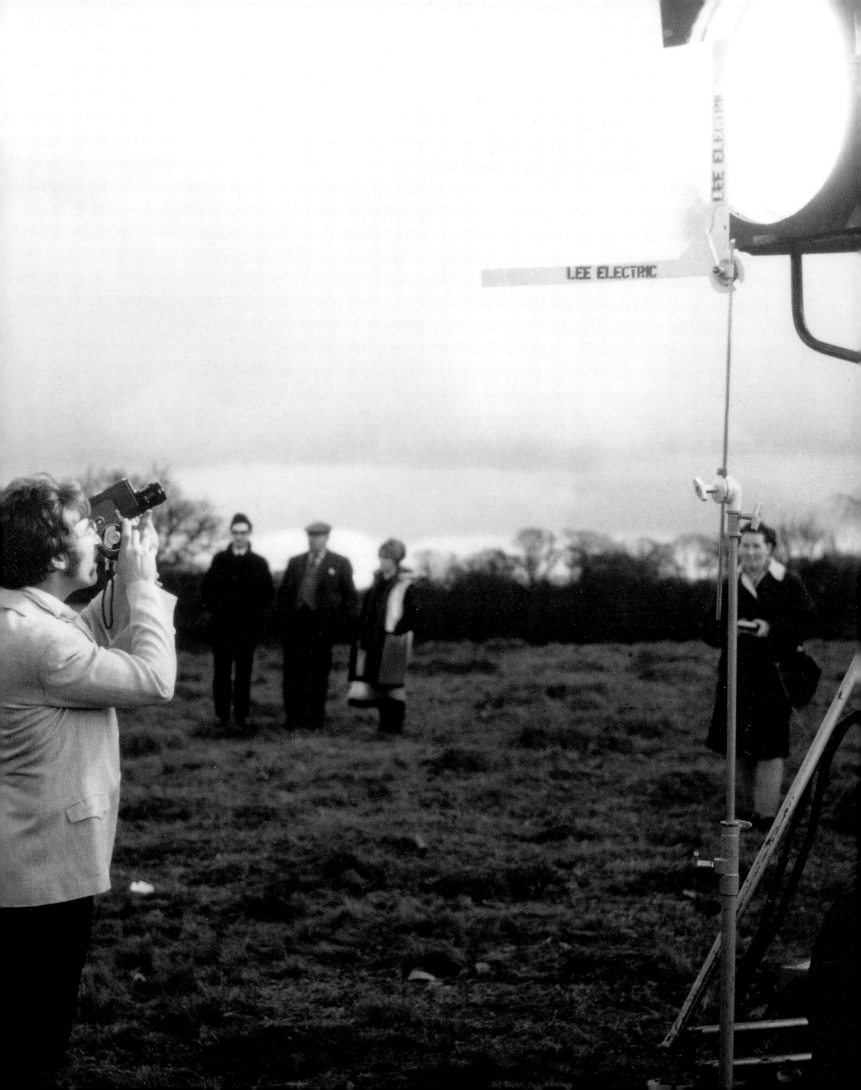

The light is labelled "LEE ELECTRIC".

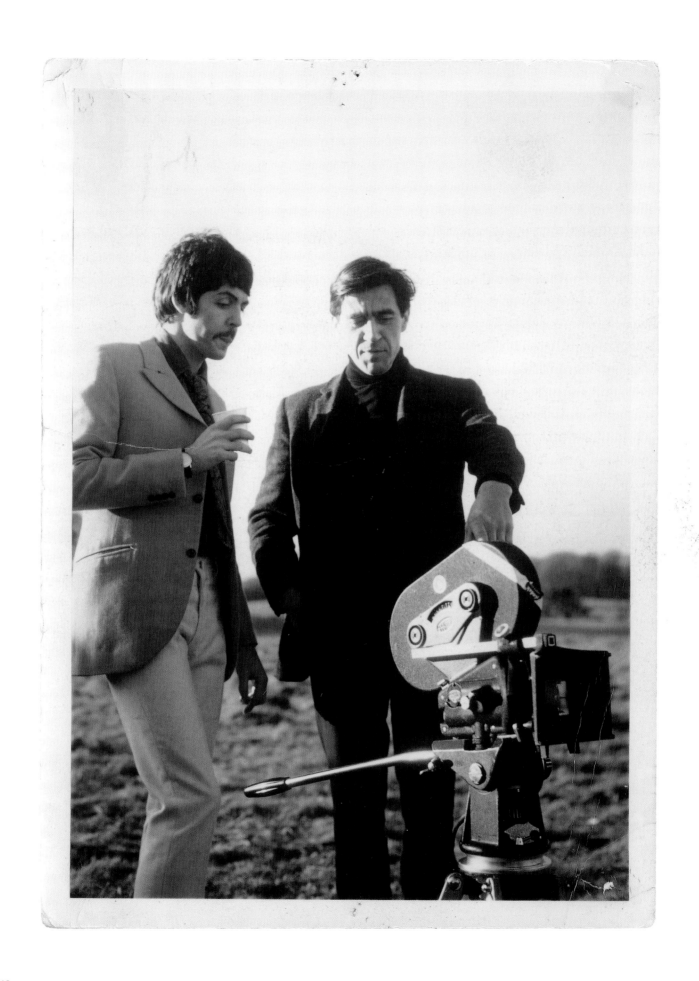

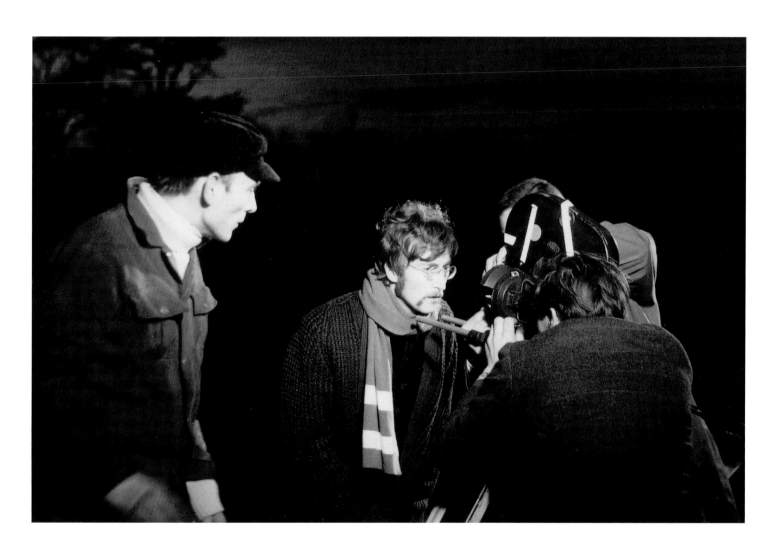

Opposite: Swedish film director Peter Goldmann explains the workings of the camera to Paul.
This page: A cameraman really had to work at getting special effects in the sixties, with no computers available to tweak results. Here John mimes 'Strawberry Fields Forever' as a close-up is filmed.

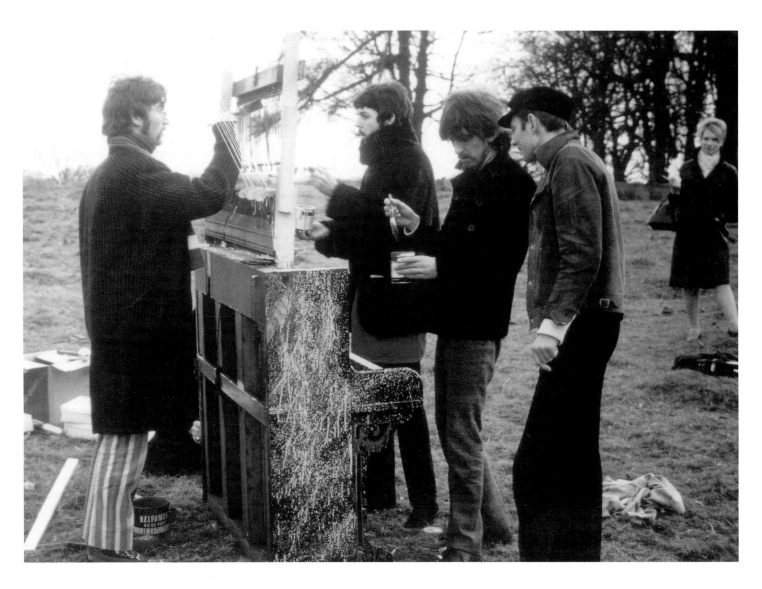

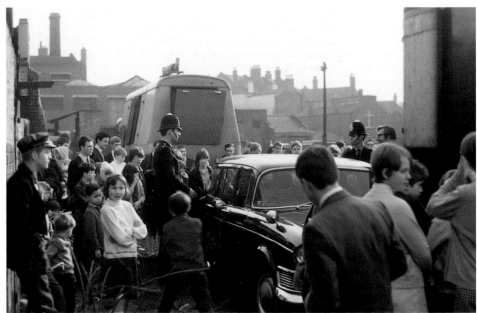

Above: The Beatles turn an ordinary piano into a masterpiece of psychedelic art.

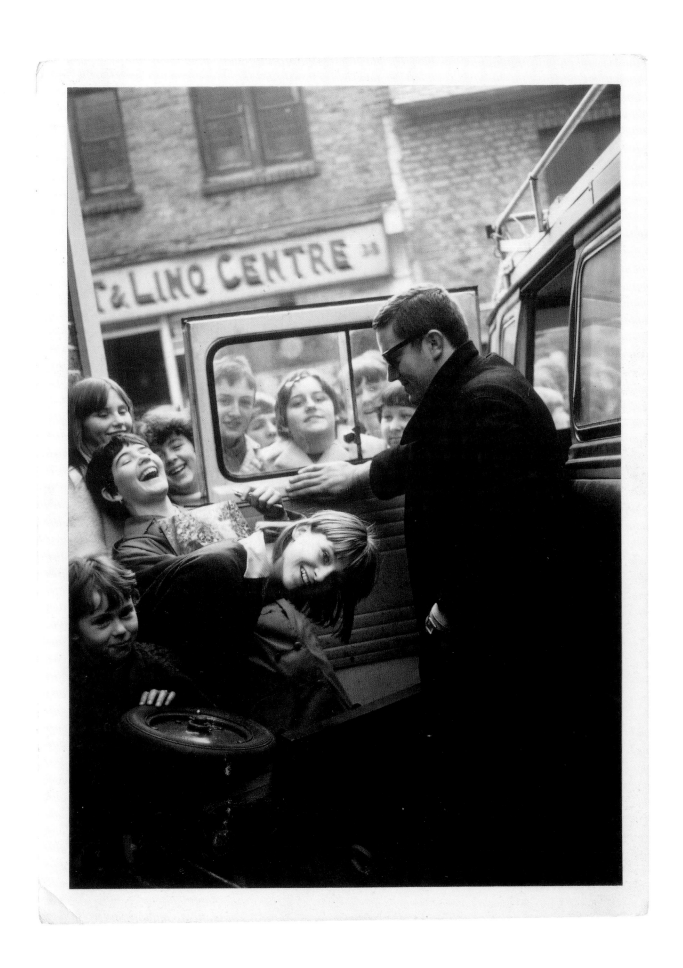

Penny Lane

'I shot "Penny Lane" and "Strawberry Fields Forever" in colour, although viewers in the UK were only able to see them in black and white. I was concerned that some of the clever lighting effects would not come off in two-tone. Unfortunately, nearly everything went wrong during the filming, but The Beatles were very patient. The horses we got for the "Penny Lane" clip proved to be spirited, and when The Beatles got off them, they just bolted. It took us a couple of hours to recapture them from the far side of the park. Then when I arranged this weird tree piano in a field for the "Strawberry Fields" clip, all the wires we had tied to the branches of the tree broke in a gust of wind, and we had to begin again.'

PETER GOLDMANN, DIRECTOR

How was Ringo Starr
persuaded to mount a horse
along with the other Beatles?
Knole Park, Sevenoaks, Kent,
7 February 1967.

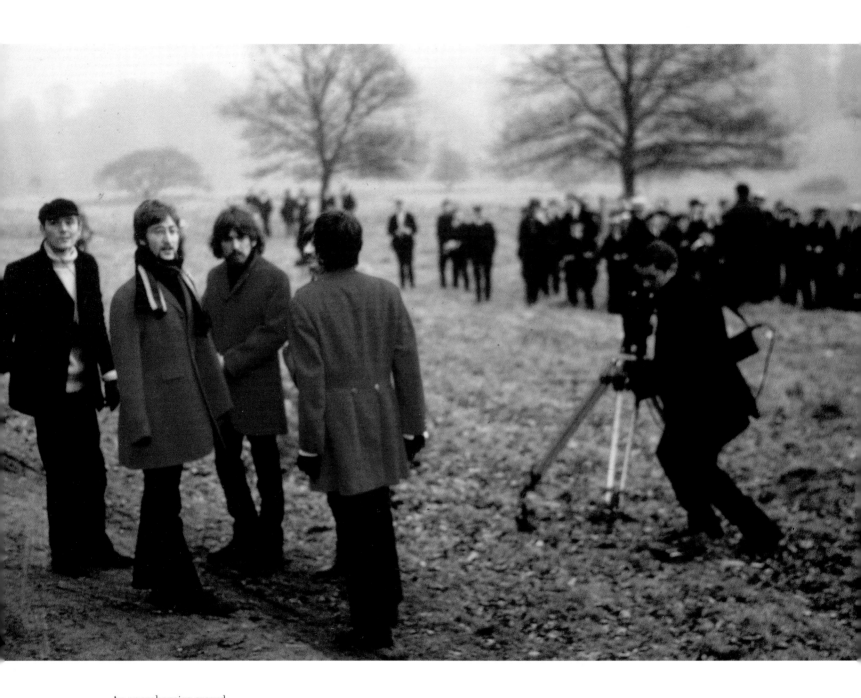

An apprehensive crowd
gathers while the camera
is adjusted to film several
takes. When horses or
animals are involved in
filming, it's not easy to get
the desired piece of footage
on the first take.

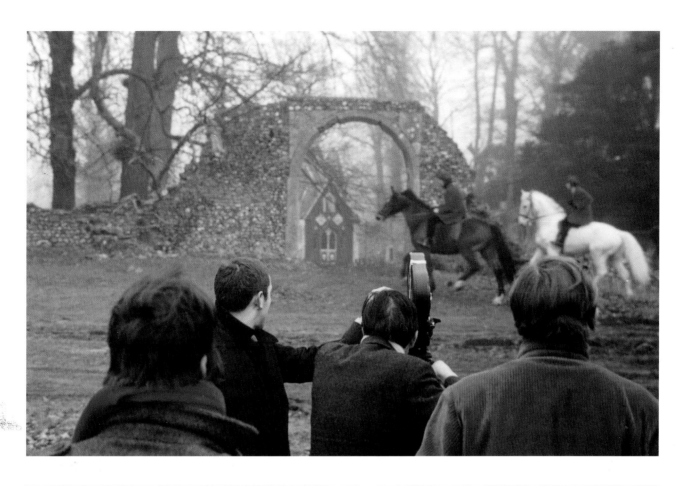

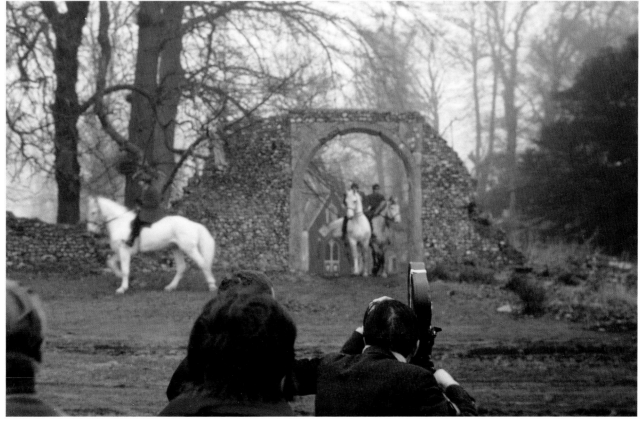

Bad news in Bangor

The Beatles' time of relaxation and attempts to find peace and tranquillity on retreat with their guru ground to a halt when, on 27 August 1967, Brian Epstein was found dead by his secretary, Wendy, at his London home. Brian's housekeepers, Antonio and Maria Garcia, became suspicious when repeated knocks on his bedroom door failed to provide a response from him. Epstein's assistant and close confidant, Alistair Taylor, recalled, 'I had just flown in from Los Angeles, where I had been with the group Cream. I had just given my wife her presents when the phone rang; it was Brian's secretary. She said that Brian's housekeepers were concerned because he was not answering their bangs on his bedroom door. I said to my wife, "I'll either be back in half an hour or I'll be a long time." I rushed to 24 Chapel Street, and I heard the door being smashed in and there was Brian lying in bed. He just looked asleep. The doctor told me he was dead. On Brian's bed were some letters, obviously he had been doing some correspondence. Beside his bed was a plate of digestive biscuits and a half-empty bottle of bitter lemon. And on the bedside table were six bottles of prescribed pills. Unfortunately, Brian needed pills to wake him up, keep him up, etc., and they were all half-full, with the tops of their bottles still on. There was no suicide note, and I remember thinking, "If you're going to commit suicide, you don't screw the lids back on top of the bottles." There was only the doctor and myself in that bedroom and I know Brian did not commit suicide. I had even rung him on Friday from San Francisco, and he was full of beans and on top of the world.' (Post-mortem verdict: accidental overdose. An official report later states that Brian's death was accidental, due to accumulation of bromide contained in a drug known as Carbitral.)

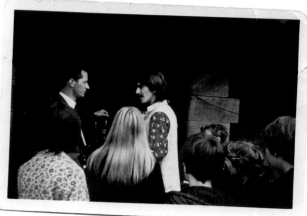

When I showed this book to Yoko Ono while she was visiting London in May 2005, she loved this photo of John (*opposite*), with fans in Wales. Taken on 26 August 1967.

The shell-shocked Beatles naturally cut short their trip to Bangor and returned home to London. On August 31, the group announced to the press that they would take over the administration of their own business interests. But Paul was quick to confirm what everyone suspected. 'No one could possibly replace Brian,' he admitted. Next day, the four Beatles assembled at Paul's home in St John's Wood, London and agreed to delay the proposed trip to India but press ahead with their next project, a self-conceived and self-financed television movie, entitled *Magical Mystery Tour*.

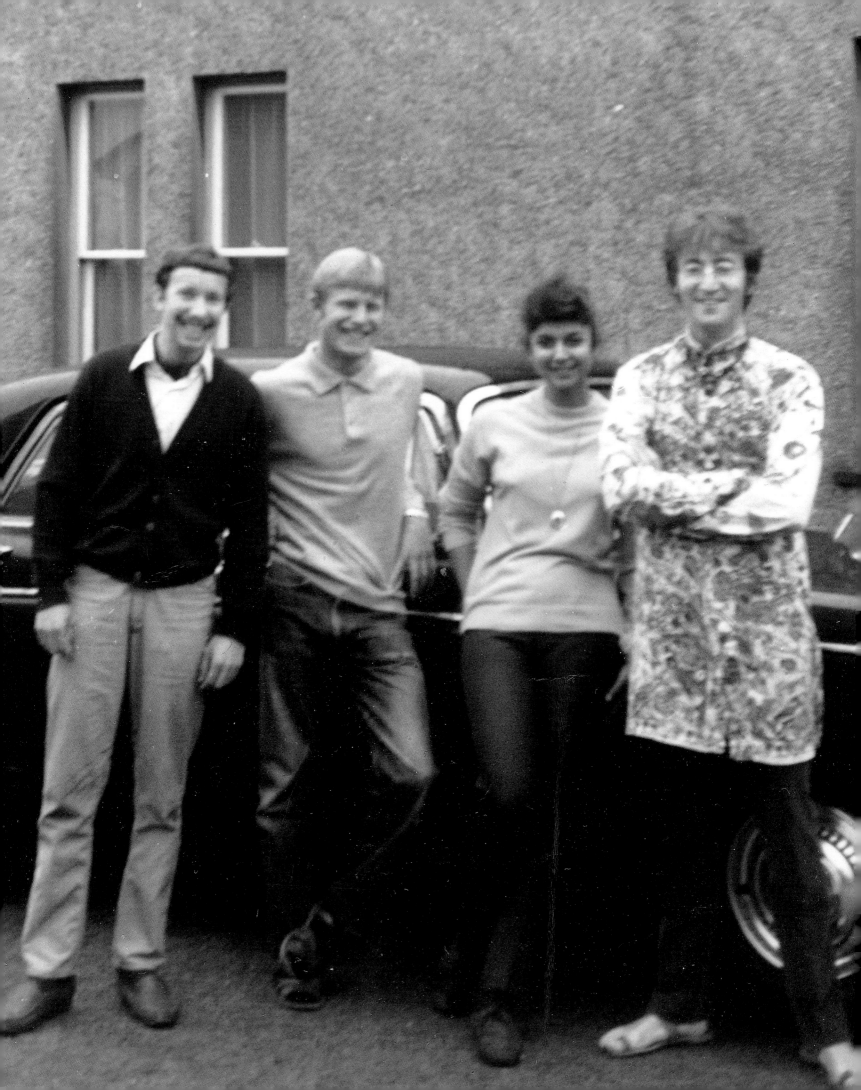

The Magical Mystery Tour

Just over two weeks after the unfortunate death of their manager, Brian Epstein, The Beatles set to work shooting their self-conceived movie *Magical Mystery Tour*, inspired by the 'bus to nowhere' stories involving California's acid-guru Ken Kesey and his hippy cohorts, the Merry Pranksters. The Beatles' close friend and assistant Alistair Taylor remembered, 'In September, I got a call from Paul on a Sunday, saying, "Can you get in a cab immediately, and get to my house, because I've got a great idea." This I did, and I found Paul sitting at his table with a piece of paper with a circle drawn on it, divided into segments. "I've got this great idea, Al," he said, before asking me, "Do they still have such things as mystery tours?" He explained: "When I was a kid, I went to the seaside and there were mystery tours, which you used to pay five shillings and you'd get on the coach and you didn't know where you were going. So, I got this idea of doing a magical mystery tour, but I've got no idea if they still do them. Can you go down to the seaside and see if they still do them?" So, I did, and lo and behold, on the sea front were a couple of coaches lined up with a big chalked sign, saying 'Mystery Tour'. I came back, and I said to Paul, "Yes, mate. They still do mystery tours." He said, "Right, what we want to do is make a magical one."'

John's recollections

During one of his American radio interviews in 1974, John recalled, '*Magical Mystery Tour* was something that Paul had worked out with Mal Evans. He showed me what his idea was and how it went, the story, the production and everything. Paul had a tendency to come along and say, "Well, I've written these ten songs, let's record now." And I'd say something like, "Well, give us a few days, and I'll knock a few off." Paul made an attempt to carry on as if Brian hadn't died, by saying, "Now, boys, we're going to make a record." Being the kind of person I am, I thought, "Well, we're going to make a record all right," so I'll go along and we made a record. That's when we made Magical Mystery Tour. Paul said, "Well, here's the segment, you write a little piece for that," and I thought, "Bloody hell," so I ran off and I wrote the dream sequence with this fat woman and all the things with the spaghetti. It was based on a dream I had. The waiter is me. I dressed like my father and my stepfather because they were waiters. Paul said, "Here, this quarter, you've got to fill it in." So, I said, "Well, how long have we got?" "You've got two days," he replied. "Well, okay," I said. He had written about ten songs and I hadn't written any! Then, George and I were sort of grumbling about the movie and we thought that we had better do it.'

> 'I got this idea of doing a magical mystery tour, but I've got no idea if they still do them.'
>
> **PAUL McCARTNEY**

Finding a coach

As ideas for the movie gathered pace, Alistair Taylor recalled an unusual request from Paul. 'He said to me, "What we need is a really bright, garish-coloured coach. Can you find one?" So, I said, "Yes, probably." Shortly after, I was in Eastbourne again, with my wife Lesley, and we were sitting having lunch in the Queen's Hotel and it was pouring with rain outside. I was looking out of the window and we had just started the main course, when this hideous yellow and blue coach pulled off from the car park outside the window I was looking out, and I just dropped my knife and fork and shouted, "I've found it! I've found it!" I just leapt up and ran out in the pouring rain. Lesley said, "Where are you going? What are you doing?" I ran out into the rain, and I ran round the back of it, getting soaking wet, and I saw it was from a firm called Fox's of Hayes. I jumped up into the coach, and I asked the driver, who was looking at me as though I had gone out of my head, if they hired these coaches out. He replied, "Yes, they do." So, I got a card from him, and I came back and said to Paul, "I've found it. I've found the coach."

Union mysteries

Filming of *Magical Mystery Tour*, and indeed the legendary tour itself, began at 10.45 in the morning on September 11, when the *Magical Mystery Tour* bus set out from London's Allsop Place. Over the ensuing two weeks, The Beatles and their bus, crammed full with an assortment of motley characters, visited a variety of randomly chosen locations in Hampshire, Devon, Cornwall (where several of the following images were taken) and Somerset, before returning to film a sequence at Paul Raymond's Review Bar in Soho, London on September 18.

Shooting at this world-famous strip club commenced at the unearthly hour of 6a.m. 'A strip club at six in the morning is not a pleasant sight,' Alistair Taylor recalled with some horror. 'I had one of the girls, Jan Carson, a dear friend of mine, stripping while the pop group The Bonzo Dog Doo-Dah Band played. It was unreal. She took her clothes off time and time again while The Bonzos played, and John and George just sat there ogling her.

'I'm sitting there, sort of overseeing this, and through the door walked in two gentlemen in trilby hats and belted raincoats,' Taylor continued. 'I saw them talking to two of the staff and they came over to me and said, "Excuse me, are you in charge of this?" So I said, "Well, sort of." So one of the gentlemen said, "We want to talk to you. We're from the cinemagraphic union." So I said, "Yes, okay. Sit down. Do you want a

coffee?" "No," one replied, "we don't want to sit down. We don't want a coffee." So I asked, "Do you have a problem?" He said, "Yes. You've not got union permission for this." So I said, "Sorry. Do I need union permission for this?" He said, "Oh, yes. We hear you're going to put this on television." I said, "Yes, that's the idea." So he said, "Well, you've only got four people on the crew. But you can't do that. You should have a crew of thirty-two!" I got absolutely nowhere. They told me, "Either you do as we say, or it'll never be shown anywhere." I tried to explain to them that this could be the very first of several crews, and we will change the crew so that everybody got work. But he wouldn't have it.

'He then gave me this list of people that we should have. I said, "This defeats the whole point of what we're doing," and he just kept on saying, "Well, okay, but we'll just black it! It'll never be shown." This put the cost about £12,000 through the roof. I said, "Okay, that's fine. If that's what we've got to do, I'll do it. But I want the phone number of every member in that list, and if I ring them and they are not there, at any time, you're in big trouble." And I did. I kept ringing them, to make sure they were available for us, as we were paying them. But what was so stupid was that they agreed that we didn't have to have them on the actual filming. But we had to pay them. So we kept on with the four people, but we had to pay the extra thirty or so people. It was a lot of money. But I made damn sure that they were available if I needed them, and they weren't working for anyone else.'

Filming at the airbase

For the movie's later, interior sequences, including its dramatic grand finale, filming was forced to shift to the perhaps unlikely location of West Malling's disused USAF airbase near Maidstone in Kent because The Beatles had not been aware that Twickenham, or any other London film studios, had to be booked well in advance. Shooting at the airbase started on 19 September and covered many of movie's most memorable sequences, including the one for John Lennon's 'I Am The Walrus'. 'I filmed "Walrus" there and I had all these policemen there on top,' he recalled. 'I was doing this [Federico] Fellini thing where we were dressed as walruses, but I ended up confusing myself, you know, with all these eggmen. I didn't know about real filming, and the cameraman apparently didn't know either, and nobody else did!'

Filming at West Malling concluded on September 24. The Beatles' good friend Victor Spinetti, actor and co-star of both *A Hard Day's Night* and *Help!*, was asked to appear in the

film. 'John wrote and asked if I would be the courier in *Magical Mystery Tour* but I was doing a play, *Oh! What A Lovely War*, in London, so I had to turn it down, and Ivor Cutler went in and did it marvellously. But John still wanted me to be involved, so he got me to drive down to West Malling Aerodrome for the day and do a little drill sergeant routine with Paul. It was something I did in the play anyway, and it was all improvised, so it was no problem. One lovely thing was that when we broke for lunch, they had set aside twenty minutes for anybody who wanted to meditate, which I did. It was a lovely calm moment in the middle of the schedule, and they were all into that since they had been with the Maharishi. The filming for *Magical Mystery Tour* was unusual in as much as it wasn't done in lots of short takes like a normal movie. They filmed long sequences, and they improvised as they went along. At one point, John spotted a stuffed cow, and he just decided to have it in the shot. They were making it up as they went along.'

Shooting the finale

After five straight days of filming, it was time to shoot the movie's grand finale, the highly choreographed 'Your Mother Should Know' sequence. The Beatles' so-called Mr Fix-It, Alistair Taylor, recalled the day's filming. 'None of us, neither Neil Aspinall or Mal Evans, knew about that. They kept it a secret. They just disappeared and reappeared at the top of the stairs in white tails. It was absolutely breathtaking for us. The idea for this sequence was because Paul was very much into the Busby Berkeley school of thought. That's why he had the Peggy Spencer Formation Team there. The hour before we were due to film in this aircraft hangar, the generator blew. Every light, the sounds, everything went. So it was panic stations. It was a Sunday and we couldn't get hold of the people we hired the generator from. So a guy brilliantly made a wooden cog, because it was a wooden cog that had gone in the generator, and we, thankfully, got it going again. But it blew again, and by this time it was getting near dusk and all the invited villagers started drifting off. Children in prams and the other older children starting going. So the final scene in *Magical Mystery Tour* was just a tenth of the people that should have been there.'

In Cornwall

These photographs, purchased at Sotheby's in 1992, show images from the *Magical Mystery Tour* bus and in Cornwall. The Cornish beach scene was cut from the movie, making these even rarer.

MARK HAYWARD

Left: John descends from a highpoint over looking the Cornish coast. *Opposite*: The Magical Mystery tourists enjoy a Cornish beach. John in his Afghan coat: nearly every trendsetter in those days possessed an Afghan coat, which would smell awful after getting drenched in the all-too-frequent English rain.

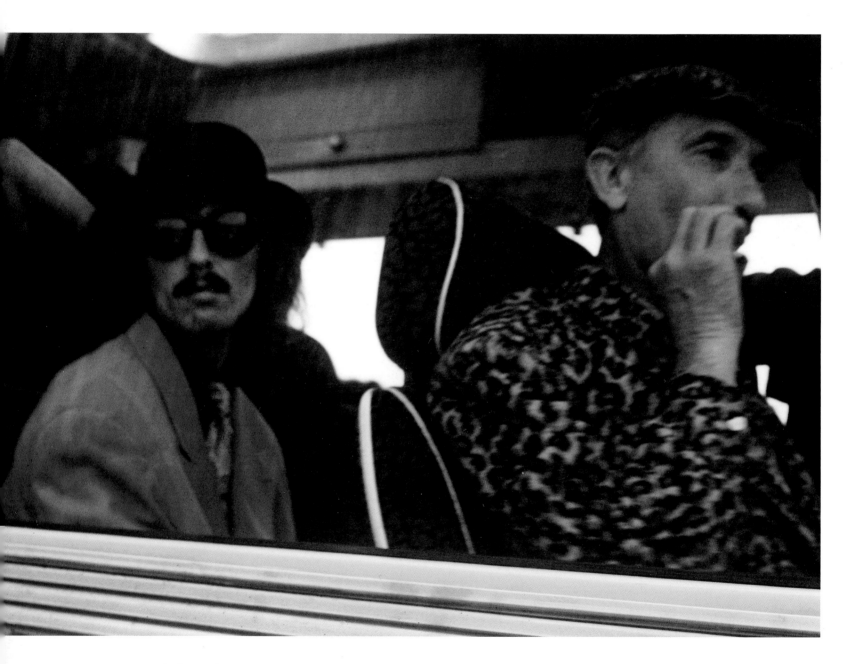

George on the bus with
'Happy Nat the Rubber
Man', the veteran comic
actor Nat Jackley.

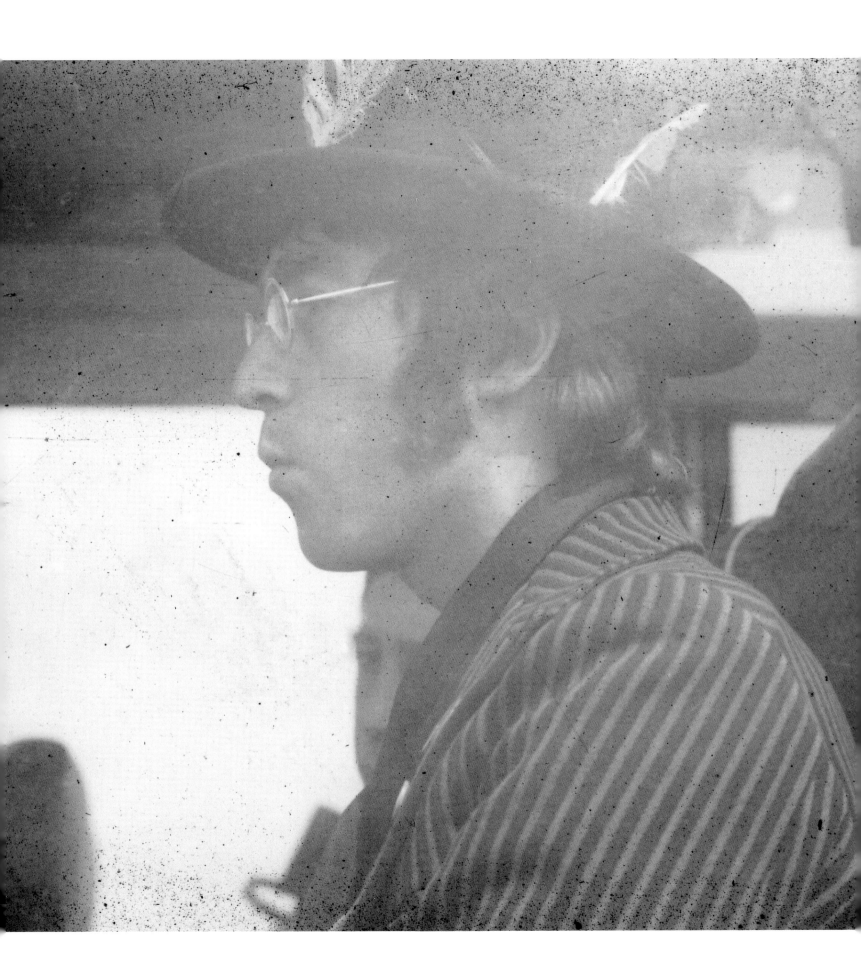

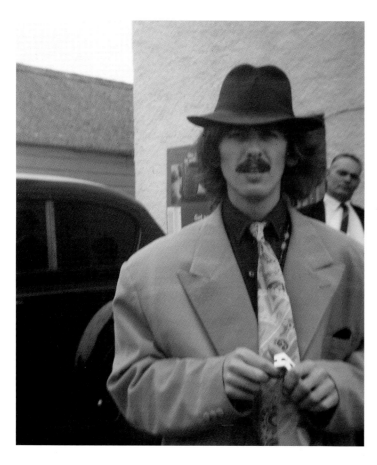
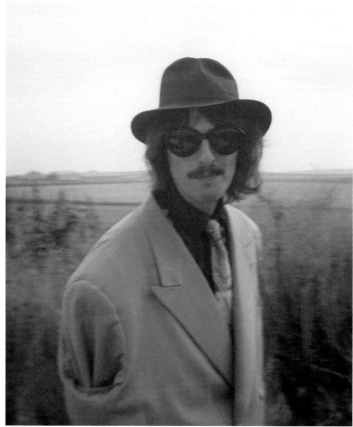

George on set

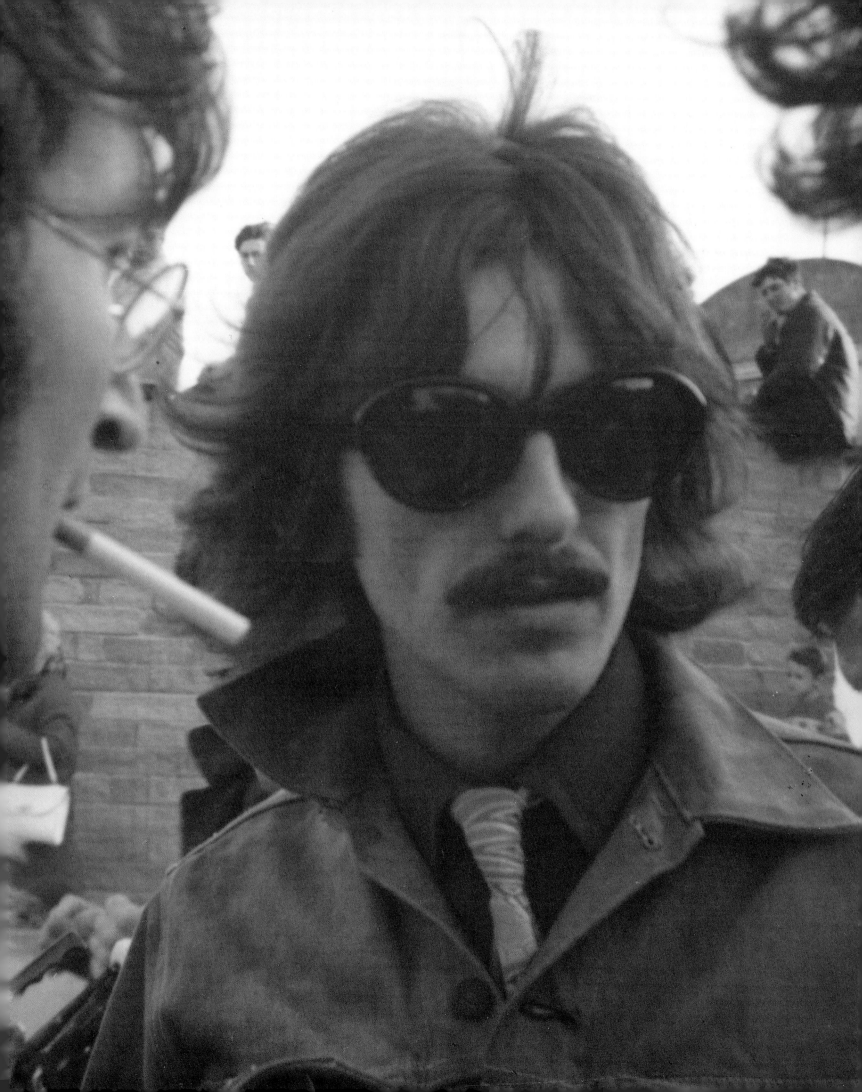

The Mystery Tour bus makes a stop to let Paul take a look at another location in Cornwall and allow everyone off to film a tent scene.

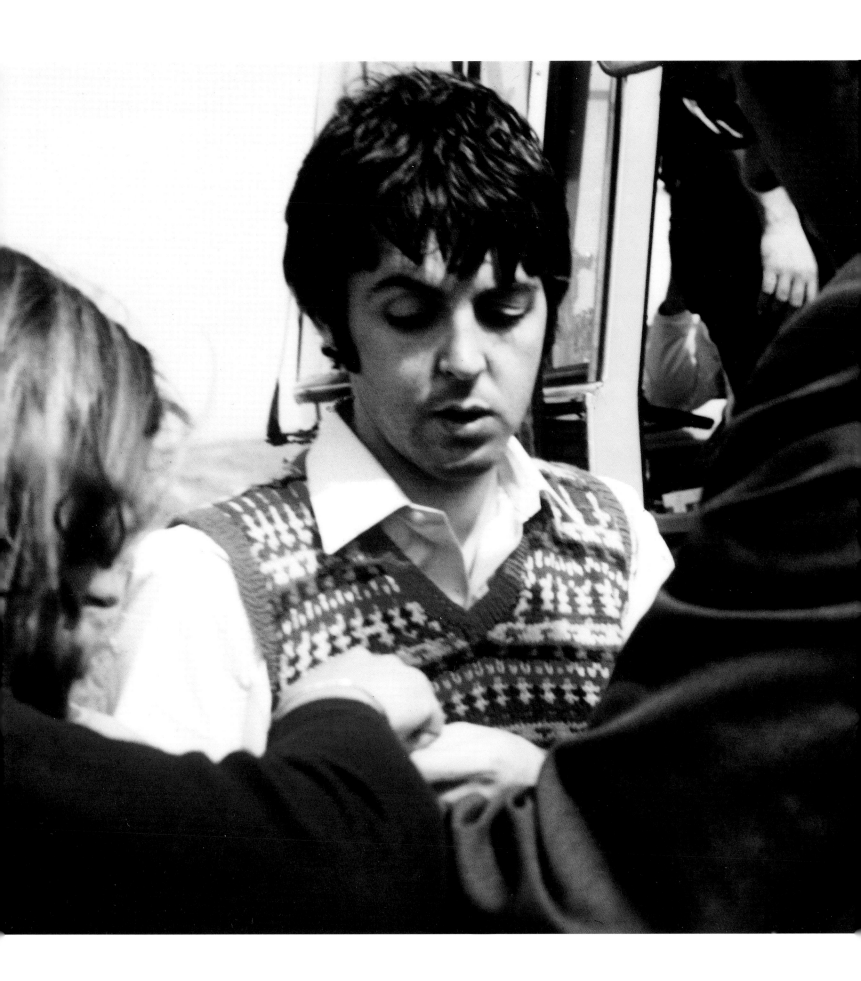

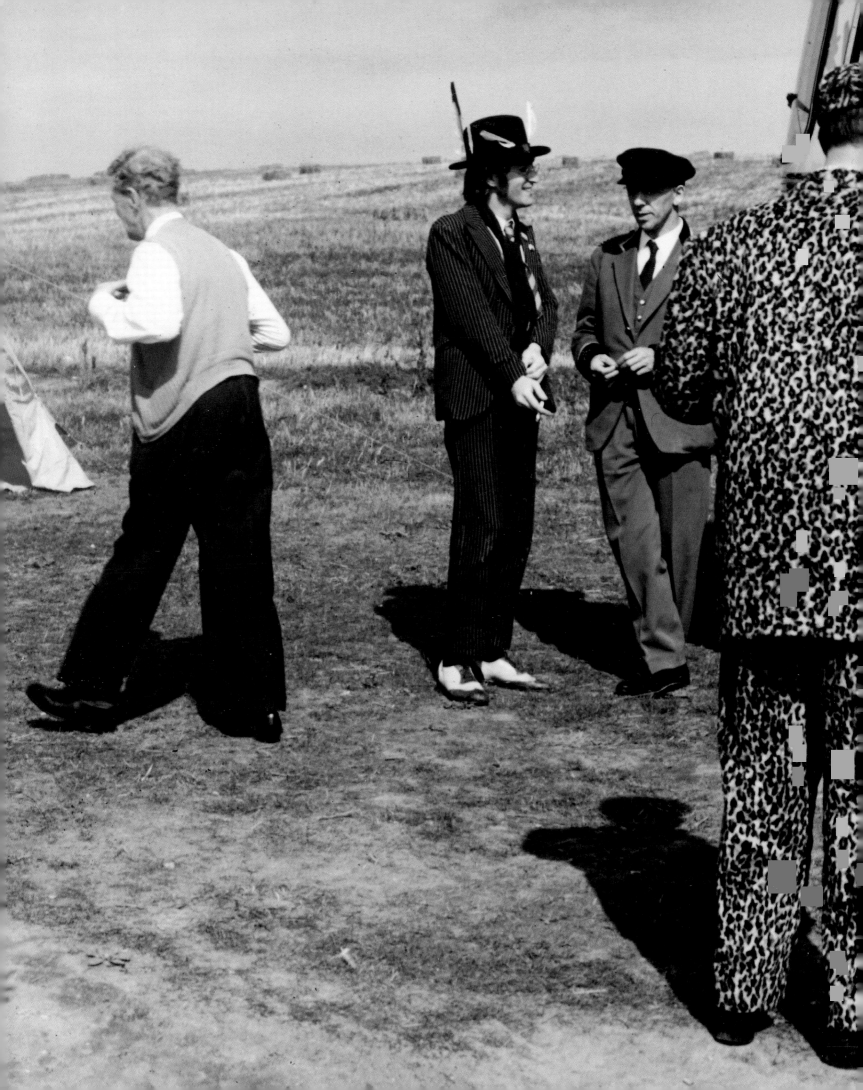

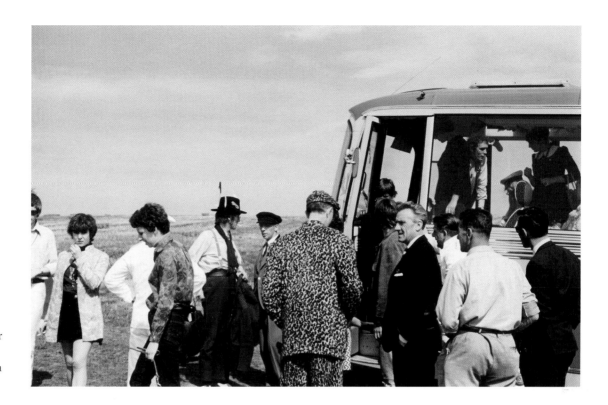

John chats with 'Mr Buster Bloodvessel', played by Ivor Cutler, while everyone stretches their legs between filming and travelling.

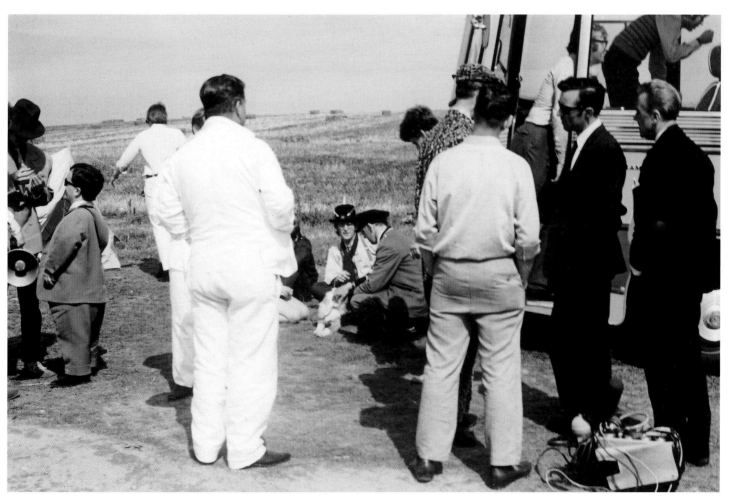

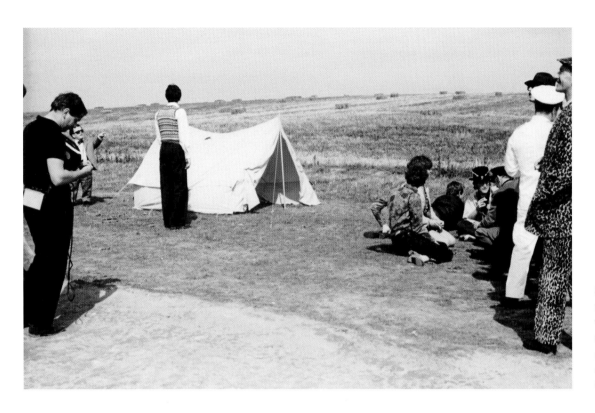

Shooting the scene leading up to 'Blue Jay Way'. The film was cut so that the cast emerged from the tent into a cinema, where they sat down to watch a film of George doing 'Blue Jay Way'.

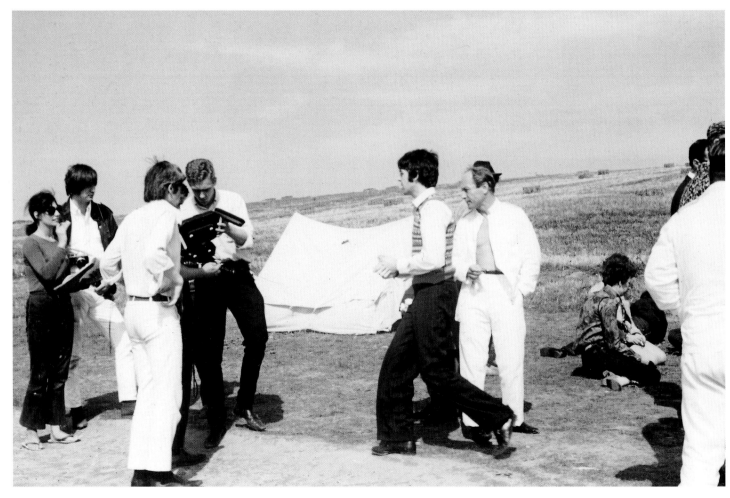

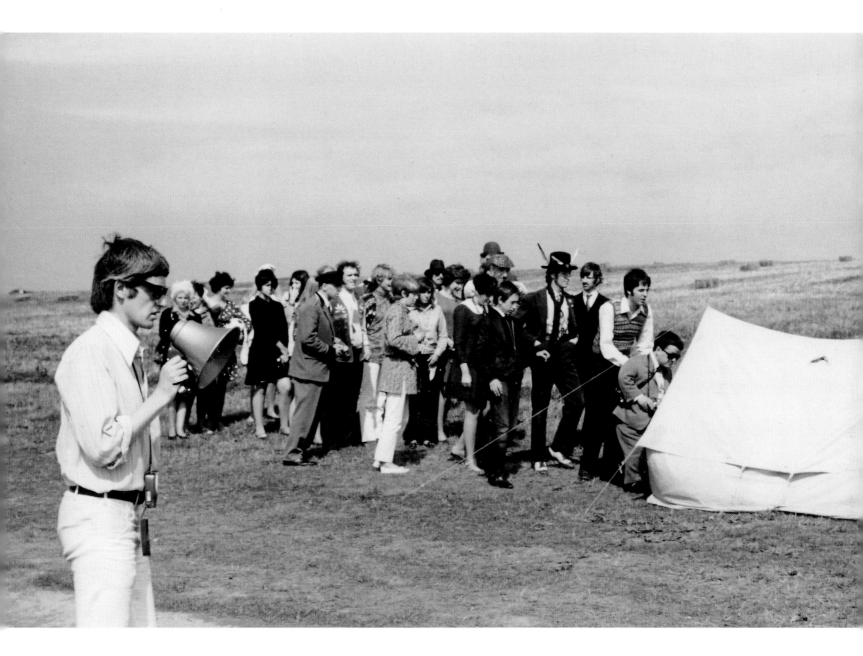

Secrets revealed: shooting the trick sequence where dozens of people appear to magically fit into a small tent and, later, magically all emerge from it.

At West Malling airfield in Kent

'*Magical Mystery Tour* was an incredible idea, and, in fact, changed as we progressed. Basically, the idea was that it took a coach load of people off around the country, and instead of saying, "On your left was such and such a castle," the courier would say this but instead there'd be a freak-out or something else would be happening.'

ALISTAIR TAYLOR

The Beatles' psychedelically decorated cars adorned the airfield. *Left*: John's Rolls Royce parked alongside the Magical Mystery bus in front of a hangar at West Malling (now a new housing development). I went to look at the Rolls at the De Young Museum in San Fransisco; it was later sold. *Above*: The Rolls Royce beside a ladder ready for use in the 'I Am The Walrus' scene. *Right*: George's Mini.

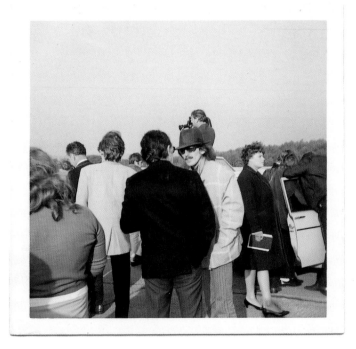
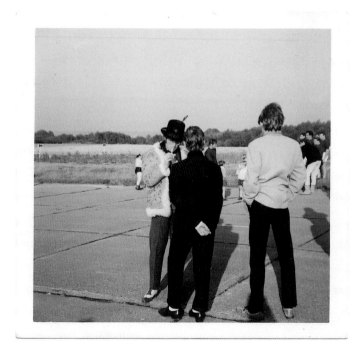

The first Mystery Tour photographs to come up for sale, at Christie's, showed children in a tug-of-war match with Paul at West Malling. I liked their innocence, Paul having a great time with the children while waiting for the next scene to be filmed.

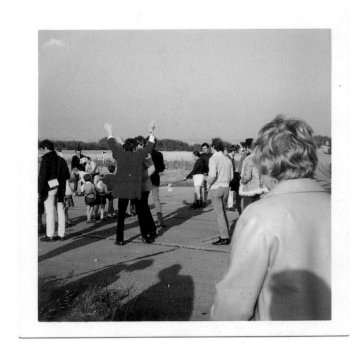

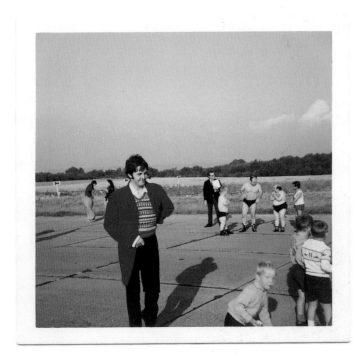 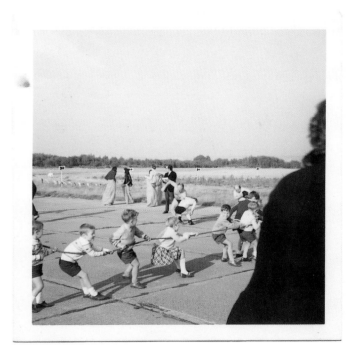

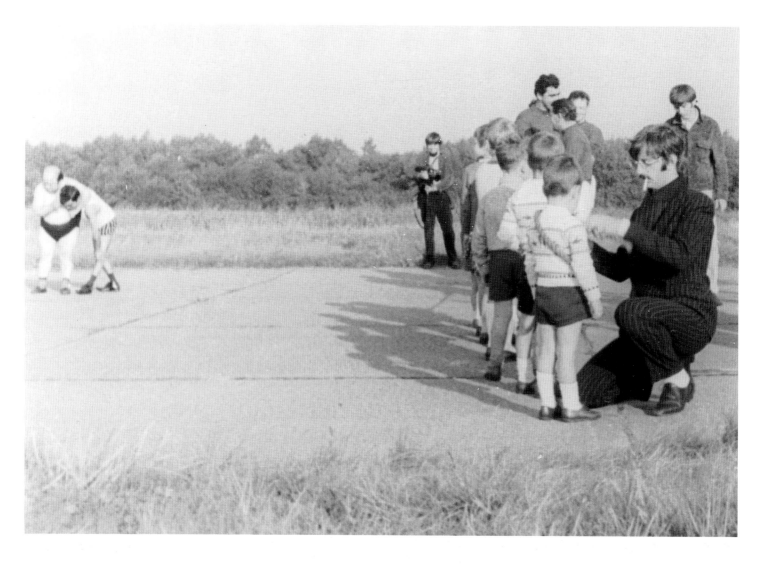

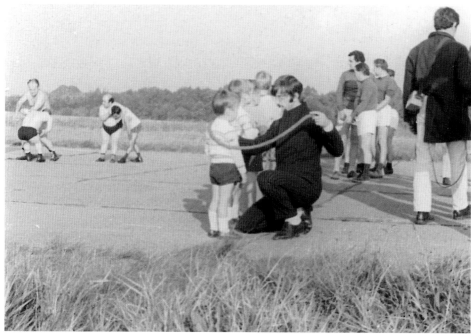

Left and above: A tug-of-war (a future McCartney album title). *Opposite*: Preparing to shoot part of the restaurant dream sequence written by John (*see also* page 258).

The Beatles shoot the 'Magicians' Laboratory' sequence in a West Malling hangar while Mal Evans, dressed in a Flower Power robe, looks on. Our photographer (*see* pages 246–7) can be seen with his back to the camera, standing behind John.

A photographer's tale

Paul Mackernan, now a property lawyer, is the photographer responsible for these great photographs taken in and outside the aircraft hangar at West Malling during filming of the *Magical Mystery Tour*.

'I was twenty years old at the time these photographs were taken,' he remembers. 'I worked at the Birmingham Repertory Theatre, changing backdrops and scenery. My slightly older friend Robin Stubbs was a costume designer for BBC programmes, including at a later date *Only Fools and Horses*. Robin and his wife Jacqui, who was a seamstress, used to drink at The Viking pub in Birmingham. Robin was introduced to the designer at the pub, who requested people to help out on set at the West Malling airfield. Robin suggested I come along to help on the props and to move scenery if required; it made no difference that I didn't have years of experience. So Robin and his wife Jacqui went up in his car, and I with a girl called Stregg in mine. Robin Stubbs turned out to be one of the eggmen in the TV special.'

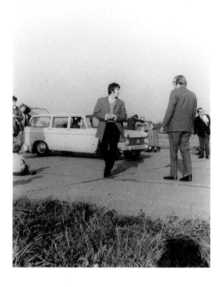

Mackernan found that getting work on the set proved simple enough. 'On arrival at the airfield, I was interviewed for five minutes, then told I had the job for 95 pounds per week plus 35 pounds expenses, a lot of money in those days. I helped to build the staircase featured in many of these photographs, using scaffolding. The balustrade was just as a guide to stop people falling off the edge, it was merely a prop: if you leant against it, it would have collapsed.'

For a short period, the airfield became their world. 'We drove in at 8.00a.m. and out at 7.00p.m. each day and parked on the airfield every day for a total of approximately four weeks. Access to the airfield was surprisingly liberal, but the hangar itself where they filmed the dance sequence had strict access regulations.'

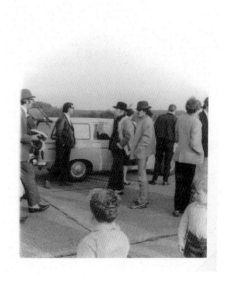

Despite the access controls, there were sometimes unique opportunities for unforgettably direct contact with The Beatles. 'We stayed in a good hotel near the airfield while the Beatles stayed in a country hotel nearby. On one occasion Paul gave me a leg up to get access to the hotel swimming pool, but we were thrown out of the hotel… Another time Ringo borrowed my car, the great Triumph Herald, as he wanted to go around the other side of the airfield.'

By chance, Mackernan even landed a brief part in the film. 'While filming the police scene on top of the 35-foot aircraft baffle (built at a 45-degree angle to dampen the noise of the aircraft) one of the policemen suffered from vertigo, so I was told to take his place. At 5 foot 8½ inches I was the smallest policeman there. I was hurried into the Magical Mystery bus to change into the policeman's costume. Then I had to negotiate climbing up on top of the wall, where we held hands purely to stop us falling off.'

He was also allowed relatively free rein to take pictures. 'While photographing, I was approached by Mal Evans,' he recalls. 'He asked why I was taking photographs, to which I replied, "For my portfolio." Many of the photographs were taken in black and white, purely due to the lack of colour film on sale in West Malling.'

Despite the fond memories, he eventually decided to part with the pictures. 'I came to sell these photographs as there was a Beatle convention held once a year at the Connaught Hotel in Wolverhampton. I decided to show these to dealers and, after being pestered over several phone calls and several years, I decided to sell them. Then Mark Hayward purchased these from the chap I sold them to with copyright.'

But the magic lure of The Beatles and his connection with them has never left Paul Mackernan. 'I have on my wall a set of cigarette cards of every film The Beatles produced, given to me by my sons – at great expense, I'm told. My children are all Beatle fans now, stating that their dad was a Beatle groupie.'

Below: Stregg (*left and centre*) and Jacqui (*right*) watch the filming with interest. Mackernan was allowed to take personal snapshots to his heart's content.

During shooting for the
'I Am The Walrus' sequence,
Paul Mackernan helps Mal
Evans adjust the height of
the cymbal.

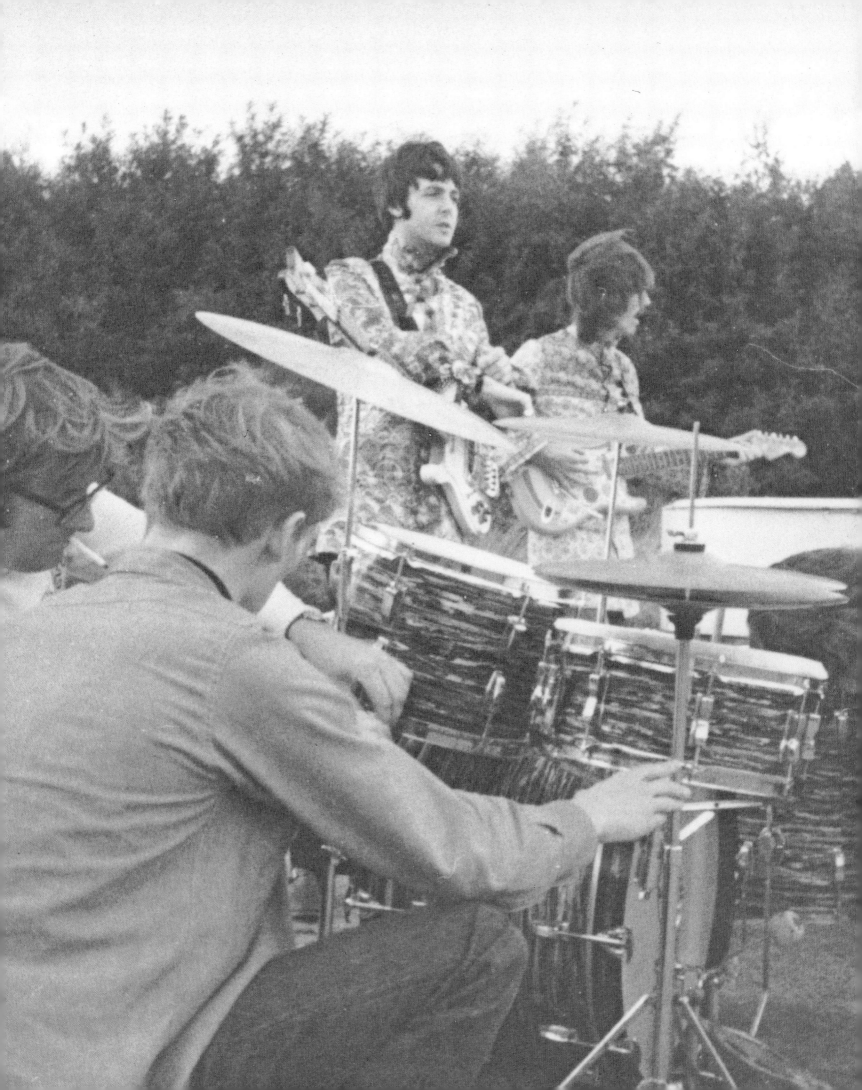

The 35-foot-high aircraft baffle (wall) in the background and right gave our photographer Paul Mackernan (*seen top left and above*) the opportunity to be in the film, thanks to one actor's vertigo.

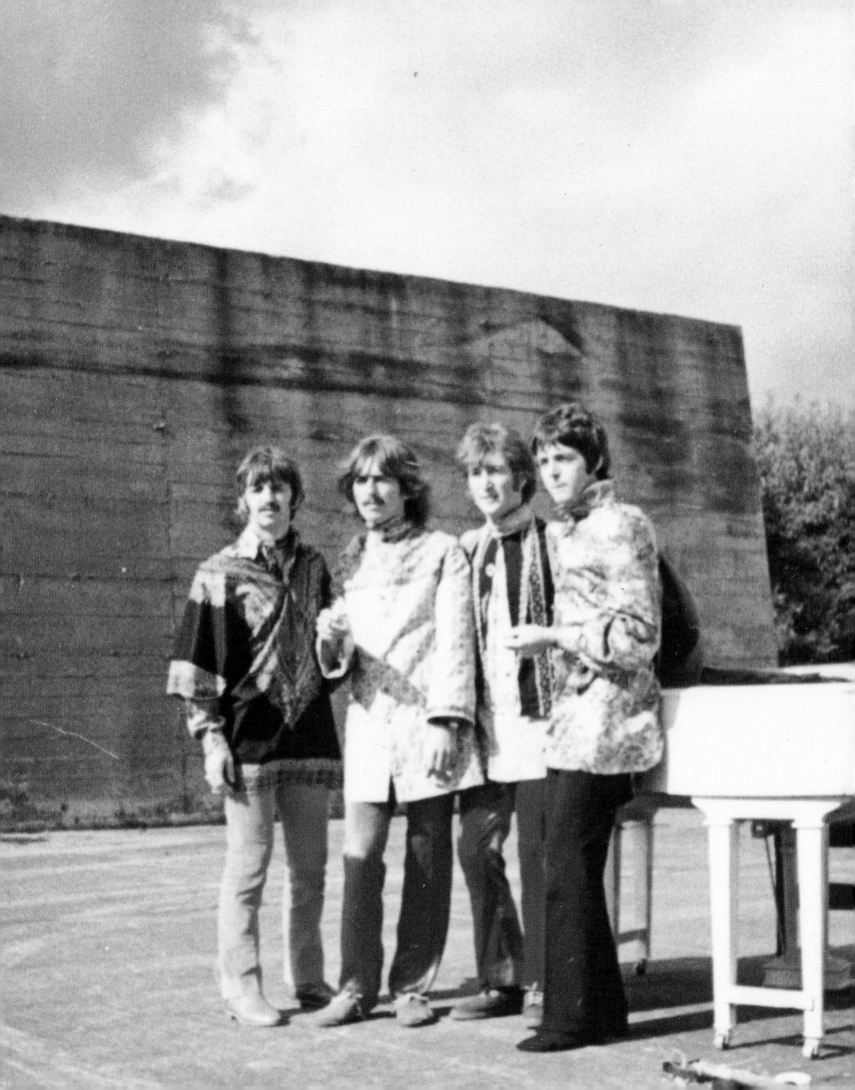

Shooting the sequence for
'I Am The Walrus'.

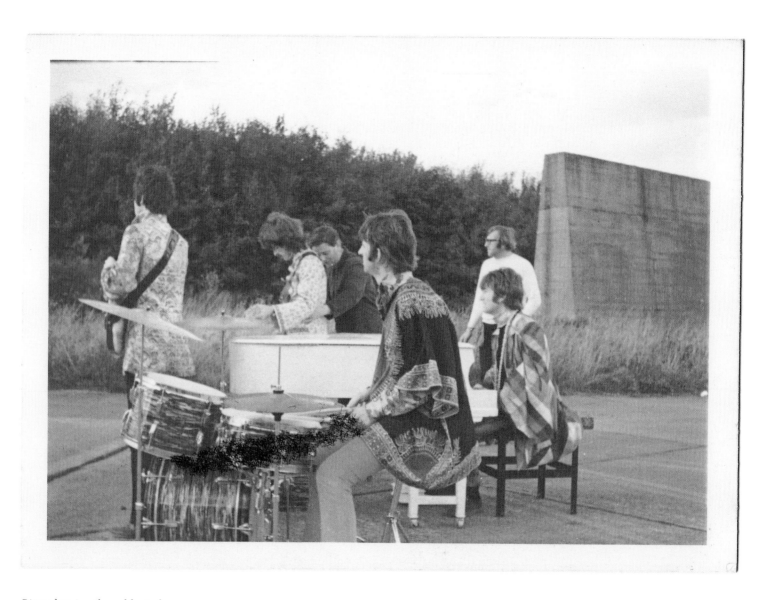

Ringo braving the cold wind
blowing across the airfield
while playing drums.

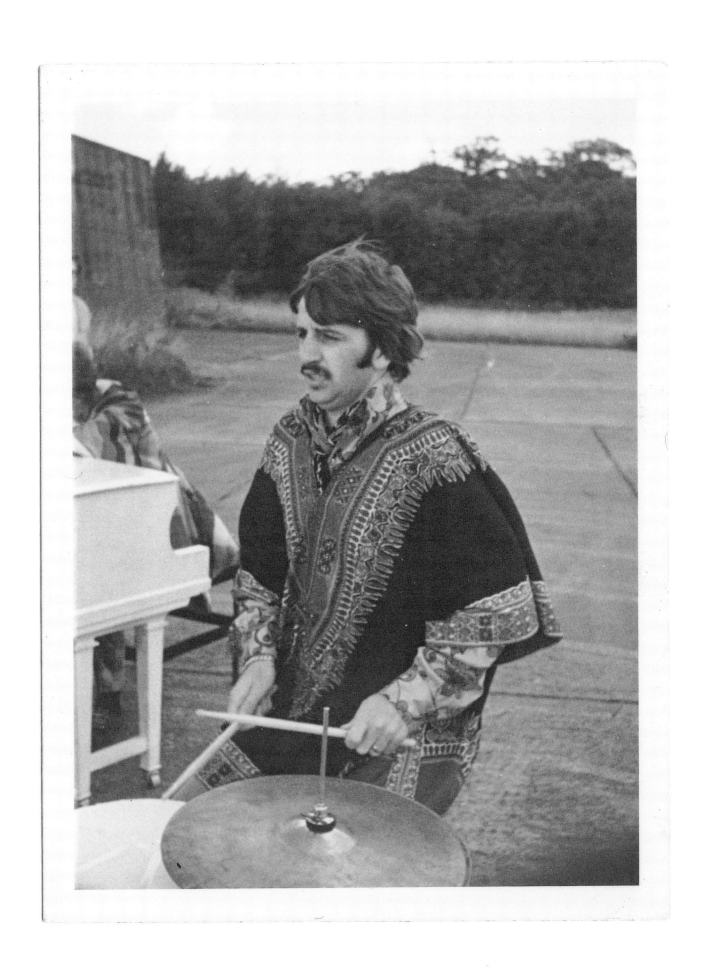

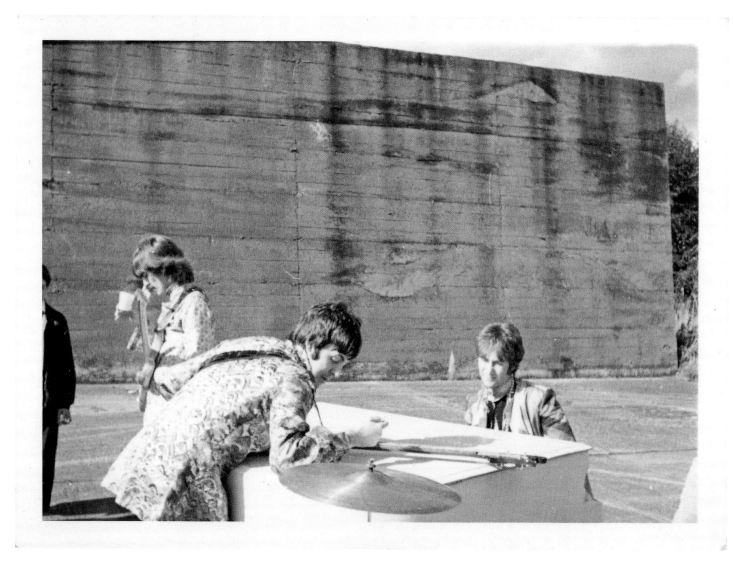

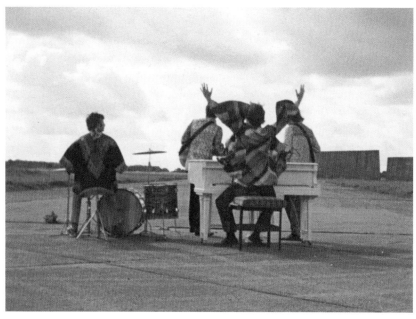

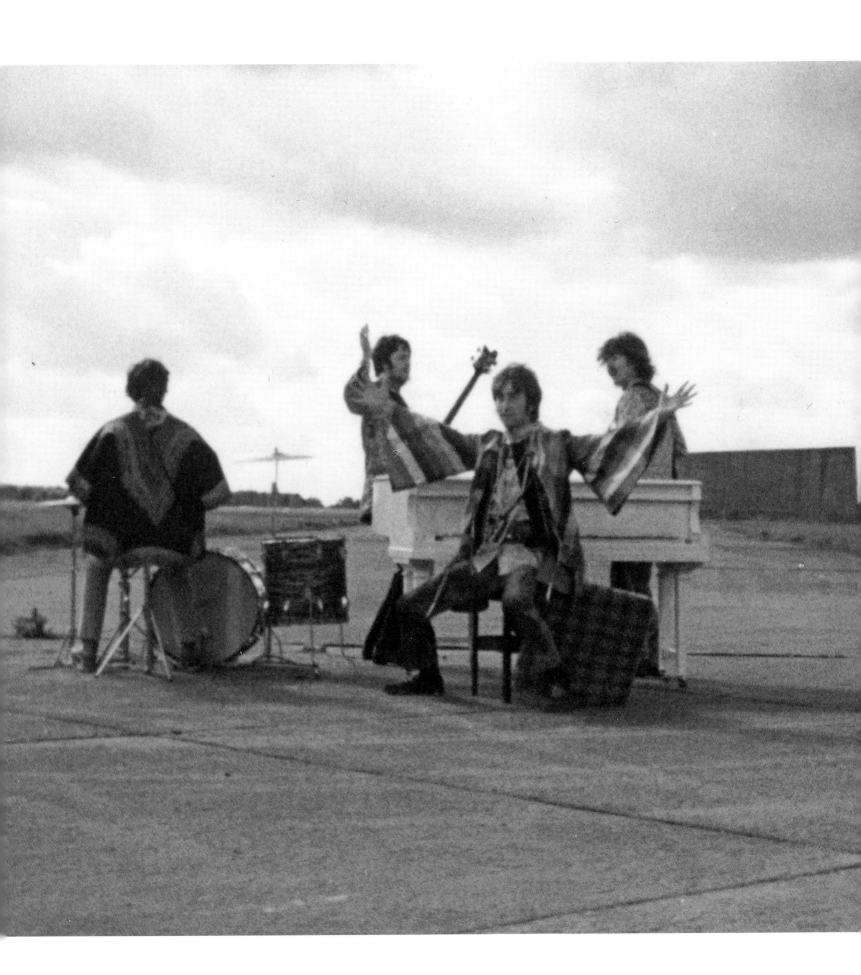

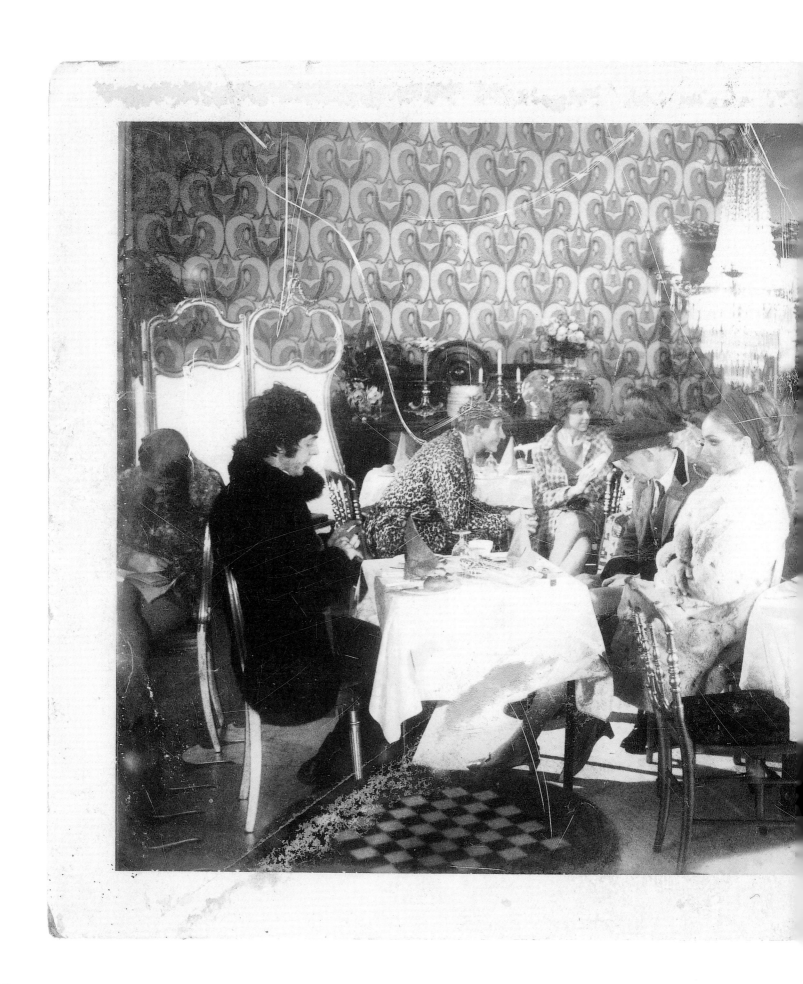

This rare photo (*left*) was taken on a Polaroid, one of the first cameras to develop a photo within one minute. Polaroid photos would scratch easily, as can be seen on this shot of the restauraunt scene.

Above: The empty hangar before filmimg started, featuring the long and winding staircase.

Filming the 'Your Mother
Should Know' sequence,
the movie's grand finale.
24 September 1967.

The Beatles salute as the dancing team walk gracefully down the hastily built staircase in the film's final sequence.

It is a complex task to film so many people in such an enclosed environment. While filming 'Your Mother Should Know', several takes were required in a limited time in order to keep to the tight budget.

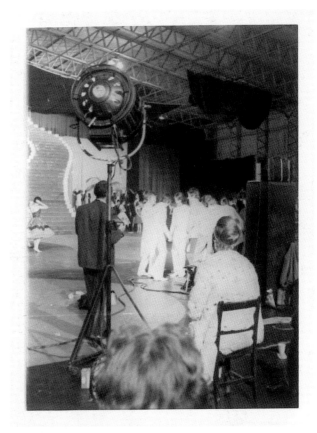

This marvellous sequence
was photographed in black
and white because the local
shops had no colour film in
stock. What a shame!

New beginnings

On 7 December 1967, while *Magical Mystery Tour* was being prepared for its television debut, The Beatles began their foray into retail management by opening their 'Apple' boutique in London. They chose a location at 94 Baker Street, an eighteenth-century corner block situated a stone's throw away from the fictional home of the world-famous crime sleuth Sherlock Holmes.

December 26, the day after Paul and Jane Asher's Christmas Day announcement of their long-anticipated engagement, saw the BBC1 television premiere (at a cost of £10,000) of the *Magical Mystery Tour* film. It attracted an astonishing twenty million viewers. But unfortunately, this highly colourful movie made its small-screen debut on BBC1 in glorious... black and white! Critics and viewers alike were united in their judgement of The Beatles' first self-conceived, self-financed film. They didn't like it. Perhaps unsurprisingly, the various media critics immediately started falling over themselves to be the first to give The Beatles and *Magical Mystery Tour* a hammering in the newspapers.

Negative feedback

James Thomas of the *Daily Express* opined, 'The bigger they are, the harder they fall. And what a fall it was... The whole boring saga confirmed a long-held suspicion of mine that The Beatles are four rather pleasant young men who have made so much money that they can apparently afford to be contemptuous of the public.' James Green, the TV critic for the *Evening News*, remarked, 'It's a long day's night since any TV show took the hammering that this Beatles fantasy received by telephone and in print. Take your pick from the words, "Rubbish, piffle, chaotic, flop, tasteless, non-sense, emptiness and appalling!" I watched it. There was precious little magic and the only mystery was how the BBC came to buy it.'

Meanwhile, Douglas Marlborough of the *Daily Mail* wrote, 'Protests from viewers about The Beatles' *Magical Mystery Tour* flooded the switchboard at the BBC Television Centre last night. Mystified viewers also phoned the *Daily Mail*. The TV critic Peter Black gave his verdict as "Appalling!". BBC TV chiefs will almost certainly hold an inquest on the show at their next programme review meeting next Wednesday. But, as criticism poured in, BBC executives were quick to emphasize last night, "The Beatles made the film – not the BBC!" One caller to the *Daily Mail* said, "It was terrible! It was worse than terrible. I watched it in a room together with twenty-five other people, and we were all stunned!"'

The Beatles respond to the critics

Not surprisingly, Paul was swift to defend the film. 'The thing is, there was a couple of main things that were really hashed up about the film,' he said in one newspaper interview. 'One was we made it in colour and it was put out, first of all, on BBC1 in black and white. There were whole big sequences that you just couldn't understand. I saw it on the telly and it just looked mad in black and white, because there were sequences where the colours changed. So that was a bit daft. I think it was put on the TV at the wrong time. Everyone was expecting a sort of Christmas extravaganza and instead they got this mad film. I think, in about ten years' time, it's gonna be one of those films that you will say, "Let's have a look at that again." It will be like another *Rock Around The Clock*. But I like it. I still think it's great!'

John was also in agreement. 'I loved it', he remarked, 'because it was a trip, you know. Everyone was down on it, but it was all right. But the thing is, there was too much "nothing happening". There was "nothing happening at all" in some scenes. But there were nice moments, like the dream sequence, the "Your Mother Should Know" sequence, you know, coming down with those silly suits on. But they [the critics] were gunning for us before that. What the BBC, stupid idiots, did was show it in black and white. Can you imagine? It doesn't look well in black and white. In colour you can just about manage it.'

But just days later, Paul was forced to climb down and, in an interview for the *Daily Mail*, he admitted that the film was a mistake. 'We thought people would understand that it was "magical" and a "mystery tour",' he announced. 'We thought that the title was explanation enough. There was no plot and it was formless. Deliberately so. We enjoy fantasy and were trying to create this. Perhaps we should have had someone say, "We are going magical now, folks!" We did not and the trouble is, if people don't understand, they say, "A load of rubbish," and switch off. We learned a lot and it was not such a bad thing that we were slated. But was the film really so bad compared with the rest of the Christmas TV? Frankie Howerd and Bruce Forsyth's show on ITV on Saturday just wasn't funny! And you could hardly call the Queen's speech a gasser!'

The year ended with more Beatles chart success as their latest single, 'Hello, Goodbye' was in the number one position in listings all over the world. However, due to their badly received *Magical Mystery Tour* film, for the first time in their careers, The Beatles had suddenly become unpopular with the British public. Strange days indeed…

'It just looked mad in black and white, because there were sequences where the colours changed.'

PAUL McCARTNEY

The Beatle belt

These photographs, taken from Janet Crawford's album, bought at Sotheby's in London, feature Beatle homes in what is now the Surrey commuter belt, before the city set moved in. The ease of access by fans to John's house and George's bungalow is extraordinary by today's standards: no one could take casual photos of a pop star's children in their driveway nowadays without being warned off by a security guard. It is in marked contrast too with the last years of George's life in a secluded manor house, where an intruder proved to be not a fan but a threat to life and limb.

MARK HAYWARD

Fan Janet Crawford and her friend take it in turns to pose outside George's bungalow in Esher, Surrey.

These very unusual shots feature George with Rolling Stone Brian Jones and his girlfriend Anita Pallenberg, standing by George's swimming pool in 1967, eighteen months before Brian was found drowned in his own pool: a unique piece of history. The shots were bought at Sotheby's in New Bond Street, undoubtedly the grandest venue to purchase rock 'n' pop memorabilia.

A young Julian Lennon,
John and Cynthia's son,
learning to ride a bicycle.

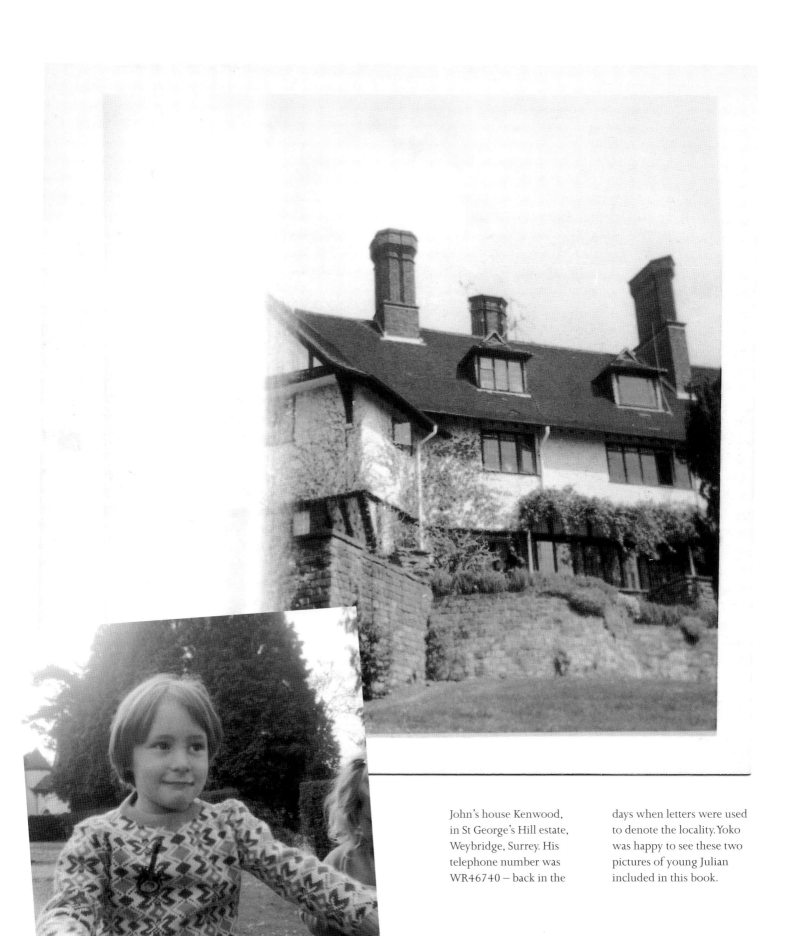

John's house Kenwood, in St George's Hill estate, Weybridge, Surrey. His telephone number was WR46740 – back in the days when letters were used to denote the locality. Yoko was happy to see these two pictures of young Julian included in this book.

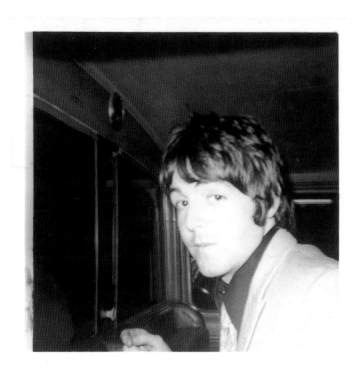

This page: Paul steps out of
a taxi. *Opposite:* With The
Beatles' genial roadie,
'gentle giant' Mal Evans.

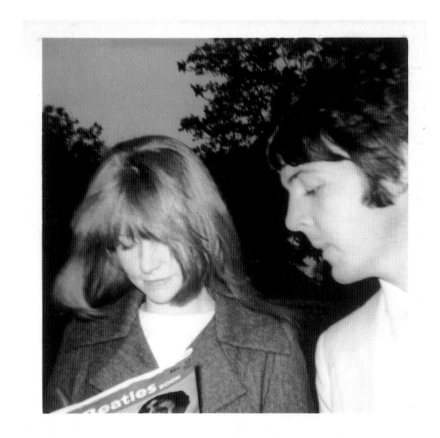

Paul and girlfriend Jane Asher outside his home in Cavendish Avenue, St John's Wood, London. Jane later became well known in her own right as a serious actress. *Left, below*: Jane reads *Beatles Monthly* magazine while Paul looks over her shoulder.

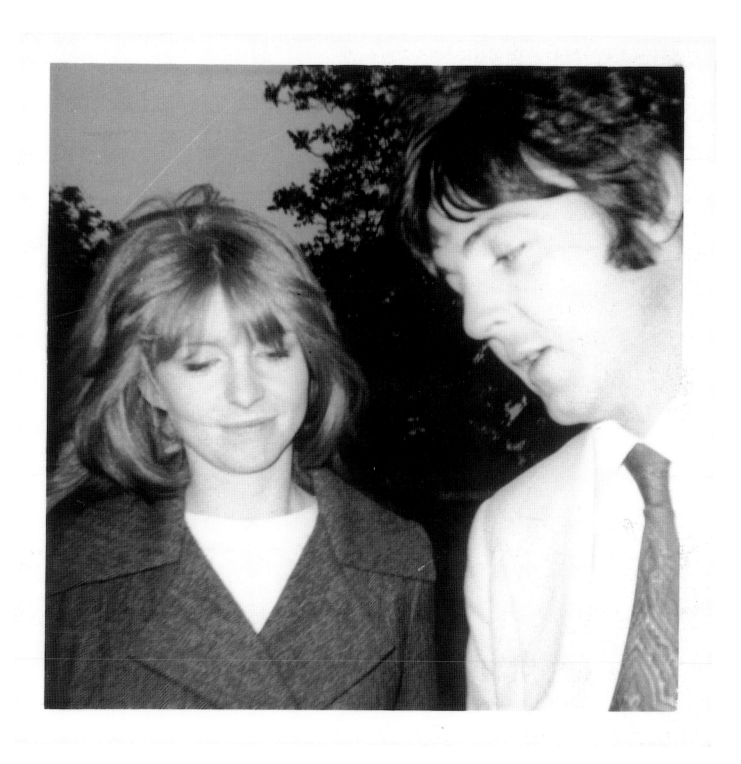

London summer

An unusual sequence of photos taken with a fish-eye lens. *Above*: John plays banjo while Neil Aspinall reads in the background. 1967.

Paul with his old English
sheepdog, Martha,
inspiration for the song
'Martha My Dear'.

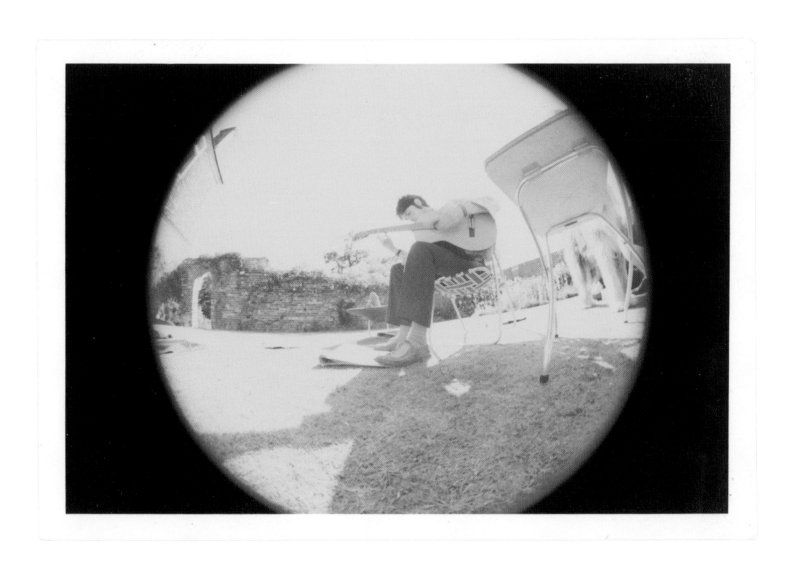

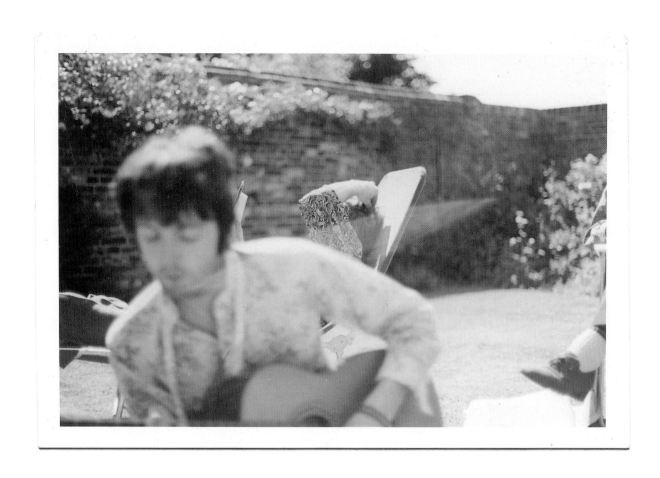

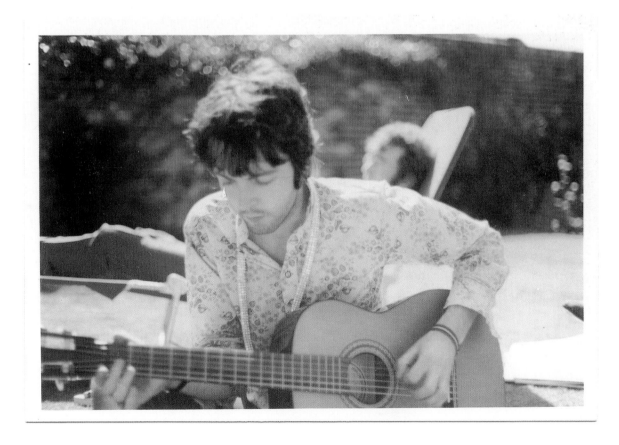

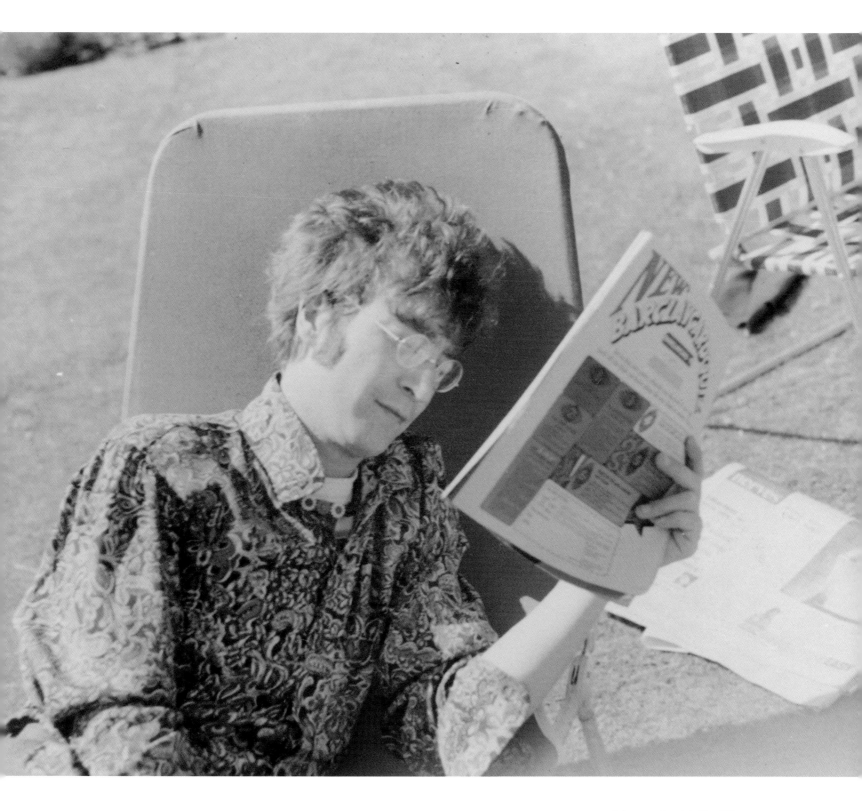

John sporting his *How I Won The War* haircut takes time out to read while Paul tries a few chords.

Photos taken by a fan
outside Abbey Road Studios
(also known as EMI Studios
after the record label) in
London in June 1968,
during sessions for what
became the *White Album*.

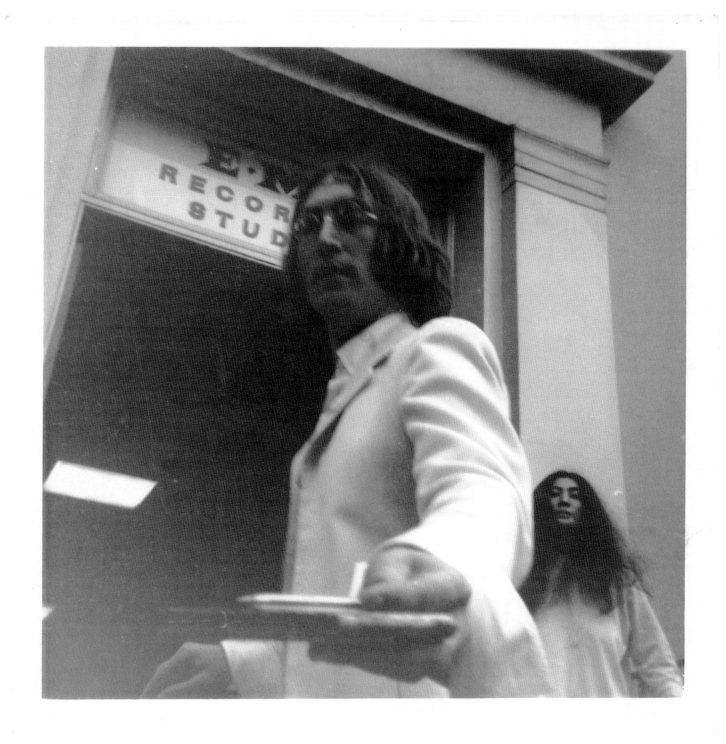

John hands back an
autograph book to a fan,
while Yoko Ono looks on.

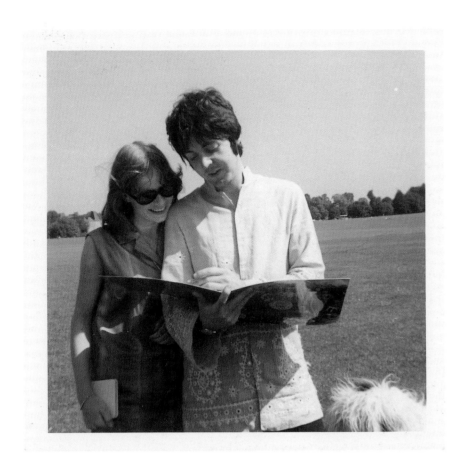

On Primrose Hill in London. *Left*: Paul signs a *Sgt Pepper* album sleeve for a fan; if the sleeve were to appear at auction nowadays, it would be extremely valuable. *Right*: Paul and his dog Martha.

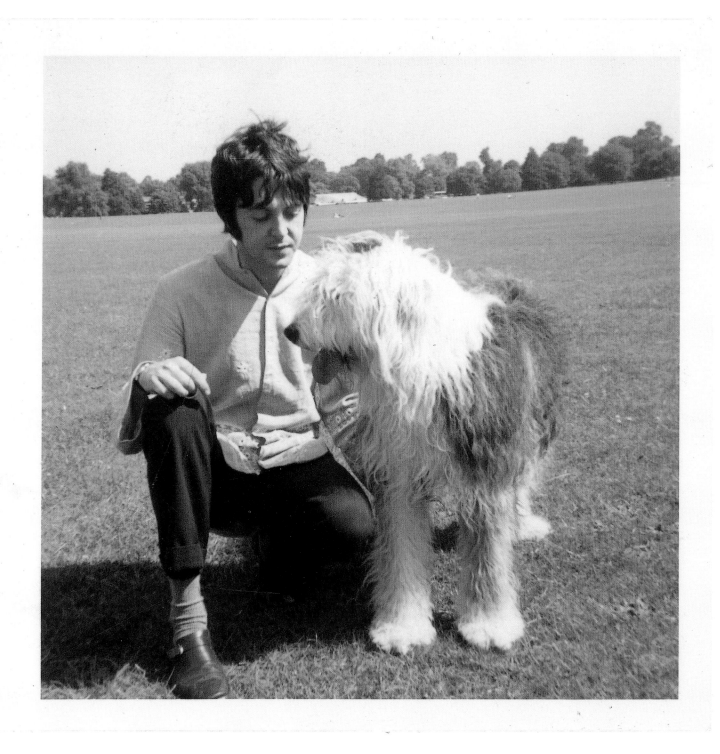

The Apple business

For The Beatles, business seemed the most operative word for 1968. The 'Apple' shop in Baker Street was up and running, and plans to launch a record label bearing this moniker were now formulating in the group's minds. As the new year swung in, their latest single, 'Hello, Goodbye', was still in the top slot of most of the world's singles listings. For George, meanwhile, the opening week of 1968 saw him flying off to Bombay, India for soundtrack work at EMI's studios for the movie *Wonderwall*. The five days of session work also produced recordings for his track 'Untitled', the working title for the sitar-flavoured track 'The Inner Light', ultimately to appear as the B-side of The Beatles' next single, 'Lady Madonna'. George returned to London on January 17, five days before the group opened the doors of their first Apple Corps office, at 95 Wigmore Street in Marylebone, London.

Setting up the label

The formation of Apple Records was underway. 'Paul said, "Right, let's have a record label,"' The Beatles' assistant and Mr Fix-It, Alistair Taylor, recalled. 'They had heard about this American guy called Ron Kass, who was a big record man, and Paul found out that he was passing through London, through London Airport, one day, on his way to LA. So, Paul rang him, and asked him to stop over and have some lunch. So Paul and myself went out to the airport to meet this guy off the plane and we went to lunch. And there and then, over the lunch table, Paul offered him the job of head of Apple Records.'

Jane Asher's brother, Peter, one half of the popular singing duo Peter & Gordon, was also hired for the label. 'Paul was round at my house one day, and he asked me if I would like to produce some records for Apple, and I, naturally, said yes,' Peter Asher remembered. 'The next day, he called up and said, "Well, why don't you become the head of A & R [Artists & Repertoire]," and I said, "Sure, great. I would love to." This was the way that Apple was being set up at the time. The only other person appointed to the Apple Records in any capacity was The Beatles' roadie and close friend Mal Evans, who was appointed as general manager.'

Years later, Mal Evans remembered how the label came to be set up. 'When Apple was starting to get together', he recalled, 'we all had a meeting and Paul said to me, "What are you doing, Mal?" And I said, "Well, not much at the moment, 'cos I'm not working." So, he said, "Right, you're going to be president of Apple Records." I thought, "Great, but what does a managing director do? He's got to be groovy and go out and find talent for the label." So I found this group called The Iveys, which turned into Badfinger, another signing for the label.'

Across The Universe

On February 4 at Abbey Road, during the recordings for John's 'Across The Universe', an unprecedented event in Beatles history took place when John and Paul decided that falsetto harmonies were required for the track. The seventeen-year-old Londoner Gayleen Pease and the sixteen-year-old, Brazilian-born Lizzie Bravo, two Beatles fans who had been waiting patiently outside the EMI building, provided them. 'I liked "Across The Universe",' John admitted. 'It was one of the best lyrics I'd written. In fact, it could be the best, it's good poetry, or whatever you call it. It's a poem, you know.' He later revealed that the song was influenced by the bedtime ramblings of his wife, Cynthia. 'I was lying next to me first wife in bed and I was irritated. She must have been going on and on about something. She'd gone to sleep but I'd kept hearing her words over and over, flowing like an endless stream. So I went downstairs and it turned into a sort of cosmic song rather than an irritated song. It drove me out of bed. I didn't want to write it, I was just slightly irritable and I went downstairs and I couldn't get to sleep until I put it on paper, and then I went to sleep.' But unfortunately, John wasn't happy with the first version The Beatles recorded. 'They didn't make a good record of it. I think, subconsciously, sometimes, we, I say 'we' though I think Paul did it more than the rest of us, Paul would, sort of, subconsciously, try and destroy a great song. It was a lousy track of a great song and I was so disappointed by it. I ended up giving it to the Wildlife Fund of Great Britain charity album.'

The first biography

On February 9, *The Times* in London proudly announced, 'The first "authorized" life of The Beatles is complete and will be published by Heinemann in September.' The piece continued, 'It is, unsurprisingly, by Hunter Davies, who is thirty-two and says he has spent "every spare second of the last fourteen months thinking and dreaming of it". He has filled many hours and notebooks with their conversation, followed their tracks to America and Hamburg, interviewed all The Beatles' parents, and, I gather, had the files of EMI thrown open to him by Sir Joseph Lockwood [of EMI].' The report concluded by saying, 'Mr Davies is remembered for recently having failed to see any warts on The Beatles' first TV film, *Magical Mystery Tour*… unlike almost all the critics and letter writers.'

'It's good poetry, or whatever you call it. It's a poem, you know.'

JOHN LENNON

Meditation break

The Beatles' enthusiasm to develop their current interest in meditation saw the group eagerly accept an invitation to join their guru, the Maharishi Mahesh Yogi, at his transcendental meditation camp in Rishikesh, India. John, George, respective wives, Jenny, Patti's youngest sister, and friend 'Magic' Alex flew out on February 15, and Paul, Ringo and their partners joined them on February 19. On the second flight over, the two Beatles got into the mood of things by deciding to become vegetarians.

But expectations of the visit to India were not high. During the first flight, George remarked to his fellow passengers that he expected the transcendental meditation centre to be something like a 'Billy Butlin holiday camp'! While others, like John's wife Cynthia, had a different take on the visit. 'It would be a time for us all to drop out for a while,' she remarked years later. 'The years of fame and fortune had taken their toll on our nerves and minds.' A fellow traveller to India was another sixties chart star, the singer Donovan. He remembered the holiday as 'a chance to meet The Beatles on a level far away from pop music. It was quite a unique experience to be able to shut ourselves off from everything that was going on. The press was waiting outside [the camp] but inside the compound it was great. I got a chance to learn and play and hang out with the musicians that I was very impressed by. We were all able to lay back and relax. We played music and George experimented with Indian instruments that were brought in.'

However, on February 29, only ten days after they had arrived, Ringo and Maureen's great journey of discovery concluded when they returned home to England. 'We didn't come home early. We never planned to be away from the children for more than a couple of weeks,' Ringo told the UK music press just days after his return. 'I thoroughly enjoyed the visit and so did my wife.' But John's wife Cynthia had other views. 'Unfortunately, Maureen couldn't stand the flies and insects, or the food. Ringo's stomach was weak from many operations as a child.'

Two weeks later, in the UK, EMI released the next Beatles single, 'Lady Madonna', a song based on Humphrey Lyttleton's 1956 hit 'Bad Penny Blues'. The US release followed soon afterwards and by April 8, 'Lady Madonna' had sold enough copies for it to be awarded a Gold disc.

On March 26, Paul and Jane Asher were the next to return home from India. For those of the group who were still in the subcontinent, all was not well. 'There was this big hullabaloo about him [the Maharishi] trying to rape Mia Farrow [the actress] or somebody trying to get off with a few other women and things like that,' John recalled in an interview for *Rolling Stone*. 'We went to see him after we stayed up all night discussing was it true or not true. When George started thinking it might be true, I thought, "Well, it must be true, because if George started thinking it might be true, there must be something in it." So we went to see the Maharishi, the whole gang of us, the next day. We charged down to his hut, his bungalow, and, as usual, when the dirty work came, I was the spokesman, and I said, "We're leaving." "Why?" he asked, and I said, "Well, if you're so cosmic, you'll know why!" He said, "I don't know why. You must tell me,"

'The years of fame and fortune had taken their toll on our nerves and minds.'
CYNTHIA LENNON

and I just kept saying, "You ought to know," and he gave me a look like, "I'll kill you, you bastard." I knew then I had called his bluff and I was a bit rough to him.'

As a result, on April 20, John, Cynthia, George, Patti and 'Magic' Alex rounded off the exodus. Just days later, when the Beatles entourage was safely back home, it was announced the group had not received the diplomas they thought they'd earned, which would have credited them as 'gurus'. Apparently, they did not pass the three mandatory tests of the Maharishi's Academy of Transcendental Meditation. The Beatles showed little concern. Their flirtation with the Maharishi Mahesh Yogi was over.

Apple in the Big Apple

Five months after the 'Apple' boutique had opened in London's Baker Street, on May 8, it was announced that the syndicates of the Portman Estate, landlords of that part of London, had warned The Beatles that they would have to erase the brightly coloured psychedelic paintings on the walls outside their shop. Bowing to pressure, the beautiful decoration, provided by the Dutch artists The Fool, was reluctantly painted over.

Just three days after the warning about the Apple mural, John and Paul flew to New York to promote Apple Corps. They took up residence at 181 East 73rd St, New York, the residence of their lawyer, Nat Weiss, and held a press conference at the Americana Hotel in New York's Central Park, an event attended by two hundred of the nation's media. During the conference, John and Paul spoke enthusiastically about their new record label and announced that they had ended their relationships with the Maharishi.

The two Beatles held their first Apple Corps board meeting on May 12, in a Chinese junk sailing around New York's Statue of Liberty. Their promotional activities continued on May 15 when John and Paul taped a less-than-spectacular appearance on the prestigious late-night TV programme *The Tonight Show*. The show's regular host, Johnny Carson, was away. A temporary host, the American baseball player Joe Garagiola, had replaced him. 'It was terrible,' John recalled. 'There was a baseball player hosting the show, and they didn't tell us. He was asking, "Which one's Ringo?" And all that shit! You go on the Johnny Carson show, and when you get there, there's this sort of football player, who doesn't know anything about you, and Tallulah Bankhead [the actress, another on the show that evening] was pissed out of her head, saying how beautiful we were. It was the most embarrassing thing I've ever been on.' During their stay in the Big Apple, Paul met up again with the American photographer Linda Eastman.

John entertains Yoko

On May 19, just days after returning from America, and with his wife Cynthia away on a short holiday, John took the opportunity to invite the Japanese artist Yoko Ono over to his home in Kenwood, to hear some experimental sound tapes. 'When I got back from India', John remembered, 'we were talking to each other on the phone. I called her over, it was the middle of the night and I thought, "Well, now's the time if I'm gonna get to know her any more." She came to the house and I didn't know what to do; so we went

upstairs to my studio and I played her all the tapes that I had made... all this far-out stuff of mine, and some electronic music. She was suitably impressed and then she said, "Well, let's make one ourselves," so we made "Two Virgins". It was midnight when we started "Two Virgins", and it was dawn when we finished, and then we made love at dawn. It was very beautiful.'

Three days later, John joined George at a lunchtime party for friends and the press to celebrate the opening of their new premises, Apple Tailoring (Civil and Theatrical), a shop situated at 161 King's Road, London. It was John and Yoko's first public appearance together. 'I had never known love like this before,' John freely admitted. 'It hit me so hard that I had to halt my marriage to Cynthia. My marriage to Cynthia was not unhappy. But it was just a normal marital state where nothing happened and which we continued to sustain. You sustain it until you meet someone who suddenly sets you alight. With Yoko I really knew love for the first time. Our attraction for each other was a mental one, but it happened psychically too... I just realized that she knew everything I knew and more, probably, and that it was coming out of a woman's head. It just bowled me over. It was like finding gold, or something. As she was talking to me, I would get high, and the discussions would get to such a level that I would be going higher and higher. When she would leave, I'd go back to this sort of suburbia. Then I'd meet her again, and me head would go open like I was on an acid trip.'

White Album

A week after the Apple Tailoring (Civil and Theatrical) shop had opened to the public, on May 30, The Beatles returned to EMI's Abbey Road Studios, to begin work on their new album, ultimately to be called *The Beatles* (or the *White Album* as it became affectionately known). Most of the songs recorded for the disc were written in India earlier in the year. 'The entire *White Album* was written in India while we were supposedly giving money to the Maharishi, which we never did,' John admitted. 'We got our mantra, we sat in the mountains eating lousy vegetarian food and writing all these songs. We wrote tons of songs in India.' In another interview at the time, John announced that he 'wasn't interested in following up *Sgt Pepper*. I didn't know whether the others were or not, but what I was going for was to forget *Sgt Pepper*. That was *Sgt Pepper* and that's all right. But it was over! I wanted to get back to basic music and not try and string everything together and pretend it was a show.'

In complete contrast to the overwhelming blaze of psychedelic colour that was *Sergeant Pepper*, the design of the *White Album* foreshadowed the minimalism of future decades. The album cover was simply white, with The Beatles' name embossed in white and a limited-edition number on the bottom right of the front cover. At the time, all shops, clothes and furniture were in the bright colours that epitomized the joyous sixties. The Beatles were ahead of their day yet again. It was a stroke of genius to present an album in stark white, with no colour at all, black inner sleeves, a poster and just four colour photos, one of each Beatle, which fans could stick on their walls to remind

'We got our mantra, we sat in the mountains eating lousy vegetarian food and writing all these songs.'
JOHN LENNON

everyone in the world that the Beatles were still the masters of the recorded album even though they had retired from touring.

The original plan for the album cover was in fact to have the four Beatles' faces carved in a rock face, emulating those of the US presidents at Mount Rushmore, South Dakota. Some prototypes were made and a few proofs showing the cover escaped, but very few survived.

The Beatles' *White Album* was released on their own Apple label in mono and stereo with a few export copies (albums manufactured in the UK but destined for South Africa, Scandinavia and a few other territories, pressed on the black-and-yellow Parlophone label). The early editions of the *White Album* on Apple records were produced in very restricted numbers and given to executives or people who worked on the album. Double albums were not commonplace in those days, and are still rare today; the decision to make the *White Album* a double one provoked both criticism and acclaim.

Recordings started with the slow version of John's 'Revolution', ultimately retitled 'Revolution 1'. As before, George Martin was the producer at the sessions, which continued intermittently until October 18 and would produce many classic tracks, such as John's 'Dear Prudence', Paul's 'Back In The USSR', George's 'While My Guitar Gently Weeps' and Ringo's 'Don't Pass Me By', which became the first Richard Starkey composition recorded by the group.

John's new companion, Yoko Ono, was an unexpected visitor at the sessions (*see* page 287). A technician during the recordings of the *White Album* recalled, 'Yoko had her bed moved into the EMI studios, though she wasn't confined to it. She would follow John everywhere, even to the men's room. Paul and George gawped and let their opinions be known none too subtly. Yoko wanted to be one of the boys and participate with her new beau's buddies.' Beatles producer George Martin added, 'I remember Yoko fell ill and John insisted on bringing Yoko into the studio in her bed while we were recording. That kind of thing doesn't make for an easy relationship with the other Beatles, or with anyone, to have the wife of one of the members lying ill while you're making a record.' Above Yoko's bed, which had arrived from Harrods, was a microphone, placed there in case she wanted to make a comment during the recordings.

On June 7, sessions for the new album come to a halt when George flew out to Los Angeles to film an appearance for the new Apple-financed Ravi Shankar film Raga, and Paul travelled to North Wales to attend the wedding of his brother, Mike.

White wedding

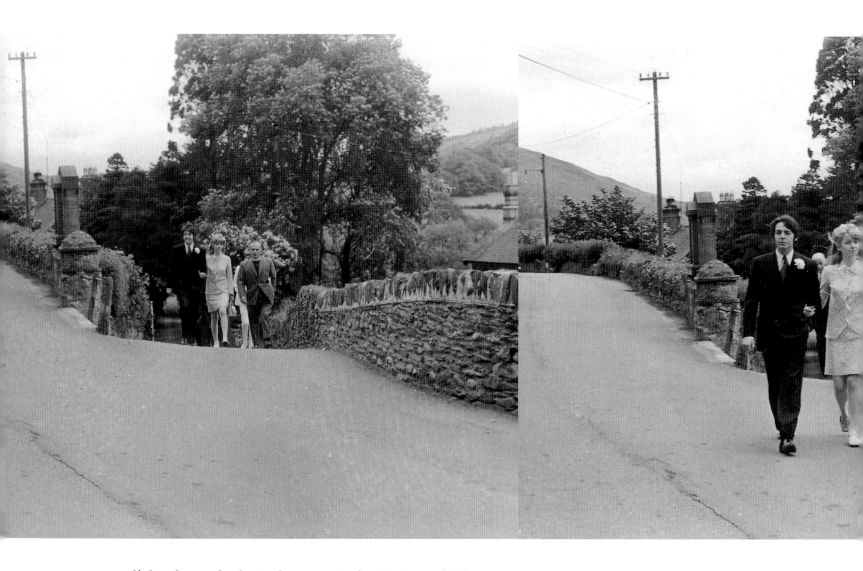

Paul's brother, Mike, better known as Mike McGear, a third
of the recording act The Scaffold ('Do do do do do you
remember, Do do do do do you recall, The day we went out
into the country, Just to get away from it all…?'), married his
long-time girlfriend, Angela Fishwick, in a country church
ceremony in Caerog, North Wales, with Paul as best man. Also
present at the wedding was the McCartneys' father, Jim. Paul's
companion of five years, the actress Jane Asher, accompanied
him to the event and can be seen on the following pages.
But only a few weeks later, on July 20, Paul and Jane separated.

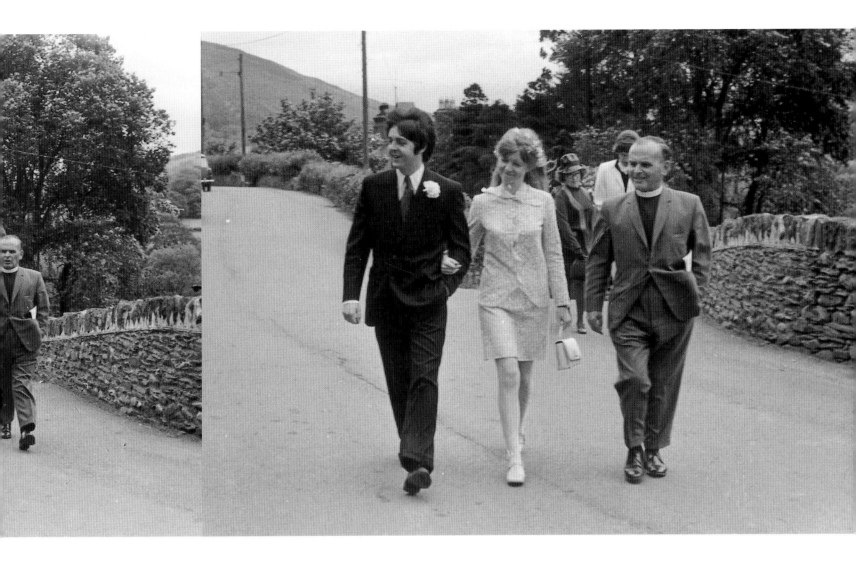

Paul, Jane Asher and the
vicar walk through the
village of Caerog on the way
to Mike and Angela's
wedding. 7 June 1968.

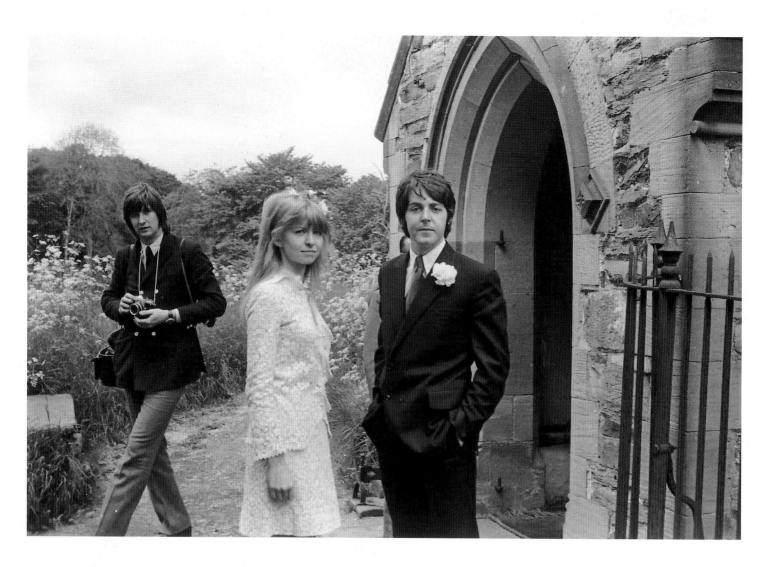

Paul and Jane Asher must
have been as much of a
magnet to photographers as
the bridal couple were. Here
they appear to be avoiding a
cameraman who lurks in
the background.

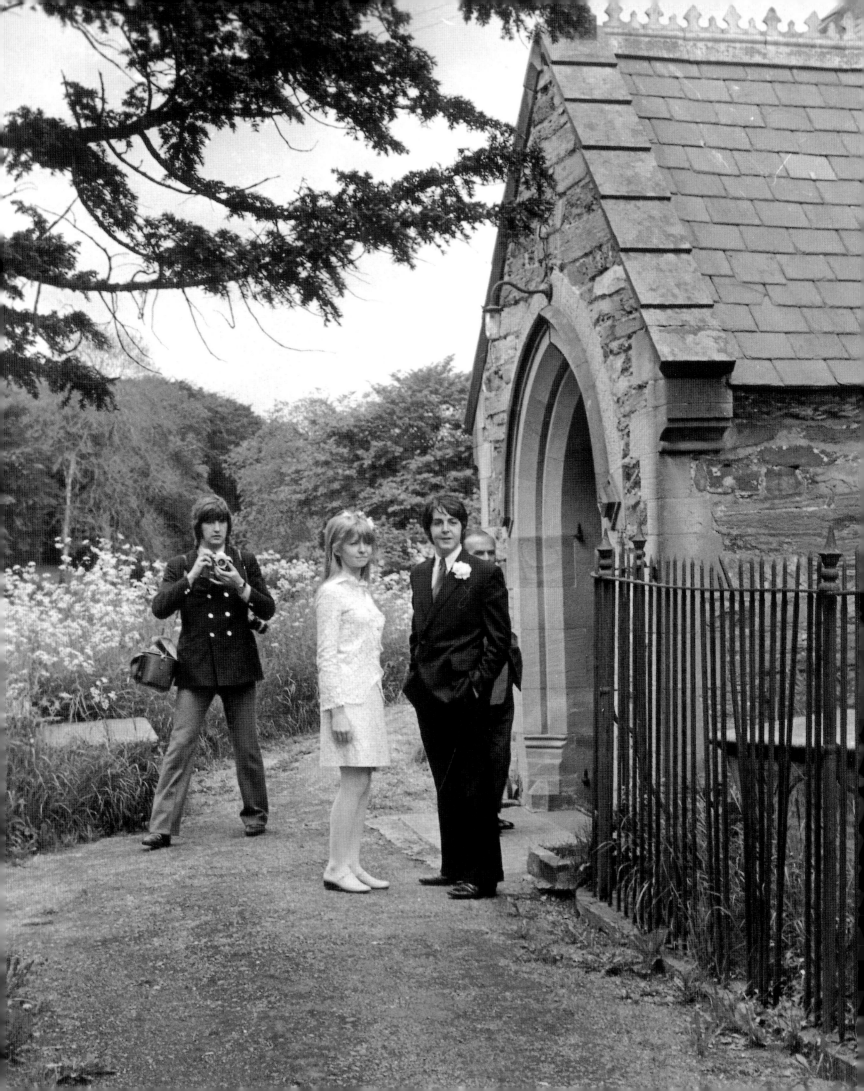

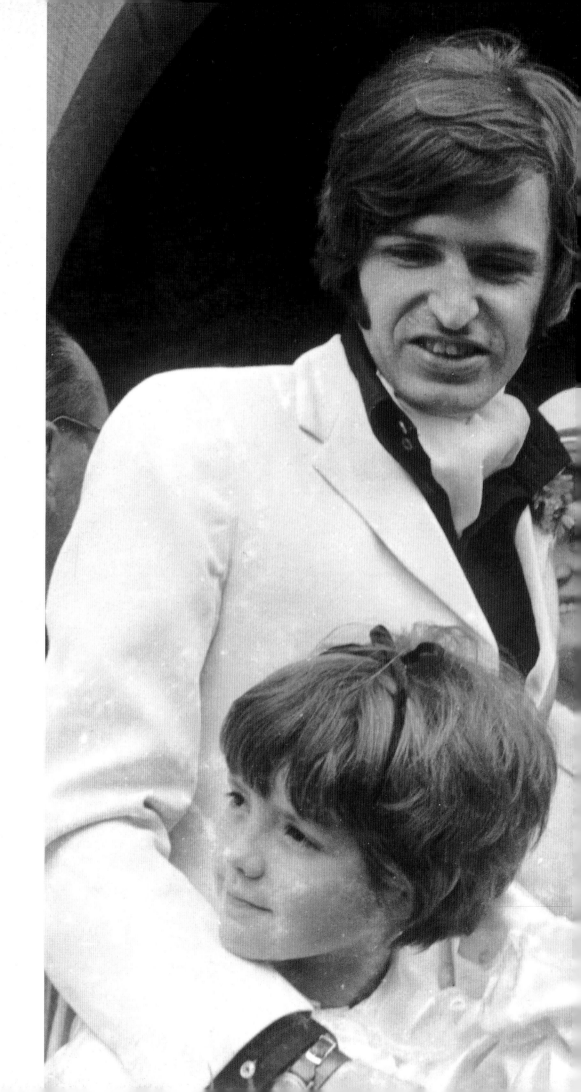

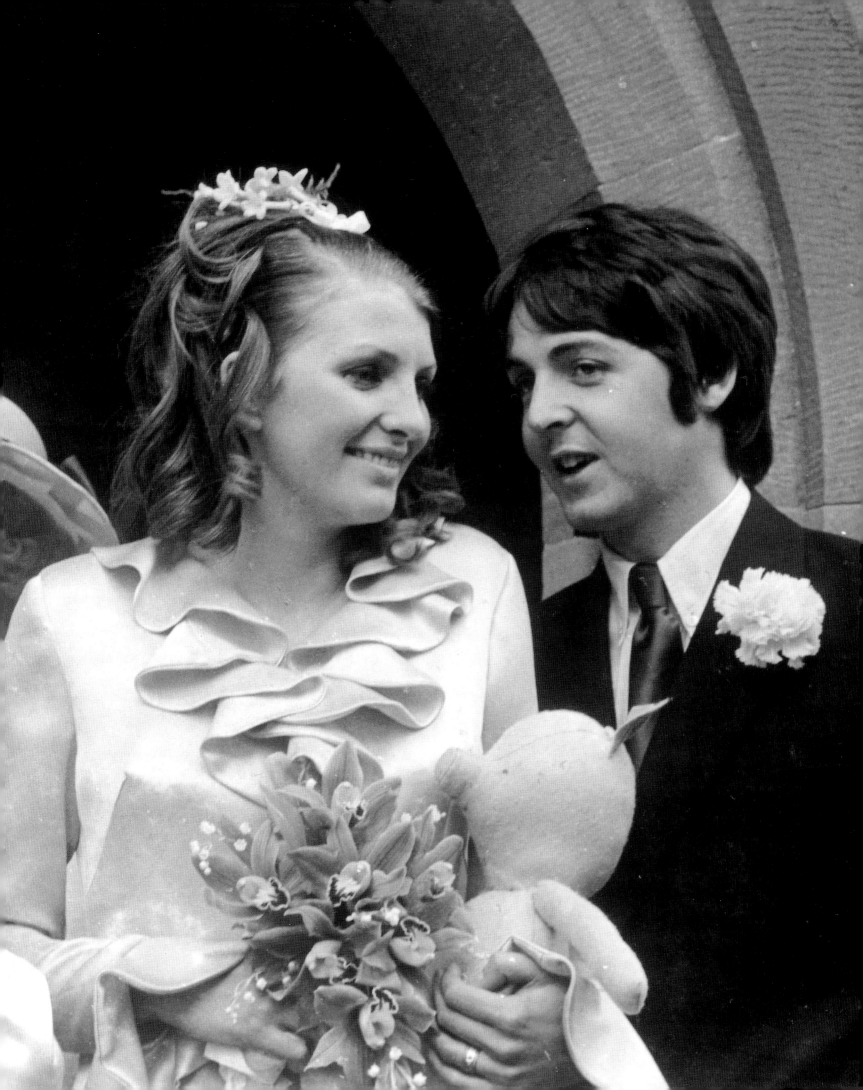

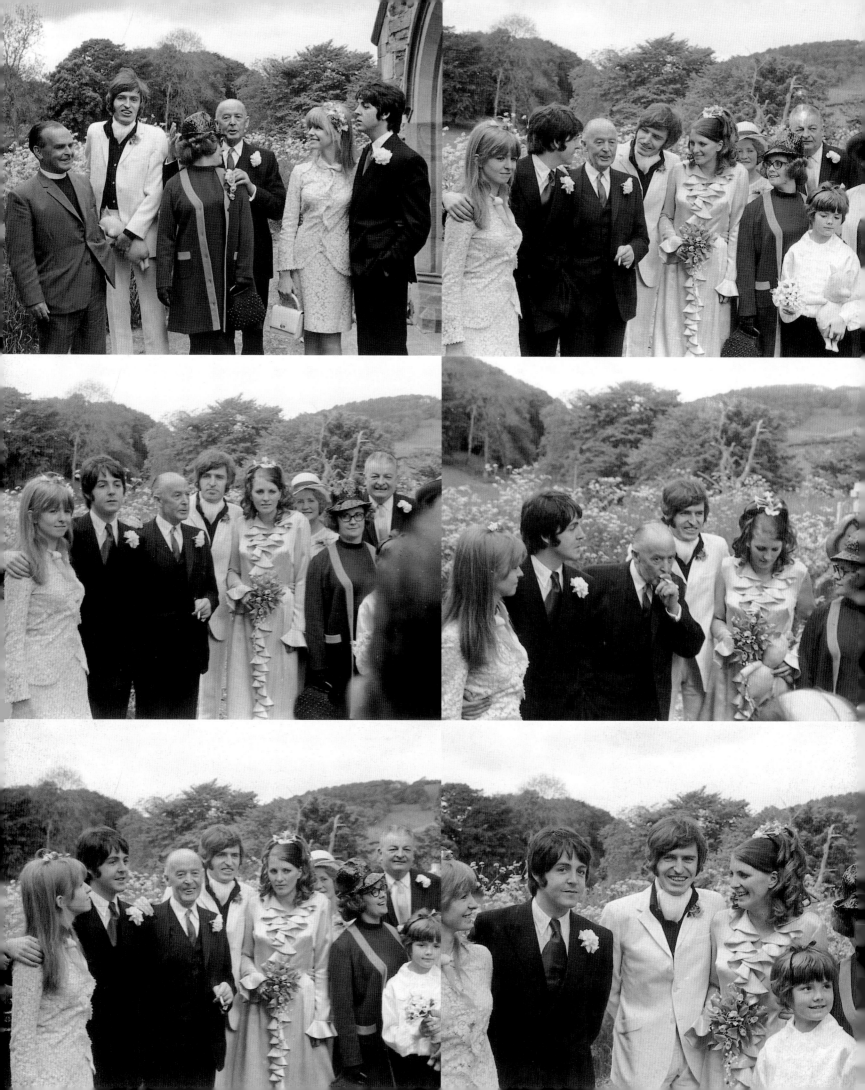

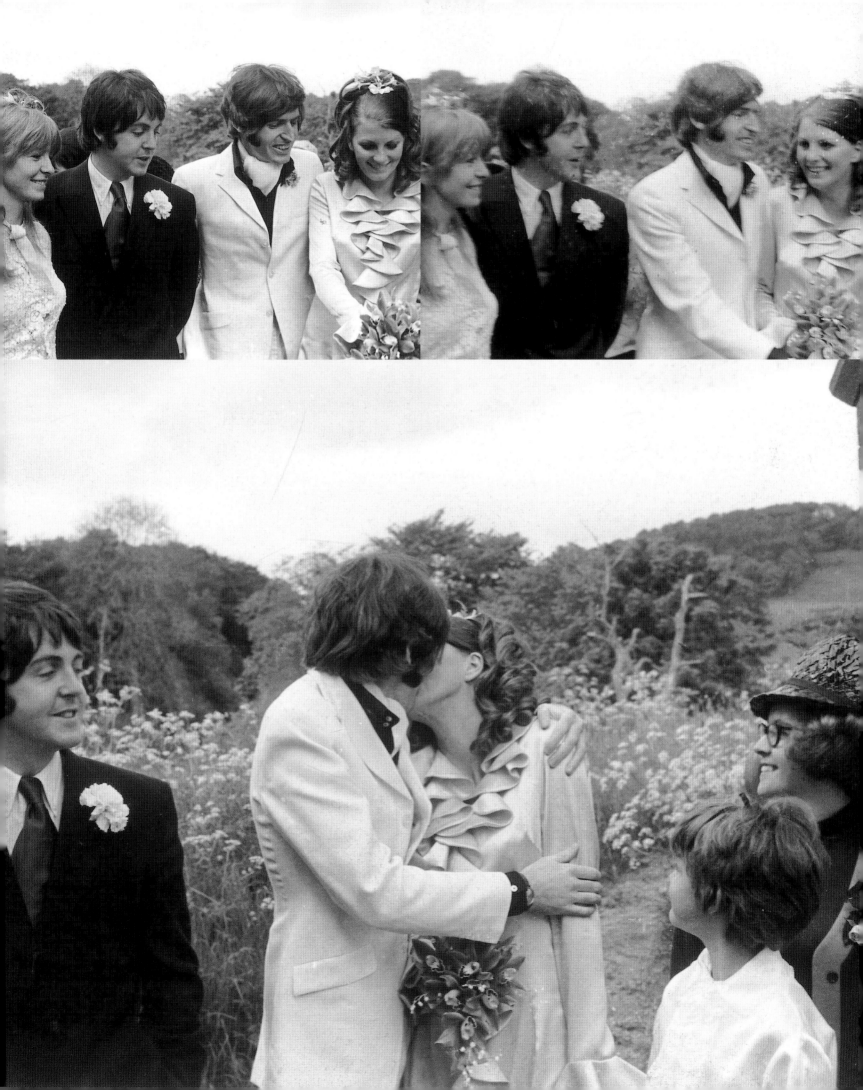

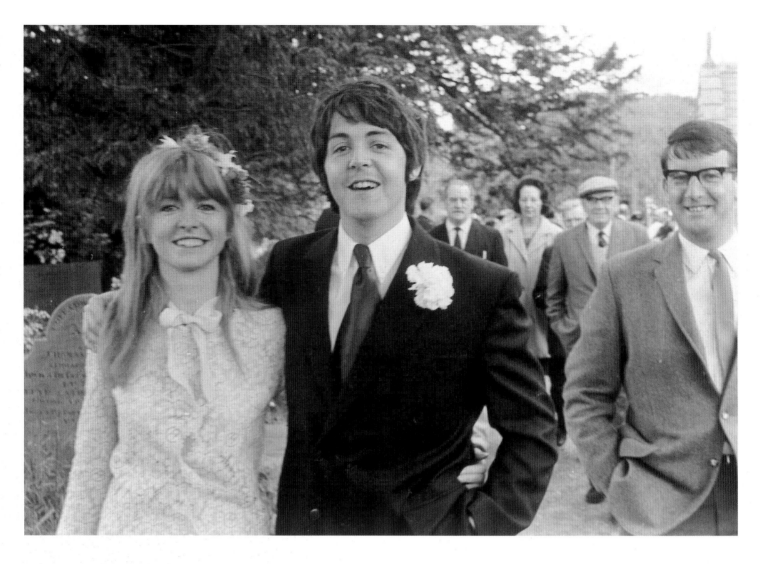

Paul and Jane seem very much together at this happy family occasion. But only six weeks later, their relationship was to fall apart.

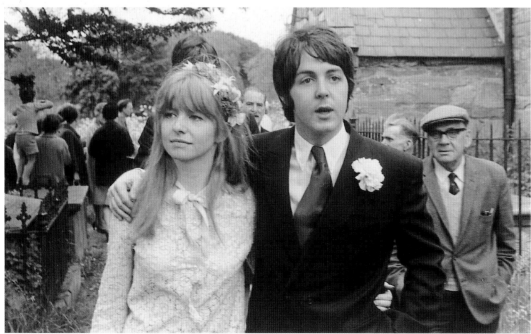

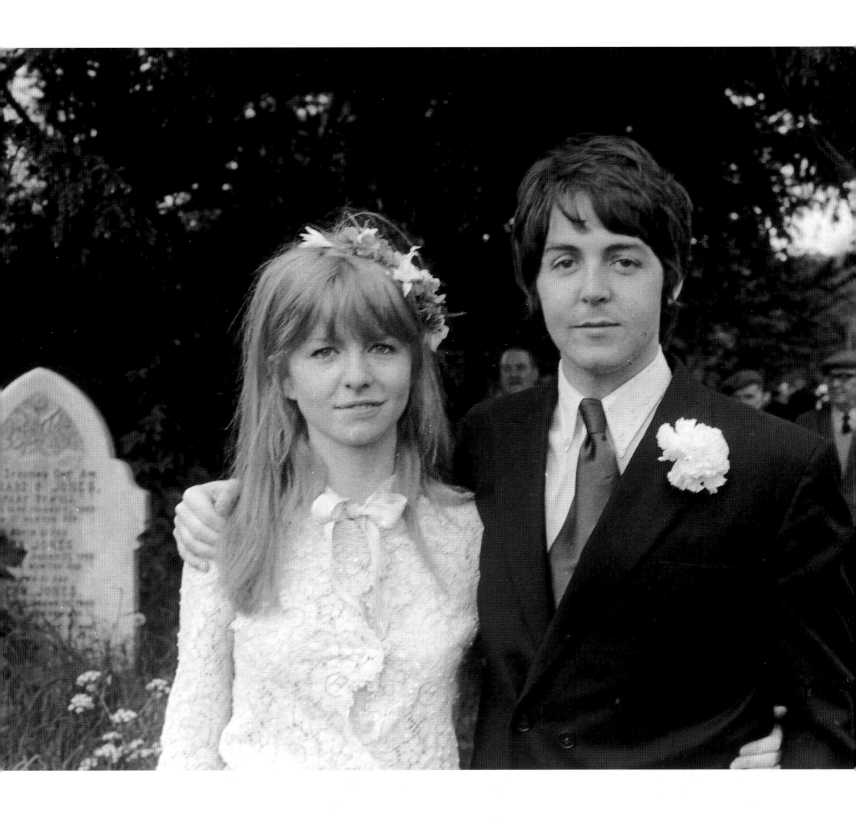

Releases and romances

The Beatles' Apple empire increased on 22 June 1968 when the group purchased the freehold of 3 Savile Row in London for £500,000 from bandleader and impresario Jack Hylton. The five-storey Georgian property was previously the Albany Club, frequented by sporting and theatrical 'men about town' until the mid-fifties. Plans were immediately put into action to build a recording studio in the building's basement. Luxurious furnishings and fittings, including thick apple-green carpets, were ordered and installed. The building in Savile Row became 'open-house', and visiting music superstars, such as The Beach Boys, The Doors and The Jefferson Airplane, came to pay The Beatles a visit.

On July 1, John and Yoko attended the opening of Yoko's latest art exhibition, entitled *You Are Here (To Yoko From John Lennon, With Love)*. The Beatles' new movie, the animated fantasy *Yellow Submarine*, received its world premiere at the London Pavilion on July 17 with Ringo, Maureen, Paul, John, Yoko, George and Patti in attendance. After the screening, The Beatles attended a party at the Royal Lancaster Hotel, which named its new discotheque 'Yellow Submarine' in honour of the film. The following day, the group returned to Abbey Road, where work on their new album, *The Beatles*, continued.

Paul splits with Jane

On July 20, on the teatime BBC1 show *Dee Time*, actress Jane Asher announced to the host, Simon Dee, that her engagement to Paul was over. Asher's entanglement with the Beatle came to an end when she found Paul in bed with another girl, American-born Apple employee Francie Schwartz.

A week later, on July 27, The Beatles decided to cut their losses and abort their attempt at clothes retail by closing their 'Apple' store in Baker Street. It was estimated that, after just seven months of business, the boutique had lost over £200,000. Instead of having a cut-price sale, Yoko came up with the idea of giving the stuff away. But prior to the stock being offered as a free-for-all to the general public, everyone in The Beatles' camp went along to the boutique to choose the item they fancied. Paul grabbed a raincoat. John recalled, 'We all went in and took what we wanted. It wasn't much. It was like robbing. We took everything we wanted home, and the next day, we were watching and there were thousands of kids all going in and getting their freebies. It was great. Of course, Derek [Taylor] and the others hated it, but it so happened that I was running the office at that time, so we were in control.'

The following morning, the first customers who arrived at the boutique were casually told that there would be no charge for the merchandise they had selected.

Word quickly spread of the giveaway and soon hundreds of people flocked to the shop and emptied the premises of everything that might conceivably be carried away, right down to the clothes hangers.

Recording again

July 29 saw the start of recording for 'Hey Jude', which was released in America on August 26 and in the UK four days later. Paul wrote the track for John and Cynthia's son, Julian. The first public airing of the song came on August 8, at the Vesuvio Club in Tottenham Court Road, London, during a belated twenty-fifth birthday party for The Rolling Stones' Mick Jagger. He had intended to use the get-together to spin the long-awaited new Stones album, *Beggars Banquet*. But unfortunately, Paul was to steal the show. An eyewitness that evening recalled, 'As Paul walked in, everybody was leaping around to *Beggars Banquet*, which was far and away the best album of The Stones' career. Paul discreetly handed the DJ a record and said, "Here's an acetate, do you want to slip it on some time during the evening?"'

Rolling Stones assistant Tony Sanchez took up the story. 'I stuck the record on the sound system and the slow thundering build-up of "Hey Jude" shook the club. I turned the record over, and we all heard John Lennon's nasal voice pumping out "Revolution". When it was over, I noticed that Mick looked peeved. The Beatles had upstaged him. I remember Mick Jagger going up to Paul and saying, "Fuckin' 'ell! Fuckin' 'ell! That's something else, innit? It's like two songs."'

'Hey Jude' marked the debut of Apple Records. On August 31, just five days after its US release, it entered the *Billboard* ranking at number ten, a record for this singles chart. By September 3, the disc had sold a million copies in the USA alone. On September 5, at Abbey Road, recording took place for George's 'While My Guitar Gently Weeps', with a guitar solo by Cream guitarist Eric Clapton.

White Album release

The double album sold over two million copies in the first week after its release on November 22 and thus established a British sale record. Unsurprisingly, due to the high volume of advance orders from UK record retailers, EMI were forced to ration the ninety-five-minute set. More than 250,000 sets were pressed for distribution, but this was just not enough to keep pace with demand.

The hysteria was lost on some critics. Alan Smith of the *New Musical Express* wrote, 'The Beatles' double album in full – the brilliant, the bad and the ugly!'

'The first cracks appeared in The Beatles' set up on the *White Album*,' Ringo admitted. 'We never really argued. That was the funny thing. We always sort of held back a bit, and maybe if we had argued a lot more, then it wouldn't have got to the stage it got to.' John was quick to agree with his Beatles colleague. 'The break-up of The Beatles can be heard on the double album, on which I thought that every track sounded as if it came from an individual Beatle. Paul was always upset about the *White Album*. He never liked it because

> 'The first cracks appeared in The Beatles' set up on the *White Album*.'
> **RINGO STARR**

I did my music, he did his, and George did his. And first, he didn't like George having so many tracks, and second, he wanted it to be more a group thing, which really meant more to Paul. So he never liked that album. I always preferred it to all the other albums, including *Pepper*, because I thought the music was better. The *Pepper* myth is bigger, but the music on the *White Album* is far superior, I think. I wrote a lot of good stuff on that. I like all the stuff I did on that. I like the whole album.'

But George had other feelings. Shortly after the album's release, he admitted, 'I think it was a mistake doing four sides because, first of all, it was too big for people to really get into. There are a couple of things that we could have done without on the album and maybe have made it compact with fourteen songs. There are all these different types of music and types of songs and there was nothing shocking about it. I don't think there was anything particularly poor about it, but it was a bit heavy. I find it heavy to listen to myself; in fact, I don't listen to it myself.'

John and Yoko: *Two Virgins*

Five weeks before the release of The Beatles' new album, controversy once again befell John and Yoko when, at 11.30a.m. on the morning of October 18, drug-squad police raided Ringo's flat at Montague Square. Following a search, they found 219 grams of cannabis resin and arrested John and Yoko, the current occupants, for possession of drugs. They were taken to Paddington Green police station, where they were also charged with obstructing the police in execution of a search warrant. A day later, they appeared at London's Marylebone Magistrates' Court, where they were remanded on bail until a further hearing, which took place on November 28 at Marylebone Magistrates' Court. During the hearing, John pleaded guilty to possession of cannabis resin and was fined £150 plus 20 guineas costs.

Next day, on November 29, three weeks after John's divorce from his first wife, Cynthia, was granted, John and Yoko's first album together, *Unfinished Music Number 1 – Two Virgins*, was released in the UK. It faced a barrage of controversy because of its graphic cover, which featured a full-frontal image of the couple.

EMI supremo Sir Joseph Lockwood refused to distribute the disc unless the controversial sleeve was changed. Naturally, he was forced to enquire as to why John did the album cover. But it was Yoko who gave the response. During a meeting at EMI's London headquarters between John, Yoko, Lockwood and Paul (who was summoned to attend by John for moral support), she replied, 'Because it's art.' To which Lockwood unfavourably responded, 'Well, if that's the case, why not show Paul in the nude? He's much better looking.' It was a remark that angered both John and his new girlfriend.

John went on to explain, '*Two Virgins* was a reflection of where we were then. We were two virgins conceptually. Our minds met on the music on the record and our bodies met on the cover of the record. It was just a concept.' Yoko agreed. 'It was the time of the sexual revolution', she said, 'and it was to show we were beautiful. Not just John and I, but the human race in general.'

> 'I don't think there was anything particularly poor about it, but it was a bit heavy.'
> **GEORGE HARRISON**

A settlement with EMI was not reached and so Track Records in the UK and Tetragrammation in the USA handled the distribution of *Two Virgins*. The few record shops that did carry the album either stocked the disc under the counter or housed it within a brown paper bag.

Hell's Angels

During a brief encounter in California, George had invited the Hell's Angels to drop in on The Beatles at their base in London, should they ever pass through the city. Fr'isco Pete and Billy Tumbleweed, of the San Francisco chapter of the Hell's Angels motorcycle club, took George at his word. 'We have come to see John Lennon and have a party,' Fr'isco Pete remarked. His motive for the visit soon became clear. 'We're also worried about the power that The Beatles have. We want to get inside that John Lennon. We listen to his lyrics and he's trampling over our minds. We want to find out what someone with that power is planning to do, where he's at and where he's going.'

The visit of the motorcycle gang was a reflection of the craziness Apple had succumbed to: 3 Savile Row was party central. 'We used to do a lot of entertaining,' Alistair Taylor recalled. 'So I suggested that we set up a little kitchen with a cook, but the only people I could remember eating in there were Peter Brown and Neil Aspinall. We ended up with two cordon bleu chefs and this huge, eight-foot-high steel cabinet packed with vintage wines and champagne. All us executives had our little bar, for entertaining, and every week we'd put our order in to the wine merchants. I kept getting this bill from the wine merchants and it was monumental! So I said, "I want to check these more thoroughly." I found out that Derek and Richard Delilio, in the press office, were having a dozen brandys, two dozen scotches, a dozen gins and six dozen cokes, and it was like, "What?"' It was estimated that Apple's liquor bill was costing approximately £600 a month, an exorbitant amount for 1968.

First solo steps

In the second week of December, John and Yoko filmed an appearance for The Rolling Stones' proposed television special, *Rock And Roll Circus*. Ably supported by musicians such as Eric Clapton, Keith Richard and Mitch Mitchell, they performed 'Yer Blues' at the Intertel Studios in Wembley, London. 'The first time I performed without The Beatles for years was the *Rock And Roll Circus*,' John recalled. 'It was great to be on stage with Eric and Keith Richard and a different noise coming out behind me, even though I was still singing and playing the same style. It was just a great experience. I thought, "Wow! It's fun with other people," you know.'

On December 17, Ringo's first solo film, *Candy*, was launched on the world, with a premiere in New York.

Fan photos – a mixed bag

The Beatles were thoroughly idolized by their fans. They were England's answer to the American outpouring of rock 'n' roll; they were British, conquering the world, and in the fans' eyes, they were theirs. Welcoming their heroes home from tours, fans waited for hours outside McCartney's house in Cavendish Avenue in St John's Wood, then rushed to see him leaving his car a few minutes later at the Abbey Road Studios. These fan shots show The Beatles accessible to their fans. This is a very personal and rare set of photographs featuring The Beatles at the end of their career as a group, lovingly kept in a photographic album.

MARK HAYWARD

Above: Paul with Jane Asher in 1964.
Left: Paul outside his Cavendish Avenue house, early 1967.

Paul with some of his
relatives, 1968.

Time passes, loves come and go. In this one album are snaps of both Jane Asher (*above*) and Linda McCartney, née Eastman (*see* page 332), both taken in 1970. Here a happy-looking Jane leaves the theatre after a performance on 30 July 1970, her acting career taking off a couple of years after her split with Paul.

OCT · 70

Paul surrounded by fans
leaving Abbey Road Studios
in St John's Wood, London,
only a few minutes from his
home in Cavendish Avenue.
October 1970.

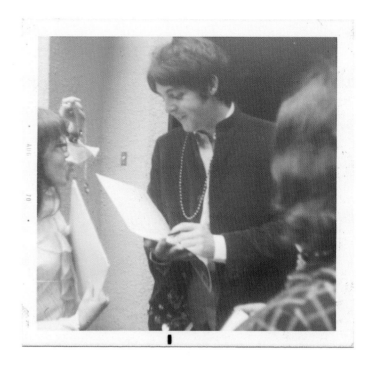

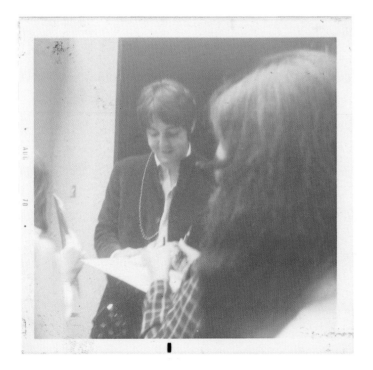

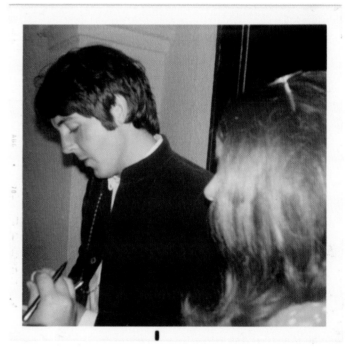

Paul makes time to sign
more autographs for his
adoring fans. The ease with
which fans reached The
Beatles is striking; nowadays
even lesser celebrities would
be fenced in by numerous
bodyguards. 1967.

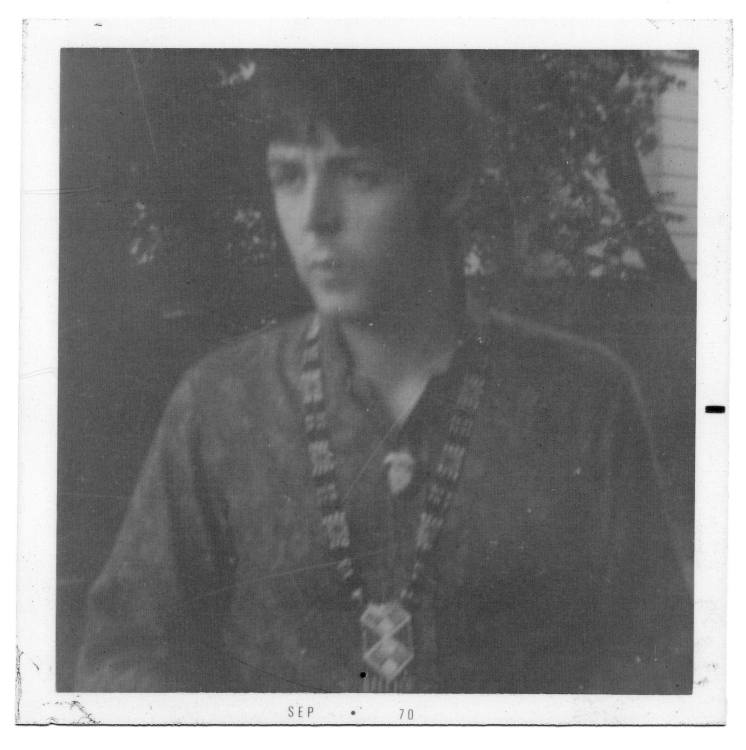

SEP • 70

Paul photographed late in
the day in 1967.

Above: Paul in the back of
a car signing yet another
autograph, 1966.
Opposite: Up close and
personal. A fan photograph
of Paul taken in 1964.

APR • 70 •

Shots from 1970. *Left*: Paul.
Opposite: George in the
doorway at Abbey Road
Studios in April of that year.

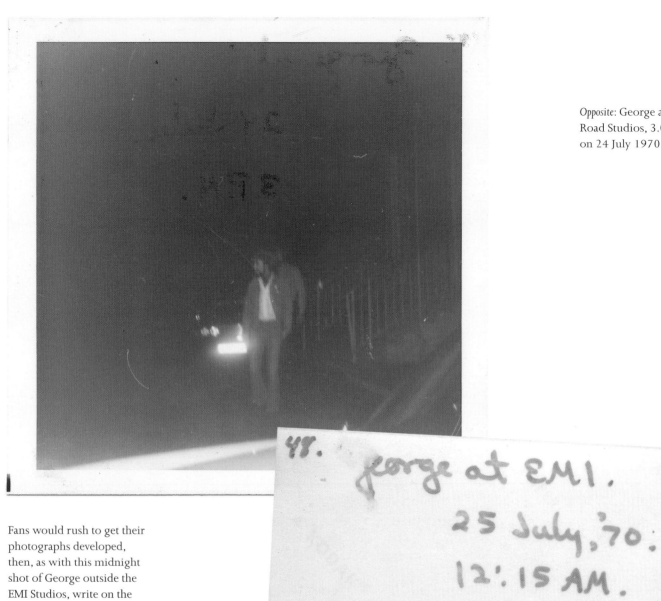

Opposite: George at Abbey Road Studios, 3.00p.m. on 24 July 1970.

Fans would rush to get their photographs developed, then, as with this midnight shot of George outside the EMI Studios, write on the reverse the exact time and place the picture was taken. 25 July 1970.

48.
george at EMI.
25 July, '70.
12:15 AM.

Above: George's wife Patti in Trafalgar Square, London, April 1970. *Right*: Patti in her car at Friar Park, the Harrisons' house in Henley, 14 August 1970.

APR • 70

Patti with Ringo, April 1970.

John's son, Julian, looking
very proud, April 1970.

Julian and his mother,
Cynthia, John's former wife,
on 31 July 1970.

Ringo in Hampstead,
London in his Mini, an
icon of the times, on
20 July 1970.

George goes slightly more
upmarket than a Mini in a
Mercedes. Esher, Surrey,
18 July 1970.

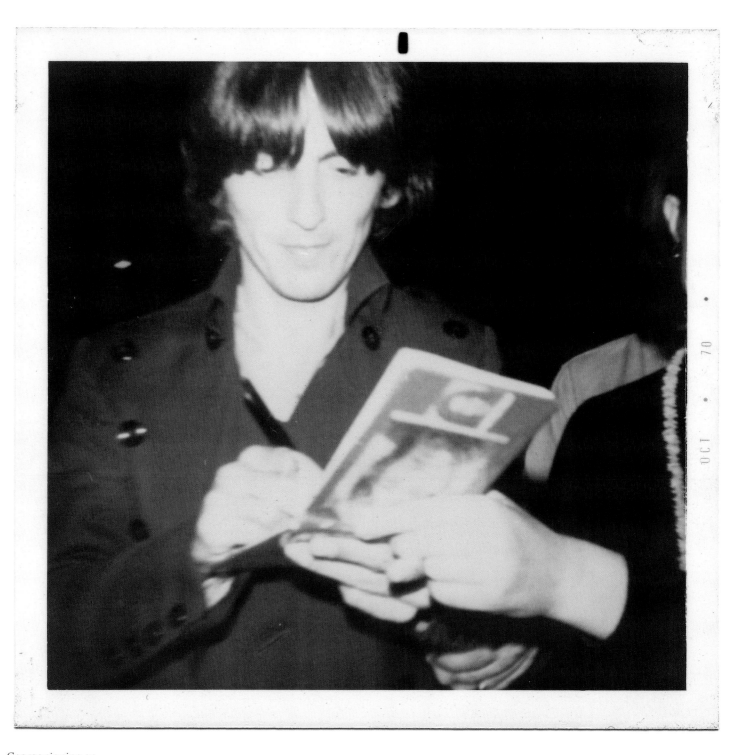

George signing an
autograph for a fan in 1968.

APR • 70

Paul at Abbey Road Studios
in 1969.

Paul in September 1970.

SEP • 70

Paul and wife Linda, September 1970. Behind them is Linda's daughter Heather, from her first marriage.

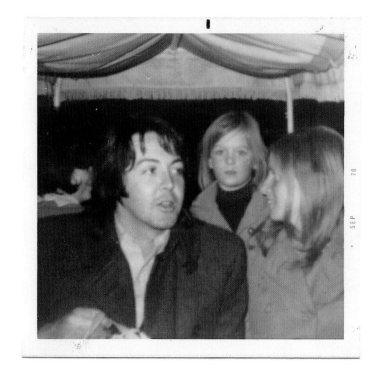

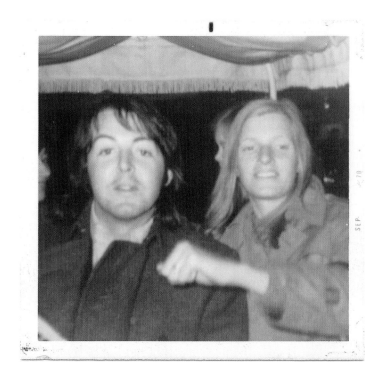

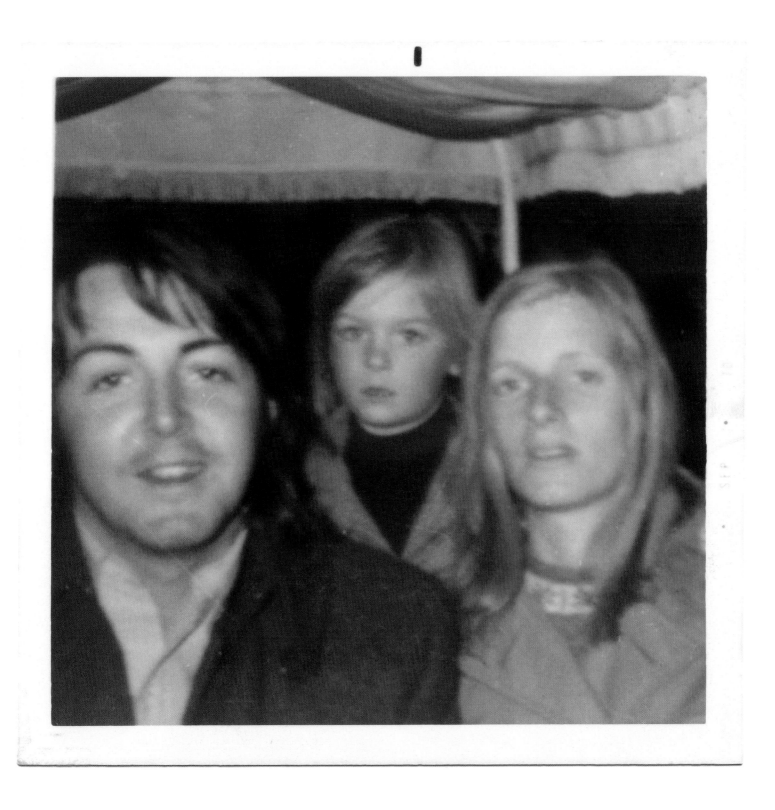

Yoko, June 1968.

John, June 1968.

Let It Be

1969 began with preparations for a television special, originally titled *Get Back* but ultimately *Let It Be*, at London's Twickenham Studios. The plan was to show, for the first time, The Beatles at work, creating and recording. In truth, instead of depicting a flourishing musical act, the images and sounds largely showed the rapidly worsening relationship between all four Beatles. Early start times and freezing cold studios didn't help. The sessions were fraught and on January 10, following a heated conversation with Paul, George walked out. On January 15, he agreed to return if the live concert was scrapped and rehearsals and filming moved to the new studio in Apple's basement at 3 Savile Row.

Problems

There was also trouble for John and Yoko's album *Two Virgins*. On January 3, US police confiscated 30,000 copies at Newark Airport, New Jersey, on a judge's order classing the album's cover as 'pornographic'. In the UK on January 17, The Beatles' *Yellow Submarine* soundtrack album was released.

This was the month, too, when Apple first hit major financial problems. Years later, in an interview for *Rolling Stone*, John remembered, 'People were robbing us and living on us. Eighteen or twenty thousand pounds a week was rolling out of Apple and nobody was doing anything about it. All our buddies that had worked for us for years were just living and drinking and eating like fuckin' Rome!' The Beatles were musicians, not administrators, and needed a business saviour. This turned out to be The Rolling Stones' manager, thirty-four-year-old American businessman Allen Klein, who had long dreamt of managing The Beatles. John met Klein on January 28, and was impressed. Unfortunately, Paul had independently decided that John Eastman, brother of his companion Linda, should be put in control of The Beatles' financial affairs.

Last performance

At John Lennon's suggestion, on January 30 The Beatles gave their very last public performance. Unannounced and free of charge, the forty-two-minute lunchtime concert was held on the roof of Apple's offices in Savile Row. As expected, police soon arrived and put an end to the show – but only after one final rendition of 'Get Back'. Recording and filming for *Let It Be* were wrapped up the following day.

On February 3, Apple's press office issued a statement: 'The Beatles have asked Mr Allen Klein of New York to look into all their affairs and he has agreed to do so.' Just a day later, on Paul's insistence, Apple announced: 'The prestigious New York lawyers Eastman and

Eastman have been appointed as Apple's general council in order to keep an eye on Allen Klein's activities.' There was conflict from the start: Eastman had suggested The Beatles buy Brian Epstein's company, NEMS, for £1 million, using a loan from EMI set against future royalties; Klein pointed out that they would have to earn £2 million to repay the debt.

Meanwhile, on February 22, at London's Trident Studios, with producer Glyn Johns, The Beatles began recording John's 'I Want You' (later known as 'I Want You [She's So Heavy]'), and thus work began on the album *Abbey Road*. On March 2, John joined Yoko to perform at Lady Mitchell Hall in Cambridge. The first solo performance by a Beatle and the first public performance by John and his new partner, it was recorded for the album *Unfinished Music Number 2 – Life With The Lions*.

Marriages and takeovers

Controversy struck again in mid-March, when the drugs squad raided the Harrisons' home in Esher, Surrey. They had brought with them a large, 350-gram piece of hashish in case they did not find any. George and Patti were arrested for possession of cannabis resin, charged and released on bail. On March 31, they appeared in court; they pleaded guilty and were fined £250 each plus 10 guineas costs.

But there was time for rejoicing too. On March 12, at Marylebone Register Office in London, Paul married Linda Eastman. On March 20, on the rocks of Gibraltar, John married Yoko Ono, whose divorce from Tony Cox had just been finalized. Five days later, the Lennons began a honeymoon at the Amsterdam Hilton: throwing open their bedroom doors to the press, the couple called the four-day event a 'bed-in'.

On March 28, publisher Dick James sold his shares in Northern Songs to ATV. Although John and Paul felt James had been short-changing them, from his Amsterdam bed John responded furiously, 'I won't sell. They are my shares and my songs and I want to keep a bit of the end product. I don't have to ring Paul. I know damn well he feels the same as I do.' But on April 15, four days after the release of the Beatles single 'Get Back', he rejected the chance of control of Northern Songs by an alliance with City shareholders.

Turning briefly from business, on April 22 John undertook a short ceremony on the roof of 3 Savile Row before the Commissioner of Oaths, changing his middle name from Winston to Ono by deed poll. Three days later, John, George and Ringo signed a three-year management contract with Klein, who started to cut costs. Among those fired was the company director, The Beatles' close, reliable friend Alistair Taylor. Paul did not sign Klein's contract, saying later that part of the reason he resisted the appointment was Klein's failure to deliver on claims such as being able to get NEMS for a reasonable price. On May 19, control of Northern Songs was lost when ATV teamed up with other stockholders.

May 26 found John, Yoko and her daughter Kyoko in Montreal for a second 'bed-in', in Room 1742 at the Reine Elizabeth Hotel. On the penultimate day, June 1, John and Yoko were joined by showbiz friends, including LSD guru Dr Timothy Leary, poet Allen Ginsberg and record producer Phil Spector, for a recording of 'Give Peace A Chance'. The Beatles' new single, 'The Ballad Of John And Yoko', was released in the UK on May 30.

'They are my shares and my songs and I want to keep a bit of the end product.'

JOHN LENNON

Live Peace in Toronto

'I was really terrified because I hadn't played for so long and I was worried about Beatles-type hysteria. So I was really uptight, edgy and nervous. I just threw up for hours until I went on. I nearly threw up during "Cold Turkey" ... I could hardly sing ... We started off doing things like "Blue Suede Shoes"; things that we'd rehearsed on the plane. It was a mad house. Everybody was really together. It was really sound. So we did all the "Money" and "Dizzy Miss Lizzy" bits and it was fantastic. Everybody was with us and leaping up and down doing the peace sign, because they knew most of the numbers anyway.'

JOHN LENNON

Relaxing by the pool on the morning after the Toronto Rock & Roll Revival concert. *Left to right:* Alan White, Eric Clapton, Klaus Voorman, John and Yoko. Clapton gives the two fingers while his companions opt for the other way around, signalling peace, hence the Apple album release *Live Peace in Toronto*.

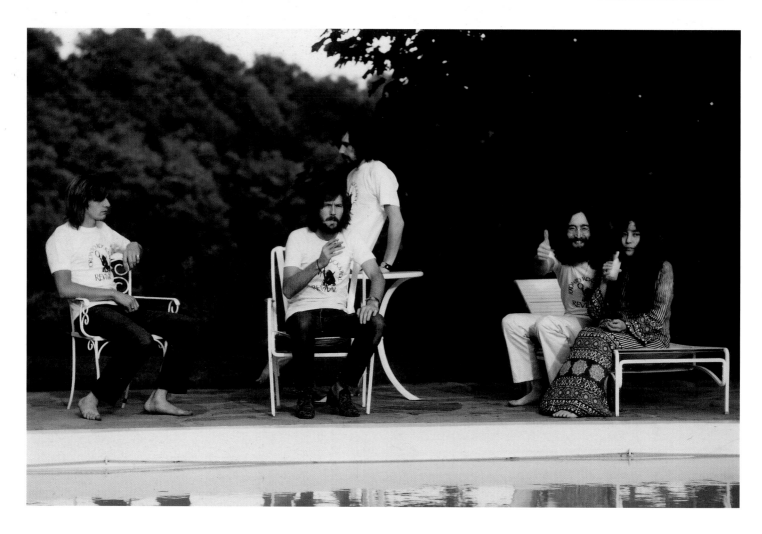

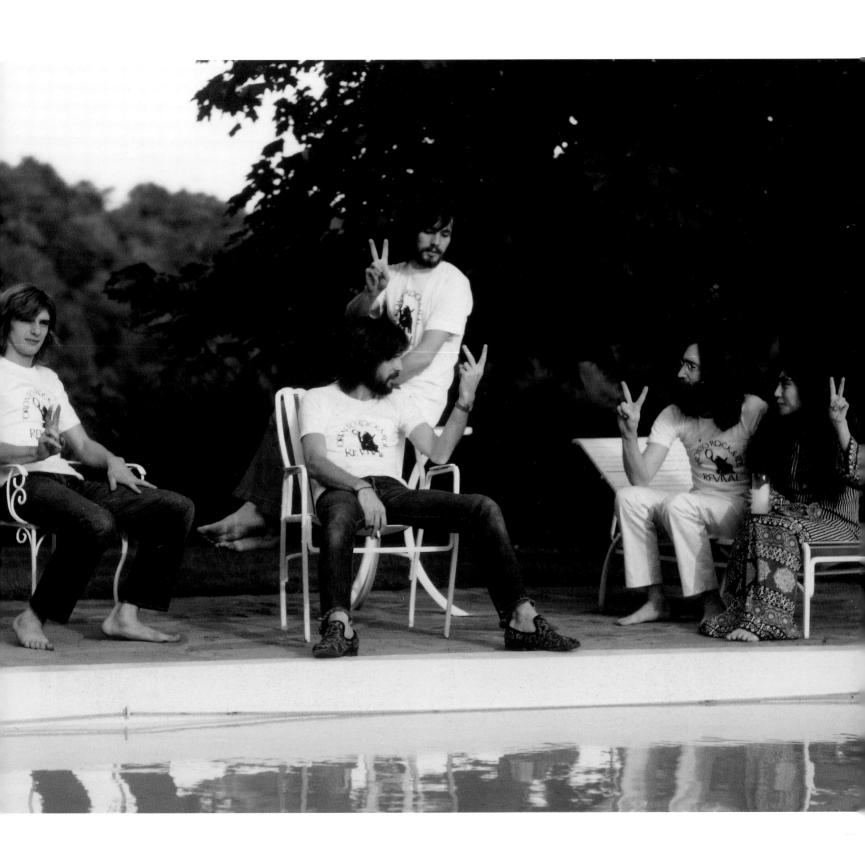

The last albums

Work began on The Beatles' new album, called *Abbey Road* in honour of their recording home of the past seven years, on July 1. Once again the producer was George Martin, who recalled, 'I was quite surprised when Paul rang up and said, "You know, what happened to *Let It Be (Get Back)* is silly. Let's try to make a record like we used to. Would you come and produce it like you used to?" I said, "Well, I'll produce it like I used to if you'll let me." It really was very happy, very pleasant.'

John missed the start of recording. He, along with Yoko, his son Julian and her daughter Kyoko, had been involved in a car accident during a short vacation in Golspie, Scotland. They were hospitalized, missing the launch of The Plastic Ono Band's 'Give Peace A Chance' on July 3; Ringo and Maureen substituted for them at the event, at Chelsea Town Hall. John's first session for *Abbey Road* was on July 9, recording Paul's 'Maxwell's Silver Hammer'. As at the *White Album* sessions, Yoko sat patiently at her husband's side. John excitedly told reporters, 'This next Beatles album is really something. So tell the armchair people to hold their tongues and wait.'

The album cover was shot by photographer Iain MacMillan on August 8, on the zebra crossing near the studio. Six pictures were taken of the group attempting to cross the busy road. Another session two weeks later, photographed by Ethan Russell, was in John's recently purchased Tittenhurst Park Mansion in Suningdale, Berkshire. It would be the group's last photo session as a four-piece.

On August 31, John, George, Ringo and their partners were in the 150,000-strong crowd at the Isle of Wight Festival to witness the concert return of Bob Dylan. Three weeks later, John himself came out of performance retirement for the Rock & Roll Revival Concert in Toronto, Canada.

Splits

September 20 brought earth-shattering news when John, exhilarated by the Canada concert, announced he was leaving the group. Paul recalled for American radio: 'Our jaws just dropped. Everyone blanched except John, who said, "It's rather exciting. It's like I remember telling Cynthia I wanted a divorce."' Paul and Allen Klein both insisted John did not announce to the papers that he was leaving, perhaps hoping nothing would really happen.

The same day's edition of the *Melody Maker* contained an interview with John by Richard Williams which revealed, 'John hasn't had a Beatles royalty cheque for two years and, believe it or not, he's feeling the pinch.' Five days later, it was announced that ATV had taken control of Northern Songs; John and Paul's battle to regain their back catalogue looked bleak.

'That was fun. I could just stand at the back, long hair and a guitar.'
GEORGE HARRISON

Abbey Road was issued in the UK on September 26. The second side featured a medley of half-finished songs, an idea conceived and directed by Paul. 'They weren't real songs,' John blasted at the end of the year. 'They were just bits and pieces stuck together.' Producer George Martin remarked that John contributed reluctantly to this side. 'He never liked production; he liked good old rock 'n' roll. So one side was to please John, a collection of songs, and the other was to please Paul.' But the critics loved the album. *Disc & Music Echo* described it as 'just superb'.

Changing focus

In October came a strange American rumour that Paul was dead. The unexpected publicity took the *Sgt Pepper* and *Magical Mystery Tour* albums back into the Top 200 US album chart, at No. 124 and No. 146 respectively. On October 22, John and Paul sold their shares in Northern Songs to ATV, each receiving around £3.5 million. Meanwhile, Ringo returned to Abbey Road on October 27 to record his first solo album, *Sentimental Journey*, working with George Martin. Four days later, The Beatles' single 'Something'/'Come Together' was released in the UK. On October 24 came The Plastic Ono Band single 'Cold Turkey'.

John and controversy continued hand in hand. On November 25, he returned his MBE to the Queen. For the past four years, it had sat on top of his Aunt Mimi's television at her home in Poole, Dorset. Accompanying the medal, delivered to Buckingham Palace by John's chauffeur, was a short note: 'Your Majesty, I am returning my MBE as a protest against Britain's involvement in the Nigeria-Biafra thing, against our support of America in Vietnam and against "Cold Turkey" slipping down the charts. With love, John Lennon.'

On December 2, while stories circulated about John being asked to play Christ in a London musical, George was at the Colston Hall in Bristol, making his first stage appearance since 1966. He appeared as part of the group Friends, led by Eric Clapton, backing the American 'white soul' couple Delaney & Bonnie. 'That was fun,' George remarked years later. 'I could just stand at the back, you know, long hair and a guitar, and join in with the band.'

December 12 saw the release of The Plastic Ono Band album *Live Peace In Toronto*. John recalled how a higher royalty was agreed: 'Capitol said, "Sure you can have it. Nobody's going to buy that crap!" It came out... and it went Gold.' Meanwhile, John and Yoko turned to politics, campaigning over the alleged incorrect prosecution and hanging of the 'A6 murderer', James Hanratty. On December 15, they launched their 'War Is Over' campaign. Posters and billboards sporting the slogan were displayed in twelve major cities worldwide. Later, at London's Lyceum Ballroom, John and Yoko were at the 'Peace For Christmas' gig in aid of UNICEF as part of The Plastic Ono Supergroup, also featuring George, Billy Preston, Eric Clapton, Keith Moon and Delaney & Bonnie. It was John's last public performance in Britain.

Next morning, John and Yoko flew to Toronto to promote 'War Is Over'. Canadian Prime Minister Pierre Trudeau was among those lining up to shake hands. December 31 brought the BBC TV programme *The Man Of The Decade*, a third of which was dedicated to John, while America's *Rolling Stone* magazine also nominated him 'Man of the Year'.

4

POSTSCRIPT

A FINAL GLIMPSE OF JOHN

The final days

The new year and new decade began with a Beatles recording session at Abbey Road. But, unlike previous years, 1970 found only Paul, George and Ringo in attendance. John was away with Yoko in Denmark and Sweden. The three Beatles set to work overdubbing parts onto George's 'I Me Mine' and, next day, Paul's 'Let It Be'. George Martin was once again producing. It was to be the last recording session of The Beatles as a band. The final session for the *Let It Be* album came on January 8, when George re-recorded his lead vocal on 'For You Blue'.

Yohn and Yoko

Spending time with Yoko, rather than recording with his fellow Beatles, was obviously more appealing to John in early 1970. On January 15, the Lennons launched *Bag One*, an exhibition of some of his lithographs and drawings at the London Arts Gallery. Within twenty-four hours, the police raided the premises and closed the exhibition under the charge of obscenity. *The Times* newspaper reported, 'Scotland Yard abruptly removed the illustrated revelations of the life of John Lennon and his wife, Yoko Ono, from the public gaze at mid-morning. Armed with a search and seizure warrant, under the Obscene Publications act of 1959, they raided an exhibition of Mr Lennon's lithographs at the London Arts Gallery in New Bond Street, London, and confiscated eight of them. The gallery was reopened to the public in the afternoon with five remaining lithographs still in their frames on the wall. The exhibition, which opened to the public on Thursday, has been seen by about 6,000 members of the public, and every set of the portfolio of fourteen has been sold at £550 a set and some individual prints have been sold at £40 each. John, who was still in Denmark with Yoko and Kyoko, aged six, said, "It's a laugh!"'

The couple were in Aalborg, Denmark, swapping their extremely long hair for a severely short version. On January 21, the Associated Press news agency reported it gave him 'a new personality', while UK newspapers remarked that 'John cut his hair to be able to travel without being recognized'. Back in the UK, the morning of January 26 was most prolific for John, when, with the help only of a piano, he composed the song 'Instant Karma! (We All Shine On)' in a few short hours. This speed of creativity was replicated twenty-four hours later when he recorded it in Abbey Road Studios. On George's suggestion, the legendary American 'wall of sound' record producer Phil Spector was at the controls. John recalled, 'We booked the studio and Phil came in and he said, "How do you want it?" And I said, "1950s," and he said, "Right," and boom, I did it in about three goes. He played it back and there it was. The only argument was I said a bit more bass.

That's all, and off we went… He doesn't fuss about with fuckin' stereo or all that bullshit.' The single had its UK release on February 6, credited to John Lennon/Plastic Ono Band.

Predicting the future

Even though The Beatles had practically ceased to exist, March 6 saw the UK release of 'Let It Be', the group's new single. Nonetheless, newspaper reporters and fans alike around the globe feverishly believed the rumours that the group had split up. And so, on March 7, Don Short of the *Daily Mirror* cornered the usually elusive George and asked him outright, 'Have they split for all time?' 'Everybody keeps asking the same question,' the quiet Beatle knowingly replied. 'There are some people around who can't imagine the world without The Beatles. That's what it must be. But this had to happen. It was the natural course of events… We've all left The Beatles one by one. I left because of a musical policy dispute with Paul; Ringo went into films; and John got into the bed-in bit with Yoko; and now Paul's making his own album. It's true we don't see much of Paul, he's gone off the 'coming-into-the-office' scene. He wants to be quiet and left alone... and after ten years, he deserves to be quiet.'

On March 13, George and Patti moved to Friar Park, a spacious mansion and former convent in Henley-on-Thames. Just a day after taking residence, George was again being grilled about the current state of The Beatles. In a phone interview with an American newspaper, he cryptically announced, 'We still see each other, still make contact. But we had to find ourselves, individually, one day. The thing is that so many people think we know all the answers about The Beatles, and we don't. Who are we to say? We can't give the answer, and I, for one, can't define that special something that made us as we are. I know it wasn't just the records or our concerts. You tell me.' But George had more important matters to contend with: his desire to see God. 'It's pointless to believe in something without proof,' he told the reporter, 'and with Krishna, here is a method where you can actually obtain "God perception". You can actually see God, and hear him, play with him. It might sound crazy, but he is actually with you.'

Angry clashes

Further conflicts within The Beatles' organization came in April. Apple promotions manager Tony Bramwell recalled, 'Paul's *McCartney* album was to be released at the end of April, as was The Beatles' *Let It Be* album… The other Beatles suggested that it would be easier if his album was delayed to allow *Let It Be* to make its initial impact and then the McCartney album was virtually the follow-up to *Let It Be*. Ringo even offered to go round to see Paul at his home in Cavendish Avenue and try to explain this to him, which resulted in a strong argument taking place and Ringo leaving Paul and deciding to let the album go out on the date that McCartney had insisted on.'

'He got angry', Ringo remembered, 'because we were asking him to hold his album back and the album was very important to him. He shouted and pointed at me. He told me to get out of his house. He was crazy. He was out of control... prodding his finger at

'We had to find ourselves, individually, one day.'

GEORGE HARRISON

my face. He told me to put my coat on and get out. I couldn't believe it was happening. I had just brought the letter [from John and George]. I said, "I agree with everything that's in the letter," because we tried to work it like a company, not as individuals. I put my album out two weeks before, which makes me seem like such a good guy, but I wasn't really, because I needed to put it out before Paul's album, else it would have slayed me.'

Paul also relived the drama. 'These letters confirmed that my record had been stopped. I really got angry when Ringo told me that Klein had told him that my record was not ready and that he had a release date for the *Let It Be* album. I knew that both of these alleged statements were untrue and I said, in effect, this was the last straw, and, "If you drag me down, I'll drag you down." What I meant was, "Anything you do to me, I will do to you."'

The split made real

On April 1, at Abbey Road, Ringo became the last member of the group to perform on an original Beatles session when he overdubbed drums onto 'Across The Universe', 'The Long And Winding Road' and 'I Me Mine', working with producer Phil Spector. It was also the last recording session for an original Beatles album. Next day, stereo mixing for 'The Long And Winding Road', 'I Me Mine', 'Across The Universe' and editing for 'The Long And Winding Road' and 'I Me Mine' took place at the studio. It was to be Spector's last for The Beatles and the last period of work on *Let It Be* (for thirty-three years, that is: it was remixed and remastered in 2003).

A week later, knowing that a major news story involving him was about to break the following day, Paul phoned John, who was residing with Yoko at Arthur Janov's 'primal therapy' clinic in London. Lennon recalled, 'He called me in the afternoon and said, "I'm doing what you and Yoko was doing last year. I'm putting out an album and I'm leaving the group, too." And I said, "Good!" I was feeling a little strange because he was saying it this time, although it was a year later, and I said "good" because he was the one that wanted The Beatles most, and then the midnight papers came out.'

The front page of the April 10 *Daily Mirror* screamed 'Lennon-McCartney song team splits up – PAUL IS QUITTING THE BEATLES'. The report, by Don Short, read: 'Paul McCartney has quit The Beatles. The shock news must mean the end of Britain's most famous pop group, which has been idolized by millions the world over for nearly ten years. Today, twenty-seven-year-old McCartney will announce his decision and the reasons for it, in a no-holds-barred statement. It follows months of strife over policy in Apple, The Beatles' controlling organization, and an ever-growing rift between McCartney and his song-writing partner, John Lennon. In his statement, which consists of a series of answers to questions, McCartney says, "I have no future plans to record or appear with The Beatles again. Or to write any more music with John." Last night, the statement was locked up in a safe at Apple headquarters in Savile Row, Mayfair…'

Years later, Paul was quick to point out that this 'no-holds-barred statement' was a misunderstanding. 'I never intended it to mean I'd quit,' he admitted. 'We got some people at the office to ask some questions just on paper, you know, and they sent them

'I'm putting out an album and I'm leaving the group, too.'
PAUL McCARTNEY

over to our house and I just filled them out like an essay, like a school thing. When I saw the headlines, I thought, "Christ, what have I done? Now we're in for it."'

The damage was done. When John saw the headline, he was fuming, especially as he had declared his intention to quit The Beatles some seven months previously but had been persuaded from making it public by Paul and Allen Klein. 'I was cursing because I hadn't done it,' he announced years later. 'I wanted to do it; I should have done it. What a fool I was… We were all hurt that he didn't tell us what he was going to do. He claimed that he didn't mean that to happen, but that was bullshit!'

Freedom at last

For The Beatles, however, Paul's announcement came as a relief. After years of being closeted as one of the Fab Four, each member of the group was now free to pursue their own individual careers. 'It is probably something to do with growing up,' Apple's Derek Taylor announced to the press in April 1970. 'Once they were boys, but now they're four men with wives and children. One of the reasons for the split is that John has been going it alone for a long time and that has left Paul out on a limb. They have to work out a way of going solo after being collective.'

John agreed. 'I was always waiting for a reason to get out of The Beatles from way, way back, but I just didn't have the guts to do it because I didn't know where to go, and what Yoko did for me was liberate me from that situation. We all had basically enough and nobody knew how to say it. We might not even have been aware that we had had enough ourselves. Perhaps we should have finished earlier.'

Going solo

Free from Beatles commitments, each member of the group started carving out their own musical and business path. On April 12, Paul formed the company McCartney Productions Ltd. Five days later came the UK release of his first solo LP, *McCartney*. The Beatles' last album offering, *Let It Be*, appeared in the UK on May 8, just twelve days before the premiere of the film of the same name. In stark contrast to their previous, high-profile movie launches, The Beatles' last film together, the semi-documentary *Let It Be*, premiered simultaneously at the London Pavilion and in Liverpool at the Gaumont, with none of the group in attendance.

It was a time for solo offerings for the ex-Beatles. On November 30, the UK release took place of George's impressive, critically acclaimed triple album *All Things Must Pass*. John's album, *John Lennon/Plastic Ono Band* followed suit, to less critical acclaim, in the UK and United States two weeks later, on December 11. A simultaneous offering, *Yoko Ono/Plastic Ono Band*, also appeared.

But, for The Beatles, the year ended on an unhappy note when, on December 31, Paul began High Court proceedings to end the group's partnership. As years of lawsuits and unpleasantness began, Paul was forced to admit, 'I didn't leave The Beatles – The Beatles left The Beatles, but no one wants to be the one to say the party's over.'

> 'We all had basically enough and nobody knew how to say it.'
> **JOHN LENNON**

The Hit Factory interview

Perhaps the saddest photographs in this book, taken on 6 December 1980, two days before John died. He had found peace and happiness with Yoko, living in New York. The Warner Brothers record crew decided to go to meet him at the Hit Factory, New York, along with DJs Andy Peebles (then of BBC Radio 1) and Jonathan King. I was in New York at the time (we saw *The Elephant Man* on Broadway, starring David Bowie). On our way back into the UK, Andrea, the girl accompanying me, was pulled over by customs as she had blue hair, a real novelty in those days. While I waited for her, a man approached me saying it was tragic that Lennon was dead. I could not believe what I was hearing: he had been shot while we were in the air returning from New York.

MARK HAYWARD

Left: Andy Peebles the interviewer, Paul Williams the BBC producer, and the Warner Brothers rep pose outside the Hit Factory in New York before the interview that would make Andy a household name for all the wrong reasons, for conducting one of the last interviews of John and Yoko together. *Above*: Andy Peebles, Yoko and John.

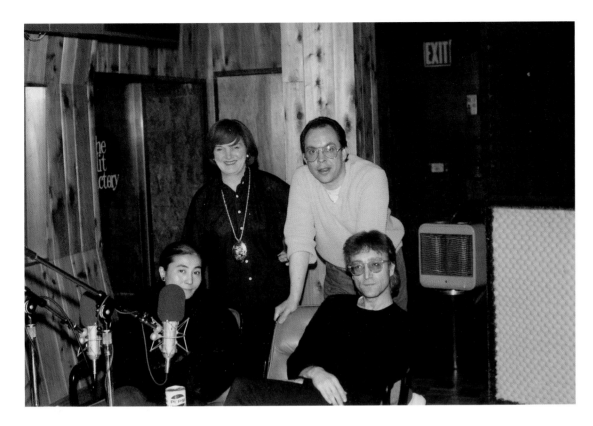

Left: Yoko Ono, Doreen Davies (executive producer for the BBC), Andy Peebles and John pose for our photographer. *Below:* John puts his message across.

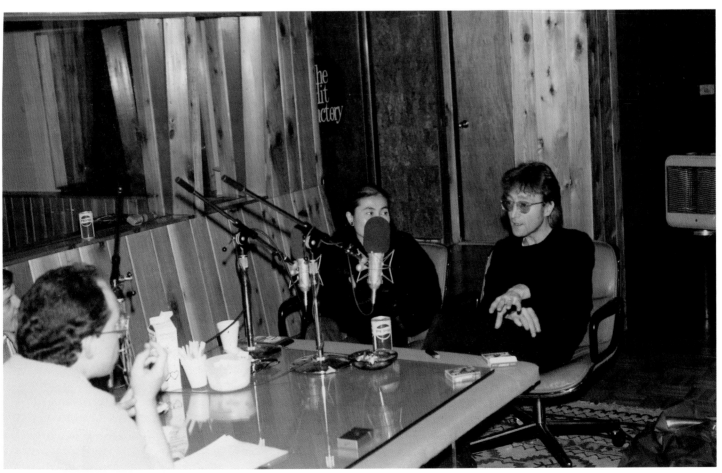

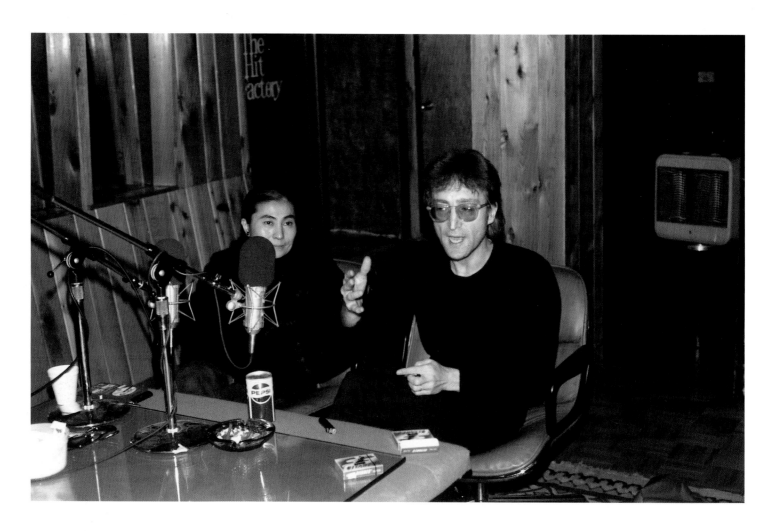

John and Yoko at the
Hit Factory.

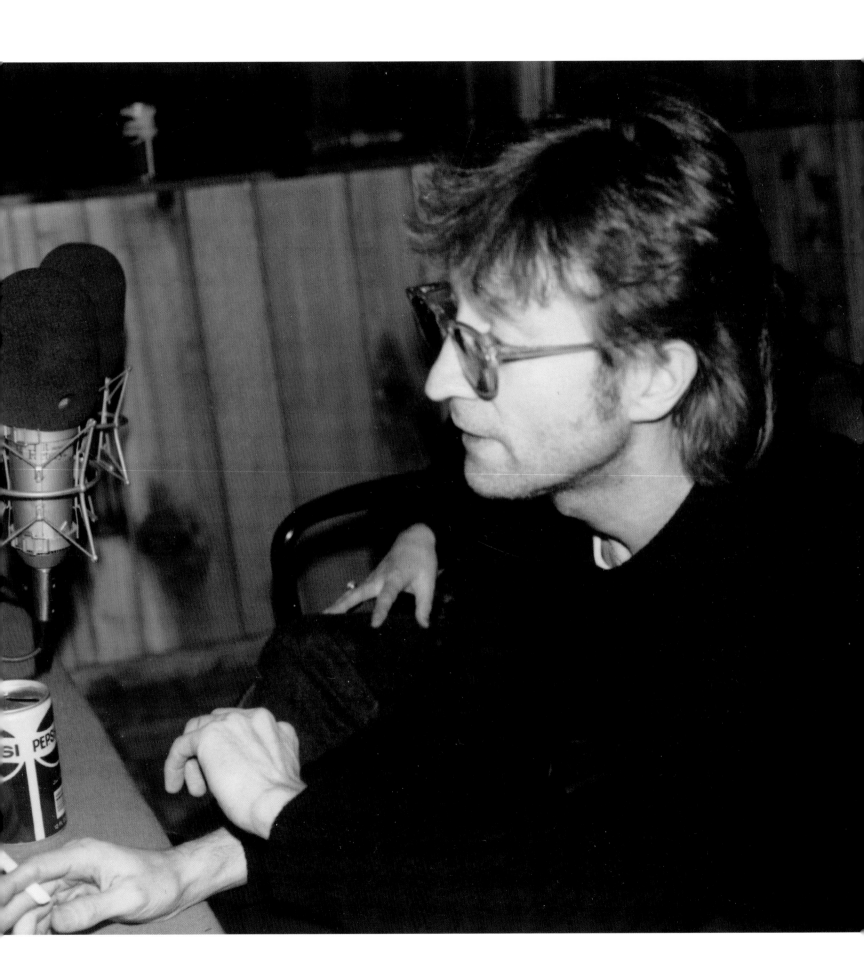

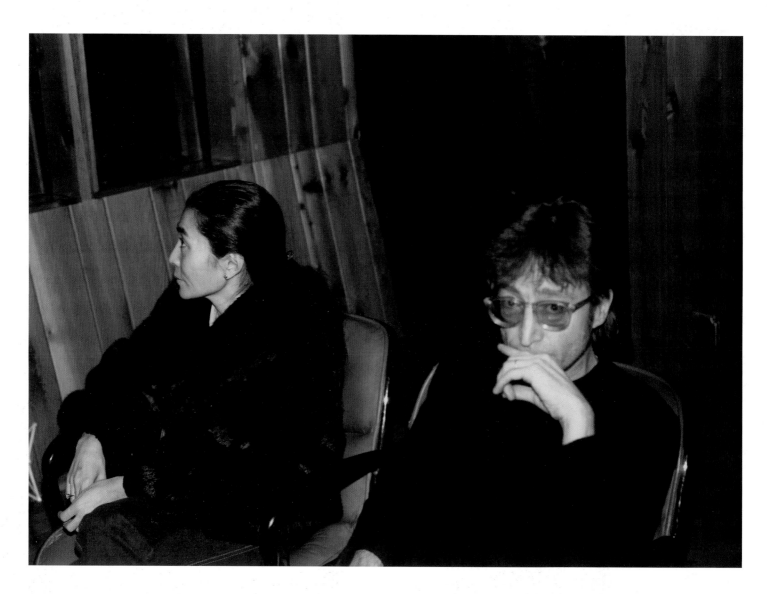

Some of the last
pictures ever taken
of John. 6 December
1980.

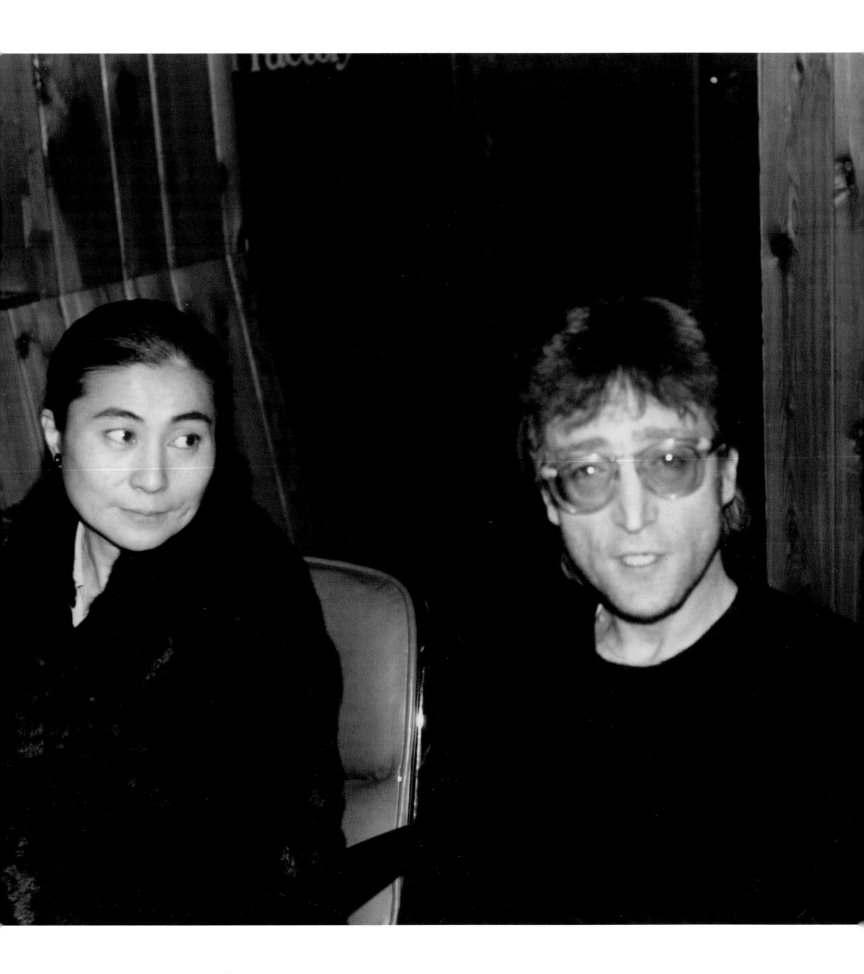

Index

Figures in *italics* indicate captions.

Aalborg, Denmark 344
Abbey Road 337, 340, 341
Abbey Road Studios (EMI Studios), St John's Wood, London 36, 106-7, 164, 165, 173, 204, 207, 286, 291, 294, 295, 306, 307, 310, *313*, *319*, *320*, *329*, 341, 344, 346
ABC Cinema, Manchester *59*
'Across The Universe' 291, 346
Adelaide, Australia 104, 106, 107
press conference 122-35
Adelphi Theatre, Slough 37
Albany Club, London 306
Alex, 'Magic' 65, 292, 293
'All I Want For Christmas Is A Beatle' 38
'All My Loving' 78, 142
All Things Must Pass 347
'All You Need Is Love' 207
Allsop Place, London 223
Americana Hotel, New York 293
Amsterdam 106
Amsterdam Hilton 337
Andrews, Cyrus 40
Animals, The 11, 148
Another Beatles Christmas Show 148, 164
Anthology 11, 27, 53
Apple 11, *42*, 290, 293, 295, 307, 309, 337, *338*, 345, 346, 347
Apple boutique, Baker Street, London 268, 290, 293, 306-7
Apple Tailoring (Civil and Theatrical) 294
Ardmore, Rockferry, Cheshire *18*, *21*
Asher, Jane *278*, 290, 292, 296, *297*, *298*, *305*, *310*, *312*
Asher, Peter 290
Aspinall, Neil 11, *40*, *44*, 106, 173, 225, *280*, 309
Associated Press news agency 344
Astoria Cinema, Finsbury Park, London 38
ATV 337, 340, 341
Australia 104-47
Avalon, Frankie 39
Aztec Services *146*

'**B**ack In The USSR' 295
'Bad Penny Blues' 292
Badfinger 290
Bag One exhibition 344
'Ballad of John And Yoko, The' 337
Bangor, North Wales 207, 220
Bankhead, Tallulah 293
Barron Knights, The 38
Barrow, Tony 174, 200
Bartello, Tony *194*
Bayerischer Hof Hotel, Munich 174
BBC 36, 38, 207, 246, 268, 269, *349*
BBC Light Programme 78
BBC Paris Studios, London 78-9
BBC Radio 1 348
BBC Television Centre 268
BBC1 268, 269, 306
BBCTV 38, 341
Beach Boys 204, 306
Beatlemania 37-8, 39, 104, 106, *116*, 148, 204
Beatlemania show *42*
Beatles, The see White Album
Beatles, The
at the Cavern *28*
Ringo meets them in Hamburg 17
television debut 36, 37
first touring 36, 37
first European tour 37
first US chart-topper 39
successful first visit to US 39
world tour 106
first major tour of America 148
drugs 148, 207, 308
MBEs 165
second North American tour 165
start of 1966 world concert tour 173
last public performance as a working band 201
transcendental meditation (TM) 207
and death of Epstein 220
criticism of *Magical Mystery Tour* 268-9
first biography 291
last public performance (1969) 336

Paul's announcement 346-7
last film 347
Beatles Book Monthly, The 173
Beatles Christmas Show 38
Beatles Come To Town 59
Beatles For Sale 148, 164
Beatles Monthly magazine *278*
Beggars Banquet 307
Bel Air, Los Angeles 165
Bennett, Cliff 173
Berkeley, Busby 225
Bernstein, Sid 201
Best, Pete 28, 29
Between The Buttons 209
Billboard chart 164, 307
Billboard magazine 148
Billy J. Kramer & The Dakotas 38
Black, Cilla 38
Black, Peter 268
Blackpool *49*
Blackwell, Rosemary 104
Blake, Peter 6, 207
'Blue Suede Shoes' 338
'Blue Jay Way' *236*
Bombay 201, 290
Bonhams auctioneers, Lots Road, Chelsea, London 6, *151*, *159*, *194*
Bonython, Kym 107
Bonzo Dog Doo-Dah Band, The 223
Booker T & The MGs 200
Bowie, David 6, 348
Boyd, Jenny 292
Boyd, Patti 82, *92*, *95*, 165, 172, 207, 292, 293, 306, *322*, *323*, 337
'Boys' 78
Brambell, Wilfrid 84, *86*, *88*, *90*
Bramwell, Tony 205, 345
Bravo, Lizzie 291
Brian, Ty *30*
Brodax, Al *178*
Brodziak, Ken 107
Brooks, Elkie 148
Brown, Joe 106
Brown, Peter 309
Bryan, Dora 38
Buckingham Palace, London 165, 341
Buckle, Richard 38
Busch Stadium, Saint Louis 200
Butlins holiday camp, Pwllheli,

Wales 17
Butlins holiday camp, Skegness, Lincolnshire *30*, *32*
Byrds, The *148*
Byrnes, John 17

Caerog, North Wales 296-305
Camden Lock market, London 6
Candlestick Park, San Francisco 201
Candy 309
'Can't Buy Me Love' 107
Capitol Records 39, 341
Capitol Records Tower, Los Angeles 200
Carson, Jan 223
Carson, Johnny 293
Cavendish Avenue, St John's Wood, London *278*, 310, *310*, *313*, 345
Cavern Club, Liverpool *28*
Caxton Hall Register Office, London 164
CBS TV 39
Centennial Hall, Adelaide 107, *138*, *142*
Chapel Street, Belgravia, London 206, 220
Charles, Tommy 198
Chelsea Manor Studios, London 207
Chelsea Town Hall, London 340
Chester, Johnny 107
Christie's auctioneers, Old Brompton Road, London 6, 11, 53, *65*, *86*, *102*, 104, *171*, *240*
Circus Krone, Munich 174
Clapton, Eric *65*, *92*, 207, 307, 309, 338, 341
Cleave, Maureen 172, 173
Cleopatra (film) 88
Cliff Bennett & The Rebel Rousers 173
Cochran, Eddie 16
'Cold Turkey' 338, 341
Coleman, Ray 206-7
Collins, Phil *92*
Colston Hall, Bristol 341
'Come Together' 341
Connaught Hotel, Wolverhamton 247
Cooper, Jim 198
Cooper, Michael 207

Cooper Owen auctioneers, Egham, Surrey *159*
Cornwall 223, 226-37
Cow Palace, San Francisco 165
Cox, Kyoko 337, 340, 344
Cox, Tony 337
Crawford, Janet 270, *270*
Cream 207, 220, 307
Cropper, Steve 200
Cutler, Ivor 225, *235*

Daily Express 38, 268
Daily Mail 268, 269
Daily Mirror 37, 38, 345, 346
Daily News 39
Datebook magazine 198
Davies, Doreen *349*
Davies, Hunter 291
Davis, Rod 15
'Day In The Life, A' 206, 207
'Day Tripper' 165, 172
De Young Museum, San Francisco *239*
'Dear Prudence' 295
Dee, Simon 306
Dee Time (television show) 306
Delaney & Bonnie 341
Delilio, Richard 309
Delminico Hotel, New York 148
Denmark 106, 107, 109, 344
Devlin, Johnny 107
Devon 223
Dietrich, Marlene 56, *56*
Disc & Music Echo 40, 341
'Dizzy Miss Lizzy' 338
Dodd, Ken *61*
Dodger Stadium, Los Angeles 200
Dominion Theatre, Tottenham Court Road, London *88*
Doncaster 66-77
Donegan, Lonnie 14
Donovan 292
'Don't Pass Me By' 295
Doors, The 306
Douglas, Kirk 67
Dream sequence 222, *242*
Dublin 84
Dundee 52-5
Dylan, Bob 6, 148, 165, 340

Eastbourne 224
Eastman, John 336
Eastman and Eastman 336-7
Easy Beat 36
Ed Sullivan Show, The 39
Egmond, Wally 17
'Eleanor Rigby' 199
Elephant Man, The 348

Elizabeth, Queen, the Queen Mother 37, 56
Elizabeth II, Queen 125, 165, 269, 341
Emerick, Geoff 173
EMI 36, 206, 291, 292, 307, 309, 337
Empire Pool, Wembley, London *99*
Epstein, Brian 39, 106, 107, 108, 123, 125, 164, 165, 172-5, 198-9, 201, 204-7, 220, 222, 337
Equity 82
Esher, Surrey *270, 327*, 337
Esher Register Office 172
Essen 174
Evans, Mal *55, 157, 163*, 173, 175, *210*, 222, 225, *245*, 247, *248, 276*, 290
Evening News 268
Evening Standard 172, 198
Express, L' magazine 165

Family Way, The (film) 201
Farrow, Mia 292
Fellini, Federico 224
Festival Hall, Melbourne 109
Filming Today 205
Fleetwood, Lancashire *15, 24*
Fleetwood, Mick *159*
Fleetwood Mac *159*
Fleetwood Owen *159*
Fool, The 293
For Love Or Money (film) *67*
'For You Blue' 344
Forsyth, Bruce 269
Fourmost, The 38
Fox's Coaches of Hayes 224
Freddie & The Dreamers 148
Freeman, Robert 164, 166, *190*
Frees, Paul *176*
Friar Park, Henley *322*, 345
Friends 341
Fr'isco Pete 309
'From Me To You' 37
From Us To You radio show 38, *78*
Fury, Billy 17, 106

Garagiola, Joe 293
Garcia, Antonio and Maria 220
Garry, Len 15
Gaumont Cinema, Doncaster *66-77*
Gaumont Cinema, Liverpool 347
Gaumont Cinema, Southampton *154*
George, Uncle (John's uncle) *23*
George V Hotel, Paris 38, 39, 81

Germany 173-4
Gerry & The Pacemakers 37
'Get Back' 336, 337
Get It Back 336
Gibraltar 337
Ginsberg, Allen 337
Goldmann, Peter 205, 208, *213*, 216
Golspie, Scotland 340
'Good Vibrations' 204
Granada TV Studios, Manchester 60-1
Greco, Buddy *56*
Green, James 268
Griffiths, Eric 15
'Guitar Boogie' 16
Guitar, Johnny *30*

Halliday, Johnny *81*
Hamburg 17, 174, 205, 291
Hammersmith Odeon, London 148, 164
Hampshire 223
Hampstead, London *326*
Hanratty, James 341
Hanton, Colin 15
Hanway Street, London *151*
Hard Day's Night, A (film) 11, 38-9, 82-98, 106, 125, 164, 205, 224
Harris, Rolf 38, *78*
Harrison, George
 meets Paul at school 16
 his group 16-17
 apprentice electrician 17
 at the Cavern *28*
 guitars *140, 142*
 proposes to Patti Boyd 165
 marries Patti Boyd 172
 buys a sitar from Rikhi Ram *193*
 spends time with Shankar 201
 comments on Abbey Road 204
 and *Raga* 295
 on the *White Album* 308
 fined for possession of cannabis 337
Haslam, Mike 148
Heinemann 291
'Hello, Goodbye' 269, 290
Hell's Angels 309
Help! (film) 164, 166-71, *190*, 192, 224
Hendrix, Jimi 6
Herald Tribune 39
Here We Go 36
'Hey Jude' 307
Hit Factory, New York 348-53
Holland 109

Holly, Buddy 16
Hollywood Bowl, Los Angeles 148, 165
Hong Kong 106, 109
How I Won The War (film) 200, 201, 285
Howerd, Frankie 269
Howes, Arthur 201
Humperdinck, Engelbert 205
Hylton, Jack 306

'**I** Am The Walrus' 224, *239, 248, 253*
'I Feel Fine' 148, 164
'I Me Mine' 344, 346
'I Saw Her Standing There' *78*, 107
'I Want To Hold Your Hand' 37, 38, 39, *78, 81*, 107
'I Want You' (later 'I Want You [She's So Heavy]') 337
'I'm A Believer' 204
India 192, *192-7*, 201, 220, 292-3, 294
'Inner Light, The' 290
'Instant Karma! (We All Shine On)' 344
Intertel Studios, Wembley, London 309
Irwin, Mayor 107, 123
Isle of Wight Festival 340
ITN 207
'It's So Easy' 16-17
It's The Beatles (television special) 38
ITV 36, 269
Iveys, The 290

Jackley, Nat 228
Jackson, Michael 151
Jagger, Mick 207, 307
James, Dick 337
Jewel, Derek 204
John Lennon/Plastic Ono Band 345
John Lennon/Plastic Ono Band 347
Johnny & The Moondogs 17
Johns, Glyn 337
Jones, Brian 272
Juke Box Jury (television show) 38
'Julia' 21

Kaiserkeller night club, Hamburg 17
Kass, Ron 290
Kennedy Airport, New York 39
Kenwood, St George's Hill estate, Weybridge, Surrey *275*, 293
Kesey, Ken 222

King, Jonathan 348
King Features 176
Klein, Allen 336, 337, 340, 346, 347
Knole Park, Sevenoaks, Kent 205, 208, *209*, 217
Kramer, Billy J. 38
Ku Klux Klan 200

'Lady Madonna' 290, 292
Lady Mitchell Hall, Cambridge 337
'Layla' *92*
Layton, Doug 198
Leary, Dr Timothy 337
Leeds 148, 152-3
Leila (John's cousin) *15, 18*
Lennon, Cynthia *180, 189, 274,* 291-4, 308, *325,* 340
Lennon, John
 childhood 14-15
 at art college 14, 17
 The Quarry Men 15-16
 meets Paul 16, 26
 on Christianity 172-3, 198-201
 appears in a Lester film 201
 meets Yoko 201
 entertains Yoko 293-4
 arrested for drug possession 308
 marries Yoko 337
 returns his MBE 341
 last public performance in Britain 341
 accident in Scotland 340
 announces that leaving the group 340
 death 348
Lennon, Julia 14-15, *21*
Lennon, Julian *274, 275,* 307, *324, 325,* 340
Lester, Richard 38-9, 81, 82, *94,* 164, 200, 201, 205
'Let It Be' 344, 345
Let It Be 336, 340, 344-7
Let It Be (semi-documentary) 347
Levis, Carrol 17
Lewis, Vic 174, 175
Live Peace in Toronto 338, *338,* 341
Liverpool 165, 204
Lockwood, Sir Joseph 291, 308
London Arts Gallery, New Bond Street, London 344
London Palladium 83
London Pavilion 347
Long, Don 208, *209, 210*
'Long And Winding Road, The' 346
'Long Tall Sally' 107, 124

Loot magazine 194
Los Angeles 295
Loss, Joe *56*
'Love Me Do' 16, 36, 40
Lyceum Ballroom, London 341
Lyttelton, Humphrey 292

Mackernan, Paul 246, 247, *247, 248, 250*
MacMillan, Iain 340
Magical Mystery Tour 220, 222-67, *240,* 268-9, 291, 341
Maharishi Mahesh Yogi 207, 225, 292-3, 294
Malacanang Palace, Manila 174
Manchester 58-9
Manila, Philippines 174-5, 198
Marcos, Imelda 174
Marcos, President 174
'Mark I' 173
Marlborough, Douglas 268
'Martha My Dear' *282*
Martin, George 36, 37, 106, 107, 164, 173, 204-6, 295, 340, 341, 344
Marylebone Register Office, London 337
Marylebone Station, London *86, 94, 96*
'Maxwell's Silver Hammer' 340
Maycock, Stephen *159*
McCartney 345-6, 347
McCartney, Angela (née Fishwick) 296, *297*
McCartney, Heather (Linda's daughter) *332*
McCartney, Jim 396
McCartney, Linda (née Eastman) 206, 293, *312, 332,* 336
McCartney, Mike (Mike McGear) 295, *297*
McCartney, Paul
 meets John 16, 26
 learns to play the guitar 16, 26
 his guitar *140*
 interest in Indian music *196*
 composes for *The Family Way* 201
 admits to drug use 207
 meets Linda 206
 splits with Jane Asher 306
 marries Linda 337
 first solo album 341
 dispute over *McCartney* 345-6
 leaves the group 346-7
 High Court proceedings 347
McCartney Productions Ltd 347
McDonald, Phil 173
McGear, Mike *see* McCartney, Mike

Melbourne, Australia 108
Melody Maker 164, 340
Mendips, Woolton, Liverpool *23*
Merry Pranksters 222
Mid South Coliseum, Memphis, Tennessee 200
Mike Cotton Sound, The 148
Mills, Hayley 201
Mills, Sir John 201
Milton, Andrew *151*
Mimi, Aunt (John's aunt) 14, 18, *21,* 23, *23,* 341
Mirabelle magazine 11, *148*
Mitchell, Mitch 309
'Money' *78,* 338
Monkees, The 204
Montague Square, London 308
Moon, Keith 207, 341
Moore, Roger *99*
Mount Rushmore, South Dakota 295
Munich, Germany 173

Nassau, Bahamas 164
NEMS 337
New Century Artists Ltd *32*
New Clubmoor Hall, Norris Green, Liverpool 16
New Delhi, India 192-7
New Musical Express (NME) 307
 end-of-year readers' poll 204
 poll winners' concert 99, 173
New York 293, 309, 348
New Zealand 109
Nicol, Jimmy 104-9, *110, 114, 117,* 123-5, *124, 126*
Northern Songs 337, 340, 341

Obertauren, Austrian Alps 164
O'Brien, Charlie 17
Odeon Cinema, Cheltenham 37
Odeon Cinema, Leeds *152*
Oh! What A Lovely War (play) 225
Olympia Theatre, Paris 38, 39, 80-1
O'Mahoney, Sean 173-4
Ono, Yoko 201, *220, 275, 287,* 293-4, 295, 306, 308, *334,* 337, *338,* 340, 344, 345, 347, 348, *348, 349, 350*
Orbison, Roy 37, *148*
Our World (television spectacular) 205
Owen, Alun 81, 84, *84*
Owen, Ted *159*

Paddington Station, London 82, *86*
Pagination, Don *171*

Pallenberg, Anita *272*
Parkes, Stanley *15,* 18, *18, 21, 23*
Parlophone 295
Pathé News *59*
'Peace for Christmas' gig (1969) 341
Pease, Gayleen 291
Peebles, Andy 348, *348, 349*
Peggy Spencer Formation Team 225
'Penny Lane' 204, 205, 208, 216-19
Percival, Lance *176*
Peter & Gordon 290
Phantoms, The 107
Phillips auctioneers, Salem Road, London 6, *100, 151*
Plastic Ono Band, The 340, 341, 345
Plastic Ono Supergroup, The 341
Plaza Hotel, New York 39
Please Please Me 36, 38
'Please Please Me' 36-7, 40
'Please Release Me' 205
Polaroids *259*
Port of Spain, Trinidad 172, *183*
Portman Estate, London 293
Presley, Elvis 39, 148, 165
Preston, Billy 341
Primrose Hill, London *288*
Prince of Wales Theatre, London 37, 56, *56*
Pwllheli, Wales 17

Quarry Men Skiffle Group, The 15-16, *26*
Queen *88*
Queen's Hotel, Eastbourne 224
Quickly, Tommy 38

Raga (film) 295
Ram, Rikhi *193*
Raymond, Paul 223
Raymond's Revue Bar, Soho, London 223
Rebels, The 16
Record Producer magazine 205
Redifussion television *100*
Reine Elizabeth Hotel, Montreal 337
'Revolution 1' 295, 307
Revolver 6, 173, 174, 199, 200, 205, 207
Richard, Cliff 11, 39
Richard, Keith 207, 309
Rikhi Ram & Sons *193*
Rishikesh, India 292
Rizal Memorial Football Stadium,

Manila 174
Rock & Roll Revival Concert, Toronto, Canada 340
Rock and Roll Circus 309
'Rock and Roll Music' 174
Rock Around The Clock 269
'Rock Island Line' 14
'Roll Over Beethoven' *78*
Rolling Stone 292, 336, 341
Rolling Stones, The 6, 198, 207, *209, 272*, 307, 309, 446
Rory Storm & The Hurricanes 17, 30, *30, 32*
Rosebery Street 'Empire Day' outdoor celebration, Liverpool (1957) 15
Rossington, Norman 84
Royal Court Theatre, London 40, *42*, 56-7
Royal Lancaster Hotel, London 306
Royal Variety Performance 37, 56
Rubber Soul 6, 165, 172, 173
Russell, Ethan 340

St John's Wood, London 204, 220, *278*
St Peter's Church, Woolton, Liverpool 16, *26*
Saint, The (television series) *99*
San Francisco Chronicle 198
Sanchez, Tony 307
Saturday Club 36
Savile, Jimmy 148
Savile Row, London 306, 309, 336, 337, 346
Scaffold, The 296
Scala Theatre, London *83, 98*
Schonfield, Hugh J.: *The Passover Plot* 172
Schwartz, Francie 306
Scotland 17, 340
Sentimental Journey 341
'Sgt Pepper's Inner Groove' 205-6
Sgt Pepper's Lonely Hearts Club Band 6, 201, 204, 205-7, *288*, 294, 308, 341
Shadows, The 36
Shankar, Ravi *193*, 201, 295
Shapiro, Helen 36-7
'She Loves You' 37, 38, *78*
Shea Stadium, New York 165, 200
Shenson, Walter 38, 81, 164
Sheraton Hotel, Manhattan 198
Short, Don 345, 346
Shotton, Pete 15
Shrewsbury Music Hall 44-7
Silver Beatles *29*

sitars 6, 192, *193*, 197
Sloane Square, London 40-3
Small Faces, *146, 148*
Smith, Alan 307
Soho market, London 6
Somerset 223
'Something' 341
Sommerville, Brian *81*
Sotheby's auctioneers, New Bond Street, London 6, *26, 32, 180*, 226, 270, *272*
Sounds Incorporated 107
Southampton 148, 154-63
Southern Cross Hotel, Melbourne 108
Spector, Phil 337, 344-5, 346
Spinetti, Victor *168-71*, 224-5
Spiritual Regeneration movement 207
Starkey, Maureen (née Cox) 164, *185*, 205, 292, 306
Starr, Ringo (Richard Starkey)
 first drum kit 17
 drum lessons 17
 Rory Storm & The Hurricanes 17, 30, *30, 32*
 meets The Beatles 17
 replaces Best (1962) *28*
 Olympia concerts 38
 Nicol stands in for 104, 106-9
 marries Maureen 164
 vacation in the Caribbean 201
 his first Beatles composition 295
 first solo film 309
 dispute over McCartney 345-6
Steele, Tommy 39
Steptoe and Son (television series) *86*
Sticky Fingers 6
Stokes, Jack 176
Storm, Rory 17, *30*, 32
'Strawberry Fields Forever' 205, 208-15, 216
Stregg 246, *247*
Stubbs, Jacqui 246, *247*
Stubbs, Robin 246
Sunday Night At The London Paladium 37, 38
Sunday Times 38
Sunderland 62-5
Surrey 270
Sweden 37, 205, 344
Sydney, Australia 106, 108
Sydney Stadium 109

Taunton, Somerset 82
Taylor, Alistair 220, 222-5, 238, 290, 309, 337
Taylor, Derek *110, 131*, 306, 309,

347
Taylor, Elizabeth *88*
Taylor, Lesley 224
Tetragrammation 309
Thank Your Lucky Stars (television music show) 36, 40
'Think It Over' 16
'This Boy' 107, *146*
Thomas, James 268
'Till There Was You' *78*
Times, The 38, 291, 344
Tittenhurst Park, Sunningale, Berkshire 340
'Tomorrow Never Knows' 173
Tonight Show, The (TV programme) 293
Toronto 338, *338*, 341
Track Records 309
Trafalgar Square, London *322*
transcendental meditation (TM) 207, 225, 292-3
Trident Studios 337
Trinidad 172, 180-91
Trudeau, Pierre 341
Tug-of-War 242
Tumbleweed, Billy 309
TV Week 112
TVC Studios, London 176-9
'Twenty Flight Rock' 16
Twickenham Film Studios 164, 166-71, 224, 336
'Twist And Shout' 56
'Two Virgins' 294

Unfinished *Music Number 1 – Two Virgins* 308-9, 336
Unfinished Music Number 2 – Life With The Lions 337
UNICEF 341
'Untitled' 290
US *Cashbox* singles chart 39

Vartan, Sylvie 38, 81, *81*
Vaughan, Ivan 15, 16
Vesuvio Club, Tottenham Court Road, London 307
Viking pub, Birmingham 246
Vincent, Gene *30*
Voormann, Klaus 6, 205, *338*

Walters, Lou *30*
WAQY radio station, Birmingham, Alabama 198
'War Is Over' 341
Warhol, Andy 6
Warner Brothers 348, *348*
Warwick Hotel, New York 165
'We Can Work It Out' 165, 172

We Will Rock You 88
Weiss, Nat 293
Wembley Studios, London 100-3
West Malling airfield, near Maidstone, Kent 224, 225, 238-45, 246-67
Weston-super-Mare 48-51
'When the Saints Come Marching In' 16
'While My Guitar Gently Weeps' 295, 307
White, Alan *338*
White Album 21, 286, 294-5, 306, 307-8, 340
Who, The *146*, 207
Wildlife Fund of Great Britain 291
Williams, Paul *348*
Williams, Richard 340
With The Beatles 37, 38
'Within You, Without You' 207
WMCA radio station 38
Wonderwall 290
Woolfe, Bob 104
Woolton, Liverpool 16, *23*, 26, *26*

Yardbirds, The 148
'Yellow Submarine' 199
Yellow Submarine 306, 336
'Yer Blues' 309
You Are Here (To Yoko From John Lennon, With Love) exhibition 306
'You Can't Do That' 124
'Your Mother Should Know' 225, *261-5*, 269

Text sources
(information and quotes)

News and music periodicals:
The Beatles Book Monthly, Circus, Daily Express, Daily Mail, Daily Mirror, Melody Maker, Mojo, New Musical Express, Record Collector, Rolling Stone, The Times.

Film, video & radio libraries: BVL Enterprises, BBC, ITN, Movietone News, Reuters and various American radio stations.

A few of the interviews to be found within the pages of this book came from interviews carried out by Keith Badman privately or during one of the many Beatles conventions he has attended over the years.

Acknowledgments

MARK HAYWARD'S THANKS TO:

My beautiful wife from New Zealand, Colleen Hayward, for living with me for ten years, not an easy task; for getting me to organize the Beatle photos to produce this book, while shuffling me from room to room; for her loving smiles, patience and belief in everything I do; for bringing three beautiful girls into this modern world – Grace, Alice and Eve Hayward, who will probably go on to form The Beatlettes.

To my newly found full brother Jonathan and his family Jane, Jessica, Juliette and Jeremy; to what was my eldest brother Anthony, now the middle brother, and his family, Liz, Holly, William and Toby. Also to my late mother for her musical influences.

To Michael Dover, David Rowley and their Publisher of the Year team at Weidenfeld and Nicolson for having the vision to commission this book after only one meeting.

A truly professional team who somehow manage to keep a whole host of artists and writers happy. Not an easy task To Keith Badman, an author I have admired for many years, now on board revealing new Beatles history by looking at these photographs.

To Nigel Soper, Judith More and Catherine Rubinstein for their expertise in layout and editorial.

To Stanley Parkes; Yoko Ono, for taking the time to look at the book before publication; Sir Paul McCartney, who sent a letter from McCartney Productions Ltd wishing us well with this project; Paul Mackernan; Tetsuo Hamada; Paul Wayne; and Cliff Yamasaki, Jeff Leve and Jordi Tarda for their knowledge and influence over twenty-four years of collecting.

And to all the Beatle fans who came to my shop over the decades at Vinyl Experience in Hanway Street in London. If any fans have taken photographs of any music/cultural event, please get in touch: mark@mpc-inc.co.uk

PERSONAL THANKS FROM KEITH BADMAN TO:

Dave Ravenscroft, Pete Nash, Stephen Rouse, Steve Holmes, Simon Lupton, Danny Wall, Terry Rawlings, Chris Charlesworth, Wendy (Espana), Carol Anne Lennie, Catherine Rubinstein (for her superb editing of my text) and to Mark Hayward (for allowing us to see his most wonderful pictures).

First published in Great Britain in 2005
by Weidenfeld & Nicolson
10 9 8 7 6 5 4 3 2 1

A CIP catalogue record for this book is available from the British Library.

ISBN 0 297 84425 3

Design director: David Rowley
Designed by Nigel Soper
Edited by Judith More and Catherine Rubinstein

Printed and bound in Italy

Weidenfeld & Nicolson
The Orion Publishing Group Ltd
Wellington House
125 Strand
London, WC2R 0BB

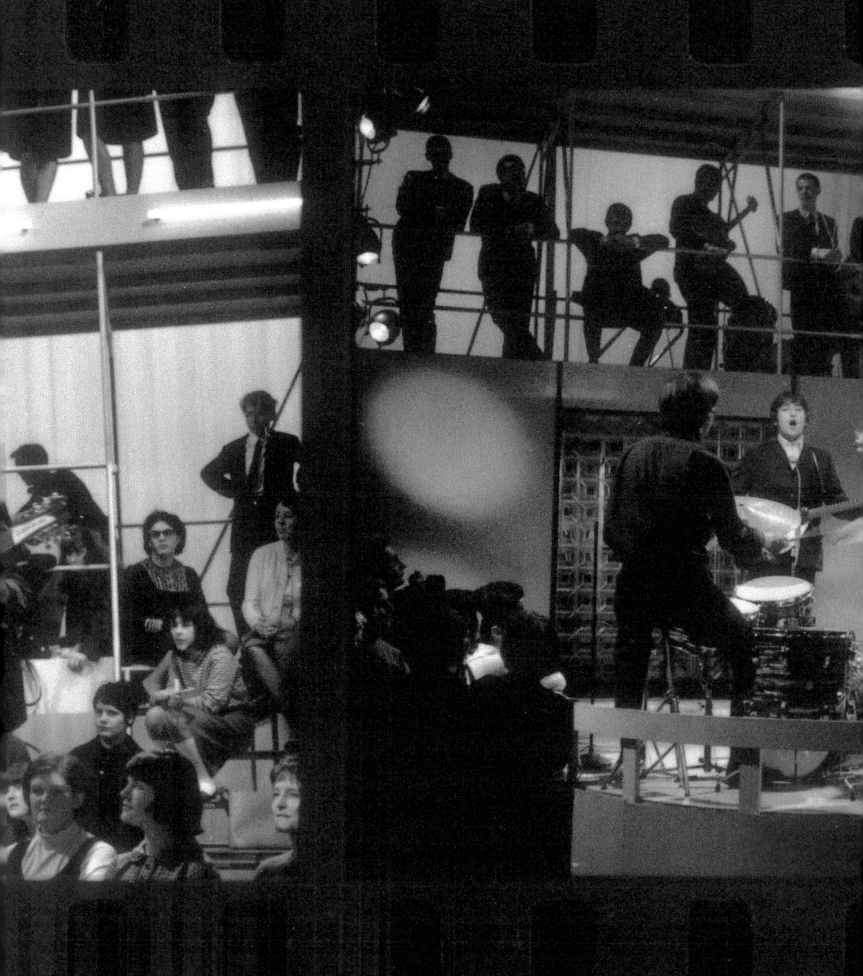